A Field Guide to
PHOTOGRAPHING BIRDS
in Britain and Western Europe

Dr Mike Hill, ARPS
Gordon Langsbury, FRPS

Collins
Grafton Street, London

To our wives Kathy and Joy

William Collins Sons & Co Ltd
London. Glasgow. Sydney. Auckland.
Toronto. Johannesburg

First published 1987
ISBN 0 00 219821 5

Designer: Caroline Hill
Illustrator: Rick Blakely
Colour reproduction by
D.S. Colour International Ltd., London
Typeset by Wyvern Typesetting Ltd., Bristol
Made and printed by William Collins Sons & Co., Glasgow

Contents

The Field Guide to Photographing Birds covers the following countries:

Austria	Greece	Portugal
Belgium	Iceland	Spain
British Isles	Italy	Sweden
Denmark	Luxembourg	Switzerland
Finland	Netherlands	West Germany
France	Norway	Yugoslavia

Acknowledgements

We should like to express our thanks to many friends and correspondents – too numerous to mention individually. We would particularly like to thank Gilly McWilliam, our editor at Collins, and all the following, who have given a great deal of help.

Roger Arnhem and
Bob Jorens, Belgium;

Lief Shak-Nielson, Denmark;

Hannu Hautala and
Olli Näyhä, Finland;

Laurant Duhautois and
Alain Pons, France;

Hans-Dieter Brandl,
Alistair Hill,
Prof. Dr W. Wiltsehko and
Thomas Wünsche, West Germany;

Dr Brinsley Burbidge, FRPS,
Jane Dawson,
David Hosking, ARPS,
Chris and Jo Knights,
Stuart Langsbury,
Fred Marr,
Nigel Phillips
Stewart Taylor,
Ken Tyson,
Ian Walker and
Roger Wilmshurst, ARPS, UK;

Dr Azelio Ortali and
Dr Vittorio Pigazzini, Italy;

A. M. Texeira, Portugal

Our thanks also to Mary Fuller and Lucy Smith for typing, and to Joy Langsbury and Richard Platt for checking the manuscript.

Picture Credits

Dr Mike Hill
Back cover (left), 41, 53 (top left) (top right), 56, 69, 73, 80 (top) (bottom), 81 (bottom), 84, 113, 138 (bottom), 149, 160, 165, 185, 192, 193, 209, 213, 225 (top).

Gordon Langsbury
Front cover, back cover (right), spine, 32 (top) (middle left) (middle right) (bottom left) (bottom right), 33, 37, 45 (left) (right), 53 (bottom), 57, 60, 61, 64 (top) (bottom), 65 (top) (bottom), 72 (top) (bottom), 76 (top) (bottom), 77 (top) (bottom), 81 (top), 85, 89, 92, 93, 97 (top) (bottom), 100, 101, 104, 105, 125 (top) (bottom), 133, 138 (top), 141 (top) (bottom), 144 (top left) (top right) (bottom left) (bottom right), 145 (top) (bottom left) (bottom right), 152, 153, 157, 161 (left) (right), 168, 169, 173 (top) (middle) (bottom), 176, 177, 180, 181 (left) (right), 188, 189, 197 (top) (bottom), 200 (top) (bottom), 204, 205, 212, 216, 217 (left) (right), 221, 225 (bottom), 228, 229, 232 (top) (bottom), 233, 236, 237 (left) (right), 240 (top left) (top right) (middle) (bottom left) (bottom right).

Foreword

by Eric Hosking, OBE, Hon. FRPS, FIIP

Interest in bird photography has flourished, particularly over the past decade. Better photographic equipment is more readily available at not too great an expense, and there is a healthy demand from magazines, book publishers and photographic libraries for really good quality slides. Even the birdwatchers – the serious ornithologists, as well as the twitchers, are no longer confined to their binoculars. They recognize the potential of the camera to record and enhance their observations and study; they have discovered that you learn a tremendous amount about a bird's way of life, its habitat and 'jizz' in the process of striving for a good photograph.

To start in bird photography you need, of course, go no further than your garden or local park – this book will tell you what you need to know to obtain the best possible results, and to take full advantage of the considerable opportunities to be found there. But in addition, by directing you to some of the most fruitful and exciting bird locations in Europe, it inspires you to go further, to meet the new challenges of different species, dramatically contrasting habitats and light conditions.

In fact, this book works very effectively as a travel guide, too. Many of you who are making the most of cheaper European travel and the growing availability of special interest holidays, carry pretty sophisticated camera equipment with you (many take far too much). This guide's **Where to Go** section will lead you to many locations which are reserves or wildlife parks, and where the local landscape and wildlife can be appreciated at its most representative and spectacular. It will also help you to decide what equipment to take and what to leave behind – for too much can be a curse and handicap your movements.

A Field Guide to Photographing Birds really is a very practical combination of ideas. Bird photography is a subject that cries out for individual treatment, and a book like this, that concentrates specifically on the techniques required and the all-important relationship between photographer and the birds themselves, has long been needed. But to tell you where you can actually go to get your pictures too... is a wonderful touch. With the added bonus of the authors' enthusiasm, their skill and first-hand experience – Mike and Gordon are respected in both photographic and birdwatching circles – this book quite simply gives you the information and encouragement to get out into the field. You only have to remember to add that vital ingredient of your own initiative – for almost every photograph you take will need a slightly different approach.

Introduction

The upsurge of interest in wildlife photography has led to a number of books on the subject, and you may ask why another one is necessary. We believe that most of these books omit important *practical* hints that would be of specific interest to the aspiring bird photographer, and none of them gives detailed indications of where you stand a good chance of getting the photographs: this publication fills these gaps.

Recent trends have seen a move away from nest photography because of concern about the disturbance to nesting birds. This remains a debatable point as many feel that a sensible, well-planned approach to nest photography probably causes less harm than, for instance, the chasing of an already exhausted migrant bird across the countryside in an attempt to obtain a portrait away from the nest. However, birds do spend only a small part of the year at the nest site, and our own preference has been to attempt to record some of the other activities of the bird's life-cycle. This preference will become apparent from the text.

As the majority of bird photographers now work with the 35mm format and colour transparencies this book is mainly concerned with the use of these media. Other texts have already dealt quite adequately with the use of larger formats and black and white film materials.

This book assumes a basic understanding of the principles of photography – and there are plenty of basic primers around to fill any gaps. The factual information on techniques, equipment and bird behaviour, as well as many of the ideas based on our own experience, will prove useful to enthusiastic amateurs and experts alike.

With increased experience and ability, many photographers want to share their work with others, either in the form of lectures and exhibitions, or by publication in books and magazines. These pursuits are not only immensely satisfying but may also repay some of the costs involved. So in chapter 8 we discuss at some length our ideas as to how this may best be achieved.

It is our hope that the *Field Guide to Photographing Birds* will allow others to derive as much pleasure as we have from what has become, for us, a total dedication to bird photography.

How to Use the Book

The text of this field guide is broadly divided into two sections. The first covers the actual techniques, advice on how to use your photographs and some discussion on the relevant laws in Britain and Europe. The second section comprises an extensive gazetteer covering Britain and western Europe.

The **Where to Go** section of the book is divided into habitats that broadly reflect the main categories of bird photography – towns, parks and gardens; coast, estuary and islands; inland fresh water; open country; forest and woodland; mountain regions. The introduction to each habitat focuses in on particular techniques, equipment and considerations for photographing the bird species found there. Actual locations are then listed country-by-country in alphabetical order, and numbered to link with the maps on pages 252–256. The maps themselves enable you to see at a glance where the locations are in each country and refer back to the appropriate numbered gazetteer entry. The book covers western European countries only – see the contents page for a list of those included.

Symbols used in the Gazetteer

☛ Basic route directions, accommodation, access, and opening times, contacts

✎ Species – the ones you're most likely to see *and* be able to photograph

📷 The best time for photography, usually seasonal, but time of day where relevant

☎ Telephone (excluding international codes)

The photographs are all taken by ourselves and are intended to illustrate specific photographic points. Technical details are given in each photograph including: camera, lens, film, shutter speed, f-stop, other details of interest, time of year and location.

In the appendix is a list of useful addresses which include nature, conservation and photographic societies throughout Britain and Europe. Before planning a trip to any foreign locations you would be well advised to write to the appropriate organization well in advance for the latest information. Contact addresses which are specific for certain locations are included in that section in the gazetteer.

An extensive bibliography is included and this consists of books and papers which we feel would be worthwhile consulting either for further information on some of the theoretical aspects of photography, for bird identification, or before planning a trip to a specific area. References also include books which contain photographs of particular merit, and

although not necessarily portraying European species, they may prove instructive to the photographer.

The indexes include a technical index, an index of locations and an index of species.

In our choice of locations we have tried to direct you to where the birds are, but this does not, of course, guarantee photographs and some species and locations will be more difficult than others. For instance an accessible seabird colony is likely to be more productive and easier to work than a mountain area. However, those who are really keen will do all they can to gain local knowledge, and find local contacts in order to increase their chances of success in the more difficult or less productive habitats.

Useful Addresses

AUSTRIA
Österreichische Gesellschaft für Vogelkunde,
Naturhistorisches Museum, A-1014 Wien 1,
Burgring 7, Postfach 417.

BELGIUM
Comité de Coord, pour la Protection des oiseaux (CCPO), Durentijdlei 14, 2130 Brasschaat,
Antwerp.

BRITISH ISLES
British Ornithologists' Club, c/o British
Ornithologists' Union, Zoological Society of
London, Regent's Park, London, NW1 4RY
☎ (01) 586 4443
British Ornithologists' Union, Zoological Society
of London, Regent's Park, London, NW1 4RY
☎ (01) 586 4443
British Trust for Ornithology, Beech Grove,
Station Road, Tring, Herts, HP23 5NR
☎ (044 282) 3461
Field Studies Council, Preston Montford,
Montford Bridge, Shrewsbury, SY4 1HW
☎ (0743) 850674
Irish Wildbird Conservancy, Southview, Church
Road, Greystones, Co. Wicklow, Dublin
☎ (0001) 875759
National Trust, 42 Queen Anne's Gate, London,
SW1H 9AS ☎ (01) 222 9251
Northern Ireland Office, Rowallane, Saintfield,
Ballynahinch, Co. Down ☎ (0238) 510721
National Trust for Scotland, 5 Charlotte Square,
Edinburgh, EH2 4DU ☎ (031) 226 5922
Nature Conservancy Council, Northminster
House, Peterborough, PE1 1UA ☎ (0733) 40345
Scottish Office, 12 Hope Terrace, Edinburgh,
EH9 2AS ☎ (031) 447 4784
Wales Office, Plas Penrhos, Penrhos Road,
Bangor, Gwynedd, LL57 2LQ ☎ (0248) 355141
Nature Photographers' Portfolio, Secretary;
A. Winspear-Cundall, 8 Gig Bridge Lane,
Pershore, Worcs, WR10 1NH ☎ (0386) 552103
Nature Photographic Society, Secretary; Tommy
Tomlinson, Merton Lodge, Baker's Hill, Tiverton,
Devon, EX16 5BS ☎ (0884) 254 227
Royal Photographic Society (Nature Group),
The Octagon, Milsom Street, Bath, BA1 1DN
☎ (0225) 62841

Royal Society for Nature Conservation, The
Green, Nettleham, Lincoln, LN2 2NR
☎ (0522) 752326
Royal Society for the Protection of Birds, The
Lodge, Sandy, Beds, SG19 2DL ☎ (0767) 80551
Scottish Ornithologists' Club, 21 Regent Terrace,
Edinburgh, EH7 5BT ☎ (031) 556 6042
Scottish Wildlife Trust, 25 Johnston Terrace,
Edinburgh, EH1 2NH ☎ (031) 226 4602
35mm Postal Club, Secretary; Mrs. Elaine Hill,
66 Spiceland Road, Northfield, Birmingham,
B31 1NT ☎ (021) 475 5735
**United Photographic Postfolios of Great Britain
(Natural History Colour Circle 2),** Secretary;
E. E. Emmett, Beck House, Hornby Road, Caton,
Lancaster, LA2 9QR
Wildfowl Trust, Slimbridge, Gloucester, GL2 7BT
☎ (045) 389 333
World Wildlife Fund, 11–13 Ockford Road,
Godalming, GU7 1QU ☎ (048 68) 20551
Zoological Photographic Club, Secretary; Martin
B. Withers, 93 Cross Lane, Mountsorrel,
Loughborough, LE12 7BX ☎ (0533) 302281

DENMARK
Dansk Ornithologisk Forening,
Vesterbrogade 140, 1620 Copenhagen V.

FINLAND
Ornitologiska Föerningen, P. Rautatiekatu 13,
SF-00100, Helsinki 10.

FRANCE
Ligue Française pour la Protection des Oiseaux,
La Corderie Royale, BP 263, F-17315 Rochfort.
Société d'Etudes Ornithologiques, Ecole Normale
Supérieure, Laboratoire de Zoologie,
46 rue d'Ulm, F-75230 Paris.
Société Nationale de Protection de la Nature,
57 rue Cuvier, 75221 Paris.
Société Ornithologique de France, Muséum
National d'Historie Naturelle, 55 rue de Buffon,
75005 Paris.

GERMANY
Dachverband Deutscher Avifaunisten,
Bundesdeutscher Seltenheitenausschuss,
Albrecht-Haushofer-Str. 10, 3200 Hildesheim.

Deutsche Ornithologen-Gesellschaft,
Hardenbergplatz 8, 1000 Berlin 30.
Deutscher Bund für Vogelschutz (DBV),
Achalmstrasse 33a, D7014 Kornwestheim.

GIBRALTAR
Gibraltar Ornithological Society, c/o Gibraltar
Museum, Bomb House Lane.

GREECE
Hellenic Ornithological Society, Kyniskas 9,
Athens 502.

ICELAND
Museum of Natural History, PO Box 5320,
125 Reykjavík.

ITALY
Centro Italiano Studi Ornitologici, c/o Instituto di
Zoologica, Via dell'Università 12, 43100 Parma.
**Lega Italiana per la Protezione degli Uccelli
(LIPU),** Lungarno Guicciardini 9, Firence,
Or Vicolo San Tiburzio 5A, 43100 Parma.
Societa Italiana di Scienze Naturali, Museo Civico
di Storia Naturale, Milan.
Societa Ornitologica Italiana (SOI),
Via de Roma 13, Ravenna-Logetta, Lombardesca.

LUXEMBOURG
**Ligue Luxembourgeoise pour la Protection de la
Nature et des Oiseaux,**
BP 709, 2017 Luxembourg.

MALLORCA
Grup Balear d'Ornitologia (GOB),
c/Veri 1–3, Palma.

NETHERLANDS
Nederlandse Ornithologische Unie,
Sec. A. L. Spaans, Sylvalaan 12, 6818 RB,
Arnhem.
**Nederlandse Vereniging tot Bescherming van
Vogels,** Dreibergseweg 16C, 3708 JB Zeist.
Stichting Dutch Birding Association, Postbus 473,
2400 AL Alphen aan den Rijn.

NORWAY
Norsk Ornitologisk Forening, Innherredsveien
67A, 7000 Trondheim.

PORTUGAL
Centro Estudos Migracoes e Proteccao des Aves,
Rua de Lapa 73, 1200 Lisbon.

SPAIN
CODA, Aizgorri 5, Madrid 28.
**Inst. Nacional Para la Conservación de la
Naturaleza,** Gran via de San Francisco 35,
Madrid 5.

SWEDEN
Sveriges Ornitologiska Forening, Runebergsgaten
8, 11429 Stockholm.
Swedish Society for the Conservation of Nature,
Box 6400, S11382 Stockholm.

SWITZERLAND
**Schweizerische Gesellschaft fur Vogelkunde and
Vogelschutz,** c/o Frau Heidy Jenni, Im Dentschen
19, 4207 Bretzwil.
**Societie Romande por l'etude et la Protection des
Oiseaux,** Case Postale 548 1401 Yverdon,
CCP 20-117 Neuchâtel.
Verband Schweizerischer Vogelschutzvereine,
Secretary: Agnes Grunvogel, Gablerstrasse 36,
8002 Zürich.

YUGOSLAVIA
Institute of Ornithology, Yugoslav Acad. of
Sciences, Ilirsk trg. 9, Zagreb 1.

INTERNATIONAL ORGANIZATIONS
Fauna and Flora Preservation Society,
c/o Zoological Society of London, Regents Park,
London, NW1 4RY ☎ (01) 586 0872
International Council for Bird Preservation,
219c Huntingdon Road, Cambridge, CB3 0DL.
International Federation of Wildlife Photography,
60 rue des archives, 75003 Paris.
**International Union for the Conservation of
Nature and Natural Resources,**
1196 Gland, Switzerland.
Scandinavian Ornithologists' Union,
Dept. of Animal Ecology, Ecology Building,
S-223 62 Lund, Sweden.
World Wildlife Fund, 1196 Gland, Switzerland.

Further Reading

**BIRD AND WILDLIFE
PHOTOGRAPHY TEXTS**
Angel, H. Nature Photography –
its Art and Techniques, Fountain
Press, 1972.
Boufle, J.-M. and **Varin, J.-P.**
Photographing Wildlife, Kaye
and Ward, 1972.
Freeman, M. Wildlife and Nature
Photography, Croom Helm, 1981.
Freeman, M. The Wildlife and
Nature Photographer's, Field
Guide, Croom Helm, 1984.
Gibbons, B. and **Wilson, P.**
The Wildlife Photographer –
A Complete Guide,
Blandford Press, 1986.
Hosking, E. and **Newberry, C.**
The Art of Bird Photography,
Country Life, 1948.
Hosking, E. and **Newberry, C.**
Bird Photography as a Hobby,
Stanley Paul, 1961.

Hosking, E. and **Gooders, J.**
Wildlife Photography – A Field
Guide, Hutchinson, 1973.
Izzi, G. and **Mezzatesta, F.**
The Complete Manual of
Nature Photography,
Victor Gollancz, 1981.
Launchbury, K. Nature
Photography, Focal Press, 1983.
Marchington, J. and **Clay, A.**
An introduction to Bird and
Wildlife Photography,
Faber and Faber, 1974.
Preston-Mafham, K. Practical
Wildlife Photography, Focal
Press.
Richards, M. The Focal Guide to
Bird Photography, Focal Press,
1980.
Shaw, J. The Nature
Photographer's Complete Guide
to Professional and Field
Techniques, Amphoto, 1984.

Turner Ettlinger, D. M. Natural
History Photography, Academic
Press, 1974.
Warham, J. The Technique of
Bird Photography, Focal Press,
1983 (4th ed).

IDENTIFICATION
Cramp, S., Simmons, K. E. L. et
al. The Birds of the Western
Palearctic. Oxford University
Press, Vols. 1–4 1977 onwards.
**Ferguson-Lees, J., Willis, I.,
Sharrock, J. T. R.** The Shell Guide
to the Birds of Britain and Ireland,
Michael Joseph, 1983.
Flegg, J., Hosking, E. and **D.**
Which Bird? – Birds of Britain and
Ireland, Deanes International
Publishing, 1986.
Grant, P. Gulls; A Guide to
Identification, T. and A.D. Poyser,
1986 (2nd ed).

Hammond, N. and **Everett, M.** Birds of Britain and Europe, Pan Books, 1985 (2nd ed).
Harrison, P. Seabirds: An Identification Guide, Croom Helm, 1985.
Hayman, P., Marchant, J., Prater, A. Shorebirds – An Identification Guide to the Waders of the World, Croom Helm, 1986.
Heinzel, H., Fitter, R., Parslow, J. The Birds of Britain and Europe, Collins, 1985 revised.
Jonsson, L. Birds of the Mediterranean and Alps, Croom Helm, 1982.
Peterson, R., Mountfort, G., Hollom, P. A. D. A Field Guide to the Birds of Britain and Europe, Collins, 1983 (4th ed).
Pforr, M., Limbrunner, A. The Breeding Birds of Europe – A Photographic Handbook, Croom Helm, 1981/82.
Porter, R., Willis, I., Christensen, S., Nielsen, B. P. Flight Identification of European Raptors, T. and A.D. Poyser, 1981 (3rd ed).

LOCALITIES
Alden, P., Gooders, J. Finding Birds Around the World, André Deutsch, 1981.
Bayliss Smith, S. Wild Wings to the Northlands, Witherby, 1970.
Butler, D. Isle of Noss, Garth Estate, 1982.
Belfast RSPB Members' Group. Birds Beyond Belfast, RSPB, 1985.
Belfast RSPB Members' Group. Birds Around Belfast, RSPB, 1981.
Campbell, B., Ferguson-Lees, J. A. Field Guide to Birds' Nests, Constable, 1972.
Cunningham, P. Birds of the Outer Hebrides, The Melven Press, 1983.
Duffey, E. National Parks and Reserves of Western Europe, MacDonald and Company.
Ferguson-Lees, J., Hockliffe, Q., Zweeres, K. A Guide to Birdwatching in Europe, The Bodley Head.
Gantlett, S. J. M. Where to Watch Birds in Norfolk, S. J. M. Gantlett, 1985.
Gooders, J. The New Where to Watch Birds, André Deutsch, 1986.
Gooders, J. Where to Watch Birds in Britain and Europe. André Deutsch, 1970.
Gordon Booth, C. Birds in Islay, Argyll Reproductions, 1981.
Hammond, N. RSPB Nature Reserves, RSPB, 1983.
Handrinos, G., Demetropoulos, A. Birds of Prey of Greece, Efstathiadis Group.
Hunt, D. A Guide to Birdwatching in the Isles of Scilly, J.G. Sanders, 1978.

Hywell-Davies, J., Thom, V. Guide to Britain's Nature Reserves, Macmillan, 1984.
Lack, P. The Atlas of Wintering Birds in Britain and Ireland, T. and A.D. Poyser, 1986.
Meek, E. Islands of Birds – A Guide to Orkney Birds, RSPB, 1985.
Nethersole Thompson, D. Highland Birds, Highlands and Islands Development Board, 1978.
Norman, D., Tucker, V. Where to Watch Birds in Devon and Cornwall, Croom Helm, 1984.
Ogilvie, M. A. The Bird Watcher's Guide to the Wetlands of Britain, B. A. Batsford, 1979.
Parslow, J. Birdwatcher's Britain, Pan Books/Ordnance Survey, 1983.
Roberts, P. Birds of Bardsey, 1985.
Sanders, J., Berg, K. A Guide to Bird-Watching in Sweden, J.G. Sanders.
Sanders, J., Berg, K. A Guide to Bird-Watching in Denmark, Fack. Stockholm, 1976.
Sharrock, J. T. R. The Atlas of Breeding Birds of Britain and Ireland, BTO and Irish Wildbird Conservancy, 1976.
Shepherd, M. Ornitholidays' Guide Series: 1. Let's Look at Montenegro, 1975 / 2. Let's Look at Lapland and Arctic Norway, 1979 / 3. Let's Look at North-East Greece, 1981 / 4. Let's Look at South West Spain, 1983 / 5. Let's Look at Eastern Austria, 1985. Ornitholidays.
Taylor, D. Birdwatching in Kent, Meresborough Books, 1985.
Tulloch, B., Hunter, F. A Guide to Shetland Birds, The Shetland Times, 1979.
Vaughan, R. Arctic Summer – Birds in North Norway, Anthony Nelson, 1979.
Voous, K. H. Atlas of European Birds, Anthony Nelson, 1960.
Watkinson, E. A Guide to Bird-Watching in Mallorca, J.G. Sanders, 1982.

PHOTOGRAPHERS' WORKS
Cruickshank, A. D. Cruickshank's Photographs of Birds of America, Dover Publications.
Cruickshank, H. The Nesting Season – Bird Photographs of Frederick Kent Truslow, Elm Tree Books.
Guilfoyle, A. Wildlife Photography – The Art and Technique of Ten Masters, Amphoto.
Hautala, H. A Year in Kuusamo – Diary of a Finnish Bird Photographer, Weilin & Goos, 1985.
Hazelhoff, F. Four Seasons of Nature Photography, Fountain Press, 1982.

Hosking, E., Hale, W. G. Eric Hosking's Waders, Pelham Books, 1983.
Hosking, E., Kear, J. Eric Hosking's Wildfowl, Croom Helm, 1985.
Hosking, E., Lane, F. W. An Eye for a Bird, Hutchinson, 1970.
Hosking, E., Lockley, R. M. Eric Hosking's Seabirds, Croom Helm, 1983.
Hosking, E., Flegg, J. Eric Hosking's Owls, Pelham Books, 1982.
Hosking, E. Eric Hosking's Birds, Pelham Books, 1979.
Polking, F. Nature Photography Year Book, Fountain Press, 1985/ 86, 1986/87.

PERIODICALS (UK only)
BBC Wildlife – independent monthly magazine.
Birds – quarterly magazine of the RSPB.
Birdlife – bi-monthly magazine of the Young Ornithologists' Club.
Birdwatching – independent monthly magazine.
British Birds – independent monthly magazine.
BTO News – newsletter of The British Trust for Ornithology.
Natural World – magazine of the Royal Society for Nature Conservation.
Nature Group Newsletter – Group newsletter of The Royal Photographic Society.

1. Equipment

The natural world is vast and varied, so a photographer who wants to tackle all aspects of wildlife needs to carry a wide range of cameras, lenses and accessories to cover every possible contingency. Specializing in birds, though, brings one enormous advantage – the photographic requirements are quite specific, and you can achieve a surprising amount with just a camera, one lens and a tripod.

This is not to say that equipment is an unimportant aspect of bird photography; on the contrary, by comparison with other fields, equipment for bird photography is highly specialized. For example, landscape photography has few equipment requirements, and an accomplished photographer could potentially create great landscape pictures with even a simple snapshot camera. With similar equipment, the bird photographer would achieve virtually nothing: on film, the birds would be so small as to be almost invisible; their images would be unsharp, and blurred by movement.

So in the following pages you'll find details of the constraints and requirements of bird photography, and an explanation of how specific pieces of equipment can help or hinder you in catching on film one of nature's most fascinating forms of life.

The 35mm film format is ideally suited to bird photography: smaller cameras lack the necessary sophistication; larger ones are too cumbersome for most applications. There are many points for and against each size of camera, but at the present time the majority of bird photographers work with 35mm. For those interested in publication, recent advances in printing techniques allow superb 35mm reproductions to the size required for full- and double-page spreads in most magazines. Whilst there is little doubt that the large negative size of the larger formats produces superior quality because of the smaller degree of enlargement necessary, this is often difficult to appreciate at the reproduction size used in most publications.

Cameras

The most suitable 35mm camera for photographing birds is the single lens reflex (SLR) type which incorporates a viewing system that allows the user to see exactly what will be recorded on the film. The basis of this set-up is a mirror and a prism which direct the image of the subject to the viewfinder during focusing and on to the film during exposure. The mirror is hinged and set at an angle, thus directing the light entering the lens upwards on to a prism, which in turn transfers the image so that it is correctly orientated in the viewfinder. When the shutter is released the mirror springs up, allowing the light to fall on the film and causing exposure.

The great advantage of this system is that the photographer can see exactly what the image will look like, and this allows very precise focusing and framing. Other types of camera do not incorporate this

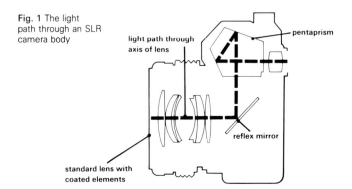

Fig. 1 The light path through an SLR camera body

light path through axis of lens

pentaprism

reflex mirror

standard lens with coated elements

reflex mechanism so the scene in the viewfinder does not correspond exactly with that which is produced on the film. The disparity is particularly acute with objects close to the camera.

There are numerous makes of high quality 35mm SLR available commercially today, so your choice of manufacturer makes little difference; however, only the more reputable manufacturers sell a wide range of the long telephoto lenses that are essential when photographing birds. Look at a selection of cameras at your local photographic retailer, talk to others with a similar interest and choose a camera with which you feel comfortable, and which you can afford. As a general rule you should economize on the camera body and spend as much as possible on your prime telephoto lens. The majority of camera bodies will suit most, if not all, of your requirements and, as long as they are sturdy and have an adequate range of shutter speeds (a speed of 1/1000 sec is the slowest acceptable at the fast end of the range), almost any make will do.

Modern SLR cameras come with a bewildering array of additional features, many of which are of little use for bird photography and which invariably add to the cost of the basic unit. The characteristics which are of major importance in wildlife photography are a bright focusing screen, a range of shutter speeds up to 1/1000 sec or 1/2000 sec, interchangeable lenses, flash synchronization, through-the-lens light metering (TTL), and the ability to operate the camera in the manual mode. Most other features are only of occasional use, despite manufacturers' claims that they are essential.

Numerous people take up photography as a short-term fad, while others are constantly changing their camera systems, as models with more sophisticated specifications become available. This keeps the second-hand market going and a careful search of the photographic magazines and local newspapers will usually turn up the equipment you need at a price you can afford. Make sure that you check the equipment carefully and ask if you can run a roll or two of film through it before

purchase. The great disadvantage of buying used cameras and lenses is that they are not usually under guarantee, and repair costs can be considerable.

Light Meters

The introduction of built-in, through-the-lens (TTL) light metering systems was one of the most useful advances for the wildlife photographer. They are far from foolproof, but when used intelligently, automatic light meters increase the accuracy of exposure as well as removing yet another burden from the shoulders of the aspiring bird photographer. Nest photographers are able to use a hand-held light meter (see page 28) to ensure accurate exposure but unfortunately the stalker is rarely in a position to get close enough to the subject to obtain a light reading in this way. In such a situation the TTL meter is quite adequate. Most new cameras incorporate a centre-weighted meter which biases its readings towards a small area of the image – usually 10–20% – at the centre of the field of view and this is especially useful for the bird photographer. The method by which the exposure meter readings are displayed differs from system to system: some have a swinging needle to indicate shutter speed or aperture; others incorporate light-emitting diodes and liquid crystal displays which actually show digital readings.

Exposure Automation

The automatic metering facilities now fitted to most 35mm equipment are a tremendous asset to the photographer interested in the portrayal of birds in action. Time is at a premium and any advance which cuts down on the complexity of manipulations in the field is to be welcomed. Critics of the automatic camera have suggested that it takes both freedom of choice and the need for skill away from the photographer but this is a one-sided view especially in flight photography, where even this automatic exposure has to be used intelligently to obtain satisfactory results.

There are several different sorts of exposure automation, some of which require no intervention from the photographer. Although such 'programmed' systems work well for snapshots, semi-automatic systems are a better choice for serious wildlife photography. On semi-automatic cameras of the 'shutter priority' type the photographer selects the shutter speed and the camera sets the aperture which will give correct exposure. This system is ideal for the wildlife photographer who often needs to select certain specific shutter speeds for action shots. Aperture priority cameras work the opposite way. The photographer sets the aperture and the shutter speed is selected automatically by the camera to give correct exposure according to the built-in light meter. This mode is said to suit photographers who are more concerned with how much of the picture is sharp than with subject movement. We have used both types over a number of years, and have come to the conclusion that once you have become familiar with either type, there is little to

choose between them. The important point is that with either mode you are able to end up with the shutter speed you desire.

Focusing Screens
An enormous variety of focusing screens are available for most 35mm camera systems, the majority being unsuitable for bird photography. Without doubt, the most suitable is a plain, finely-ground glass screen with a central, 12mm circle. The circle is a great help in assessing the size of the subject in the frame while the plain, uncluttered screen makes

Fig. 2
Focusing
screens

a. Split image and
Fresnel screen

b. Plain Fresnel
screen

focusing easier especially with long lenses. The popular split-image screen, in which the image is separated until it is sharply in focus, is of little use when used with telephoto lenses as one half invariably blacks out, making quick and accurate focusing difficult. Try to purchase a camera body with interchangeable screens, or if the screen is fixed, as in most cheaper cameras, make sure that it is of the required type.

Lenses and Shutter Speeds
One of the bird photographers' biggest headaches is that most birds are, quite rightly, mistrustful of humans and will not allow a close approach. Long lenses go some way towards alleviating this problem, but will unfortunately set you back a bit financially.

The SLR camera body is just a light-tight box which holds the film, and incorporates a shutter mechanism to control exposure. The standard lens fits on the front of the camera body, and can be changed for other lenses which magnify the subject to a greater or lesser extent. The pictures you take are ultimately only as good as the lens you use, and in general, the cheaper the lens, the poorer the optical quality and consequently the poorer the image quality. Most cameras are fitted with a standard 50mm lens when purchased, but this is of limited use in bird photography.

Assuming that you have already chosen a camera body then, what sort of telephoto lens should you be looking for? We recommend the ideal focal length (an indication of magnification power) for a first lens should be either 300mm or 400mm as this is easily handled, and allows a magnification of six or eight times that of a standard 50mm lens. There are many reasonably-priced models around, and this set-up provides the basis for a good start in bird photography. Further lenses and other accessories can be added as and when your budget allows.

During your search for a telephoto lens you will notice that besides its focal length, each lens is given an 'f' number such as f4.5 or f5.6. This number corresponds to the maximum aperture of the lens, and gives an indication of the maximum amount of light that a lens will transmit to the film. This is an important consideration because the more light you can get on to the film, the dimmer are the conditions in which you can use the lens – much as a pair of 7×50 binoculars enables you to see more at dusk than 8×30s. Within the lens is a series of metal leaves forming an aperture like the iris of the eye. As the aperture opens up more light passes through and as it becomes smaller, the amount of light reaching the film is reduced. The aperture size is indicated by 'f' numbers – f2.8, f5.6, f8, f11, f16 and so on. The smaller the number, the larger the aperture and vice versa. Each step in the series doubles or halves the light, so by changing from an aperture of f8 to f5.6 you double the amount of light passing through the lens.

Now exposure is varied not only by changing the aperture but also by varying the shutter speed which is set in a similar stepwise fashion: each step changes the amount of light falling on the film by a factor of two. Thus there are two variables to consider when making an exposure, and the significance of aperture – especially maximum aperture – is made clearer in an example. Imagine that you are focused on a large wading bird at the water's edge using a 300mm lens. A typical exposure reading in good lighting would be a shutter speed of 1/125 and an aperture of f8. If the bird is static and you are using a good support you could reduce the shutter speed to 1/60 and change the aperture to f11 and still produce correct exposure. However, if the bird is moving around, then setting a shutter speed of 1/60 would result in a blurred image. So instead, you increase the shutter speed to 1/250 and open up the aperture to f5.6. Thus by varying both the aperture and the shutter speed you are able to choose from a variety of settings to suit your particular needs.

With fast moving subjects a still faster shutter speed is necessary to stop the action. If you are photographing a smaller species such as a sandpiper darting about in search of food, then 1/250 is too slow to produce a sharp image and 1/500 or 1/1000 is necessary. In the same lighting conditions you'll need an aperture of f2.8 for correct exposure. Owners of telephoto lenses with a maximum aperture of f4.5 or f5.6 are unable to take such a photograph without using a faster film. 300mm lenses are available with maximum apertures as f2.8 and although they are optically superb they are much bulkier, making handling more difficult, and they are usually extremely expensive.

300mm or 400mm lenses are fine for large species, but you will need a more powerful telephoto lens when photographing some of the more timid or smaller species. A 300mm lens magnifies the image about six times, taking a 50mm lens as a base – less than the average pair of binoculars. How much more useful, then, would be a lens producing an image magnified nearly twelve times? Lenses which magnify twenty-five times or more are available, but with such an increase in focal length

comes a tremendous increase in both size and cost. Powerful lenses are difficult to handle, too, because they magnify any camera shake, producing a blurred image if you do not use an adequate support. As a general rule the minimum shutter speed that is safe for hand-holding the lens should be the reciprocal of the focal length of the lens.

Long focal lengths introduce other problems: their maximum apertures are rather small. f6.3 or f8 are typical and to take correctly exposed pictures with them, you need good lighting conditions or a fast film. To hand-hold a 1200mm lens with a maximum aperture of f8 you would need to use a shutter speed of at least 1/1000 sec to be fairly sure of eliminating camera shake. To achieve these settings a film of at least ISO 200 is necessary. A further consideration inherent in the use of telephoto lenses is the small depth of field available when they are used at maximum aperture. Careful and accurate focusing is imperative if you are to keep the subject within the very narrow zone of maximum sharpness.

Lens Quality

Because long telephoto lenses have small maximum apertures, they are usually used 'wide open' – at full aperture – in order to use the fastest shutter speed possible. Unfortunately, camera lenses do not perform equally well at all apertures. Most give their best optical performance somewhere between the largest and smallest apertures, and performance is not as good at maximum and minimum apertures. This is an especially serious problem with the cheaper telephotos but recent advances in optical technology are changing the situation, making good lenses less expensive.

Mirror Lenses

Recently there has been a tremendous increase in the number of catadioptric (mirror) lenses available to the photographer. These have become immensely popular with birdwatchers who see the advantage of owning a compact, long focal-length lens, without having to pay out vast sums of money.

As the name suggests, this type of optic makes use of curved mirrors to reflect light. The image is reflected from the back mirror on to the front mirror and from there back through an aperture on to the film. This results in a lens which is considerably shorter and more compact than a conventional telephoto lens.

In principle a cheap, compact, lightweight telephoto would seem to be the ideal unit for the bird photographer, particularly when stalking. In practice however, there are a number of problems which are difficult to overcome. Mirror lenses have fixed apertures which cannot be altered. So a 500mm mirror lens must always be used at, say, f8. This only really becomes a problem when the shutter speed required for correct exposure is faster than that available on the camera, and when this happens you can fit a neutral density (grey) filter to cut down the light. In

practice, this difficulty is not apparent when using slow speed film and only applies when using very fast film types.

The fact that mirror lenses are so compact belies their power of magnification, and as a result, there is a tendency to forget that the lens must be held rock steady to avoid camera shake. But the third and potentially the most troublesome drawback is the way the lens records highlights outside the zone of focus, as indistinct haloes.

Mirror lenses are ideal for the birdwatcher who wishes to produce competent record shots of his sightings. Serious bird photographers, however, often find the limitations unacceptable and revert to conventional telephoto lenses.

Zoom Lenses

Zoom lenses have variable focal lengths, thus allowing a range of magnifications. In general, the longest focal length of a zoom lens is between two and three times the shortest. Only a few of the many zooms are of any real use to the bird photographer. The most useful zooms have focal lengths of 70–210mm or 80–200mm, and effectively fill the gap between wide-angle and medium telephoto. A zoom lens is especially useful when attempting photography at the nest, as the lens makes possible variations in framing and composition without changing lenses. It is also particularly valuable when you are composing scenes which include flocks of birds. Zoom lenses are bulkier than individual fixed focal length lenses, but are usually much lighter than a selection of lenses covering the same range of focal lengths.

Until recently, the optical quality of most zoom lenses was considerably poorer than that of fixed focal length lenses, so zooms were not considered to be suitable for the serious bird photographer. However, advances in lens design have allowed manufacturers to produce zoom lenses of excellent optical quality and few bird photographers would now be without one. A zoom usually has a smaller maximum aperture at any given focal length when compared to a fixed focal length lens, but the differences are usually small enough not to be troublesome.

Early designs incorporated separate rings for zooming and focusing, but most modern zooms use a single twist grip for both functions, thus permitting rapid and accurate operation which is so vital for action photography. Many 'macro' zoom lenses also focus much closer than was previously possible and this is particularly useful for close-up shots of birds.

Shorter Focal Lengths

Although many birds are so timid that the only way to photograph them is with a telephoto lens, others may be easily photographed with a wide angle or standard lens. Large colonies of sea birds offer ideal opportunities to portray the birds and habitat as a whole; the great depth of field produced by a wide angle lens can result in some really dramatic shots. Gannet colonies are particularly suitable where a carefully selected

viewpoint, a fast shutter speed and a wide angle lens set on infinity, can yield a picture which includes birds both in flight and at the nest. Set like this, the lens keeps virtually everything sharp, so attention can be devoted to composition rather than focusing. You can make even better use of the available depth of field by setting the focusing ring so that the infinity symbol (∞) is aligned with the depth-of-field marking for the aperture in use.

Wide angle and standard lenses are also ideal for taking photographs of birds which will fly in close to an outstretched hand offering food: the black-headed gull is one particularly good example. Such lenses also find a use in remote control work, a technique more fully discussed in chapter 3.

Autofocus Cameras and Lenses

Recent advances in lens and camera manufacture have led to the introduction of equipment which focuses automatically, and this would appear to be tailor-made for the wildlife photographer, especially when pursuing action shots. Such systems now offer automatic focusing with even long telephoto lenses and the prices of items of equipment compare very favourably with the cost of good conventional equipment. Most leading camera manufacturers have now committed themselves to investing large sums of money in the research and development of this new venture. In ideal conditions and with a static subject, autofocus equipment offers much quicker focusing than is possible manually. However there is some way to go before these new cameras are ideally suited to wildlife photography. On some makes the lens does not respond quickly enough in dim light; some backgrounds may confuse the focus sensor; and the subject must be of a good size and in the centre of the frame for the system to work efficiently.

The development of this sophisticated equipment is in its infancy, though, and it will not be too long before the autofocus is perfected.

Teleconverters

There are many occasions when the bird photographer would like to be much closer to his subject to achieve an adequate image size. Conditions often dictate that this is possible only by using a lens considerably longer than the prime 300mm or 400mm telephoto. A 600mm super-telephoto, for instance, is ideal for bird photography from a car but while there are many reasonably priced 300mm and 400mm lenses available, super-telephotos are usually too expensive for the amateur photographer. Teleconverters fit between the camera body and the main lens, and multiply the focal length of the prime lens by between 1.4 and 3 times. They would seem to be the ideal answer, being relatively cheap, light-weight and adding little in bulk to the main lens. However, there are a number of disadvantages and at best teleconverters are a compromise.

A two times converter doubles the focal length of a 300mm lens to 600mm but this increase in magnification brings with it a marked

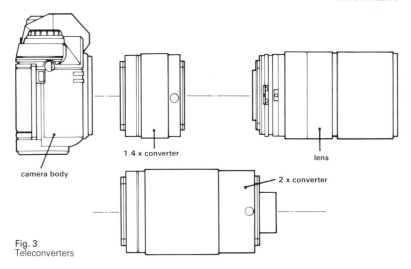

1.4 x converter

lens

camera body

2 x converter

Fig. 3
Teleconverters

reduction in speed. Adding a 2× converter turns a 300mm lens with a maximum aperture of f4.5 into a 600mm f9 lens. When a 3× converter is attached to the same 300mm lens, you have a 900mm lens with a maximum aperture of f13.5. Such a reduction in speed obviously limits the lens to very good lighting conditions unless you use a fast film.

One compensation is that the close focusing distance is unchanged, so a 300mm lens with a near focusing distance of 2.5 metres can focus down to the same distance with a converter attached. By contrast the average 600mm telephoto only focuses down to a distance of about 5.5 metres. The unchanged near-focus distance combined with the increase in focal length makes the combination particularly useful when photographing small birds. As teleconverters are generally lightweight optics, their addition to a prime lens adds little weight and the outfit weighs considerably less than a prime optic of the same focal length. There is a temptation to forget that this combination should be handled with the same care as any other long telephoto lens, so use a tripod and take great care to avoid camera shake.

Until recently teleconverters gave poor image quality and they were of little use to the serious photographer. However, recent design changes in the top-of-the-range models have resulted in better definition, provided the converters are used carefully. Unfortunately only the more expensive models provide anything like acceptable image quality and even then definition still does not approach that of a prime optic. The serious photographer will find little use for the cheaper models.

Motordrives and Autowinds
Motordrive or autowind attachments are often used unnecessarily in other branches of photography by both amateurs and professionals

alike, but in wildlife photography this is a genuinely useful accessory. When things are changing unexpectedly and quickly, automatic film advance can make the difference between success and failure. Valuable time can be spent on accurate focusing and composition rather than on manual film advance.

Most SLR cameras can now be fitted with a variety of such accessories that vary both in degree of sophistication and in price. At the top of the range, the most powerful motordrives are capable of advancing film at a rate of at least five frames per second, either one frame at a time, or in a continuous sequence. On some models you can even pre-select a sequence of a set number of frames, and rewind film automatically. At the lower end of the range is the autowind which can achieve speeds of up to two frames per second usually only in single frame mode. Some newer cameras have autowind facilities built into the body, rather than as bolt-on accessory.

Motordrives have a prodigious appetite for film: at a speed of five frames per second, you can use up a 36-exposure roll of film in about seven seconds, and a certain amount of practice is necessary when using the continuous shooting mode if film is not to be wasted. For remote control work where the motorized camera is left unattended, bulk film cartridges holding up to 250 exposures are available, making reloading less of a chore.

At faster speeds of film advance the motordrive causes vibration, so it is necessary to use a fast shutter speed in order to prevent camera shake. This is not usually a great problem, though, as moving subjects require fast shutter speeds anyway.

Power for the motor is usually supplied by a battery pack inside or attached to the motordrive unit. The fastest speeds are only attainable with new or fully-charged batteries. It is worthwhile investing in a small battery charger rather than buying new batteries which can become an expensive item when the motordrive is used regularly. Check that the rechargeable cells provide as much power as the expendable batteries they replace – often rechargeable nickel cadmium batteries provide only 1.35 volts, instead of 1.5 volts of the alkaline cells of the same size.

Design changes have made motor drive units smaller and quieter but they still make a significant amount of noise, certainly enough to frighten away many birds. Careful use, however, can often minimize this problem, and in some cases the noise can even be used to advantage: the buzz of the motor often makes birds look alert, producing a more lively image. On other occasions it will induce them to take to the air giving the opportunity for a sequence as they take off. It is surprising how effective this technique can be with practice. Some units which offer a single shot mode, do not advance the film until finger pressure is released from the drive button. Thus you can wait for an opportune moment to advance the film after making an exposure.

A motordrive is most valuable for action sequences. Your chances of obtaining at least a few successful pictures are markedly increased when

you expose several frames over a short time span, and if you are lucky you may obtain a really stunning action sequence. Remember though, that if you are using a shutter speed of 1/500 with the film advancing at five frames per second you will still only capture the action taking place during 5/500th sec, and the remaining 495/500th sec will be missed. You therefore need luck and skill to capture the action you want. The use of a motordrive does not automatically ensure superb photographs!

Fig. 4 Carrying your equipment

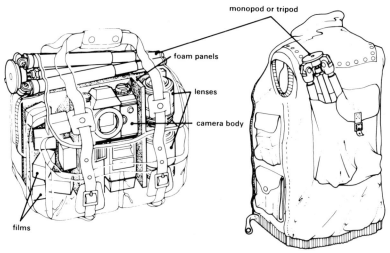

monopod or tripod

foam panels

lenses

camera body

films

a. Waterproof canvas bag b. Camera jacket

Camera Bags, Jackets and Holdalls

For the hide photographer carrying equipment is not a problem as any sturdy bag or rucksack will do, but the stalker must be able to select any piece of equipment in seconds so ease of access is all-important. The basic necessity is to have a sturdy container which combines mobility, ease of access and protection. Probably the most satisfactory type of container is a hardwearing waterproof canvas bag. These come in varying sizes to suit the needs of the amateur and professional. Foam panels within the bag customize it to accommodate virtually any mix of equipment. This type of bag has the added advantage that it does not look like a conventional camera bag and thus attracts less attention from potential thieves. Most bags of this type are weather-proofed and some brands consist of units which you can add to as your space requirements increase.

Aluminium box camera cases are really not suitable for most bird photographers because of their unwieldiness, although they do make useful makeshift seats which soft bags do not.

For the photographer who requires mobility and ease of access above all else, a camera jacket or vest may be the answer. These are essentially waistcoats made up of materials of varying weight suited to different climates. Despite their scanty appearance, most will take two camera bodies, several lenses including a long telephoto and twenty to thirty rolls of film. Many have a large pocket at the back in which you can carry a medium-sized tripod or monopod. This type of garment is also ideal for the birdwatcher who, in addition to some camera equipment, wishes to carry a telescope and binoculars.

Many bird photographers prefer to use a conventional rucksack to transport their gear. The great advantage is that equipment can be carried on the back leaving both hands free. Quick access to lenses can be a problem, though, because you have to remove the rucksack to get at your gear.

Supports

Telephoto lenses with focal lengths longer than 300mm are difficult to hold steady for any period of time, and in a hide, a camera support of some description is essential. The traditional support – and the most cumbersome – is a tripod, and this should be high on the list of priorities for a novice bird photographer.

Each photographer has his own preference for the type of tripod he buys; however, as a general rule, it should be the sturdiest model you can afford, and be fitted with a pan-and-tilt head. Before purchase, check that it is easily adjustable in a confined space, that the pan-and-tilt head runs smoothly, and that it will hold the camera and heavy lens absolutely steady when extended to its full height.

The **shoulder pod** is based upon the principle of the rifle stock and there are a number of models of varying efficiency available commercially. The design of the shoulder support is a matter of personal choice. For those who are proficient handymen it would be better to design and construct one to your own specifications. The most important prerequisite is that it should be sturdy and light, that it has a butt which fits securely into the shoulder, and that it has some means of allowing easy release of the camera shutter, leaving one free hand to focus on the subject – usually this means some type of trigger release. When using a shoulder pod it is essential that you hold the apparatus tightly into your shoulder in order to steady the camera. If you don't, you are only adding to the weight of the camera and lens, and actually increasing camera shake.

The **pistol grip** is really designed for lenses of shorter focal length and is of little use except when you are confronted with a large, or very tame small bird for which you might be using a lens of 200mm focal length or less. In such a situation it may be easier to hand-hold the camera and lens.

The **monopod** is a single telescopic leg topped with a screw thread on which to attach the camera body. More sophisticated models carry a pan-and-tilt or ball-and-socket head. A desirable feature is that the telescopic parts should have a quick release and secure facility: on a number of occasions we have experienced the frustration of finally managing to adjust the monopod to the correct height just as the bird we were attempting to photograph flew off! It is often better to maintain a fixed height and just to tilt the monopod towards the subject, thus making the most of the limited depth of field inherent in the use of longer lenses by photographing from a higher viewpoint. The great advantages of the monopod are its portability when closed up and its sturdiness and mobility when opened up to its full height.

Film

The ideal film for wildlife photography would be a very fast, fine-grain film with wide exposure latitude, and good colour saturation with an emulsion which will not fade or change colour even after storage for a hundred years. Unfortunately this ideal is still just a dream. Film technology has progressed considerably over recent years but it has lagged behind camera technology during the same period.

Be it subtle or spectacular, nature is colourful, and as a result most nature photographers work with colour materials. Numerous different colour films are marketed and the choice may appear to be difficult for the newcomer. Colour films themselves are available in two different types and many brands, and there is a range of different characteristics within each brand.

The two sorts of colour film are negatives, which must be printed to get a finished picture, and slides or transparencies, which form images in their correct colours and tones without a printing process. Because slides are formed directly on the film, they can be seen clearly only when enlarged with a viewer or projector or viewed on a lightbox; however, slides have certain advantages, such as permanence and sharpness, that prints cannot match, and there aren't many serious wildlife photographers now who use negative film.

Choice of film manufacturer is a personal matter, but for those who wish to publish their work for profit the choice is already made – at least in the 35mm format. Most agents and publishers only accept transparencies on Kodachrome, so unless you take pictures purely for your own pleasure you must get to know this make of film. The bird photographer who only wishes to show slides at lectures or to enter competitions is in many ways more fortunate in that there is a wider choice of transparency films available, all with their own particular characteristics of colour and tone. There is no 'right' film as everyone sees colours slightly differently and we all develop our own preference for a particular brand of film. The important thing is to make choices which please you and then stick with one or two films so that you get to know their particular characteristics well.

Film Speed

Each box of film is marked with the 'film speed'. This is basically an indication of sensitivity to light. The higher the number, the greater the sensitivity, or in other words the less light needs to fall on the film for an image to register. Speed is always expressed in numbers which are designated DIN (Deutche Industrie Norm), ISO (International Standards Organization) or ASA (American Standard Association). ISO and ASA are numerically equal, and for the purpose of convenience we shall use the ISO designation as this is now the internationally recommended standard.

Put simply, the image on a film is the result of the light reacting with tiny grains of silver bromide in the emulsion – the gelatin coating on the surface of the film's plastic base. The larger the grains, the more sensitive the film is to light; so the faster the film, the larger the grains – which accounts for the often unpleasant random 'sandy' texture that you may have in pictures taken on the fast films. Slower films have smaller grains and thus produce a smoother texture and a sharper picture. It follows that in order to produce the best quality, you should use the slowest film possible.

Colour Saturation

Another film characteristic to which you will often see reference is colour saturation or colour richness. This is essentially an expression of how 'strong' the colours are, and slower films generally give more saturated colours than fast films. If transparency films are slightly underexposed, the resulting images have richer, more punchy colours. Some photographers find this desirable while others find it unpleasant and rather artificial: it is really a matter of personal taste. In practice we underexpose by $\frac{1}{3}$ or $\frac{1}{2}$ a stop by setting the film speed on the camera slightly higher than the nominal speed marked on the box. This practice is good with colour slides, but can result in poorer quality with negative film.

FILM SPEED ADJUSTMENT FOR RICHER COLOURS	
Manufacturer's Recommended Film Speed Setting	Our Recommended Film Speed Setting
ISO 64	80
ISO 000	125
ISO 100	250
ISO 400	500

Exposure Characteristics

For a film of one particular ISO rating, the shutter speed and aperture combinations needed to achieve an optimally exposed image should, in

theory, be constant. In practice, however, the actual film speed will differ slightly between batches released from the manufacturer though this difference is noticeable only in very critical work. In an attempt to minimize this problem manufacturers have introduced 'Professional' grade film. This is aimed at the photographer who takes hundreds of pictures a week and each film is marked with the batch number. Within each batch there is a guarantee of constant film speed provided the film is processed within a short time of exposure. Such films are rather more expensive than regular films, and must be stored in the refrigerator if their precise colour and speed characteristics are to be retained.

To give good results, all films must be correctly exposed, but some types have more margin for error, or 'exposure latitude', than others. Those photographers who have used both negative and transparency films will already know that the margin of error for acceptable exposure is greater for negatives than for slides. This accurate exposure is imperative when working with slides in high-contrast conditions such as sunlight. Colour negative film is generally more tolerant of error.

Purchasing and Processing

Individual rolls of film are cheap compared to the cost of camera equipment, but photographers who are particularly enthusiastic will soon find that they build up a substantial film bill. If you expect to be using large quantities of film materials, you should investigate the numerous discount outlets which advertise in the photographic press. For quantities of more than ten rolls there are significant discounts and even if you are unlikely to use the film quickly, any excess can be stored in a refrigerator until it is used.

This type of bulk purchase is particularly applicable, for instance, prior to a 'safari' holiday when you will inevitably take many photographs. At other times you may be able to join together with a few other photographers to purchase in bulk and share the cost. Pay particular attention to the 'use by' or expiry date which is always printed on the film packet. Many shops sell outdated film at reduced prices and although this is often acceptable there is a danger of serious changes in colour balance owing to poor storage and a photographic holiday would be ruined by rolls of unusable photographs. If you are interested in publication you should never take such a risk.

Most transparency films can be processed in independent laboratories, so you can see your pictures soon after taking them, and for best results, all films should be processed as soon as possible after exposure. Take care in the selection of a processing laboratory, as not all are careful enough with your precious film; scratches, finger prints and water marks are all common problems which result from careless processing. Often a friendly word with the lab manager helps to ensure that you get the best possible results.

The processing of the Kodachrome range of films involves complex multi-step procedures which can be done only in the manufacturer's

own laboratories. Although theoretically this should produce the best results, it does involve sending away the film to a central laboratory, and even then there is a large variation in quality between laboratories in different countries. In the USA, Kodachrome may be processed in the laboratory of your choice but this facility is not available elsewhere.

Kodachrome colour reversal film is supplied with a postal packet which is marked with two index numbers, one of which is detachable. Retain this for identification purposes later, in case a film is mislaid during processing. After rewinding films onto the spool make sure that the film leader is wound completely inside the cassette before sending it away to be processed. A loose film end left protruding may tempt one of the laboratory workers to pull the film off the cassette through the slot, thus increasing the chance of scratching the film. It also ensures that you do not use the film again thinking that it is a fresh roll.

With the exception of process-paid films, transparencies are more expensive if mounted after processing, but you cut costs if you have the film processed but not mounted. Any suitable shots can then be mounted at home. Colour negative films are generally more expensive to have developed and printed, and many photographers make contact sheets – same-size prints of every negative – and then select only the successful shots for enlargement. Other photographers process both transparencies and colour negatives in their own dark rooms, preferring to follow the whole process all the way through themselves.

If you use transparency film, you can make prints either directly through the Cibachrome process or other reversal processes, or via an intermediate colour negative. Inevitably prints from slides are more expensive than prints from colour negatives but such reversal prints are particularly suited to the photographer who predominantly uses colour reversal film and only wants the occasional transparency made into a print.

In recent years, faster films have been developed for those who work in low light situations or require very fast shutter speeds for action photography. However, with increased speed, there is a considerable increase in grain and a decrease in sharpness. Colour films are now available with speeds of up to ISO 3200, and still faster films are likely to be introduced soon. It is also possible to uprate or 'push' slower films to a higher ISO rating. For instance when using ISO 400 film you can set the film speed indicator at ISO 800 or even ISO 1600 in order to use a faster shutter speed, or to take pictures in dimmer light. To compensate, the development time for the whole roll is increased during processing so you must expose each and every frame at the higher speed. Most laboratories make an extra charge for this service and the results are often less than satisfactory. Not only does the grain size increase but there is also a noticeable colour shift. Some photographers believe that it is better to use ISO 200 film and uprate it to ISO 400 for exposure and then develop accordingly, rather than using ISO 400 film. There is no doubt, though, the ISO 400 film will give a better quality image.

2. Basic Techniques

Today's cameras are so highly automated that they seem to take care of every aspect of photo-technique – even focusing. It is certainly true that automatic exposure has relieved the photographer of mechanically reading a meter and manually transferring the readings on to the camera's controls. However, no exposure meter is foolproof – especially an automatic one – and in the hands of a photographer who has some knowledge of basic techniques, even the most automated camera is capable of producing better results than when used slavishly by an ignorant photographer. So in the next few pages you'll find details of how to make the most of today's cameras, and how to anticipate and compensate for their failures and foibles, and all with special emphasis on the photography of birds.

Photography, of course, is not just technique. A technically perfect photograph can be worthless if the content and composition isn't right – just as perfect spelling and punctuation doesn't make a good novel. So here too you'll find useful information on how to compose and light your pictures, and advice on where best to start photographing birds.

Exposure

Automatic exposure metering allows the photographer to spend more time on composition and accurate focusing. As time is usually of the essence in bird photography, this facility is often invaluable. However automatic light meters are reliable in only average light conditions and are often unable to cope with more difficult lighting. Probably the most frequent problem occurs when the light is coming from directly behind the subject. Here an automatic meter usually gives a reading that is correct for the bright background which fills most of the image in the viewfinder. Such a reading will expose the background correctly but leaves the subject underexposed or silhouetted. Although this may be attractive in a pictorial sense it will not produce a good record shot and in order to correctly expose for the subject you need to give more exposure than that indicated by the light meter. To determine how much extra exposure is needed, take a meter reading from a nearby object which is of similar shade to the subject, but which fills the picture. If your camera has an exposure memory lock, the camera will remember this reading while the button is depressed so you can turn back to the original scene, and take the picture, and the subject will be correctly exposed. With other less sophisticated cameras you will have to set the appropriate shutter speed and aperture manually before turning to the subject.

You may experience similar exposure problems when photographing very light-coloured or very dark birds because the light meters incorporated in most cameras take an average reading from the whole scene. Thus a dark bird in light surroundings will be under-exposed, showing no feather detail, while the background will be correctly exposed. Some compensation is necessary to expose the subject cor-

rectly, and a meter reading from a similarly-coloured object is usually sufficient.

Selecting the correct exposure for white birds is equally difficult. In direct sunlight the light meter will give a very high reading and this may record the bird as grey, not white. Nevertheless, if you wish to show the maximum feather detail this reading should be used. Any surroundings will be depicted much darker than is accurate but extra exposure to compensate will result in a loss of feather detail. The most satisfactory solution is to photograph white birds in the diffused lighting given by light cloud over the sun; this reduces contrast so that you can retain detail in all parts of the picture. These comments apply mainly to colour transparency film: the photographer working in black and white or with colour negatives has fewer exposure problems because appropriate compensation can often be made during the developing and print stages.

The most accurate method of setting exposure is to measure the light falling on the subject with a hand-held meter, but in bird photography, at least away from the nest, this is impractical. Recently more advanced metering systems have been introduced in which there is a 'centre-weighting' to the light reading. This means that the meter takes its readings predominantly from an area around the centre of the viewing screen, and this system yields more consistently accurate results.

Camera Shake

Telephoto lenses are the mainstay of the bird photographer's armoury, but they must be used carefully to achieve the best results. Not only is the subject magnified, but so is any shake transmitted from photographer to camera and lens. Most telephoto lenses are heavy, especially in the super-telephoto range (500mm and longer). As a result you must take great care to hold such equipment really steady. The problem is more acute with the modern compact and lightweight 300mm and 400mm telephotos and even more so with mirror lenses. These are so compact there is a temptation to use them as if they were shorter focal length lenses but it is important to pay particular attention to ensuring that they are adequately supported, and to setting a fast enough shutter speed, as explained on page 22.

Camera shake is easily diagnosed in a photograph because the whole image is slightly blurred. Subject movement, on the other hand, blurs only some parts of the image, for instance the head or leg of the moving bird. Camera shake can be prevented, even at slow shutter speeds, by using a tripod. This approach doesn't cure subject movement, which can be eliminated only by using a fast shutter speed. The appropriate shutter speeds for various activities are given on page 29.

Selected blurring can actually add to a picture, giving the impression of movement or action. The success or failure of this technique lies in the ability of the photographer to catch the bird in an interesting pose, with the head and most of the body sharply focused, and just one moving part

SHUTTER SPEEDS	
1/60	Motionless while feeding or walking
1/125	Wing stretching, feeding young at nest
1/250	Feeding, preening, swimming, copulating, or bathing
1/500	Medium or large birds taking off or flying with slow wing beats
1/1000	Flying with fast wing beats

blurred for effect. Blurring of the wing tips or a leg is acceptable, but head movement is not and the eye of the subject should be sharp at all times.

Depth of Field

Depth of field is the distance between the nearest and the farthest points which are acceptably sharp in a photograph and you can increase it by using smaller apertures (see *fig. 5*). In other words, more of the scene will be sharp when using an aperture of f16 than one of f4.5 on the same lens. Exact depth of field figures at different apertures are usually given in the manufacturer's instruction leaflet.

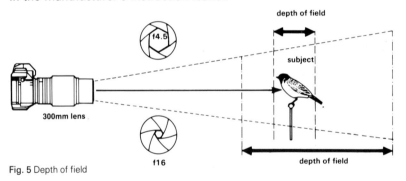

Fig. 5 Depth of field

In many instances, poor lighting conditions will force you to use the largest available aperture just to get an adequate shutter speed. However, in good light it is possible to use a smaller aperture, and this will keep more of the subject in focus – there will be more depth of field. This can make the difference between a photograph in which only a part of the subject is sharply focused and one in which the whole bird falls within the zone of maximum sharpness. Conversely there are occasions when the use of a wide aperture creates shallow depth of field, and produce a more satisfying result. The narrow zone of sharpness ensures that the subject stands out clearly, and what would have been a confusing background is thrown completely out of focus. At best, this technique produces a sharply focused subject against a softly diffused pastel backdrop. The same is true of foreground detail. If you can't move

around to eliminate a distracting foreground it is possible, by use of a wider aperture, to reduce this distraction by throwing it completely out of focus.

Automatic lenses allow you to focus at full aperture, so that the focusing screen is at the maximum possible brightness and focusing is accurate. As you press the shutter, the diaphragm automatically stops down to the selected aperture ready for exposure. While this is a distinct aid to accurate focusing, it does not help you to visualize the available depth of field, which is much narrower at full aperture than at the working aperture. Many cameras now have a depth of field preview button which, when you press it, stops down the lens to the selected aperture. This allows a direct visual preview of depth of field, enabling you to see exactly how much of the subject will be sharply focused in the final picture.

Fig. 6 The Law of thirds

Composition and Subject Placement

One of the most important principles of composition is the 'Rule of Thirds': this is the imaginary division of any scene into three parts, both horizontally and vertically; whenever taking a photograph it should become second nature to draw in these imaginary lines. The main subject should be placed at or near the point at which two of these lines intersect. The principle is that the third of the picture that contains the dominant feature of the image, is balanced by the remaining two thirds, which may contain little of comparable interest. As a general rule, birds

are placed on or near one of the lower intersections thus ensuring a small area of foreground and a larger expanse behind and above the subject. Central placement of the subject usually produces an arrangement which is too symmetrical, thus losing some of the dynamism of the overall picture. Always make sure, too, that the subject is looking into the picture.

If you have time while preparing to take your photograph, try to experiment with different subject positions by moving the camera horizontally and vertically. You will soon come to know which compositions look right and those which just look wrong, and as you gain experience, the best subject placement will become almost second nature. The position of the subject is particularly important when the bird is small in the frame. In this case careful positioning can make the difference between an indifferent and a really good overall image.

Viewpoint

Many photographers give insufficient thought to the selection of a viewpoint, although on occasions there is really no choice because of constraints imposed by the location. The most commonly chosen camera position is slightly above the subject, and in many cases, this is highly effective. However, before releasing the shutter think again: 'Can I improve upon the photograph by choosing a different viewpoint?' Often by taking a lower view, you are able to introduce more drama into your photograph; alternatively you could try an even higher vantage point actually looking down on your subject. This is particularly effective with flocks of shorebirds on a sandy beach where you can take advantage of the geometric patterns of the birds against a plain background. Whenever possible, change your viewpoint whilst looking through the viewfinder to arrive at the most satisfying composition.

Size of the Subject

Just how big should a bird be in the frame? Within reason this is purely a matter of personal taste. Many American photographers prefer to fill the frame with the subject, including as little of the background as possible. European bird photographers tend to prefer a slightly smaller image.

As a general rule, we try to obtain an image which covers at least one third of the width of the viewing screen. In some viewfinders this is conveniently marked-out by a 12mm central circle engraved on the focusing screen. Of course this is only a guide, and there are many occasions when a smaller image can be just as effective. In such cases, however, it is essential to have the subject critically focused and a background or lighting conditions which make the subject stand out. Above all, do not become too rigid about subject size. Try some close-up shots which include only head and bill as well as some in which the bird is shown in the context of its habitat. If you remain flexible and are prepared to experiment, you will inevitably come up with some really interesting images.

BASIC TECHNIQUES

Depth of field
Herring Gulls (*Larus argentatus*) and Puffins (*Fratercula arctica*), Craigleath, Scotland, July, Nikon F3, Nikkor 80–200mm f4 zoom lens, 1/250 sec @ f16, Tri X, monopod, stalked.

Viewpoint
Puffin (*Fratercula arctica*), Craigleath, Scotland, July, Nikon F3 with motordrive, Nikkor IF ED 300mm f4.5 lens, 1/1000 sec @ f8, Tri X, handheld, stalked.

Subject placement
Arctic Tern (*Sterna paradisaea*), Farne Islands, Northumberland, July, Nikon F3 with motor drive, Nikkor IF ED 300mm f4.5 lens, 1/1000 sec @ f8, Tri X, hand held, stalked.

Size of Subject
Lesser Golden Plover (*Pluvialis dominica*), Cornwall, October, Nikon F3, Nikkor IF ED 300mm f4.5 lens, 1/500 sec @ f11, Tri X, monopod, stalked.

Composition
Turnstone (*Arenaria interpres*), Dyfed, South Wales, April, Nikon F2, Nikkor 300mm f4.5 lens, 1/250 sec @ f5.6, Tri X, stalked, monopod.

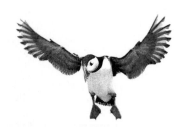

Depth of field

Viewpoint

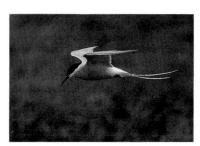

Subject placement

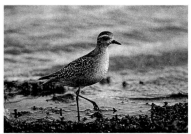

Size of subject

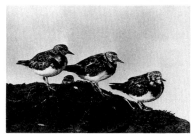

Composition

COMMON MISTAKES

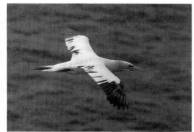

Out of focus

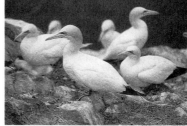

Inadequate depth of field

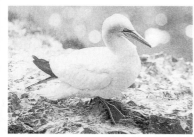

Over exposure

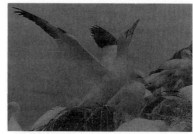

Under exposure

Camera shake

Blurring

Poor viewpoint

Image too large

Lighting

Light is the very essence of photography and unlike the landscape photographer the bird photographer is seldom able to just sit and wait until the lighting is just perfect. More often, it is necessary to compromise just to obtain any photograph at all.

The quality of light varies not only according to weather conditions, but also with the time of day. The ideal lighting for most bird photography is the softly diffused sunlight of the early morning or late afternoon. The sunlight around midday is usually too harsh, even in temperate climates, to produce a satisfactory image. Lighting direction is important, too: sidelighting ensures that there is a catchlight (a twinkle) in the eye of the bird, and this can add enormous impact to the picture. Although there are times when you are able to predict where your subject will be when the lighting is ideal, this is not always so, and you are stuck with whatever lighting is available; but do not be deterred. Try moving around and selecting different viewpoints; there will usually be one view of sufficient interest to photograph even if you have to try direct backlighting to produce a silhouette image.

Format

Photographers working with 35mm equipment have the advantage of being able to use both the horizontal and vertical formats. Some birds such as herons, cranes and storks automatically suggest vertical format pictures. Often however, there is a tendency to forget the vertical option so it's always worth stopping to consider it before releasing the shutter. Remember too that most magazines and books are set in this format and that there is generally a shortage of good quality bird photographs suitable for use on book and magazine covers.

Pictorial Aspects

It is hard to define exactly what is meant by the pictorial aspects of bird photography. Some photographs simply have it; others do not. We're talking of subjective impressions, those features which elevate the technical side of bird photography to an art form; the creation of a picture rather than a simple snapshot; the elements which make a picture repay a second look – and a third and fourth look.

Any well-equipped and half-way competent photographer can take acceptable record shots of birds. There is, however, more to photography than a mere record of an event. A good photograph should also convey an atmosphere, either that prevailing at the time the picture was taken or one that is purely manufactured by the photographer. Although in the strictest sense, photography is purely mechanical and chemical, by the manipulation of the photographic processes the photographer is able to put an individual stamp on a photograph.

All photographers are unique and see their subjects slightly differently; only good photographers, though, use a combination of technique and an artistic eye to produce their own particular interpretations

of a scene. The birdwatcher who carries a camera purely for record purposes may be satisfied with competent portraits but the photographer who has turned to the avian world for subjects will always be striving for something different. Sometimes this means using prevailing lighting or weather conditions to introduce atmosphere; other times it means actually going out to seek special conditions in the hope of achieving a special image. Much of this sort of photography is pure experimentation, and carefully kept notes will aid future attempts. Experimentation does not always work, but the knowledge gained in the process is invaluable. A good way to begin formulating ideas is to look at the work of others: sift through as many books and magazines as you can lay your hands on and then go out and try for yourself.

Subject position and size are integral parts of picture-making, but we should not lose sight of the fact that the backdrop can contribute as much to the final image as the subject itself.

Provided the subject is sharply focused and correctly positioned, it can appear small against an extensive background yet still the image will be primarily a bird photograph and not a landscape. This is particularly true if the background consists of out-of-focus bands of pastel colours which complement the small but sharply-focused subject. A small subject size can also be effective when using a wide-angle lens from close range, showing some of the dramatic landscapes in which birds are so often found.

The relative positions of the various parts of the birds body are a crucial consideration: the way the bird holds itself, the position of the head relative to the body and the way the tail is held. The perfect picture should capture the 'jizz' of the bird, its individual quality and character. Catching a bird in a characteristic position helps: a straight side view is very ordinary and dull, but the bird which has its head and bill turned slightly to one side, and a catchlight in the eye provides the necessary extra lift. This applies particularly to portrait studies, in which the bird fills most of the frame: here attention is usually concentrated on the head and in particular the eye, which should be placed near the centre of the frame. A good example is the jackdaw photograph on page 144. This cheeky character is captured in a characteristic pose, leaning inquisitively forwards, against a soft but striking background. The whole gives the feel of a painting rather than a photograph. The exposure is just about right, showing detail in the dark bird whilst retaining a correctly exposed background. This was possible because of the overcast conditions at the time the portrait was taken.

The bird photographer seeking to produce pictures in the true sense of the word should be able to utilize the tremendous variations in daylight to great advantage. The obvious highspots of the day for this are sunrise and sunset, when the wonderful range of lighting effects are easily within reach of the stills photographer.

The sunset colour and scene changes from minute to minute; dramatically nearer the equator, and more subtly in the northern

latitudes. Locations near water are especially suitable for dramatic sunset pictures, because of the added interest of the reflections – and you may also find that as the sun descends towards the horizon, many birds become less timid and easier to approach.

Arrive at your selected spot a few hours early, and scan the area for the best viewpoint opposite the point at which the sun will set. Check the horizon for any objects which could spoil overall composition – you'll notice that by moving a few paces to either side, the make-up of the horizon changes considerably. The sun seems to descend faster the closer it gets to the horizon. About one hour before it sets, it should still be high enough to be excluded from the field of view of all but the shortest focal length lenses. Now's the time to take photographs directly against the light, particularly if the subject is in the water. The bird is silhouetted and reflected patterns in the water add interest. The overall effect is almost that of a monochrome picture.

As the sun goes down, the reflective areas change from white through yellow to orange and red, and finally to purple. Exposure causes little problem when trying to produce silhouettes and you can safely depend upon your built-in meter.

Exposure can, however, be a little more tricky when the sun descends low enough to be included in the field of view. Much then depends upon what you wish the final effect to be and probably the safest method is to make several exposures above and below the reading given by your light meter. Exposing at intervals of $\frac{1}{2}$ a stop up to 1 stop above and 2 stops below should give you a reasonable safety margin. In fact you may even find that all of the results are acceptable, with each one differing slightly in colour rendition.

It is advisable to have a range of lenses available to make the most of your photographic session. We usually take a 28mm wide angle, a 70–210mm zoom as well as a medium telephoto lens of 300mm or 400mm. With the longer lenses it is not possible to get both nearby subjects and the setting sun in focus as a result of the narrow depth of field and sometimes this ruins the whole effect of the photograph. There are two answers: either take two shots, one of the subject and one of the sun, and then sandwich the two together after processing; or else use the multiple exposure facility available on most modern cameras. These techniques are particularly useful when you wish to increase the size of the sun. Photograph the selected scene, including your chosen subjects, using a medium telephoto whilst the sun is not visible in the viewfinder, then sandwich this picture with a long telephoto shot of the sun. The end result can be quite stunning if you take care to match up the two transparencies. Use a lens hood when taking photographs against the light; this reduces the amount of flare which could detract from an otherwise good result.

To attach a pictorial label to some bird photographs and not to others is a rather artificial division because so much is a matter of individual taste and interpretation. Before you make an exposure, always think

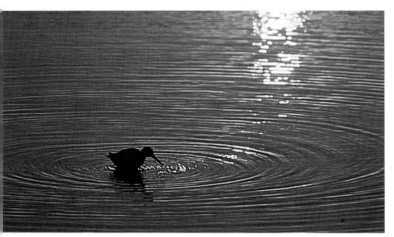

Bar-tailed Godwit *(Limosa lapponica)*, Berkshire, England, September. Nikon F2, Nikkor 300mm f4.5, 1/125 sec @ f8, Kodachrome 64; stalking monopod.

'Could this scene be portrayed more effectively another way?' Try to see particular patterns which are pleasing to the eye. Look carefully at the way grass, reeds or leaves are arranged around your subject. Do not shy away from adverse weather conditions. You can often add that extra something to your picture by waiting for waves to break on the rocks behind your waders or sea birds; or you could utilize mist or rain to soften the background and turn it into an attractive pattern of pastel shades. Above all do not be afraid to try something different!

Where to Begin Photographing Birds

Many birds have become used to humans, and actually take advantage of their presence so you do not always have to travel to exotic locations to find good subjects. Gardens, parks and ponds, where many bird species can be found, give plenty of scope for the beginner. Even areas to which ornamental species have been introduced also attract a number of naturally-occurring bird species which have become tame because of their frequent association with people.

Water provides an added attraction to many birds, especially at times of natural shortage. A garden pond is ideal for photography as it can be landscaped to provide a suitable backdrop. The use of a hide in this situation may produce some excellent shots of birds bathing or drinking.

A number of species which breed in small town parks have become particularly tame and some have even become used to being fed regularly by visitors. These birds offer fine opportunities for photography and it is well worth watching those birds carefully before you take up a suitable position with a camera; as long as you remain still, many of them will approach close enough to produce a good image size with a 300mm lens.

3. Nest Photography

Virtually all early bird photography took place at the nest. This was in part because the parent bird's strong link with the nest guaranteed regular attendance and partly because the bulky photographic equipment then available made the photographer relatively immobile. Consequently there are now innumerable superb studies of many species at the nest.

In recent years there has been much debate as to whether the disturbance caused by nest photography is justified, and as a result legislation has been introduced in some countries to control the photography of certain species at the nest. In fact, there is considerable pressure from some quarters to put a stop to nest photography altogether and this aspect and other ethical points are covered more fully in chapter 9.

In this chapter you'll find a step-by-step guide to photographing birds at easily accessible nests. Most species will tolerate the erection of a hide in close proximity to the nest, and this solves the perennial problem of how to get close enough to your subject to obtain an adequate image size.

Hides or Blinds

With the exception of some colonial nesting birds, it is either impossible or impractical to photograph birds at the nest without some sort of concealment, and even colonial birds are probably better photographed from a concealed spot. Concealment usually takes the form of a hide or blind which may range from a simple canvas or plastic cover thrown over the photographer, to an elaborate wooden structure erected many metres up on a scaffolding at a permanent nest site. The most commonly used, and probably the most adaptable hide, is a small canvas tent about 1½m high and 1m square with a rigid lightweight frame. This has the tremendous advantage of being both mobile and easy to erect. Hides such as these are available commercially in various specifications, but few are satisfactory. Although the actual hide cover is usually quite adequate, the framework often leaves much to be desired. In general you are better off making your own, so that you can design a structure suited to your own particular needs.

There are several important points to consider when designing a photographic hide. The materials should be light enough to make the whole structure easily portable, but heavy enough to ensure that the photographer's silhouette is not visible to birds from the outside. The sort of canvas used for making tents is ideal, and the colour should be fairly neutral or drab so that it is unobtrusive to both birds and inquisitive humans. Some photographers paint or dye the canvas in typical camouflage styles in order to break up the outline but the advantage of this is debatable. Weather conditions are variable in most parts of Europe, so it is wise to have the material waterproofed.

Most of the commercially available hides are supported by a frame made of four upright pieces of dowling, each of which is divided into three sections and fitted with male and female connecting pieces. Unfortunately these do not form a particularly good fit, rendering the whole structure rather unstable. The foot pieces are sharpened to a point so that they may be driven into the soft ground for added stability. Not all ground is soft enough, however, and this arrangement can be particularly trying when attempting to set the hide up on a pebble beach or a rocky shoreline. A better approach is to use an interlocking sectional aluminium frame which is not only lightweight but also quite sturdy. Manufactured tent supports are ideal – they separate into three pieces and are connected internally by metal springs. You can add extra stability to the hide by fitting horizontal top and bottom struts as shown in fig. 7a. This set-up makes the hide rigid, yet light enough to be picked up and moved around with the photographer inside, thus allowing late changes in position.

The canvas covering should be securely stitched as it will have to stand a fair amount of wear and tear. Position lens openings on at least two sides with conveniently-placed peep holes in the other two. Below the two main lens openings it is useful to have another one for photographs from a lower viewpoint; just to the side of each lens opening there should be a small viewing aperture so you can see what is going on at all times. To cover the protruding lens barrel, most commercially available hides use an elasticated sleeve. While this looks very neat it has certain disadvantages. Changing lenses is difficult without disturbing your subject and any slight movement of the hide is transmitted to the lens, causing camera shake. A loose-fitting short sleeve or a simple flap is a better choice.

Each opening in the canvas has a flap which can be tied up as necessary with tapes and a valuable addition is a loose flap of black mesh to break up the outline of the photographer's face. Pockets sewn into the skirting of the canvas can be filled with rocks to add stability and guy ropes attached to the top corners and secured to the ground using pegs serve a similar purpose. Extra pockets and loops inside the hide are always useful for storing pieces of equipment, and such additions are also handy for lifting the hide when moving it from inside.

Hides should be practical rather than pretty and almost any combination of material and supports can provide concealment provided it fits the basic requirements. Even pieces of sacking or tarpaulin and wooden supports are often adequate, and in the field you may have to improvise with whatever is available. It is vital, however, that any covering you use should fit tightly over the frame. Loose coverings flap in the wind causing disturbance to both parents and young birds.

Choice of Subjects

Nest photography always causes minor disturbance to the chosen subject and the disturbance is greater when the photographer is inex-

perienced. Most of the time, though, the bird will not be disturbed enough to desert its nest; if it does not settle down to acceptance of the hide fairly soon, you must abandon the attempt and try at another site. Species which are abundant in an urban environment are often used to the comings and goings of humans and make ideal subjects with which to begin (see page 140). Public parks and gardens are less suitable areas for hides, though they may contain numerous suitably tame species – because of the inevitable curiosity of passers-by.

Fired by an initial burst of enthusiasm there is a great temptation to work at the nests of as many species as possible during your first season. Resist this and work carefully and methodically at the nests of just a few common species. Then you will learn from your early mistakes and be better equipped to attempt more ambitious projects.

Nest Finding

Children seem to have a particular knack for finding birds' nests which goes as they reach adulthood – as many of us birdwatchers can testify. Most bird photographers find their nests by going out and searching for themselves, by using the information of others or by a combination of the two methods.

Nest finding can be a time-consuming business and you can waste many good photographic hours searching unless you really know what you are doing. You may find nests by a random search of likely vegetation but a good knowledge of the species you are seeking is a tremendous advantage. It is probably best to decide which species you want to photograph, find out as much as possible about its habits, and then put the knowledge to use; many species are easy to locate once you have found a likely habitat.

Find out what the nest and eggs look like, at what height the bird prefers to construct its nest and learn about its reaction to intruders. Often you'll see a parent bird entering a patch of vegetation with building material or food and a search around the point of entry should soon turn up the nest. Some ground-nesting species though, such as plovers and larks, are more cunning and do not give up the location quite so easily: they leave their nests and walk away unobserved long before the intruder is close and by the time they are noticed they are well away from the nest. Skylarks will also drop down in the middle of a field and walk through the grass to the nest so that the point of landing may be well away from the correct location. However by learning about the breeding habits of various species you should eventually be able to overcome such problems.

An easier but less satisfying way of finding suitable nest sites is to enlist the help of others. Once it is known in your locale that you are a bird photographer it is surprising how many people will tell you of nests in their gardens and other locations. Many of these will not be suitable for photography but it is well worth following up each piece of information if only to keep up the interest. Landowners and farmers are particu-

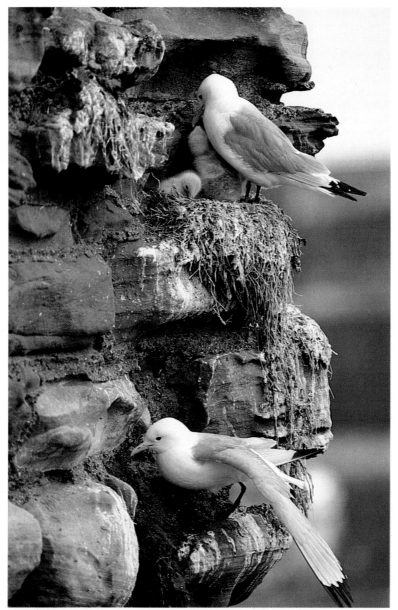

Kittiwake *(Rissa tridactyla)*, Dunbar Castle, Scotland; July; Nikon F3, Nikkor IF-ED 300mm f4.5, 1/125 sec @ f8 Kodachrome; stalked with monopod.

larly sympathetic to someone who shows an interest in their wildlife, and are often proud of some of the inhabitants on their land. Once you have been given permission to take photographs on such property, provided you behave responsibly, you will usually find that you are a welcome visitor, particularly if you return with a print of any successful sessions.

Inevitably you will meet other bird photographers and some may be willing to allow you the use of a hide they have already set up at a nest. This favour, of course, should always be returned whenever possible or this source of nests will soon dry up.

Selection of a Nest Site

You will soon learn that many of the nest sites you find are not ideal for photography. A nest may be unsuitable for any number of reasons: the vegetation cover is almost impenetrable; the nest is out of reach; there is not enough room to set up a hide; the site is too exposed, leading to probable interference from passers by; or you find the nest at the wrong time in the breeding cycle. You must consider all of these points when selecting a nest site, and make every effort to foresee potential problems before you set up a hide. Careful planning saves valuable time and avoids any unnecessary disturbance to the breeding birds.

Do not forget to check that there is adequate light on the subject, and when you site the hide bear in mind where the sun will be at the time at which you intend to conduct any photographic sessions. It is easy to forget that sunlight from behind you may cast a dense shadow of the hide on to the nest. Working with flash eliminates this problem, but check that your flash equipment does not cause an obstruction to the normal entry and exit routes of the parent birds.

A further consideration in selection of a site is the background. The foreground can often be improved by judicious 'gardening' but you may not be able to reach the background without causing some disturbance to the birds.

'Gardening'

This is a term that has been coined by bird photographers to describe the general tidying-up of the area in the frame around the nest. A careful look at many nest photographs will reveal tell-tale signs of the over-enthusiastic 'gardener'. You should only carry out the minimum of gardening necessary and your interference should not be evident in the photograph. Gardening may involve tying-back pieces of vegetation or even careful pruning of small branches or leaves, but it is of the utmost importance that your actions do not leave the nest more exposed to predators, intruders or the fierce heat of direct sunlight after your work has finished. Wherever possible use cotton to tie back vegetation temporarily, rather than cutting it away, so that you can leave the nest exactly as you found it. You can add vegetation, or a perch, too, but make sure it looks natural.

Timing of Work at the Nest
Although it may be instructive to the ornithologist to set up a hide around the time of egg-laying this is not usually the best time for the photographer, although it will depend upon the species you are working with. The ease with which birds accept a hide at the nest varies from species to species and even from individual to individual. The most important factor, though, is the point in the breeding season at which you introduce the hide. Generally, the bond between adult and young is stronger than that between a parent bird and its eggs and consequently there is a greater danger of desertion if you start to work during incubation, than if you wait until hatching has occurred. The best time to begin photography, both for photographer and the subject, is just after hatching. You will be rewarded with shots of parent birds feeding their ever-hungry young, the removal of the faecal sac, the young in various stages of development as well as any behavioural peculiarities of the species you are photographing. Photography of nidifugous species is by necessity restricted to the incubation period as the young leave the nest immediately after hatching. However the incubation period provides limited opportunities for interesting photography, and periods of activity are few and far between, resulting in long and often tedious periods of waiting in the hide. The wait is worthwhile only if you are lucky enough to witness and photograph changeover when both parent birds are at the nest together, or better still if you are able to record the male feeding the incubating female at the nest. Starting photography during the fledging period needs special care if you are to avoid the young birds leaving the nest prematurely, and is in any case restricted to birds that have nidiculous young which spend their fledging period at the nest.

Some species, including many raptors and owls, visit the nest to feed their young only a few times in twenty-four hours and you will have limited opportunities to obtain your shots during long vigils in the hide. Often the visits are only fleeting and it is easy to miss a good picture if your attention lapses. Conversely, many small passerines visit the nest every few minutes providing ample chances for good photographs. Here you should have time to observe many comings and goings before taking any photographs, allowing you to be more selective in your exposures.

Erecting the Hide and Moving into the Nest
Much has already been written about the erection of hides, and about the length of time which should be allowed to move gradually closer to the nest. Most authors generalize on this subject, and some have erred on the side of safety in their estimates. There is no doubt that almost any species will be alarmed by the erection of a hide just a few metres from its nest without any preliminaries. The best way to judge an acceptable 'moving in' period is probably to talk to other photographers who have worked the same species. Failing this, a conservative approach will do no harm.

Two basic methods are usually employed to accustom the bird to your hide. The hide is either erected to its full height some distance away from its final position and then slowly moved in; or it is gradually built up in stages at the nest site. The first method seems to be preferable when working species which nest in large open spaces such as heaths and moorlands and the second method better suits species which nest in scrub vegetation or trees.

Having decided upon the exact position of the hide, start by erecting three or four sticks, converging at the top in tepee fashion and pin some hessian or canvas around them. At the next stage, open out the sticks into the actual shape of the hide and re-pin the covering, being careful not to leave any flapping edges. At the third stage substitute the framework of the hide for the sticks and wrap around the canvas as before. Finally replace the canvas with the actual hide covering and make the final fixings to ensure maximum stability. Of course this is only one method; all sorts of variations are used by different photographers.

The time taken over hide erection depends not only on the species you are working but also on the location and the time you have available. If you can manage two stages of the process in one day, you can usually reduce the overall time because the bird has ample opportunity to become accustomed to each stage. Remember that while you are building the hide near the nest, the parent birds will be away. You should work quickly and quietly in order to minimize the period the eggs or young are exposed to the elements or to predators. If at any time during the erection or moving in of a hide the parent bird becomes obviously frightened, the structure should be dismantled or moved back. You can easily observe any such reaction from a distance with binoculars.

Equipment in the Hide

While working at a nest you are confined to the cramped conditions of the hide for prolonged periods. It is important, therefore, that you have all the equipment you are likely to need inside with you and, of course, that you make yourself as comfortable as possible. On page 45 is a list of the equipment you will find most useful while photographing at the nest.

Ideally, take two camera bodies, each loaded with different film. We choose Kodachrome 64 and either Ektachrome 200 or a black and white film. Motor drives tend to be too noisy for use at the nest but a firm tripod is absolutely essential, and positioning it carefully is time well spent. Two legs should abut the canvas of the hide whilst the third projects towards the photographer as illustrated in fig. 7a. This ensures greater stability and allows even short lenses to protrude through the lens opening. A comfortable photographer produces superior photographs so it makes sense to spend some time and thought in choosing a stool which you find comfortable as you will usually spend a long time on it.

From your preparatory work you should have some idea which lens will give an adequate subject image size but it is wise to have a selection

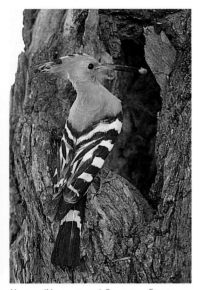

Hoopoe *(Upupa epops)*, Camargue, France; June; Nikon F3, Nikkor IF-ED 300mm f4.5 + Nikon 1.4× teleconverter, auto @ f6.3, Kodachrome 64; beanbag.

Penduline Tit *(Remiz pendulinus)*, Neusielder See, Austria; June; Nikon F3, Nikkor IF-ED 600mm f5.6, auto @ f5.6, Kodachrome 64; tripod without hide.

of lenses of different focal lengths available. Take a wide angle lens for recording the hide and its position relative to the nest; a useful subject for lectures. A 70–210mm or 80–200mm zoom lens is probably the one most used because the zoom facility is good for precise composition and framing. A medium telephoto lens of 300mm also finds its uses, either for close-up shots, or to capture other species which may appear and be visible through one of the other viewing flaps. Few 300mm lenses focus closer than 3m without accessories, but an extension tube will allow you to focus on subjects nearer than the close focusing limit of the unaided lens. This inexpensive accessory is of particular use when photographing small birds at the nest.

Checklist of Equipment in the Hide

35mm SLR body × 2	Safety pins	Lens tissues
Lenses: 80–200mm zoom	String	Head/wrist bands or
300mm	Knife	towel
28mm or 35mm	Scissors	Binoculars
Extension tubes	Torch	Food and drink
Tripod	Spare batteries	**Film stock:**
Flash heads	Notebook and pencil	Kodachrome 64 or 25
Stool	or small tape recorder	Ektachrome 200
Cable release	Blower brush	Tri X or Panatomic-X

The Photographic Session

The success of nest photography depends largely on good organization and planning; photographic technique really plays only a minor part. Before finally deciding that you have the ideal viewpoint, set up the camera on a tripod and view the scene through the lens to make sure that you can make any minor adjustments without having to move the hide. Make a final check that you have completed any 'gardening', and covered or removed any distracting objects which might ruin the background.

Companions Ideally you should have a companion who will walk you into the hide at the beginning of each session and out of the hide at the end. This ploy fools most species into thinking that the hide is empty, provided that you are not visible, and keep quiet. Some species, particularly members of the corvid family, appear to be able to count up to three and more cunning is required with these birds. A group of people walking to the hide together will give you the opportunity to slip in unnoticed, while the rest of the group retreat until you have finished your session. Of course for this trick to succeed you need to have long-suffering friends! Pre-arrange a signal, such as a handkerchief hanging out of one of the viewing slots, to summon your companion to walk you out and away from the hide at the end of the day. Such arrangements may seem rather unnecessary for some species but can make the difference between success and failure when photographing others.

On entering the hide Before entering the hide make sure that any flash units are set correctly and switched on and once inside the hide set up your equipment as quickly as possible. The subject may not object to sounds once you are established in the hide but noise may cause unnecessary wariness initially. Arrange the tripod and set the seat in a comfortable position. Ensure that any accessory you may need is easily accessible, and that it can be handled without too much noise – avoid the use of plastic bags as they rustle loudly. Check that all equipment is working satisfactorily.

Final checks Look through the viewfinder and compose your picture, imagining that the bird is present. If you are using a zoom lens set it to the desired focal length and focus on the approximate point at which you expect the bird to settle. Some photographers actually focus on a piece of cardboard and remove it before starting photography but this causes undue disturbance, and modern lenses are easy enough to focus quickly without a target of this sort. Finally, set the shutter speed and aperture, making sure that if you are using flash the shutter is correctly synchronized. All you have to do now is to wait.

The subject arrives After a while, when the parent bird is satisfied that all is safe it will return to the nest. This is a good opportunity to re-adjust

the focus and check the framing, but resist the temptation to take any photographs at this stage; just observe. If the species is one which returns to its nest at frequent intervals you can observe several visits in order to determine the best composition and the best moment at which to take photographs.

Many species land on the side of the nest and look back toward the camera before attending to their young. Except for owls and some birds of prey, whose eyes are set towards the front of their head, this is not a good moment to release the shutter as neither eye is visible; instead wait until the head is turned slightly. After feeding the young there is often a pause to retrieve any faecal sacs ejected by the young birds and this is a good time to take pictures. Initially the birds start when they hear the noise of the shutter but most become used to this after a few exposures and eventually they also ignore other noises coming from inside the hide. Do not wind on the film, though, until the bird has settled after its reaction to the noise of the shutter. Flash also induces a reaction in most birds, but it is generally believed that the bright light causes no harm to them.

On most occasions the parent bird will return to the nest soon after you have entered the hide but some more timid species take much longer. You should make up your mind before commencing photography exactly how long you can safely wait for your subject to return. This decision is made using the knowledge you have gained whilst planning your approach to photographing that particular species. Large raptors may return only three to four times during the daytime and therefore you can allow a fairly generous waiting period. However, if one of the small passerines has not returned with food after an hour you should give up your attempt at photography on that occasion and perhaps try the next day. If such a situation arises make sure that the parent birds return to the nest after you have left the hide; if they do not, the hide should be taken down. Remember birds' welfare must come first at all times.

When you leave the hide after what was hopefully a successful session, ensure that you loosen any vegetation which has been tied back and that the nest is not more vulnerable to intruders.

Tower and Pylon Hides

As you get more enthusiastic you may feel the desire to attempt more ambitious projects which are outside the scope of the beginner. The raptors of Europe are particularly impressive creatures and hold a great attraction for the serious bird photographer, partly because of their inherent beauty and partly because of the relative difficulty of photographing them. Many of them nest in inaccessible areas, usually well out of reach of the photographer using a conventional hide. Photographing a raptor's nest is therefore usually time-consuming and involves a considerable amount of planning. Many such species are protected by law (see chapter 9) and you must enquire whether special permission is necessary and obtain the appropriate licence.

NEST PHOTOGRAPHY

Fig. 7

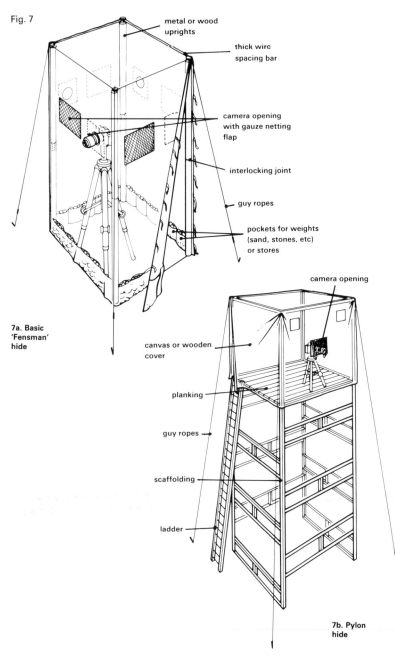

metal or wood
uprights

thick wire
spacing bar

camera opening
with gauze netting
flap

interlocking joint

guy ropes

pockets for weights
(sand, stones, etc)
or stores

7a. Basic
'Fensman'
hide

camera opening

canvas or wooden
cover

planking

guy ropes

scaffolding

ladder

7b. Pylon
hide

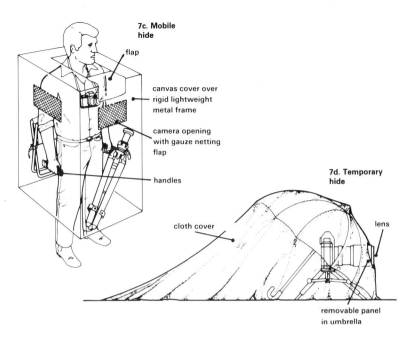

7c. Mobile hide

flap

canvas cover over rigid lightweight metal frame

camera opening with gauze netting flap

handles

7d. Temporary hide

cloth cover

lens

removable panel in umbrella

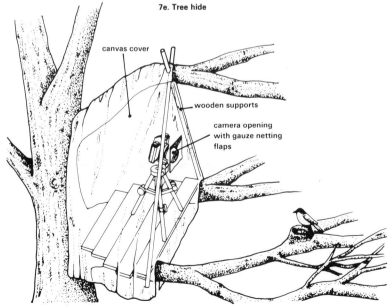

7e. Tree hide

canvas cover

wooden supports

camera opening with gauze netting flaps

49

NEST PHOTOGRAPHY

7f. Portable water hide

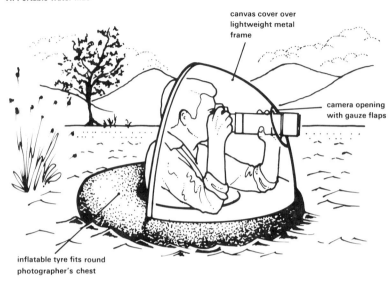

canvas cover over
lightweight metal
frame

camera opening
with gauze flaps

inflatable tyre fits round
photographer's chest

7g. Mobile boat hide

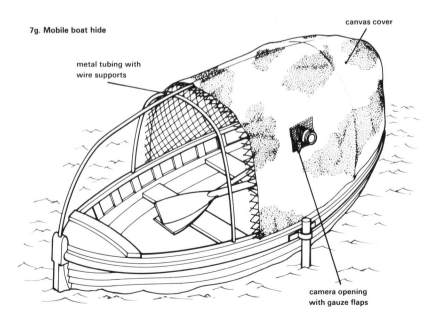

canvas cover

metal tubing with
wire supports

camera opening
with gauze flaps

The careful building of a tower hide is crucial, not only in the interests of the photographer's own safety but also because such a prolonged undertaking may easily cause disturbance to the subject. There are two common approaches which take both considerations into account. You may choose to erect a pylon hide outside the breeding season at a site which is known to be occupied annually. This of course carries the risk that the bird may not return to the same nest on this occasion or that if it does, it may not accept the hide and will build a nest elsewhere. An alternative is to wait until the nest is occupied and then to erect the pylon structure in stages. This method carries the risk of desertion and if such a problem becomes evident you should abandon your attempts.

Early pylon hides were made of wood and were troublesome and time-consuming to erect but recently bird photographers have made use of materials used in the building trade. For hides of up to 4–5m from the ground, a Dexion-type pierced angle-iron frame is ideal; you can bolt it together easily just like a child's construction set. For anything higher only conventional builder's scaffolding is strong enough. Building should take place in easy stages, allowing a few days to let the nesting birds become accustomed to each section of the structure. At the top, fit a firm wooden floor to allow some freedom of movement and to add stability. For the actual hide, some photographers prefer wood; others use a custom-made canvas hide which fits onto the scaffold. The higher the tower, the more unstable the whole structure becomes, particularly in windy conditions and it is advisable to add extra cross-struts and guys to increase stability – you may even decide to attach these cross-struts to the tree or rock on which the nest is situated.

It is a tremendous advantage to be a practical handyman when attempting this type of photography as there is a constant need for improvisation. Before attempting such an ambitious undertaking it is wise to take a short apprenticeship with a photographer who is an acknowledged expert in this field.

Hides on Water

Water is a great attraction to many birds and numerous species have evolved a life-style which is almost totally aquatic. Water birds also hold a peculiar attraction for the bird photographer and photographing them at the nest poses its own special problems. The vegetation surrounding the rivers, lakes and swamps of Europe provides ideal conditions for such species to breed, but the dense reed beds make nests difficult to find and restrict access. Occasionally, you may be lucky enough to locate a nest which can be overlooked from the bank, in which case you can erect a hide in the conventional manner but those species which nest deep in the reedy margins or maybe on a floating island call for more ingenuity. If the nest is not too far from land it may be possible to erect a platform attached to stakes driven well into the lake or river bed and you can then place a conventional portable canvas hide on the platform, and carefully secure it. Take great care during such an operation so that you

do not cause too much disturbance to the subject: tie back any reeds in stages after erection of the hide, making sure that you do not expose the nest to potential predators. A stout pair of waders is essential if you hope to remain dry during the erection of the hide.

An alternative technique for nests which are not easily accessible from the land is to erect a camouflaged hide on a flat-bottomed boat and to move it closer to the nest in stages as you would on land, mooring the boat after each move. When the hide is in its final position you'll need to make a more stable mooring by driving a series of stakes into the bottom to stop any movement which will make photography difficult.

Remote-control Nest Photography

In recent years electronic advances have automated not only the camera body itself but also many innovative accessories. Bird photographers have taken advantage of such gadgetry to break new frontiers or just to make their task easier and some now use remote-control set-ups to take photographs at the nest. This means that a motorized camera can be set up at the nest, the lens pre-focused and the whole apparatus fired from a distance by an infra-red beam or radio device. One major problem is that the photographer still needs to see the nest to decide exactly when to

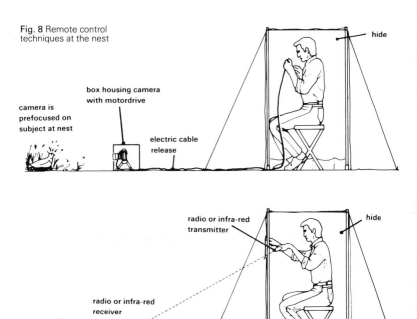

Fig. 8 Remote control techniques at the nest

hide

box housing camera with motordrive

camera is prefocused on subject at nest

electric cable release

radio or infra-red transmitter

hide

radio or infra-red receiver

Fulmar *(Fulmarus glacialis)*, Craigleath, Scotland; June; Nikon F3, Vivitar 70–210mm zoom f4.5, auto @ f11, Nikon SB17 (TTL) flash unit on camera, Kodachrome 64; stalked.

Little Grebe *(Tachybaptus ruficollis)*, Norfolk, England; May; Canon AE1, Canon 135mm f3.5, 1/60 sec @ f3.5, Kodachrome 64; hide on platform in water.

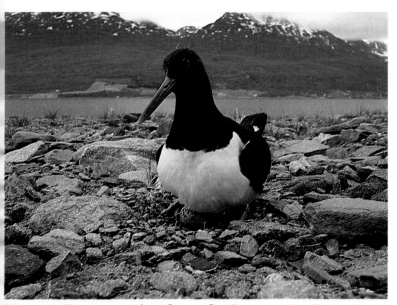

Oystercatcher *(Haematopus ostralegus)*, Porsanger Fjord, Norway; June; Nikon F3, Nikkor 28mm f3.5, auto @ f11, Kodachrome 64; infra-red remote-control.

release the shutter. A few photographers have even found an answer to this problem by setting up a video camera at the nest and viewing the whole scene in the comfort of their own living rooms on a monitor. To us, however, this separation from the 'action' really takes much of the excitement away from the whole process. 'Being there' is still one of the most exhilarating facets of bird photography.

53

4. Away from the Nest

Birds spend only a relatively small proportion of their lives at the nest and there is a growing feeling among photographers and among the general public that photographs of birds away from the nest are more natural and appealing than the traditional nest portrait. Not only does this type of photography cause less disturbance to the subject than pictures taken at the nest, but, to many, the results are more aesthetically pleasing. Taking pictures away from the nest challenges the photographer's ingenuity, too: at the nest site the bird is bound by the instinctive desire to care for and protect its young. This behaviour makes possible controlled conditions on the breeding ground that are not available elsewhere. Part of the recent upsurge of interest in away-from-the-nest photography stems from the increased mobility allowed by modern equipment: in the past bird photographers were virtually tethered to the nest by the immense bulk of their cameras.

Stalking

Stalking is only one of several ways of photographing birds away from the nest but is probably the method which makes most use of the increased portability of equipment: a 35mm SLR gives the photographer an ideal tool for stalking birds. Most birds are, quite rightly, nervous of humans so long focal length lenses are almost always necessary. The most useful lenses are 300mm–600mm focal length, but with notoriously tame birds, a 135mm lens may be all that is necessary. Zoom lenses are a great help in composing and framing the subject but the popular focal lengths, such as 80–200mm, will rarely render a large enough image size to give good results from stalking, unless of course you are photographing a flock of birds.

It is usually an advantage to carry two camera bodies, one with an extreme telephoto – 500mm or 600mm – and one with a 300mm lens attached. In this way you can change lenses quickly, causing less disturbance as you approach, without having to remove the lens from the camera body. Nothing is more frustrating than your subject taking to the air just as you are in the process of changing lenses.

Steadying long focal length lenses is a special problem when stalking, as any camera support must be easily movable; this effectively rules out the tripod. The shoulder support or rifle stock is highly portable, but some photographers prefer to use the slightly more cumbersome monopod.

Technique

All the traditional rules which hunters through the ages have used to catch wild animals and birds are equally valuable to bird photographers. Prior knowledge of the behavioural patterns of the bird is of utmost importance when planning your shot. Some birds are, by nature, more tame or inquisitive than others: dotterel and phalaropes for example,

allow a close approach and individual wading birds which have settled to roost will also let you get quite near. This information is of particular use when selecting a lens of the correct focal length.

A number of other factors also need to be considered when the shot is planned in advance: decide on likely shutter speeds and apertures by taking meter readings from objects of similar shade and lighting to the subject, allowing for variations in likely backgrounds. With this information you can select your settings and then make only minor adjustments during the stalking. Where is the light coming from? Do you want your subject to be lit from the front, the side, or even back-lit?

It is not essential to have the sun directly behind you in the conventional manner. Sidelighting usually gives more modelling and, provided you remember to try to highlight the bird's eye, gives a very pleasing result. Do not totally dismiss the possibility of taking your photograph directly against the light, either. Although you are unlikely to obtain a good record shot the results can be very satisfying artistically.

Having made your choice and prepared the camera decide upon the route you are going to take to the bird, making use of all available cover. This may take the form of bushes, trees, rocks or tufts of grass. A low profile is generally more successful and, during the final approach, a 'belly crawl' may be necessary. What is the wind direction? Approach downwind if possible in order to drown the noise from your tread.

If it is only possible to stalk in the upright position a straightforward slow walk is the best method; ducking and weaving rarely results in successful photographs. The birds are less likely to be disturbed by a figure approaching slowly and in direct vision at all times than by someone who keeps appearing and disappearing. Once you have shown yourself, it is better to remain in view, and it is worth remembering that a photographer silhouetted against the sun is more formidable to the bird than one walking towards the light. Even tame birds become alarmed when the shadow of an intruder falls upon them so when the sun is behind you, it is better to keep a low profile.

Birds rarely remain still for long periods except when roosting and you can turn this fact to your advantage. Chances of success are higher when any movements or camera adjustments are made whilst the subject is engaged in some activity, such as preening or feeding. Periodically, birds stop and scan their surroundings for potential danger before returning to what they were doing before. Until the bird is reassured it is important to stay as still and quiet as possible.

It soon becomes obvious to the birdwatcher that some species are particularly nervous of humans and will begin to utter alarm calls even when the observer is still some distance away. Many is the time that the cry of a lone redshank sends a flock of otherwise approachable birds of other species hurtling into the distance, much to the chagrin of the approaching photographer. Careful observation helps pinpoint such birds and it is worthwhile waiting until a nervous individual leaves the area, or else plan a path which gives it a wide berth.

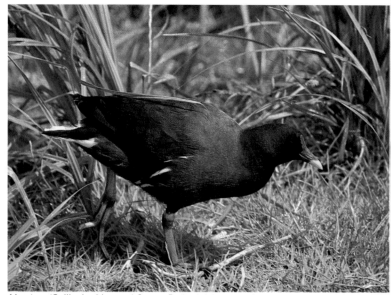

Moorhen *(Gallinula chloropus),* Sussex, England; July; Nikon F3, Nikkor IF-ED 300mm f4.5, 1/250 sec @ f6.3, Kodachrome 64; stalked with monopod.

Some birds which are nervous of human intruders on land are markedly less so when approached through the water; this is particularly true of birds which inhabit the rocky shorelines. Stalking from water, though, is not without its own problems. As there is no available cover you should approach your quarry in a straight line as slowly as possible, while watching for signs of apprehension, and stopping for a short time if this becomes evident. Once again you should move and make camera adjustments only while the bird is otherwise occupied. In general the larger the proportion of your body concealed under water, the closer you will be able to get to your subject.

Keeping the camera dry is a priority: salt water is particularly damaging to the lens coating and camera parts alike. A shoulder pod enables you to keep the camera at shoulder height throughout the approach and thus relatively free of water spray. An ultraviolet or skylight filter should be kept on the lens to protect the front element. A damaged filter is far less costly to replace than a lens.

Most sea or lake beds are uneven or muddy and unstable to say the least, so before releasing the shutter make sure you are in the most stable position possible so as to minimize camera shake. If there is wave action this only serves to aggravate the problem but it may be possible to dig yourself into the mud or sand using a slow twisting action of the feet to obtain more stability. It goes without saying that you should use the fastest shutter speed possible in this situation.

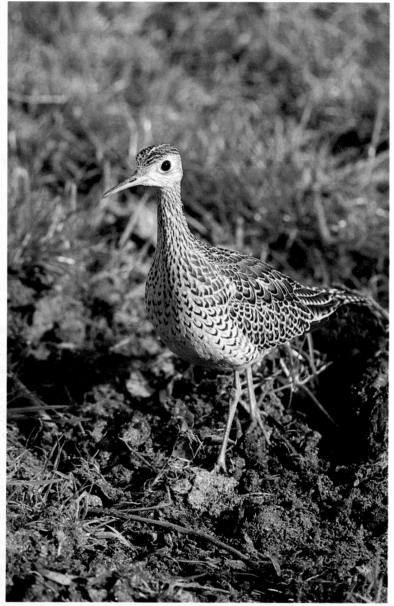

Upland Sandpiper *(Bartramia longicauda)*, Isles of Scilly, England; October; Nikon F3, Nikkor IF-ED 300mm f4.5, auto @ f5.6, Kodachrome 64; stalked with monopod.

Instead of wading to approach birds, you can use a boat or raft to float towards them. This is only really feasible in calm waters and suffers from relative lack of directional control, unless you have a companion who can paddle. Even this may not help because of the need for concealment. Necessity is the mother of invention and it was just this problem which spurred Dick Bordon, the American photographer, to invent a portable water hide for use in water at least waist-deep (see fig. 7f). This consists of a rubber inner tube with a canvas umbrella arrangement to conceal the photographer. A slit in the canvas allows the lens to protrude and the birds can be stalked to fairly close range. There is, however, still the problem of holding the camera steady and this can only be done successfully with practice. The other major difficulty is that the water must be of fairly constant depth, otherwise you may find yourself suddenly protruding from the water with the hide roosting on your head, as the water has become too shallow.

Various weeds and rushes can be used to camouflage a boat, and in the cooler areas you will need some sort of protection against the cold (see page 99).

Where to Stalk

Experience suggests that certain types of environment are more suitable for stalking than others. On wide open mud flats with no relief, birds can see intruders from great distances, and you are therefore unlikely to be very successful. However, other types of terrain which provide natural cover but allow adequate lighting are ideal.

Coastal areas can be particularly rich in migratory species and as most birdwatchers know, migrating individuals are often very tame and easy prey for the stalker. The numerous seabird colonies of Europe are ideal – and very exciting – places for the beginner to stalking. A number allow reasonable access, and the opportunities for photographing bird behaviour are almost limitless, yielding good results with little disturbance to the birds, if care is taken. Mudflats, lagoons and beaches can be rather exposed, but surrounding vegetation often enables you to get close to the species that congregate there; if the lagoon is tidal, many of the birds will assemble on predictable roosting areas at the periphery. Stalking in such areas is often easier in continental Europe than in the British Isles – the birds are often more approachable (see pages 146–148).

Seasons and Stalking

Migration is an exceptionally good time to use stalking as a means of photographing birds. Many countries have an unofficial 'grapevine' system of informing birdwatchers which birds have arrived and where. The beauty of working in this way is that there is no preparation; you need only to pick up your photographic bag and turn up at the site to be in with a good chance of obtaining worthwhile photographs. Remember too that there may be other people who want to see the bird and in your

enthusiasm to photograph it you should not interrupt the viewing of others. If a rarity appears you will probably meet many other birdwatchers and photographers at the site and it is wise to place yourself away from the main crowd in the hope that the bird will come your way whilst retreating from the other watchers. Naturally, no bird should be harassed in order to obtain photographs.

As the breeding season approaches, some birds take up territory and make use of singing posts in order to proclaim their occupation of the area. Observation should make such birds obvious. Once again these are ideal subjects for stalking, and practice will tell you how close you can approach without causing undue disturbance. Take care, when composing your photograph, to exclude twigs or banches outside the zone of sharp focus as these may spoil the end result, especially if you are using a mirror lens, when they will be rendered as double images. Birds on singing posts usually perform only on calm days, especially in exposed areas. If there is a wind they will be skulking in the undergrowth.

In summary, with practice, patience, a little forethought and luck, stalking can produce photographs of birds which are quite different to the traditional portrait and opens the way to photography of species which would be impossible or very difficult to work at the nest.

Using a Hide

The hide is usually associated only with nest photography. There is, however, a place for hides of various kinds, including motor vehicles, when working on birds in other environments. It may come as a surprise that many birds still do not associate the motor vehicle with the presence of humans, and as a result a car or minibus may be used very successfully as a mobile hide, with very little in the way of alteration or accessories. Most birdwatchers have noticed that they get good views of birds in trees, hedgerows or on mudflats adjacent to the road whilst driving so it is wise to carry your camera equipment with you at all times on the road.

Many birds are not in the least disturbed by a slowly-approaching car and will continue with their normal activities when you stop, provided you do not immediately push your camera lens through the open window. The more prior warning you have that your subject is in the area, the better. If you are fortunate you may know where your quarry is to be found regularly so you can choose the time of day at which the lighting conditions are ideal, and you'll know how close you can approach and which focal length lens to use. If so you should stop the car some distance from the site and prepare your equipment. Attach the appropriate lens to the camera body and check that you have enough film and that all other accessories are easily to hand. Roll the window down – even clean glass distorts the picture – and rest the camera support on the door frame. A bag filled with beans is invaluable in this situation as it will mould readily to the shape of the lens allowing it to be held completely steady, and eliminating camera shake. With shy birds

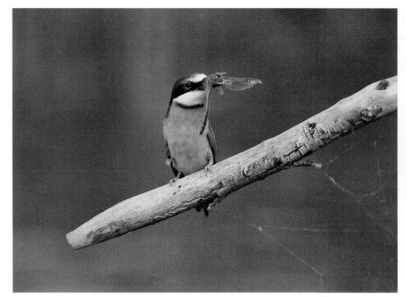

Bee-eater *(Merops apiaster)*, Camargue, France; June; Nikon F3, Nikkor IF-ED 600mm f5.6 + Nikon 1.4× teleconverter, auto @ f8, Kodachrome 64; car bracket.

you may find the need for some camouflage. This is easily arranged by cutting appropriate openings in a dull-coloured piece of cloth and shutting it into the door, or pinning it around the door frame.

Once the equipment has been organized drive slowly towards the chosen position. The vibration caused by the car engine makes it virtually impossible to take photographs without resultant camera shake so you must now choose whether to switch off the engine a few yards short of this position and coast to a halt or to reach the spot and then switch off the ignition. Some birds are quite content to continue their activities while the car engine is running, but as soon as it is switched off they will fly away. In this case it is better to turn off prior to arrival but you can only determine which is the better option by trial and error.

Once at the site, keep still and conceal yourself as much as possible. Inclining the car seat backwards helps break up your outline behind the door frame. Watch for a short while until the subject is at ease and then slowly rest the lens on its support, keeping any movements as slow and quiet as possible. You will be pleasantly surprised to find that once you have set up your equipment in this way the birds will begin to tolerate your presence and may even become inquisitive and move closer, allowing fine close-ups.

On some occasions you will undoubtedly come across a suitable subject by chance whilst out driving and in this case there is little opportunity for pre-planning as the chance usually appears quite sud-

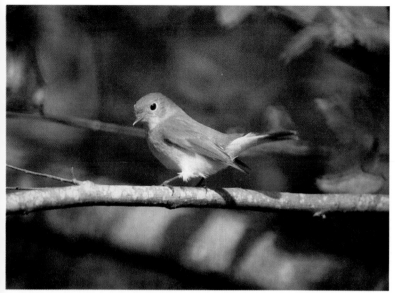

Red-breasted Flycatcher *(Ficedula parva)*, Isles of Scilly, England; October; Nikon F2, Nikkor Mirror 500mm f8, 1/250 sec @ f8, Ektachrome 200; stalked with monopod.

denly. If you are far enough away it may be possible to stop short and arrange your equipment: you may even be able to set the camera and lens up on its support and then drive up to the bird with one hand holding the camera in place. Needless to say this should only be attempted in areas with no other traffic. You may wish to switch off some distance away and cruise to the exact spot, but you must always be ready to focus and take your photographs quickly, as the bird will rarely stay long.

If you have no opportunity to stop short upon seeing the bird, it is better to drive past, set up the equipment, then turn back to your chosen position. It is usually more comfortable to take photographs from the driver's seat but this may put you in the bird's direct line of sight, and it will be more likely to fly off. Often you will be more successful photographing from the passenger window by leaning across from the driving seat. This is less likely to startle the subject but tends to be uncomfortable, making camera shake a potential hazard.

Success is obviously more likely in circumstances which allow prior assessment and planning than in surprise situations, but it is always as well to have your camera at the ready and react quickly so as not to miss some really exciting opportunities. Indeed, we have had some success with owls on road-side fence posts during daylight using this method.

Any locations where birds are used to the presence of motor vehicles will produce a good variety of subjects for the bird photographer. Car parks at picnic spots, zoos or reserves are often ideal places for smaller

Fig. 9 'Wait and See' high tide wader hide

hide erected at low water birds brought in with incoming tide

birds which are used to feeding on titbits left by visitors. Here you have the opportunity to photograph birds on the ground feeding, or on natural perches waiting for food to appear. Species which are renowned for their nervousness, such as corvids, may become more tame in their search for easy pickings but although they appear to be confident they also seem to know which car windows are open and which are closed. Invariably they avoid open windows making photography frustrating to say the least. However, a little thought will suggest many such locations in your own areas which are particularly suited to this type of photography.

Although the mobility of the car is an attractive feature, you are limited to firm ground and areas where there is good access to the site. On rough or inaccessible ground, a more conventional hide is better for photography away from the breeding area. You may choose to build a permanent, sturdy structure, or else opt for a mobile, collapsible hide. The ideal siting for such a hide is an area where birds are known to congregate, such as a high tide wader roost or a rubbish tip. This usually requires precise knowledge of the area involved.

If you don't have local knowledge, a less predictable approach is to erect a hide on the edge of a pond, lagoon or woodland pool and wait until birds turn up to drink; in some cases birds will also come to suitably prepared bait. Each of these methods has its own individual problems.

Wader Roosts

Any birdwatcher knows that birds tend to congregate in certain locations at particular times. The most spectacular example of this phenomenon is the build-up of waders at high tide. During the autumn migration and winter-time, enormous numbers of birds congregate in relatively small areas on the coast, making photography both exciting and rewarding and some spots in all parts of Europe are renowned for this spectacle.

Photography at high-tide roosts though is not as simple as it might initially appear. In order to be successful, you must know the area well and check the estimated tide times in the newspaper or from the local coastguard. It is also essential to know the predicted height of the tide and what this means in relation to the shoreline features of the area.

Some wader roosts, such as those on small islands, are fairly constant in their placement regardless of the height of the tide, but birds roosting on sand or gravel banks will shift according to the water level. If the tides are exceptionally high the birds may move off on to some higher ground further away which may be inaccessible or unattractive for photography.

Most amateur photographers have only limited time at their disposal so any wasted time is infuriating. It is of course impossible to control weather or tide, but adequate planning helps prevents major disappointments on the day. Careful study of the tide tables for the coming weeks will tell you how many days will produce high tides at times when lighting conditions are likely to be ideal. Remember that in the northern latitudes the daylight hours diminish considerably during the winter, limiting the occasions when both tides and lighting are correct.

Having chosen your location, and obtained permission if necessary, it is as well to visit the area for a few hours either side of high tide to choose the best site for your hide. Try to note, with reference to landmarks, the precise area in which the birds congregate because unless you have adequate reference points you may find it difficult to find it again when you return with your camera. Any information gleaned from other photographers who have worked the site will prove especially valuable.

From the safety point of view always leave an escape route in case your calculations prove to be wrong and remember that the tide may also be advancing around you along the numerous channels which usually criss-cross mudflats. If possible, make sure somebody else knows where you are as a precaution should the location prove dangerous.

On the chosen day, try to arrive two to three hours prior to high tide, set up the hide and arrange your equipment inside so that all accessories are easily found. At this time, there should be little fear of disturbing or frightening off the birds as they will be dispersed over the mudflats, feeding. If possible, you should place the hide among some natural cover in an attempt to break up its outline but if the hide has to be sited in the open, make sure the canvas is stretched tightly over the frame. Weight the bottom down with stones or pegs, so that there are no free parts to flap in the wind and frighten your quarry. The wind in coastal areas is stronger than inland and it is a good idea to have guy ropes attached to the hide for extra stability. Some photographers attempt to camouflage the structure by tying seaweed or grasses around the canvas but pieces often work loose and frighten the birds.

For once, you won't need long telephoto lenses: a standard or even a wide angle lens is fine for recording the whole spectacle; a 135mm or mid-range zoom helps isolate small groups of birds and a 300mm is necessary only to isolate single birds on the edge of the roost.

Once you are set up in this way and have made sure your coffee and sandwiches are accessible, all that is left is to wait for the advancing tide to bring the birds to you. If your planning has been accurate and luck is with you, several hours of exciting photography should be ahead.

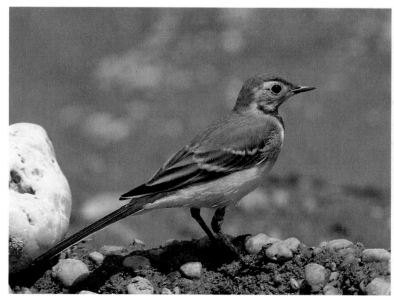

White Wagtail *(Motacilla alba alba)*. Neusielder See, Austria; June; Nikon F3, Nikkor IF-ED 600mm f5.6 + Nikon 1.4 × teleconverter, auto @ f11, Kodachrome 64; car bracket.

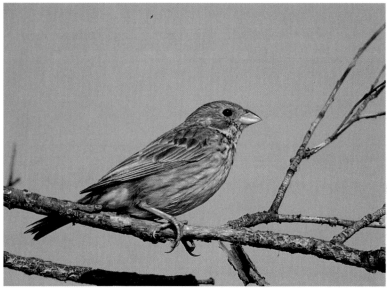

Corn Bunting *(Miliaria calandra)*. Camargue, France; June; Nikon F3, Nikkor IF-ED 600mm f5.6 + Nikon TC300 2 × teleconverter, auto @ f11, Kodachrome 64; car bracket.

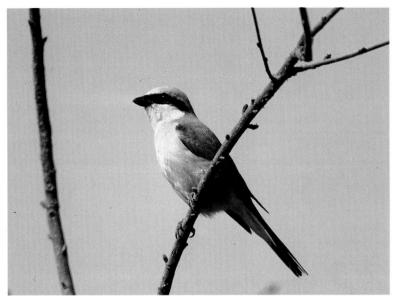

Red-backed Shrike *(Lanius collurio)*, Camargue, France; June; Nikon F3, Nikkor IF-ED 600mm f5.6 + Nikon TC300 2× teleconverter, 1/60 sec @ f11, Kodachrome 64; car bracket.

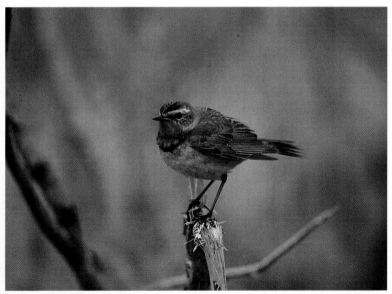

Bluethroat *(Luscinia svecica)*, Varanger Peninsula, Norway; June; Nikon F3, Nikkor IF-ED 300mm f4.5, auto @ f5.6, Kodachrome 64; hide, tripod.

The approaching tide will drive the birds up towards the hide. At first, having ceased feeding, they will be restless and noisy and there will be parties of birds flying in and out of the roost. This presents good opportunities for pictures of groups of waders landing against a background of the advancing sea. However birds are easily frightened at this stage and may move to alternative roosts if unduly worried. Later, the flock will settle and become less active and whatever you may do inside the hide, the birds will pay little attention, so you are able to change lenses and take photographs at will. Unfortunately inactive birds give limited opportunity for imaginative photography and you may soon run out of ideas. Don't be tempted to leave the hide, though, until the tide recedes and the birds begin to disperse. Some photographers become bored and leave the hide suddenly, to put the roost into the air in the hope of fine flight studies, but this is seldom successful because the flock of birds fly away from the intruder giving only a backside view. It is better to attempt shots of the birds coming in to land when arriving at the roost.

Some roosts may be inaccessible for a number of reasons and thus photography in this way is impossible. You may still get good pictures, though, because flocks of birds leaving the roost as the tide recedes have fairly well-defined flight lines. For instance, in a good position along the shoreline you may be able to obtain some superb flight studies here without causing undue disturbance.

Birds at Bait

The drive to feed is one of the strongest urges in all animals, including humans. Birds are no exception and food is an invaluable way to attract subjects into a selected location for photography. It may also be the only simple way to take pictures of species which are very difficult to work at the nest – corvids are a prime example.

Certain locations such as parks, gardens and picnic areas are especially suitable for baiting, but with patience bait will attract birds in other areas, too. Photographing birds at bait almost always means using a hide in order to conceal the photographer.

Even non-birders know that scraps left on a garden bird table attract various species from the surrounding area and to a certain extent the type of food offered determines which species turn up to feed. Woodpeckers are fond of suet crammed into cracks in tree trunks, magpies seem to be particularly attracted to eggs, and finches will usually come to seed, for example.

A number of photographers begin by taking pictures of birds at their garden table. However this setting makes rather unattractive photographs and it is better to extend the idea to attracting birds into more natural surroundings. This is easy if you feed the birds in the chosen area regularly for some time before attempting photography. Once they know that there is likely to be food available, birds will begin to turn up daily and at this time you can introduce a hide, and camouflage it to blend in with the surrounding vegetation. You should be able to site the

hide so as to include an attractive and natural backdrop, and you can pick the best lighting conditions possible. In wooded habitats, the lighting is often poor and the sun breaking through the canopy overhead produces a dappled effect, so it may be better to use fill-in flash to augment the available light and give some shadow detail. Having allowed time for the subjects to become familiar with the hide you can begin work.

Bait tends to look messy in photographs and unless you actually want to show the bird in the process of feeding, try to place the food in areas which will not be visible in the frame. For instance, if you are using an old log, squeeze the bait into crevices on the side away from the camera.

Just as at the nest, 'gardening' helps: try limiting the number of natural perches around the hide so that birds waiting their turn to feed will have to use just one – conveniently situated in the best position for photography! If you introduce an artificial perch, make sure that it is changed from time to time because nothing looks more rigged than a series of shots of different birds on the same branch.

Baiting is particularly successful when the winter snows arrive and the temperature drops so that much of the usual foodstuff is frozen into the ground. At this time you'll get some very pleasing pictures with the birds framed against a backdrop of snow-laden vegetation. Apples and other fruit will attract thrushes such as the redwing and fieldfare. These usually shy species become more bold in harsh winter conditions. Try tying red berries on to the bare branches of bushes to attract the species which usually feed there. A photograph of the bird feeding in this way will look false as your ties will almost certainly show but you may get some fine shots as the birds perch on nearby branches to investigate the potential food source.

For carnivorous birds, you can use offal and butcher's scraps. In the appropriate habitat rabbit carcasses will attract buzzards, though this will involve a regular programme of baiting the area if you are to be successful. Baiting of this type should always make use of naturally occurring or introduced dead animals, not live creatures. The only situation where live bait may be acceptable is the use of fish confined by wire netting in a stream or pool in kingfisher territory. Many photographers have used this method successfully for close-ups of the birds on their favourite perches.

At times when the weather is not severe enough to decrease the natural food supply, birds are not so easily enticed to bait. However, they are always in need of water and this may act as a potent attraction especially in arid areas. Artificial ponds make photogenic backgrounds only with a considerable expenditure of ingenuity and skill but fortunately birds often use natural drinking pools and puddles. Make sure your subject comes to the right puddle by filling in any others nearby. A carefully positioned hide will provide surprising opportunities not only of different species coming down to drink but also bathing, giving a chance of some exciting action photography.

5. Action and Flight Photography

Action and flight pictures are probably the most challenging aspects of bird photography and as with any other demanding pursuit, success is particularly satisfying. It can be financially rewarding, too: dramatic and original flight photographs are constantly in demand by publishers. Action pictures require a quick eye for composition and framing, fast reactions, imagination and a detailed knowledge of your quarry and you will succeed only if you are thoroughly at home with your equipment and already proficient in the basics of bird photography. A good slice of luck is also a component of many successful action photographs, but when the opportunity presents itself, the photographers who turn luck into great pictures are the ones who have spent time and film on practising their skills and honing down their reaction times.

Equipment

The 35mm format particularly lends itself to action photography and the compact and lightweight equipment really comes into its own. Mobility is all important, and while larger format cameras may be superior for recording birds at the nest, they are really too cumbersome to be seriously considered for action and flight photography.

As with most other aspects of bird photography, the basic problem is how to achieve a good image size on film. As explained in chapter 1, long telephoto lenses provide a partial answer, but the size and weight of these large lenses is considerably more of a handicap when photographing birds in flight than when the lens is tripod-mounted and pointed at a nest. For most action photographs, a tripod is not a practical option, and even with the aid of a monopod or shoulder pod, the weight of a 600mm lens is difficult to support without the risk of camera shake.

A more satisfactory answer is to use your knowledge of bird behaviour to get closer to the subject, then to use a lens with a shorter focal length. Such a lens is easier to hold steady, and tracking a moving bird is simplified because focus changes require smaller twists of the focusing ring than when using a lens of longer focal length. Modern 300mm and 400mm lenses are compact enough to handle easily, and these are the maximum focal lengths that can be recommended for normal flight photography.

Hand-holding lenses of this size is just possible – particularly if you use fast film and a comparably fast shutter speed – but you will certainly find it easier to eliminate camera shake if you use some extra support. The ideal solution is to use a shoulder pod or rifle-stock support. This can be held tightly against the shoulder, allowing a good range of smooth movement which is essential for flight photography. In particular, smooth panning (swinging the camera to follow a passing bird) is relatively easy.

In special situations monopods are of some use to the flight photographer. When attempting flight shots from the car window a mono-

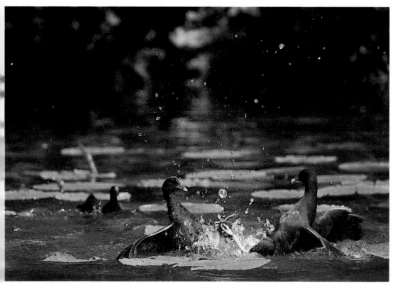

Moorhen *(Gallinula chloropus)*, Cambridgeshire, England; May; Canon AE1 and autowind, Canon 300mm f5.6, 1/500 sec @ f5.6, Kodachrome 64; stalked with shoulderpod.

pod jammed against the car door and fitted with a ball-and-socket head provides more stability but you are really limited to birds below, at or just above eye level. Photographing anything flying high in the air is difficult because of the physical restrictions placed on a photographer in a car.

While motordrives are not strictly necessary for most other aspects of bird photography, they really prove their value when you are taking flight and action pictures. Even the most dextrous of photographers can only advance film manually at a maximum rate of about two frames per second, but with a typical motordrive you can expose four or five pictures in the same period. The great advantage of such an accessory is obvious when photographing a moving subject; because you can take more pictures during a short burst of activity, there is a greater chance that more will be correctly focused and framed. If you are extremely lucky, you may end up with a running sequence of perfect images.

Technique

There are a number of features common to both stalking birds and to flight photography. In both the photographer is essentially free to roam at will in search of subjects. This adds to the excitement as unexpected opportunities may arise at any time and you must be prepared to seize them. Much of the advice regarding cover and concealment given in the previous chapter is equally applicable to the photography of birds in flight and indeed stalking is often an integral part of getting close enough to obtain an adequate image size.

If you are just starting to take action pictures, don't expect instant results. Inevitably there will be failures initially, but you can turn these to advantage by learning from your mistakes. Do not just consign your failures to the waste bin but look at them carefully and try to identify exactly what you have done wrong. A well-used notebook and exposure log is a great asset in the learning process.

Start by attempting flight or action shots of easy subjects: excellent examples include birds which are used to humans and easy to approach – at the local village pond or wildfowl refuges.

As a general rule, larger birds make easier targets, not only because of their size but also because of their slower wing beats. Swans are an ideal species to begin with as they tend to be tame in most locations and, even if not flying, are usually engaged in some other activity worth photographing. As they are large birds, they give ample opportunity to practice panning and focusing with a relatively short lens, thereby at least cutting out some of the practical difficulties of using longer lenses. One drawback is that you may have to wait a considerable time for swans to take to the air unless you visit one of the wildfowl reserves where various species spend the winter, and there is a continual passage of flocks.

Seabird colonies also provide fruitful locations for the flight photographer. These large populations of birds are constantly leaving and returning to the colony during the breeding season and therefore provide repeated opportunities to practise your technique. Although the seabirds are smaller than swans they offer a diversity which can cater for beginner and expert alike: the fulmar or gannet are relatively easy, but the puffin taxes the patience of even the best photographers. Most colonial seabirds tend to be relatively tame, and activity is guaranteed with the constant noisy comings and goings. As with any breeding species, you should take particular care to avoid disturbance although in the large colonies this should not be a great danger. One particular advantage of seabirds as subjects for the flight photographer is that many have a predictable flight path which is repeated time after time. Fulmars, for instance, are particularly good to start with, because just a few minutes of watching them from a distance reveals a well-defined flight pattern. The flight begins with the bird leaving its ledge on a coastal cliff and heading straight out to sea for a short distance. It then wheels and heads back into the cliff face before turning once again and gliding parallel to the cliff edge for some distance on the updraught. After a fairly constant distance it sets off out to sea again to repeat its cyclical flight path. The fulmar gradually moves down the coastline in this fashion before heading back to its starting point. Variations in the height of this flight path provide opportunities for photographs from above and below, head on, shots on the turn, as well as really dramatic photographs of the bird coming to land on the ledge with feet forwards and wings acting as brakes, to be greeted by the outstretched neck of its screeching partner. Just this one species provides numerous opportuni-

ties for bird photographers, and other species of seabirds provide different but equally satisfying chances: gannets, kittiwakes and the many species of gulls are also ideal species to begin with.

Spend time observing the whole scene, decide which species you are going to attempt, and then give some thought to your approach; this will pay dividends later. It is far wiser to attempt one species at a time and to put all of your effort into producing a few first-class photographs of that one species. Only once you are satisfied that you have got as much as you can from one species should you turn your attention to another. During your period of observation give some thought to the images you are seeking. Lighting, wind direction and flight paths all need to be taken into account when choosing the best vantage point for photography.

Another easy subject for the novice is to photograph the flock of seabirds which 'hang on' behind boats and ferries. Brace yourself in a secure position and follow the birds through the lens as they glide and weave in the slipstream of the boat. Although this is far easier than photographing moving birds from a static position, the technique provides a good chance to practise following and focusing with longer lenses. As the birds are moving at about the same speed as the boat, fast shutter speeds may not be necessary to freeze the action but vibration from the boat transmitted through your body to the camera is a problem. Use shutter speeds of at least 1/500 sec. to be sure that there is no blurring due to camera shake.

These should provide ample simple and some rather more difficult examples on which to practise the art of flight photography. Once you have begun to master 'side on' or oblique flight shots you should try to graduate to something rather more demanding and imaginative. Start thinking more about lighting effects and about how you might use existing light conditions to best advantage. Try taking photographs directly against the light to produce silhouettes. Once again, using the fulmar as an example, you can achieve quite dramatic results with *contre-jour* studies of the birds coming in to land on their nesting ledges. Often there is just not enough light to freeze landing birds using frontal or side lighting, but if you look for a different photographic position and point the camera directly into the light, you can throw the birds into silhouette with great effect. Take a light reading from the bright background and you should be able to use shutter speeds up to 1/1000 or even 1/2000 sec.

Focusing and Framing

Before focusing is even possible you must learn to locate the bird in the viewfinder, and this is especially tricky with a long lens when the subject is flying against a backdrop made up entirely of featureless sky where there are no convenient reference points. The same problem frequently occurs when using high-power binoculars for the first time. With a little practice, though, you should soon become quite adept at 'homing in' quickly on your subject. Once the bird is located in the viewfinder, you

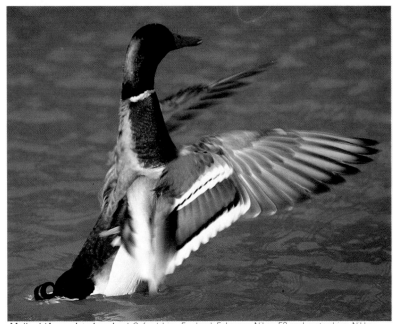

Mallard *(Anas platyrhynchos)*, Oxfordshire, England; February; Nikon F3 and motordrive, Nikkor IF-ED 300mm f4.5, auto @ f4.5, Kodachrome 64; stalked with monopod.

Shelduck *(Tadorna tadorna)* and Avocet *(Recurvirostra avosetta)*, Schouwen, The Netherlands; June; Nikon F3, Nikkor IF-ED 600mm f5.6 + Nikon 1.4× teleconverter, 1/125 sec @ f8, Kodachrome 64; car bracket.

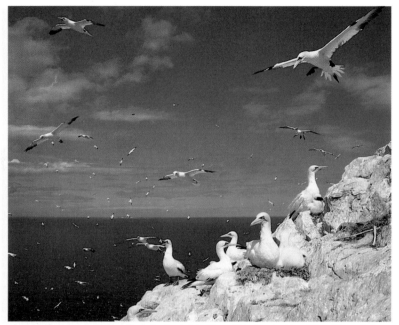

Gannet *(Sula bassana)*, Bass Rock, Scotland; July; Nikon F3 and motordrive, Nikkor 28mm f2.8, polarizing filter, 1/500 sec @ f8, Kodachrome 64; stalked, handheld.

then face the problem of keeping it in focus. Few birds pass the camera at a constant distance and the most common situation is that they fly obliquely towards or away from you, remaining sharp and in the field of view of a static camera for only a short time. Birds flying in this way provide the most worthwhile opportunities so it is therefore essential that you become adept at focusing as this happens. By contrast, direct side views of a single bird in flight are easier to take, but rarely yield such satisfying results.

Quick and accurate focusing is an essential skill in flight photography. Most people eventually develop their own individual style of focusing, but this is usually based on one of three conventional methods:

Fixed focus technique This is the simplest method for the beginner, and is most likely to provide at least one successful exposure. The general idea is to focus approximately on the subject as it approaches and then quickly refocus on a point closer to you, waiting for the bird to appear sharp in the viewfinder before releasing the shutter. Although very often successful, this technique relies on anticipation and quick reactions because a fraction of a second passes between deciding that the bird is in focus and actually pressing the shutter release. One variant is to use a motor drive and start to shoot when the bird is just outside the far limit of

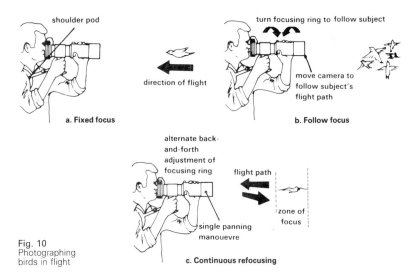

Fig. 10
Photographing
birds in flight

a. Fixed focus

b. Follow focus

c. Continuous refocusing

focus and to continue making exposures until it passes through the near focus limit. Although this appears to be wasteful of film as some shots will definitely be out of focus you will usually end up with at least one which is critically sharp.

Follow focus technique Theoretically, the most successful method of focusing on a moving bird is to attempt to keep it sharp at all times by rotating the focusing ring as the bird approaches, so that there are several opportunities to make exposures. In practice, this is probably the most difficult of the three methods to perfect. It is surprisingly hard to rotate the ring at exactly the right speed so that the approaching bird remains consistently sharp. Inevitably you will tend to misjudge and overcorrect several times and this will often coincide with the moment that the bird is the ideal size in the viewfinder. Certain specialized lenses are available commercially which go some way towards solving this problem. The Novoflex lenses incorporate a spring-loaded 'trombone' mechanism operated by a pistol grip. On releasing the grip the lens focuses out to infinity, and when the grip is squeezed, the lens focuses progressively closer. Although this would appear to be an ideal arrangement, focusing one of these lenses still takes a good deal of practice and the problem of overcorrection still remains – although less acutely so.

Refocusing technique The most popular method of focusing for this type of photography is the continual refocusing technique. It is common practice when focusing on any object, to rotate the ring backwards and forwards around the exact plane of focus. The initial large movements gradually become finer until the subject is sharply focused. With experi-

ence the majority of photographers find this the most accurate method of all. After each exposure the ring is rotated deliberately, the subject thrown out of focus and the whole procedure repeated. This is not as slow and awkward as it sounds and with practice you may have the bird sharply in focus several times in a single panning manoeuvre.

Each of the three techniques described above has its merits but you should try to settle with the one which you find most comfortable and which routinely gives the best results.

Shutter Speeds

In order to freeze a moving bird, you will need to use shutter speeds faster than those normally used in the photography of static objects. For even slow-flying birds you will need a speed of at least 1/250 sec, and a much faster speed for small, fast-moving species. A good general rule is to use the fastest shutter speed possible, with the lens set at maximum aperture. For instance, using a 300mm lens with a maximum aperture of f4.5 and using Kodachrome 64 film, a bird flying against a clear blue sky would be correctly exposed at a shutter speed of about 1/500 or 1/1000. An indication of the shutter speeds needed to stop wing movement in various species of birds is shown below.

SHUTTER SPEEDS FOR BIRDS IN FLIGHT	
Shutter Speed	**Species**
1/1000 sec	Ducks, waders, auks
1/500 sec	Herons, storks, geese
1/250 sec	Swans, large birds of prey

On duller days there is less light and you will have trouble in achieving shutter speeds fast enough to stop all movement. In this situation you will need to use one of the faster films with a speed of ISO 200 or even 400. In very dull light when ISO 400 film is still not fast enough for your needs, it may be uprated to 800 or even 1600 and 'push' processed by the lab, but this increases grain size and may create a colour cast. Nevertheless, an imperfect picture is certainly better than no photograph at all.

So far we have talked of 'stopping the action', but is this always desirable? Often the answer is no. Many pin-sharp shots of birds in flight look inactive which is just the opposite of what you want. Flight is movement and unlike the movie photographer, you must attempt to portray this action in a single frame. There are two ploys you can use. First, you can try panning to follow the subject as it flies past, keeping the bird in focus the whole time. This method is usually only successful when the birds are flying against a background which is not to be an

ACTION AND FLIGHT

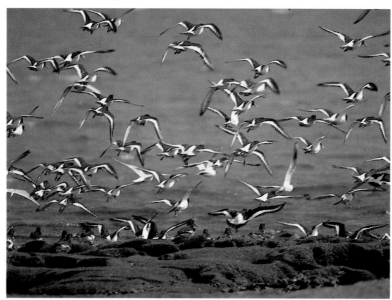

Oystercatcher *(Haematopus ostralegus)*, Isle of Islay, Scotland; April; Nikon f3 and motordrive, Nikkor IF-ED 600mm f5.6, 1/500 sec @ f5.6, Kodachrome 64, stalked with monopod.

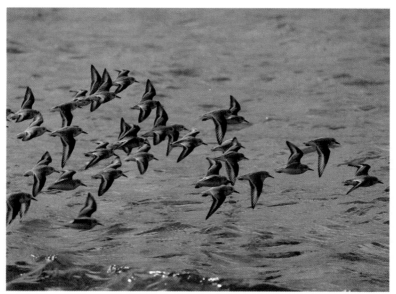

Sanderling *(Calidris alba)*, Isles of Scilly, England; October; Nikon F3 and motordrive, Nikkor IF-ED 300mm f4.5, 1/1000 sec @ f6.3, Ektachrome 200; stalked, handheld.

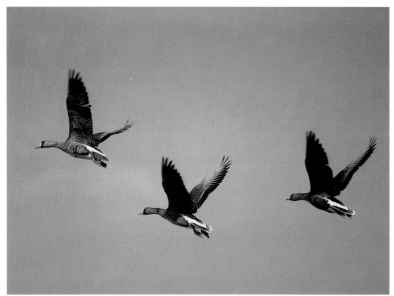

White-fronted Geese *(Anser albifrons flavirostris)*, Isle of Islay, Scotland; April; Nikon f3 and motordrive, Nikkor IF-ED 300mm f4.5, 1/500 sec @ f4.5, Kodachrome 64; stalked, handheld.

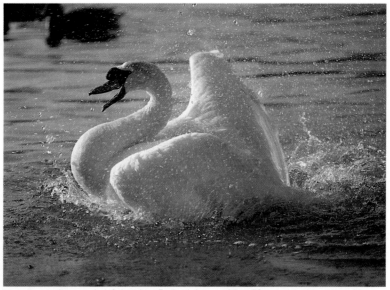

Mute Swan *(Cygnus olor)*, Oxfordshire, England; January; Nikon F3 and motordrive, Nikkor 80–200mm zoom f4, 1/500 sec @ f5.6, Kodachrome 64; stalked, handheld.

integral part of the whole image because the technique makes the background unrecognizable. Using this method you are able to select a slower shutter speed than usual because the camera and bird are moving in the same direction and the speed of the subject relative to the film is therefore slower than when the camera is static. The end result is a blurred, out of focus, background with a sharply focused subject, giving the suggestion of movement. Experiment with different shutter speeds until you get the results you want; 1/125 is a good starting point.

The second way to suggest motion is to allow some subject movement to register on the film as a slight blurring. Basically you decide which shutter speed will stop all of the action and then use a setting or two slower. The result is that the bird's head and body remain sharp and clear, while the wingtips – which are moving faster – are slightly blurred to suggest action. This technique is particularly successful when the background is predominantly sky as the blurring appears to bring an otherwise static picture to life. Perfection of this technique takes some luck, a lot of practice and a certain amount of film wastage but the dynamic and elegant results will make it all worthwhile.

Selecting a Viewpoint

Your view of a bird will often largely be determined by factors outside your control. There are however many situations where you can exert some influence over the position you select. A straight side view of a bird often produces an image which is less than satisfactory, especially if the wings are caught on the downstroke, so try instead to select a viewpoint which evokes more drama. An oblique or head-on view, although technically more difficult to achieve, produces a more pleasing image and these positions have the added advantage that a highlight is usually visible in the eye.

Similar rules apply to birds flying overhead: photographs of birds from directly below seldom have much impact, but if you move slightly to one side, the resulting photograph is much improved. This particularly applies to hovering species, such as terns and some birds of prey.

Opportunities of looking down at birds in flight are rare, but should you be lucky enough to get above a flock of flying birds in a light aircraft or helicopter, you can produce some very unusual photographs. Occasionally a cliff-top vantage point gives a similar view of birds flying in the valley or over the sea below.

Positioning your subject in the frame is simple: the rule is – always to have birds flying into the frame; birds flying out of the picture just do not look right. Except in unusual circumstances where there is a strong pattern content to a picture, the direction of flight should be towards the camera, not away from it. Birds flying away from the camera are not acceptable and usually give the impression that the photographer has frightened the subject away – which does nothing for the photographer's reputation among other birdwatchers and the public in general.

These and other rules of composition are not unbreakable, though; it often pays dividends to try something a little different. All too often photographers have the fixed idea that a telephoto lens is always necessary for pictures of birds in flight. There are, however, a few occasions when a 50mm standard lens is perfectly adequate, because some birds are so approachable. Indeed, some will actually take the initiative and approach visitors in the hope of a tasty morsel. A typical example is the black-headed gull (see photograph on page 80). If you can persuade an accomplice to hold out a piece of bread and toss it into the air some gulls will hover above the cameraman in an attempt to cash in on the free food. Even with a standard lens you can frame some superb action shots without the problems of handling and focusing with long lenses.

Flocks of birds are easier to photograph in flight than individuals. This is partly because the flock presents a larger target to the photographer, and is easier to focus upon; and partly because it is simpler to get close enough to produce a good image size. Again, as a general rule, the larger the species, the easier it is to photograph in flight. Particularly good opportunities are to be found in the most unlikely places: rubbish tips, for example, attract the larger species of gulls, which may be approached quite easily, and the activity affords ample and varied opportunities for the flight photographer.

One notable problem encountered with certain species of bird such as geese is their tendency to fly in single file which makes composition difficult. However, this may be overcome by shooting as they take off or land, when they form into more compact groups. Check the wind direction before taking up position, because most large birds usually take off into the wind in order to gain altitude; their flight is consequently relatively laboured and slow and gives you more time to focus and compose. With a motordrive you should be able to expose a good number of frames before they turn downwind. When focusing on a line of birds make sure that those nearest to you are sharply focused; blurred birds in the foreground will spoil your photograph, but blurred background birds can be quite tolerable.

Waders in flight present quite a different problem. As they are usually more timid, the initial approach is more difficult and on taking to the air they fly directly away from any intruder, presenting little opportunity for good photographs. However a group will often break away and fly back past you, so always be alert. Watch the tide, too: as it rises over the coastal mudflats, waders are pushed up from their feeding grounds to roost above the tideline. As the tide recedes some hours later they return once more to feed. Careful observation will reveal that they usually follow well-defined flight-paths, and the strategically placed photographer should be able to catch some worthwhile flight studies. Don't restrict yourself to telephoto lenses: if the numbers are large enough, a wide angle provides some unusual shots, showing not only the birds but the whole landscape as well.

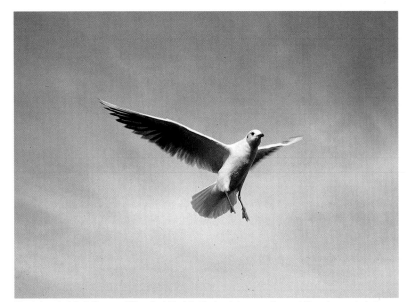

Black-headed Gull *(Larus ridibundus)*, Norfolk, England; January; Canon AE1 and autowind, Canon 50mm f2.8, 1/1000 sec @ f2.8, Kodachrome 64; stalked, handheld.

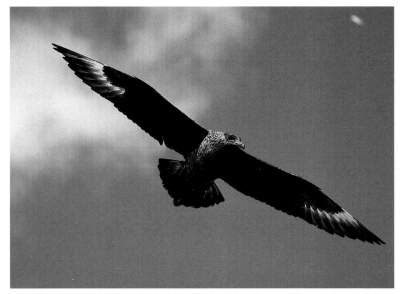

Great Skua *(Stercorarius skua)*, Shetland Isles, Scotland; June; Canon AE1, Canon 135mm f3.5, 1/500 sec @ f4.5, Kodachrome 64; stalked, handheld.

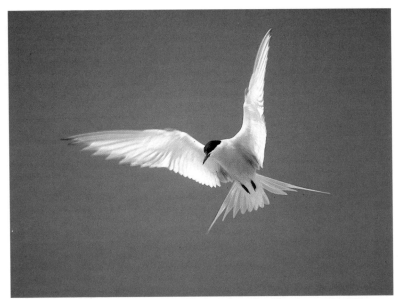

Arctic Tern *(Sterna paradisaea)*, Isle of Islay, Scotland; June; Nikon F2 and motordrive, Nikkor 300mm f4.5, 1/500 sec @ f5.6, Kodachrome 64; handheld from hide.

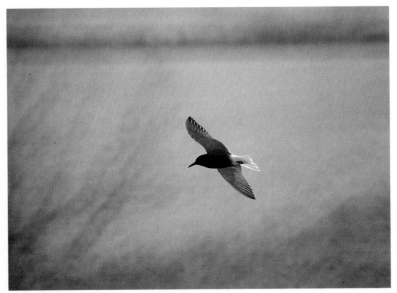

Black Tern *(Chlidonias niger)*, Norfolk, England; April; Canon AE1, Tamron Mirror 500mm f8, 1/500 sec @ f8, Ektachrome 200; stalked with shoulderpod.

6. The Use of Flash

In the correct circumstances, the competent use of flash may improve photographs taken in daylight, or enable a picture to be taken where it might otherwise have been impossible. As such flash has become an indispensable tool in all branches of nature photography. Flash is usually necessary in one of three situations: the most obvious is when there is just not enough light to obtain a photograph in any other way, such as at night or indoors. Flash may also be useful, though, to arrest the movement of an active bird in flight or when engaged in other activities. Finally, when the available light is not sufficient to permit the use of small apertures, the additional light from the flash allows a smaller aperture to achieve maximum depth of field.

Rapid advances in microtechnology have enabled manufacturers to make powerful flash units sufficiently portable to be of use in bird photography, but this is a recent development. In the past, powerful flash units were extremely cumbersome, demanding very large and often potentially dangerous power sources. However, even with these advances, and the provision of automatic exposure facilities, this branch of bird photography is the one which appears to be most daunting to the beginner.

This chapter therefore provides a simple introduction to the use of flash as an aid to bird photography, and a more detailed discussion of some of the techniques currently in use. Expendable flash bulbs are not discussed here as these have now been largely superseded by the more convenient electronic flash tube.

Basic Principles

Most modern flash units use computerized circuitry and sensors to change the duration of the flash in response to the light reflected by the subject. In theory, this results in correct exposure over a range of lens aperture settings and at various different subject distances. This may sound ideal but unfortunately, as with automatic exposure mechanisms on cameras, the electronic 'eye' is often fooled into giving incorrect exposure in unusual conditions. The sensor system performs well in an indoor setting where light is reflected evenly off interior walls, and as such should be fine when taking photographs of birds nesting in barns or other enclosed areas. However when using a flash outdoors on 'automatic' you may experience more difficulty in obtaining correct exposures. To take this into account, all such units have a manual setting which yields a precise pulse of light of fixed intensity and duration. For the beginner it is easier to use flash apparatus in this manual mode than to master the automatic facilities.

Manufacturers of flash units assign each model a guide number which is just a convenient means of expressing the power of the unit and its light output. The higher the guide number the more powerful the flash unit. Guide numbers are given for several different film speeds so you

should easily be able to work out the correct aperture to use in any situation. The guide number is obtained by multiplying the lens aperture required for correct exposure by the distance of the subject from the flash unit. So if you know two of the parameters – usually the guide number and the flash to subject distance – it is an easy matter to calculate the correct working aperture for the film speed you are using. It is important to understand that it is the distance of the subject from the *flash* and not the subject to *camera* distance which is used in this calculation. These two distances are of course the same if the unit is mounted on camera, but in most bird photography the flash is mounted elsewhere, and the distances differ considerably.

Imagine you are photographing a bird at the nest in a barn and that you have positioned a flash unit 10m from the nest. You are using one of the more powerful units which has a guide number of 40m when using ISO 64 film. Using the information given above you can calculate the aperture which will give the correct exposure as follows. (Guide numbers are given in either feet or metres and your distance measurements must be in the same units.)

$$\text{Correct aperture} = \frac{\text{Guide number (in metres)}}{\text{Flash to subject distance in metres}} = 40/10 = f4$$

As you can see, given an accurate manufacturer's guide number you can easily calculate the correct settings for any situation. It is unfortunate though, that most manufacturers err on the side of optimism in the calculation of their guide numbers, and this is misleading for the user. Most guide numbers are calculated on the result of tests performed indoors where the surrounding reflective surfaces concentrate light on the subject. Guide numbers calculated in this manner will be artificially high when the flash unit is used outdoors owing to the lack of reflective surfaces close to the subject. So if you follow the guide number too rigidly, your pictures will be constantly underexposed.

The only satisfactory method of overcoming this problem is to calculate the guide number of the flash unit, for yourself, both for outdoor and indoor use. This is simply done with a little patience and some detailed exposure records. Set up your camera on a tripod indoors in a situation of the type you are likely to encounter whilst photographing a bird in a building. Place a 'set up' subject, say a stuffed bird, at the approximate distance at which you would expect to photograph a live bird of the same size. Next to the subject place a card with details of the flash to subject distance, film speed and lens aperture used. Now make your exposure. For the next exposure change the aperture up or down $\frac{1}{2}$ or 1 stop and enter the details on another card and place this next to the subject. Make your exposure. This process can be repeated, varying the aperture, flash to subject distance and even flash head positions. You will then have a detailed record of all exposures on the resulting transparencies or negatives. All that remains is to sort through the

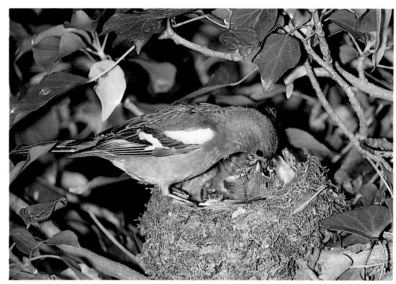

Chaffinch *(Fringilla coelebs)*, Norfolk, England; June; Canon AE1, Canon 300mm f5.6, Vivitar 283 flash unit, 1/60 sec @ f8, Kodachrome 64; pylon hide, tripod.

results selecting those which are correctly exposed and note the exposure details for future reference.

Outdoors, the flash provides just as much light, but you will nevertheless need to use wider apertures owing to the lack of reflective surfaces and to the rapid fall-off of light as the flash to subject distance increases. In order to obtain consistently correct exposures in outdoor locations you should repeat the test outlined above to obtain the correct settings for a number of varying circumstances. This method may be of equal help in determining the correct exposure for a combination of flash and daylight and even for variable positioning of your flash heads, provided you record all of the information on a card set up next to the subject.

There will, on occasions, be times when you are working so close to the subject that the aperture you obtain using a guide number calculation will be smaller than the minimum aperture available on your lens. For instance, a powerful flash unit with a guide number of 55 used at a distance of 1.5m will need an aperture of f36 for correct exposure. On most lenses the smallest aperture is f22. There are several ways to tackle this problem. First you could move the flash unit back to a distance of 2.4m, if possible, which would give an aperture of about f22. Second, some units have the ability to vary their power by means of a vari-power selector which cuts the light output in a stepwise fashion to as little as 1/64th. This facility is of particular use in those situations where space restrictions do not allow the flash units to be moved back. A third alternative is to use neutral density (grey) filters on the front element of

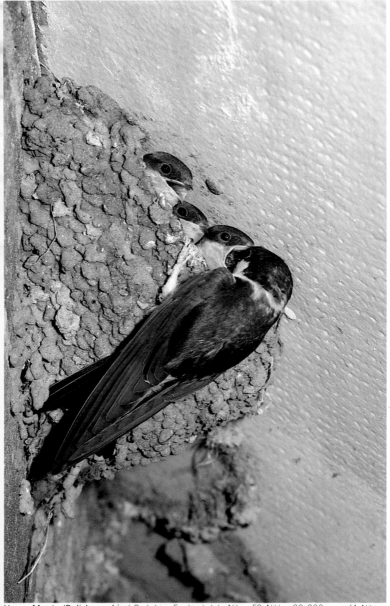

House Martin *(Delichon urbica)*, Berkshire, England; July; Nikon F3, Nikkor 80–200 zoom f4, Nikon SB16 (TTL) flash unit, auto @ f16, Kodachrome 64; remote-control cable, tripod tied to ladder.

the lens to effectively decrease the amount of light reaching the film and thus making possible correct exposure at a wider aperture.

Synchronization

All modern cameras have electrical contacts which ensure that the flash unit emits a pulse of light exactly at the moment when the shutter is fully open. This synchronization is made either via a coaxial flash socket in the camera body or the 'hot' shoe and a complimentary contact on the flash unit. The versatility of the synchronization depends very much upon the type of shutter built into the camera: cameras fitted with leaf shutters – mostly rollfilm cameras – can be used with flash at any shutter speed, but the focal plane shutter – fitted to most 35mm cameras – is not so versatile. In cameras fitted with such a shutter the flash is synchronized only with a limited range of shutter speeds which are indicated on the shutter dial. On most 35mm format cameras, the fastest speed is 1/60 sec and more rarely 1/125 or 1/250 sec. The use of anything faster will result in the light only reaching a portion of the film and thus giving a partially exposed picture.

In fact it is best to use the fastest shutter speed possible, as at slower speeds the available light may record a second image on the film as well as the image produced by the flash. This phenomenon is known as 'ghosting' and it becomes apparent only when photographing moving subjects. Ghosting is only seen when the available light is bright enough to produce an image on the film without the flash, even if that image is not fully exposed. The slower the shutter speed, the more likely there is to be subject movement whilst the shutter is open, thus registering this unwanted second image on the film.

Using Flash Automatically

In the manual mode a flash unit produces a consistent amount of light in terms of brightness and duration. The flash is always set to the maximum power possible for that unit, assuming a fully-charged battery. The duration of the pulse of light varies, depending upon the specifications of the unit but the flash usually lasts between 1/500 to 1/2000 sec. As the light output of the unit is constant, changes in the illumination of the subject must be made by changing the subject to flash distance or the lens aperture.

Computerized or automated flashguns make guide number calculations unnecessary and would appear, therefore, to be ideal for the bird photographer. The amount of light emitted from the electronic flash tube is controlled by a sensor which is situated either on the camera (TTL), or on the flashgun itself and directed at the subject. When the flash is fired, the sensor measures the amount of light reflected from the subject and quenches the flash tube when enough light has been reflected to give correct exposure with the aperture selected. However, in some conditions the sensor may be fooled into giving incorrect exposures, because it measures only the light reflected from the central area of the scene.

This is fine if everything in the viewfinder is of similar tone and if the subject is central, and close to the background. If the subject is dark and off-centre, and the surroundings are light, the flash will be quenched when the background has received enough light, thus leaving the subject underexposed. Equally if a light subject is small in the frame, with a dark background taking up most of the field of view, the background will be correctly exposed whilst the subject will tend to be overexposed. This situation is very common when photographing birds.

In view of these disadvantages we tend to use the automatic mode only when on short visits to areas where time is important and it is impractical to set up flash equipment in the usual manner. Such situations might include birds in nesting holes, or owls found roosting in poorly-lit sites during daylight. A single flashgun mounted to the side of the camera and set to the automatic mode may allow you to obtain otherwise difficult photographs even though they may not be technically perfect.

Teleflash

One feature of many modern flash units, the teleflash facility, is of particular use to the bird photographer. Teleflash consists of a plastic lens which concentrates the beam of light onto a smaller area. This has the effect of increasing the guide number of the unit making it particularly suited to use with telephoto lenses when working at some distance from the subject. Many of the units are of the 'hammerhead' variety which can be attached to the camera and lens by means of a bracket. This results in a particularly compact and portable but powerful flash set up. One disadvantage of such a feature is that the beam of light may only cover an angle of 8 degrees so the flash unit must be accurately aligned with the lens to ensure even lighting of the subject. You can avoid this difficulty however by taping a small torch to the top of the flash unit, so that its beam acts as a directional aid. This facility is particularly useful when photographing birds perched in trees or bushes against the light.

Single Head Flash in Practice

Before making the decision to use artificial lighting it is important to try to visualize the effect you hope to achieve. Inept use of flash to photograph diurnal birds creates a black background, giving a nocturnal effect which is quite unnatural. If it is at all possible such birds are obviously better shown in a natural setting, but this does not rule out the use of flash: the thoughtful use of artificial lighting can often achieve this aim.

Most 35mm cameras have an accessory shoe on top of the camera body but this is probably the worst possible site for a flash gun, because it creates straight frontal lighting which gives a very flat and unnatural image lacking any subject modelling. When attempting photographs of a bird usually active in the daytime, you should instead use the light source to simulate natural sunlight. One way to do this is to position the

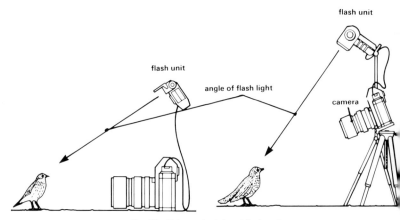

Fig. 11a Using a single head flash unit

flash unit so that the direction of the light is what one would expect if the subject were sunlit; this usually means positioning the flash to one side of the camera and above it. The quality of light produced by a flash tube is much harder than natural light and creates hard shadows which are rather unattractive. By positioning the flashgun to one side of the camera body you will achieve more sense of form and shape but the bird will still have a long hard shadow. By moving the light source higher the modelling effect is retained but the shadow will be shorter and less obtrusive as it will fall under the subject. A procedure that works well is to set the unit on a stand or tripod approximately 0.6m to the right or left of the camera position and about 0.6m above, angled down towards the subject. However, even with these alterations the result is often a rather hard and contrasting image. This effect may be lessened by placing a diffuser or handkerchief over the front of the flash unit to produce a more diffused lighting which casts softer shadows and results in less contrast overall. Unless you are working with flash equipment fitted with an automatic sensor or 'Through-the-Lens' (TTL) flash you will need to open up the lens aperture to allow for the decreased light output. Alternatively you may prefer to use a reflector opposite the light source to provide some 'fill-in' lighting to the areas in shadow, thereby reducing the harshness of the image on the film.

A simple way to visualize the effects of changes in position of the flash unit is to set up an object on a table and to place an adjustable light in various positions, noting the shadow and highlight areas on each occasion.

Multiflash Use

A more successful way of using flash lighting to mimic the effect of sunlight is to use more than one unit. The simplest arrangement is to use

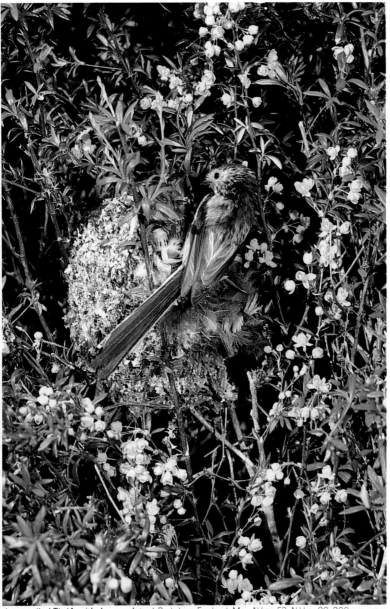

Long-tailed Tit *(Aegithalos caudatus)*, Berkshire, England; May; Nikon F3, Nikkor 80–200mm zoom f4, Nikon SB 16 and SB 17 (TTL) flash units auto @ f11, Kodachrome 64, hide, tripod.

two heads, one as the main light and a second, less powerful unit, to soften the shadows produced by the first. In more complex set-ups extra units light up the background and even produce comprehensive lighting of the whole scene.

With two flash units, the main flash is placed to the side and above the camera position, angled downwards toward the subject. The second, or fill-in flash should be positioned either next to the lens or a little to the other side of the camera. The idea is that the main flash simulates the sun and provides most of the light. The fill-in flash should provide just enough light to fill in the shadow areas. You can find the ideal power ratio of the two units by trial and error, keeping written records for each exposure; as a guide a ratio of 4:1 in favour of the main flash is a good starting point.

There are several ways to adjust the ratio: assuming that the two units are of equal power, the easiest way is to place the fill-in light twice as far from the subject as the main head. For instance, with two flash units having an effective guide number of 24m with ISO 64 film and an aperture of f8, the main flash would be placed 3m from the subject. In order to produce an output ratio of 4:1 in favour of the main flash, the fill-in light should be 6m from the subject. Alternative methods include decreasing the power of the fill-in source using the vari-power facility available on some of the more powerful units, keeping both units the same distance from the subject. Another less precise method is to place a white cotton handkerchief over the fill-in flash head. Some photographers prefer this method as it not only decreases the power by approximately one half but also produces a more diffused lighting.

By using these methods as a starting point you can experiment and move the fill-in light to various positions to produce the effect you desire.

Picturing a diurnal species against a dark background produces a rather unnatural nocturnal effect, but this happens only if the background is far behind the subject. If the background is close enough to the subject to be adequately illuminated by the two flash-heads there is no such problem. However, as lighting power falls off quickly, backgrounds which are even a few feet behind the subject will always be inadequately illuminated. It is in just such situations that a third unit is useful to light up the background. This unit should obviously be placed in such a position that it does not appear in the final photograph.

Synchronizing several flash units to fire simultaneously requires some ingenuity. A rather cumbersome technique is to use a three-way adaptor connecting the power leads from each flash head to the flash socket on the camera body. This arrangement is somewhat unpredictable in performance and may not work at all when several different types of units are used together. It also involves long connecting leads which get in the way, especially when working in the dark.

A more convenient method of achieving synchronous firing of two or more flash heads is to use a 'slave' unit. This photo-electric device responds to a sudden increase in illumination, such as that produced by

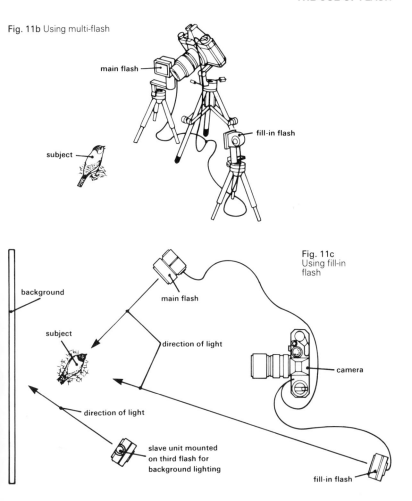

Fig. 11b Using multi-flash

main flash

fill-in flash

subject

Fig. 11c
Using fill-in
flash

background

main flash

subject

direction of light

camera

direction of light

slave unit mounted
on third flash for
background lighting

fill-in flash

a flash tube, and fires other units to which it is connected. Slave units are cheap, small, and some will work at distances up to 9m. The electrical components of the unit respond so quickly that the interval between the firing of the master and slave flash units is small enough to be insignificant. The flash head nearest the camera is connected in the usual way and the other units are positioned as required and connected to their power sources. Slave units are then connected to the respective flash units and may be pointed in the direction of the key flash, although this is often not strictly necessary as they should also respond to reflected light from the key flash gun.

THE USE OF FLASH

Fill-in or Synchro-sunlight Flash Photographs

Illuminating the background with a separate flash gun is one way to avoid the rather unnatural dark backgrounds so often associated with the use of flash in bird photography. Another very successful technique is to use a combination of daylight and artificial lighting so that natural light illuminates the background while the subject is lit by flash. This method is popularly known as 'fill-in flash' or 'synchro-sunlight photography' and the results can be extremely pleasing and natural if the technique is used correctly. It may be used successfully on subjects which are in the patchy lighting created by sunlight shining through leaves; or on a subject which is heavily backlit so that heavy shadows fall towards the camera, obliterating any frontal detail. In order to visualize the problem imagine taking a photograph of a human subject against the sun. If you expose for the background the face of the subject will be underexposed with no detail apparent; but should you take a meter reading to correctly expose the subject's face, the background will be burnt out or overexposed. This apparently insoluble problem may be overcome by using the natural light to illuminate the background and a flash unit to fill-in the shadowed area on the subject. This technique is equally applicable to birds in a similar situation.

Let us take an example to illustrate how this valuable technique may be used in bird photography. Imagine that you are using a flash gun that has an effective guide number outdoors of 32m when using ISO 64 film, and that the flash to subject distance is 2m. The aperture needed to give

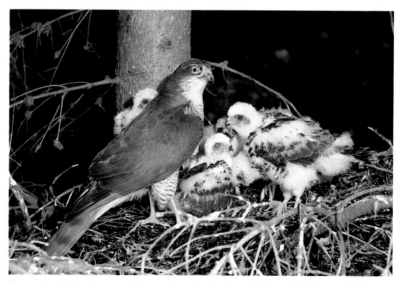

Sparrowhawk *(Accipiter nisus)*, Sussex, England; July; Nikon F3, Nikkor 80–200 zoom f4, Nikon SB16 and SB17 (TTL) flash units, auto @ f8, Kodachrome 64; pylon hide, tripod.

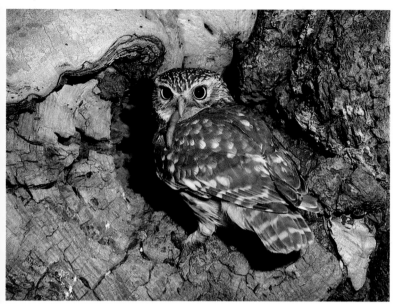

Little Owl *(Athene noctua)*, Berkshire, England; June; Nikon F3, Nikkor Micro 55mm f2.8, Nikon SB 16 (TTL) flash unit, auto @ f11, Kodachrome 64, remote-control cable, hide, tripod.

correct exposure *using flash only* would be f16 when calculated by the usual method. As a general guide the exposure for fill-in flash should be half that which would be required to illuminate the subject by flash only. Thus the selected aperture should be one stop smaller than f16–f22. After setting the aperture on the camera, you can take a meter reading to find the shutter speed which will give the correct exposure for the surroundings at the selected lens aperture of f22. This shutter speed must be no faster than the maximum allowed for the proper flash synchronization with your particular camera. This means that it should not be faster than 1/60 sec or possibly 1/125 sec on most cameras with focal plane shutters. If you are using an aperture as small as f22 you will need to select a slow shutter speed. Using ISO 64 film this would be as slow as 1/15 sec or 1/30 sec – your exposure meter indicates the correct speed.

Fill-in flash is especially simple when using one of the automatic computerized flash guns. Just set the sensor control to an aperture one stop larger than that suggested by the meter in the camera. For instance, if the correct exposure for the surroundings or background is 1/30 sec at f16, the indicator on the flash gun should be set to f11. This should fool the unit into emitting only half of the usual light output.

One problem becomes evident immediately once you start using fill-in flash. If you are working with slow shutter speeds it is essential that the

subject does not move during the exposure. If the bird does move you will record two images, one of them blurred, and formed by daylight, and the second a sharp image captured by the flash. The end result is known as ghosting as explained on page 86. There is no real solution to the problem: you may need to make several exposures before you obtain one in which the subject has remained static. However the use of this method is well worth the effort as you are able to produce very natural-looking results which would otherwise be impossible.

Mixing daylight and flash in 2:1 proportions works well, but you may choose to vary the ratio to suit your own preference by varying the lens aperture up or down by half a stop; if you have the facility to vary the output of the flash you can retain the selected aperture and change the power of the flash.

It is all too easy to lay down rigid guidelines regarding exposure with flash in various situations. However, in practice, nominally identical units of the same model often vary in their performance, particularly in the automatic mode when they may become unpredictable, especially in unusual lighting conditions. The best advice is to get to know your own flash unit and its characteristics by using it in the manual mode and noting exposure details as you go along. If in any doubt make your exposures at several different settings. In this way the use of fill-in flash will soon become second nature.

Night Photography

Diurnal birds look unnatural against the dark backgrounds so often associated with flash photography but quite the reverse is true for nocturnal birds such as owls. As flash is an essential part of photographing nocturnal species, the photographer is usually restricted to the vicinity of the nest because of relative bulk of equipment necessary. Working at the nest inevitably involves a hide unless you attempt photography by remote control, as explained on page 52.

The human retina is not well adapted for night viewing so you need to be well prepared before starting a photographic session, knowing exactly where your equipment and accessories are situated so that they are easily to hand. Always allow at least thirty minutes for your eyes to become accustomed and once they have adapted you should avoid looking at any bright lights before the end of the session. One of the major photographic problems is accurate focusing in the dark and this problem is only magnified by the use of long lenses. The most convenient solution is to tape a torch to the upper surface of the lens ensuring, of course, that the focusing ring will still rotate freely. A torch fitted with a red glass filter emits less light but is usually adequate to illuminate the subject and if left on all the time will not cause alarm.

Pre-focusing is a less satisfactory alternative, and is possible only if you know exactly where your subject will be positioned. The procedure is to focus on the spot with the aid of a normal torch, which is then switched off. Unfortunately very few photographers can sit for long

periods and resist the temptation to rotate the focusing ring at some time before the bird arrives. Most owls fly in to land on a perch near to or at the nest before entering. This is the place you focus on. Almost without exception such birds fly in silently so you must be able to keep up your concentration for long periods if you are not to miss valuable opportunities. All preparations should take place before dark when there is enough light to set up flash guns, measure flash to subject distances and position your hide to best advantage. Always take note of any unsightly vegetation or branches in the foreground and background as these may spoil the picture. As always, a thorough knowledge of the species you are photographing is essential for successful results. Some birds return to the nest at frequent intervals giving many opportunities to obtain a portrait. Many however return to the nest only once or twice during a whole night. Some species stop at the nest entrance and turn to look at the camera. This is a good opportunity to press the shutter release as the bird is likely to be carrying some item of prey in its bill. If the bird does not turn its head try making a gentle sucking noise with your lips: this will often trigger the movement.

The usual flash head sitings are used for night photography. Single units may be acceptable but careful positioning of the lamp is needed to produce some modelling and to avoid hard unpleasant shadows. A second 'fill in' flash head provides more satisfactory results as explained earlier. Remember that the guide number of your flash unit will be less outdoors than indoors owing to the lack of reflective surfaces, and consequently you will need to make appropriate exposure adjustments. A few test shots at the site when the subject is not present will allow you to confirm the correct settings before you commence photography.

It is generally accepted that the brief discharge of the flash tube does not cause much stress to the subject apart from the odd occasion when it is looking directly at one of the flash heads at the time of the discharge. In this case it is likely to be temporarily dazzled but no permanent damage is done.

Open Flash

This is a technique which, if used correctly, can produce some truly exciting night-time results. The principle is to leave the shutter open on the 'B' setting and focus the lens on the area in which the subject is likely to position itself. The method relies upon the fact that in total darkness the shutter can be left open and nothing is recorded on the film. The image of the subject is recorded only by firing the flash unit. In this way you are able to use a single flash head and repeatedly trigger it from several different positions to produce exactly the lighting effects that you desire. These may include lighting the subject from behind to produce a rim or moonlight effect, or even lighting up selected features of the background and recording the images on the film prior to the arrival of the subject. This all sounds very simple in theory but there are a number of practical considerations. First, the camera must remain

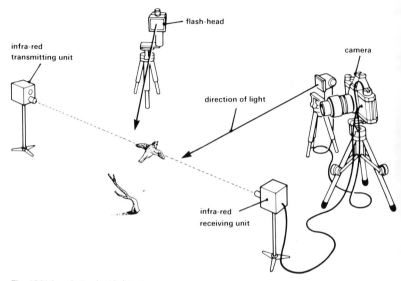

Fig. 12 Using photo-electric beam

absolutely steady during what is likely to be a lengthy process. Second, one rarely encounters total darkness and with the shutter open for such a long period an image of the background may be recorded on the film even by low levels of natural light. This may, of course, be advantageous in that a dimly-lit background simulating twilight can add atmosphere to the scene. However, if the subject positions itself in front of a background feature which has already registered on the film this may actually show through any light parts of the subject causing an unpleasant double image.

This technique can produce some very satisfying results indeed but it does require considerable practice and more than a little patience to achieve worthwhile results.

Photography of Small Birds in Flight

One of the most challenging aspects of flash photography is the portrayal of small birds in flight. The wings of a small bird beat too rapidly to be frozen by even the fastest shutter speeds available on an ordinary camera, so this type of photography is possible only with the aid of flash. Some hummingbirds, for instance, are able to beat their wings as fast as 80 times per second, and even a shutter speed of 1/4000th of a second will record the wing tips as a blur. It is however possible to utilize the very short flash duration of modern flash guns to arrest such rapid movements. As explained earlier, these units incorpor-

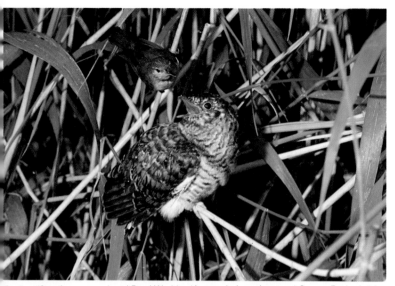

Cuckoo *(Cuculus canorus)*, and Reed Warbler *(Acrocephalus scirpaceus)*. Sussex, England; July; Nikon F3, Nikkor 80–200 zoom f4, Nikon SB16 and SB17 (TTL) flash units, auto @ f11, Kodachrome 64; hide, tripod.

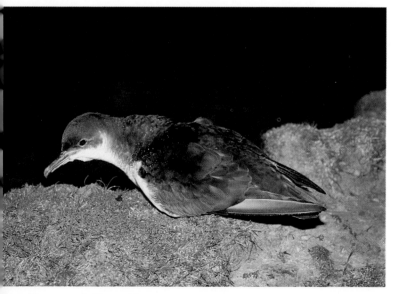

Manx Shearwater *(Puffinus puffinus)*. Bardsey Island, Wales; May; Nikon F3, Nikkor Micro 55mm f2.8, Nikon SB12 (TTL) flash unit, auto @ f11, Kodachrome 64; stalked.

ate a sensor which quenches the flash discharge once the subject has received sufficient illumination. In the manual mode, the flash lasts about 1/500th of a second but in the automatic mode with nearby subjects durations as short as 1/10,000th to 1/20,000th of a second are possible, although the flash is much weaker. To achieve such speeds, the flash gun must be placed very close to the subject and in practice it is difficult to make such a close approach unless you are working with captive birds or using some form of remote control.

With the automatic computerized type of flash unit it is possible to fool the built-in sensor into giving a very brief flash by placing a small piece of card a short distance away. The sensor 'thinks' that enough light has been delivered, and quenches the flash, ensuring a light discharge of very short duration. Such a weakly-powered flash illuminates only the nearby subject so the background appears unnaturally dark. One remedy is to place an artificial background behind the subject and to illuminate it with a separate flash gun.

A further practical problem is that human reactions are not fast enough to release the shutter at exactly the right time on each occasion and you will probably find yourself wasting much film in order to obtain a few good shots. To help with this difficulty bird photographers have enlisted the help of electronic experts. The result of the collaboration has been a set-up with which the subject takes its own photograph. Initially this technique was the preserve of a few photographers who were lucky enough to have the help of experts. However, since the work of Eric Hosking and Stephen Dalton has become well-known a few enterprising manufacturers now market such devices at a reasonable price.

The basic principle behind the equipment is that the subject breaks a beam of infra-red radiation which is focused on a photo-electric cell. The impulse from the cell activates the shutter release of a motor-driven camera and the outcome is that as the subject passes the lens its photograph is taken. In practice a large amount of patience is required to set up the apparatus in a workable fashion. One of the biggest handicaps is the inevitable delay between the subject breaking the light beam and the impulse reaching the shutter; to allow for this the camera must be set up some distance from the infra-red trip. How far the subject can fly during the delay varies from species to species and although you should be able to calculate the distance theoretically, in practice it is a matter of trial and error. Such automatic triggers vary in sophistication: some allow the photographer to change the sensitivity of the trigger so that only large objects activate the mechanism. This ensures that small flying insects do not trigger the shutter release, thereby wasting valuable film.

The results of using this technique are often spectacular but the equipment requires a considerable amount of thought, patience and preferably a very practical mind. As such it is not to be recommended for those who do not enjoy extended periods of grappling with practical problems.

7. Adverse Conditions

The bird photographer in search of the unusual or spectacular will inevitably travel to parts of Europe where conditions are far from ideal. The intense cold inside the Arctic Circle; the searing heat of the summer in southern Europe, or even the energy-sapping humidity in some of the coastal regions – all present their own special problems for the photographer. As luck would have it, many of the spectacular wildlife concentrations occur in areas which are either relatively inaccessible, or where the discomfort index is particularly high. However, good photographs seldom come easily and the effort and discomfort are amply rewarded by the experience of being there, and the pictures you bring home.

Even in temperate latitudes, conditions may be less extreme but rain or poor lighting can still make conditions unsuitable for bird photography. However, there is nearly always something you can try, especially with the use of a little imagination, and inclement weather may provide an opportunity to attempt something a little different. Examples include silhouette studies of birds against ever-changing patterns of water, or flocks of birds in flight against a dramatic winter sky.

Sometimes, though, conditions in even nominally temperate latitudes become so extreme that getting any sort of picture at all is a major achievement. So the pages that follow detail the steps you can take to make picture-taking more comfortable – or even possible – when the climate, terrain, and bird-life conspire to make things difficult.

Cold

Winter can be a blessing in disguise: snow and ice provide attractive backdrops and the potential results make the relative discomfort worthwhile; during the height of the winter season food is scarce so many birds become more tame as their hunger increases, and this provides a marvellous opportunity for baiting (see chapter 4). On the other hand, the cold weather introduces practical problems which differ only in degree between winter in a temperate area and in the polar regions.

Clothing is all-important, as the warmer you are the better you will perform. Specialized arctic clothing which is warm and yet allows sufficient mobility is commercially available for use in extreme regions but can be very costly. In areas where the temperature does not drop quite so low, a less expensive alternative is to wear thermal underwear beneath thick trousers or jeans. Most people are aware of their own tolerance to the cold and can gauge just how much extra clothing they need to keep warm, but still retain as much mobility as possible.

Remember that the body loses heat most readily when you are stationary and this is particularly noticeable while working from a hide. In such circumstances you should allow for extra insulation to prevent heat losses and some photographers even light a stove for extra warmth or use a hand warmer.

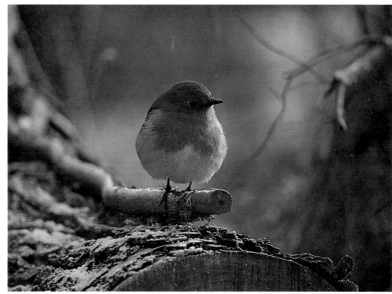

Robin *(Erithacus rubecula)*, Sussex, England; February; Nikon F2, Nikkor 300mm f4.5, 1/125 sec @ f4.5, Kodachrome 64, beanbag.

A balaclava which covers the head and neck is particularly useful especially if it can be rolled up to become a cap as you get warmer. Gloves are always a problem as those which keep your hands warm are nearly always so restricting that you cannot operate the controls on the camera and there is really no satisfactory answer to this difficulty. Gloves with the finger tips cut off rarely offer enough warmth although they do allow more freedom of movement. Fashionable clothing is very little use in extremes of cold, so be prepared to sacrifice elegance for practicality. For example, when working from a hide many photographers find that a sleeping bag covering the legs and trunk is a very effective method of retaining body warmth.

The functioning of modern camera equipment rarely causes any problem even in the harshest of winters in temperate areas. However, those travelling to the polar regions need to give some thought to this problem prior to leaving. The lubricants used in the moving parts of the camera can thicken in extreme cold and a few photographers have their equipment 'winterized' to ensure that all the mechanical components function with their usual ease. Most camera manufacturers and some independent workshops are able to provide this service, but it is very expensive. On returning home this process needs to be reversed before using the equipment again, involving further expenditure. Film stock becomes rather brittle as the temperature falls and may even break if you use a motorwind or wind on too fast. The same applies to rewinding.

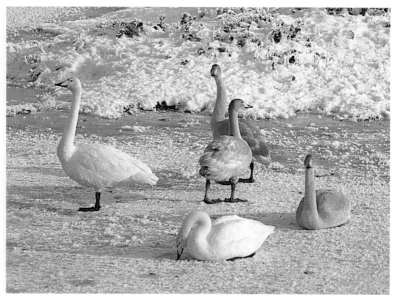

Whooper Swan *(Cygnus cygnus)*, Wildfowl Trust Refuge, Welney, England; December; Nikon F2, Nikkor 300mm f4.5, 1/125 sec @ f11, Kodachrome 64; hide, beanbag.

The biggest problem is likely to be electrical, rather than mechanical. Most batteries are designed to be used within a certain temperature range. As the temperature falls they become sluggish and may fail to function altogether. This makes the use of a motordrive or flash almost impossible, but the problem can be partially rectified by warming the batteries prior to use. However, even this only allows the batteries to function for short periods, and it might be less troublesome to do without such accessories.

Camera batteries are more of a problem. All new cameras depend on electrical power for exposure metering, and almost all have shutters that require battery power. The best way to preserve all normal functions is to buy an accessory battery pack and cable. One end of the cable fits into the camera's battery compartment; on the other end, which you keep in a warm inside pocket, is a small compartment holding the necessary button cells.

You can eliminate the battery problem altogether by using a mechanical camera, and a selenium-cell light meter such as the Weston Euromaster, which does not require electrical power.

Condensation is the arch-enemy of those working in very cold or humid conditions. When moving equipment from the warm environment of your living quarters to the cold outside, ice may form on the lenses, and conversely when cold equipment is brought inside condensation occurs. This would be little trouble if it only occurred on the outer

surfaces but it also affects the interior of the camera, becoming a potential hazard both to film and to the delicate internal mechanics.

Working conditions in cold climates are not all the photographer has to contend with. The snow and ice backdrops which add so much drama to your photographs also call for special consideration when calculating exposures. Such backgrounds are probably the most difficult to portray correctly while still showing adequate detail in the subject.

Snow and ice have bright surfaces which increase the amount of light reflected from the sun. As a result, direct exposure readings from subjects in snow tend to overestimate the amount of available light, resulting in an underexposed image on the film – the snow looks grey, and the bird appears in silhouette. Spot meters are built into some cameras, and these read from such a small area that they may just be able to cope with this situation, as the majority of the light entering the lens comes from the subject, not the white background. Even then, an adequate lens hood is still necessary to minimize reflected light from the surrounding area. Usually, however, exposure adjustments are necessary to compensate for the inordinately high light readings and the problem is to decide exactly how much to compensate. As always, the safest way to ensure at least some correctly exposed results is to use the bracketing method as explained on page 36. Unfortunately many subjects do not allow you the luxury of several exposures and you just have to get it right first time.

A sunlit area of snow or ice will give an exposure reading which may be up to four times brighter than an average area under the same lighting conditions. Thus with ISO 64 film a snow-covered landscape may yield a reading of 1/250 sec at f16, whereas in average conditions, with the same lighting the reading would be 1/250 at f8. If you follow the meter without correction, the subject will be underexposed and the background will be grey and this is obviously not a true rendition of a snow scene. In order to portray the snow faithfully you must give an extra two or three stops' exposure. Of course this method is a rather rough rule of thumb and a more accurate method of obtaining the correct exposure is to measure the amount of light falling on the subject by using an incident light meter.

Should you be confronted with a dark subject against a snowy background your problems are compounded and no matter which method you try most films, especially colour, are unable to cope with such extremes of contrast. Consequently, either the subject or the background will be incorrectly exposed, rendering the snow a blanket of white with no relief details or resulting in an underexposed subject. The only way to combat this problem is to use fill-in flash to pick out shadow detail in the subject. Unfortunately this is not always practicable. Surprisingly, some of the higher speed colour emulsions give a more acceptable portrayal of the subject and background together.

Fortunately in snowy conditions the sun does not always shine: a thin layer of high cloud gives a more diffused lighting, which reduces the

range of contrasts, creating less of a problem. The results, however, are less than spectacular. Once again both practice and experimentation combined with a detailed exposure record will soon allow you to produce the best quality results.

Heavy snowfalls transform a landscape into an almost featureless white blanket making stalking and any other movement extremely prominent. Many animals and birds adapt to such surroundings, particularly in areas where snow falls throughout the winter season. With the coming of winter the snow bunting and ptarmigan both take on predominantly white plumage in an effort to avoid the hungry gaze of ever-watchful predators. To achieve any measure of success in these conditions the photographer must learn a lesson from the subject. White clothing and a low profile will go some way towards concealment. If you can stand the cold you may try sitting perfectly still in such clothing in the vicinity your subject is likely to visit. The use of portable white screens by Eskimos, for the purpose of hunting seals and other animals for food, is a matter of folklore but this method can also be used by the photographer with some success.

Wet

The weather in many parts of Europe is far from predictable, and there is a good chance of rain in most seasons. Rather than allowing wet conditions to spoil a photographic session it is better to use your imagination and make the best of what you would normally consider to be abysmal weather. Rain can bring with it spectacular cloud formations which add drama to an otherwise ordinary background. The sun often shines after a short downpour, and anyone who has seen photographs of wading birds with their feathers ruffled up and covered with droplets of rain highlighted by the sun, cannot fail to agree that such conditions only add to the picture.

Photography in wet conditions, though, poses practical problems which are fairly obvious and, apart from the personal discomfort, are relatively easy to remedy. A good supply of polythene bags is essential for keeping your equipment and film dry especially if the bags are sealed with wire or plastic tags which are easy to undo or fasten. You can even keep the camera operational inside a plastic bag: place the camera body and lens inside the bag and use an elastic band to make a seal around the lens hood, thus protecting all but the front element of the lens from the damp. Cover the front element with an ultraviolet or skylight filter. Noise during the handling of the camera controls may be a problem initially but many birds become accustomed to this after a short time.

Photography from a hide provides some protection to both equipment and photographer during brief rainy spells but any extended downpours will show just where the leaks are. As a puddle forms on the roof of a canvas hide, you may find constant drips of water a nuisance – the most effective remedy is to place a pole centrally, giving a slope to the roof, and diverting water down the sides.

ADVERSE CONDITIONS

Any equipment left outside should be adequately covered. This particularly applies to flash units and electrical leads because if these become wet they soon develop electrical faults. The most satisfactory method is to completely cover flash heads and power units with clear plastic bags and secure with rubber bands. This does not affect the light output of the flash units in any way.

Wind often accompanies rain and while working from a hide you should make sure that the guy-ropes are well tied down with no loose parts to flap and cause disturbance to the birds. Far from being a hindrance, a strong wind may be a great help in some circumstances. Birds flying into the wind will be slowed considerably allowing more time for focusing and composition.

In wet weather, dull light is a major problem and you will need to use very slow shutter speeds if your film stock is one of the slow speed, fine grain variety. This makes a sturdy support essential, which is no problem if you are working from a hide. Some birds are relatively inactive during a rain storm and, especially at the nest, just fluff out their feathers and remain still so a slow shutter speed is often acceptable. For active birds, though, there is no alternative but to use high speed film such as Ektachrome 200 or 400 film. These can be uprated to ISO 800 or even 1600 if necessary but the resulting images will suffer from increased grain size and such photographs are unlikely to be published.

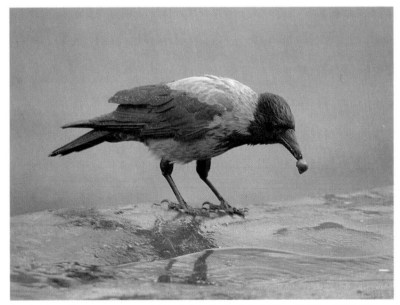

Hooded Crow *(Corvus corone cornix)*, Strathclyde, Scotland; April; Nikon F3, Nikkor IF-ED 300mm f4.5, auto @ f4.5, Ektachrome 100; beanbag, raining.

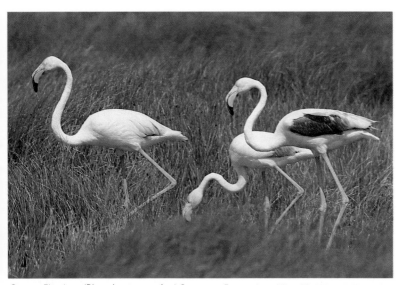

Greater Flamingo *(Phoenicopterus ruber)*, Camargue, France; June; Nikon F3, Nikkor IF-ED 600mm f5.6, auto @ f5.6, Kodachrome 64; car bracket, 40°C.

The more adventurous bird photographer will visit isolated spots which can be reached only by small boat over stretches of water and even an uneventful journey of this type will cover most objects with water spray. Detailed attention to packing equipment and film will save many anxious moments later. A waterproof carrying bag provides at least some protection but it is wise also to pack each individual piece of equipment in a polythene bag with a wire tie before placing it in the bag. Then place the camera bag inside two or three polythene garbage bags and secure each one separately. The outer bag will inevitably be torn during transfers to and from the boat, hence the need for several layers. This type of packing should give protection against even a short period of total immersion in water as one of us can testify from a trip during which equipment was dumped on the sea bed 2.5m down, when an inflatable dinghy overturned. When the bag was retrieved no water at all had reached the cameras and lenses. On another occasion one of us swam from a boat to the shore 50m away towing well-wrapped camera gear behind. Once again the equipment remained totally dry.

Heat and Dust
No part of Europe experiences the extremely high temperatures which are characteristic of tropical and equatorial regions, but high summer in landlocked parts of Europe can nevertheless create almost desert-like conditions. Unusually warm weather may also extend the northern range of summer visitors to Europe, so enthusiastic bird photographers

often find themselves working in very hot weather in the hope of catching on film species that are rarely seen this far from the equator. High temperatures cause problems to photographer, equipment and the subject, but none are insurmountable.

As well as light clothing, a small towel is handy to mop up any excess perspiration and a sports sweatband worn around the forehead and on the wrist is also useful in this respect. As soon as the temperature rises you will find that without these precautions, perspiration begins to run into your eyes and on to the eyepiece of the viewfinder causing considerable irritation and interfering with accurate focusing. In many areas, mornings are deceptively cool, but temperatures rise as the sun climbs, so take clothes that can be removed easily and silently in the hide.

When working outside always wear a hat and if you are not used to such conditions cover exposed parts of the body to avoid sunburn and heat exhaustion. Always make sure that you have adequate supplies of drink, and preferably, a supply of salt tablets too. Experience has shown that such precautions are not as trivial as they may appear at first sight. Working inside a hide in such conditions can become extremely uncomfortable and a proven routine is to spend a set period, say five to ten minutes, concentrating on photography, followed by a similar period of relaxation to dry off and replace fluid loss. In this way you can manage to work from a hide for several hours at a stretch.

Insects are often a great source of irritation in heat and a good insect repellent is invaluable. Venomous insects and reptiles are rarely a dangerous problem in Europe but you should check locally – some creatures find the shade provided by a hide extremely attractive, although the photographer may not welcome their company! An awareness of these hazards of heat will save unfortunate but rare accidents, and with a little experience you will soon realize exactly what your own working capabilities are in such circumstances.

Most modern photographic equipment is able to withstand brief exposure to extremes of temperature, but if subjected to such pressures for longer periods without adequate precautionary measures cameras and lenses are sure to break down. In dry, hot regions such as arid open plains the worst enemy is dust. It is truly amazing how invasive the small airborne particles can be: often you can hear dust crunching inside lens mounts and can imagine the damage it must be doing. Dust or grit trapped on the film pressure plate causes tramlines along a whole film making the results virtually unusable so prior to loading a new film, clean the backplate with a blower brush just to make sure.

To prevent damage, equipment should also be routinely and thoroughly cleaned with a blower brush every evening on your return from the field. Changing films can be difficult under brilliant sunlight, and a large changing bag is a useful way to create the necessary shade. The changing bag also prevents further dust particles from entering the camera body. Lenses not in use should be kept in the closed camera bag or, if they are likely to be needed quickly, in a protective cloth pouch.

Heat damages film, so keep it cool, and process immediately after exposure. Repeated changes of temperature are especially damaging and you should therefore avoid constantly taking your stock from refrigerated conditions and allowing it to warm up: instead try to pack film in small batches so that once removed, the film will be used in the near future. Stock which has been refrigerated should be allowed to warm to ambient temperature slowly prior to use. If exposed to high temperatures too quickly condensation forms on the emulsion, resulting in unsightly water marks, rendering pictures quite useless.

Heat is also a problem to birds, although those inhabiting the hotter regions of the world have adapted to the prevailing climate considerably more successfully than we have. However, these adaptations are finely balanced and persistent disturbance will, as with birds anywhere, be harmful. In particular chasing a bird from bush to bush in such conditions will soon leave it exhausted and a poor photographic subject. Just as birds in colder climates need to spend a considerable amount of time at the nest in order to prevent their eggs or young from losing heat, those in hotter regions spend this time in sheltering eggs and young from the intense heat of the sun. Extra caution is necessary to allow the parent birds to continue such essential activities. Young birds directly exposed to the rays of the sun for even relatively short periods will perish and the photographer must be prepared to abandon attempts at nest photography under hot conditions. In any case, at the times of day when the temperature is highest the lighting is too harsh for satisfactory results unless balanced with flash.

Humidity

Of the variable climatic conditions you will encounter during travel abroad, humidity is probably the one which causes most discomfort as well as damage to your equipment and film. In some areas, it is an ever-present problem which cannot be avoided. Equally, such areas boast a particularly rich tapestry of both plant and animal life to challenge even the most enterprising nature photographer.

As with other extremes of climate appropriate clothing is of utmost importance. Natural fibres absorb perspiration more readily than synthetics, increasing the cooling effect. Humidity usually goes hand-in-hand with heat, so any clothing should be lightweight. Hordes of insects thrive in hot and damp conditions, so cover exposed parts, and use an effective insect repellent. A fine mesh net covering the face will also help.

In a humid atmosphere water quickly condenses on to cool surfaces and cameras, lenses and film are particularly vulnerable. The only solution is to keep these items as near as possible to the ambient temperature, and especially to avoid taking them directly from cooled or refrigerated conditions into the working environment. Constant misting of lenses is not only frustrating but is also harmful. The continual dampness encourages the growth of fungi which will eventually etch into the lens coatings causing irreparable damage.

ADVERSE CONDITIONS

Bags of silica gel packed with each piece of equipment helps combat airborne moisture – choose the bags with a colour indicator to show when the gel becomes exhausted. Regeneration is just a matter of heating the crystals in an oven for a short time to drive off the absorbed water. Even in temperate conditions, it is good policy to store silica gel bags with photographic equipment at all times.

Humidity not only causes damage to equipment but is just as harmful to film stock. Keep film in the manufacturer's packing until use and after exposure, store the film in airtight cans or boxes with bags of silica gel to absorb moisture. Try also to observe the precautionary measures for film use in hot conditions as explained on page 107.

Bird photography in adverse climatic conditions will always be challenging both physically and mentally and may produce spectacular opportunities and results as well as a few hazards. The problems and solutions outlined here should at least help you be better prepared for some memorable moments.

8. Using your Photographs

Once you have achieved a certain degree of competence you will probably develop a desire to show your work to others, either by giving illustrated talks about birds and your trips to see them, or by exhibiting and even publishing your work. Increasing public awareness of the natural world and its conservation has led to a rapidly developing market for good quality natural history photographs, and numerous magazines now include wildlife articles illustrated by photographs. Some magazines are devoted entirely to the subject. This increase in the market for such pictures has encouraged a growing number of amateur photographers to attempt to have their work published. The thrill of showing your work to others, either during an illustrated talk or via the pages of a magazine or book is unsurpassed.

Publishing

Publication is one of the finest rewards a bird photographer can attain, but with such fierce competition, just how should you set about getting your photographs accepted for publication? The first and most important step is to ensure that your work is of a quality which can compete on equal terms with those photographs already published. Look through as many books and magazines as you can and satisfy yourself that your work is as good as the competition. If you do not feel able to produce photographs of similar or even a better standard you are wasting your time. Having decided that your photographs are good enough how do you get them into print?

Attempts to submit your work directly to publishers involve a lot of hard work, adequate funds and only limited success, unless you are exceptional. So most bird photographers, unless they are already established, place their work with one of the stock picture agencies. These agencies then act on the photographer's behalf, or link the photographs to short articles which are submitted speculatively to magazines. There are a number of stock agencies who deal exclusively in natural history photographs and it is with one of those that you are most likely to meet with success. The *Writers and Artists Yearbook* (published annually by A. & C. Black) is a fund of information for the photographer interested in having photographs published. Among the numerous useful pieces of information is a list of stock picture agencies with addresses, special interests, and also some idea of each agency's exact requirements.

Before sending anything to an agency for consideration telephone or write to make sure that they are interested in taking on new photographers. At the same time you can find out exactly what their requirements and procedures are. Usually you will be required to submit a number of examples of your work for consideration. With most agents this is as many as five hundred images, from which they can gain an idea of the depth of your photographic talent.

USING YOUR PHOTOGRAPHS

Virtually all colour reproductions in books and magazines are now taken from colour transparencies; colour negatives are no longer used. Almost without exception agents will not consider pictures submitted on any film other than Kodachrome 25 or 64 in the 35mm format for the reasons explained in chapter 1. While this situation exists, confine your choice of film to the Kodachrome series if you want to succeed.

Black and white photographs are becoming less common in most magazines although they still represent a sizeable portion of the market. This trend has been mirrored by the majority of photographers, who now prefer to work in colour. Ideally, black and white reproductions should be taken from black and white prints but the majority are now reproduced from colour transparencies. However, even with modern reprographic methods, supplying a print as an original generally produces a superior result. The publication of black and white photographs commands a smaller fee than the colour equivalent, and prints are usually not returned, although the cost to the photographer of producing a monochrome print is greater than the cost of a colour transparency.

There are both advantages and disadvantages to lodging your transparencies and monochromes with a stock agent. The great advantage of dealing through agents is that they know the market and have personal contacts in the world of publishing. As an individual you cannot hope to compete with an efficient agency unless your name and work is so well known that you are either commissioned or personally requested to supply certain photographs. It is in the interests of the agent – as well as in your interests – to keep up to date with current requirements and to attempt to provide them from the stock files. Additionally, the agency is also aware of the diversity of the market for bird pictures: the market is not solely confined to wildlife magazines and books. Increased interest in birdlife has extended the potential for sales to the manufacturers of greeting cards, postcards and calendars, and for use on exhibits at nature reserves, on posters, and as still shots on television, as well as in numerous other magazines not directly concerned with wildlife.

On the negative side, these organizations retain the work of a number of photographers in an attempt to cover all aspects of one particular field of interest. Publishers send the agency a list of requirements for forthcoming publications, and the agency selects a number of examples of each subject listed from their stock files, and sends them to the publisher for consideration. However, such requests are usually sent to several agencies resulting in fierce competition. This means that you have to rely very much on your agent's judgement and whim as to which photographer's transparencies are sent out when he has numerous examples of the required subject.

On other occasions photo researchers are sent out to the agencies with a 'shopping list' and they carefully sort through the files picking out those photographs that they think are suitable to present to the editor for final selection. Often the requirements will be narrowly defined. Examples might include flamingos in flight in the Camargue or

perhaps wood pigeon in the snow. Consequently, many superb photographs are rejected because they do not fit the editor's requirements exactly. Much depends also on clear and accurate captioning of your work, your agent's indexing system, and a good deal of luck.

Excellent photographers are not necessarily good business people, but agencies can take a lot of the hard work out of the financial side of selling pictures. Your agent will be aware of the current fees for reproduction, and the acceptable price variations for use in different publications. The same photograph used in several different publications might command quite different fees in each. For instance, the reproduction fee for a photograph printed on an inside page of a monthly special-interest magazine is far less than for one on the cover of a *Time/Life* publication. Your agent will know exactly what the differential should be. The agent is also able to protect your interests when transparencies are lost or damaged and may be able to obtain substantial compensation on your behalf in the event of this happening. A photographer working alone would find this more difficult.

Remember that you are not selling your photographs outright, but are loaning them for a once-only reproduction. Should the image be used again you will be entitled to a further fee, although repeat rights with the same publisher usually command a smaller sum. Once published you will be surprised how some photographs sell over and over again, thus earning a reasonable income. Certain pictures become best-sellers: Eric Hosking's photograph of a barn owl arriving at the nest with wings and feet outstretched, and a vole in its bill has sold numerous times. A more recent effort by Stephen Dalton of a swallow scooping water from a pool has already been published on a number of occasions. These are clearly spectacular shots which have captured the imaginations of publishers and public alike. However, do not be daunted if your photographs are not as outstanding as these examples. In the hands of a good agent less spectacular, but nevertheless competent, photographs of species which are easily recognized by the lay person often sell repeatedly.

Of course the owners of picture agencies are working to make a profit and their services to the photographer are not free. Most agencies pay the photographer a set fee for each photograph published and this can vary between 45 and 60 per cent of the reproduction fee received from the publisher, about 50 per cent being usual. In view of the service a good agent offers this is not unreasonable, especially as the agency is likely to sell many more of your photographs than you could hope to do working alone. In these competitive days you may be lucky to be accepted by an agency, but if your work is good enough, you could have the choice of several. Take a look through the picture credits in as many books and magazines as you can, and see which agents constantly appear: then make your initial approaches to these companies.

If you are doing much of your work in continental Europe, make sure that your chosen agency is able to sell to the overseas market. It is little use sending a picture agency in the UK a whole collection of superb

shots of Italian birds unless they have a market in that country. While the pictures would almost certainly be accepted there is little chance of regular publication in the UK.

When joining an agency you may have to agree to certain conditions. As well as asking for a large selection of your transparencies prior to acceptance some will also expect you to keep a constant flow of work passing into their files, which are continually upgraded. It is usually expected that you will leave your transparencies in the agent's hands for about five years. As they are usually filed by subject rather than photographer's name, a request to withdraw all of your transparencies would mean many, many laborious hours of work on the part of the agency staff. Some agencies also expect a degree of loyalty and will not allow you to lodge transparencies with any other agency dealing with wildlife subjects. Usually, however, you will not be barred from sending material to individual magazines under your own name. Most agents send out yearly or half yearly statements of earnings from your published photographs and, hopefully, a cheque should accompany such statements.

It pays dividends to maintain regular contact with your picture agency. Often the agency is asked for photographs that are not on file. In many instances these are of common, easily approached subjects which no one has thought to photograph. Regular contact and easy availability will ensure that you are commissioned to take such photographs, if you are prepared to work at short notice. For example, one of us was asked to photograph a fisherman on a river bank at a few days' notice. This resulted in a full-page reproduction in a prominent bird magazine with a worldwide circulation. Although not strictly bird photography it was illustrating an article on hazards to birds resulting from human recreational activities. The resulting cheque paid for a new piece of equipment which was subsequently used to great advantage in bird photography. Finally keep your agent informed of changes of address, and particularly, be sure to give notice of any forthcoming photographic holidays; you may go some way toward paying for the holiday with the proceeds of any photographs required from the region you are visiting.

Editing Transparencies

For every hour in the field taking photographs you can expect to spend a further hour sorting and labelling transparencies. On return of your processed work you should get yourself into the habit of editing immediately. Should you delay you will soon find yourself with a mountain of unsorted photographs, the editing of which becomes a more daunting task the longer it is deferred. The following method is quick and effective. First view the pictures through a five or eight times magnifier and discard all those which are out of focus, incorrectly exposed or damaged. Then divide the remainder into categories according to content and quality. The first category consists of those transparencies which are special in some way; the sort you might reserve for competitions. In the

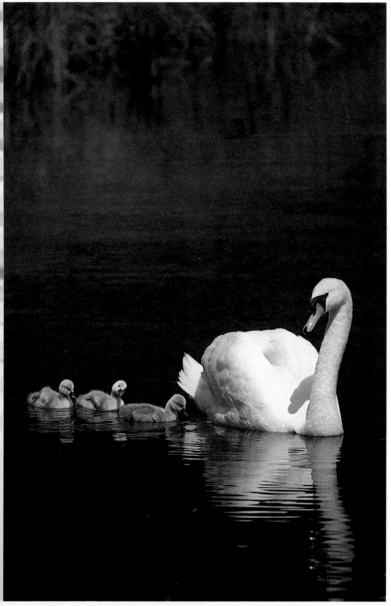

Mute Swan and cygnets *(Cygnus olor)*, Berkshire, England; June; Nikon F3, Vivitar 70–210mm
zoom, 1/125 sec @ f11, Kodachrome 64; stalked, handheld.

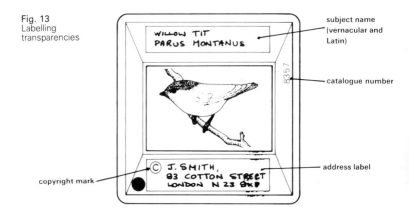

Fig. 13
Labelling
transparencies

subject name
(vernacular and
Latin)

catalogue number

address label

copyright mark

second category are those suitable for publication and you will probably want to send these to the picture agency. The third category consists of the remainder which are technically competent but are not, for various reasons, suitable for publication. This last group are kept only as record shots and may sometimes be used to make up gaps in lectures.

Label all transparencies retained with the vernacular and latin names, date and location along one edge. Stamp another edge with your own name – rubber stamps of a suitable size are available on order from most stationery shops. On one of the other edges of the transparency we print our own catalogue number. If possible your postal address should also be included on the mount. Make sure that you enclose a typed caption list to accompany any transparencies submitted to your agent or to a publication and retain a copy for your files. Any slides returned can then be marked off as rejected, as some inevitably will be.

Before leaving the topic of publication we should try to identify which photographs are most likely to be published. Most agents attempt to provide as wide a coverage as possible of the world of wildlife. Consequently they continually add new species to their photographic libraries. Any of their photographers returning from parts of Europe that are for some reason under-photographed will almost certainly have a good proportion of their pictures added to the collection, assuming they are of adequate quality. By maintaining a good width of coverage the agency is less likely to have to turn away publisher's requests owing to a deficiency in the slide library; in this way they are more likely to be used again. Obviously this is good for the agent and the photographers it represents. Unfortunately there is very little repeated demand for rare or unusual species unless for some reason they happen to be spotlighted by the media. Most demand occurs for the more common and colourful species of a particular country. For instance in the UK there is a considerable demand for robins, blackbirds, mallards, song thrushes, kingfishers, blue tits and puffins, to name but a few. Thus it makes sense

to build a good stock of species likely to be in demand regularly, as well as attempting to photograph more unusual species.

A thorough look at all the magazines in your local newsagent will show which species sell particularly well. Of course other photographers also study the market place so you should attempt to produce some really first-class studies to be competitive. A good slice of luck is also important in getting publication. On occasions you may see a magazine or book illustration which is inferior to a comparable picture in your own files. Unfortunately this is quite common. It is not always the best photograph which reaches the printed page; in fact some are really not worthy of publication at all. However, you must learn to accept this and just concentrate on producing first-rate work. Any activities which are likely to get your name noticed will only be of help. Lecturing, entering competitions and exhibitions are all ways of keeping your name to the fore if you are successful. If you are lucky as well as competent you will build up a number of contacts and you should eventually find that you are relying less and less on your agency and more on personal requests for photographs.

Many photographers seem reluctant to turn their camera through 90° and use a vertical format, partly because this tends to be rather awkward when using long lenses. However nearly all books and magazines are produced in this format and any full-page reproductions have to be enlarged and cropped to the correct proportions, with a loss of quality proportional to the degree of enlargement. Vertical pictures need very much less enlargement than horizontal images when printed full page, and a picture editor therefore rarely selects a horizontal transparency to fill a vertical space. If you can remember to 'think vertical' try also to think of the image as the front cover of magazine or book. Remember to leave a space for the title at the top of the frame and try to arrange a composition which is suitable. Many magazines also carry 'cover lines' which inform the reader of the contents of that particular issue. These are usually placed at the bottom or on the left-hand side of the page. If you take these points into consideration you will increase your chances of making a front cover which is always more rewarding financially than reproductions on the inside pages. As more and more photographers have taken up bird photography with a view to publishing their work, so the market is becoming saturated with good quality portraits of most species. The aspiring bird photographer should attempt to seek a new approach. Recently some photographers have been experimenting with short focal length lenses. There is now a demand for wide-angle close-ups of birds at or away from the nest which also show the surrounding habitat. This relatively recent trend has increased the use of remote-control devices (see page 52) because it is usually impractical to get close enough to the subject in any other way. Action shots are also more in demand by publishers. Birds are rarely static for long periods, so try to take photographs of their diverse daily activities such as flying, feeding, preening or perhaps displaying. Photographs showing particular

aspects of a bird's behaviour or character are always more informative than straight portraits.

Photo-essays are also often used in many magazines. A sequence of photographs portraying different aspects of the life of a single species and its habitat will often be published in preference to a single image. As travel has become easier the public has developed an increased awareness of life outside their own shores. A photo-essay based upon a recent photographic trip, especially if it is somewhere exotic, should not be difficult to put together and submit to suitable magazines for publication.

Picture editors are usually swamped with good quality work to consider for publication and it is often small points which make the difference between success and failure. Whilst it is desirable to wrap your transparencies well to protect them against damage in transit you should resist the temptation to pack them so thoroughly that an editor finds it difficult to open the package. A good compromise between safety and ease of opening is to put transparencies in a plastic storage sleeve and place this along with any accompanying paperwork in a padded bag. A stamped self-addressed envelope for return of your transparencies is also usually appreciated. Always send pictures by registered post as a safeguard against loss or damage.

Once your work starts to get accepted for publication you should try to keep track of where it is being used and if possible obtain copies so that you can build up a portfolio of published photographs available to potential customers on request.

Lecturing

Before the days of television and videos, public lectures were a popular form of entertainment. In his book *An Eye for a Bird*, Eric Hosking gives a vivid account of his early days when his lectures illustrated with lantern slides were a major source of income once he had turned professional. Even with the superb wildlife films televised worldwide, there is still a tremendous demand for people to give illustrated talks about wildlife to small societies ranging from bird clubs right through to Mother's Union groups. A good lecturer will never be short of requests to produce this sort of entertainment.

The art of lecturing is a gift with which few people are blessed, but at which most of us can at least become competent by practising and by following a few guidelines. Brilliant speakers are few and far between unfortunately, but so are the good bird photographers who can deliver an entertaining talk. Assuming you have become competent enough to show your own transparencies in public there is no reason why you cannot also back these up with a slick and interesting delivery.

Imagine that you are planning to deliver a talk about a recent birding trip and think about how you would plan an entertaining delivery lasting about one hour. Audience fatigue is a fact of life, and few people, however interested, can concentrate for longer than an hour, especially

in the darkened atmosphere in which transparencies should be shown. Consequently you should arrange your talk to be of about this length, inclusive of question time at the end. One of the first problems is to decide how many slides you can comfortably fit into this period and still retain the attention and interest of your audience. If you are a good story-teller with a number of anecdotes to relate, you will have less time for presenting transparencies; whereas if you wish your presentation to be mainly visual, you will get through a greater number. As a rule of thumb, aim for between 150 and 180 transparencies per hour. This allows twenty to twenty four seconds for each slide. Of course some transparencies will be viewed for less than the average time; for instance an action sequence might include five or six shots run quickly for effect. Equally, others will be on view for longer as you recount a tale or explain some feature on the slide, but on average this number represents a reasonable estimate in the time available.

The structure of the talk is just as important as the number of slides. A lecture consisting solely of 150 bird slides would be boring to say the least, even if you had that many available. To provide some relief, intersperse a few pictures of other subjects: two bird slides for each slide of another subject is a ratio that works well in practice.

Some sort of introduction is essential and this should include a short – about three to five minutes – piece about yourself, including details about how long you have been taking photographs and where you travelled in search of birds. Orientation is an important part of an introduction and a few travel details and a map or two are always well received. Maps are easily photographed from an atlas and you can even mark your route to give added interest. Note, though, that for a public lecture, you must obtain permission from the copyright holder (usually the publisher of the atlas) before copying a map. If approached courteously, most publishers are happy to give permission at no charge, but will nevertheless take a serious view of unauthorized use of their copyright material. If you are talking to a photographic society a quick resumé of your equipment is always welcome. You can actually take your equipment along so that members of the audience can take a look afterwards. Technical details can be discussed while showing your slides but try to tailor what you say to suit the interests of audience. Members of a woman's institute will probably be less interested in how you took the photograph than in learning something about the subject on view.

The next part of the planning is to decide upon a rough sequence for your slides. There are various ways to approach this depending upon your own personal preference. The simplest and most effective way is to tell the story of a trip as it happened, grouping the slides of birds to coincide with the sites visited in chronological order. If possible try to vary the attitude of your subjects as much as possible, interspersing portraits with flight shots and other action studies. Also vary the size of the bird in the frame, mixing images where the subject almost fills the

frame with others in which the habitat dominates, and the bird is fairly small. Another way of introducing variation is to show flocks of birds where appropriate, in addition to shots of single birds.

The 'filler' transparencies should include examples of the birds habitat, your accommodation, people who accompanied you and any other points of general interest relevant to the region you visited. Most audiences enjoy sunrises and sunsets but avoid the temptation to show too many. Try to paint as vivid a picture of your trip as possible and to sound enthusiastic. If at the end of your talk members of the audience are keen to visit the location themselves you have been successful!

Having decided upon the running order of the transparencies you should think about presentation. There are a number of simple steps you can take to improve the actual presentation of your talk. Just as poor quality transparencies are disappointing, so a clumsy presentation can ruin the showing of even good quality work. There is nothing more frustrating than good picture content being ruined by bumbling presentation, with slides upside down, faulty projectors, scratched and dirty transparencies, forgotten narrative and other problems that are the hallmarks of sloppy work. The only way to ensure that your lecture will work well is to practise every detail beforehand.

Before giving a new lecture, you can sort out any teething troubles if you follow a set routine prior to the presentation. Firstly, view the transparencies with a magnifier on a light box to check for correct exposure and sharpness. Then prepare a list of the approximate running order and view the whole thing using a projector and screen at home. Write out the introduction in full and memorize it. Fortunately a full script is needed only for the introduction: once a transparency is being shown it is relatively easy to talk around it, so just make rough notes on the narrative to go with each image. On the first run through you can sort out any parts which do not flow easily and rearrange the order accordingly. Some transparencies which look good on the light box may lack impact on the screen and vice versa, and at this point you can substitute as necessary.

Once the final selection has been made it is time to sit down with a watch and deliver the talk in an empty room, or if you are feeling brave enough, to a friend or relative who is frank enough to point out any weaknesses. Most talks seem to fall conveniently into several parts with each one needing a slightly longer narrative as a lead-in. Try to select suitable 'link' transparencies to show during such times. For instance when describing a journey to a new destination during your travels, a sunrise shot is often effective as a background. Once you are satisfied that the whole presentation fits into the time allowed write down your running order in large letters with 'keywords', to jog your memory, next to the slide title. This eliminates one common fault: in many talks the speaker does not know which transparency is coming up next.

There are occasions where the effect of a picture is heightened by a short introductory piece before showing the slide. This may be before a

particularly dramatic scene, or perhaps to illustrate an amusing anecdote. Obviously your timing is critical if you are to achieve maximum impact and it is wise to mark such instances on the running sheet in a different colour or with a large arrow. Keep the running sheet simple and uncluttered, so that it can be referred to quickly should your memory need jogging. Finally, run through your talk several times at home, tidying up loose ends and generally making the whole thing a compact and entertaining show.

Once the structure of the lecture has been finalized, leave the transparencies in the magazines so that they can be picked up for use at short notice. Number and spot each slide in the conventional manner as explained in fig. 13, so that in the unfortunate event of the slides being spilled out of the magazine it is a simple task to replace them quickly. Before setting off, check that all of the transparencies are clean and free from dust and placed the correct way up in the magazine.

Be prepared

If you are going to consider giving more than just the occasional talk, you should consider investing in your own projector and screen. In this way you remove the frustration of having to use inferior or faulty equipment which will ruin your talk and on occasions even your slides. Make sure that you take extension leads and spare bulbs; a pointer may also be helpful.

It is wise to arrive at least half an hour in advance of the advertised start of your lecture in order to site the projector and screen at leisure, and to spend a few minutes running any difficult parts through your mind. Most people become nervous before speaking in public and you are probably no exception. However, there is little cause for concern: if you have put in the ground work your lecture should go like clockwork. Make sure that you speak clearly, and project your voice so that members of the audience at the rear of the lecture hall can hear. A glass of water will counteract the usual dryness of the mouth. You'll be surprised how once you have started you will feel more at ease and more confident, especially if it is obvious from the outset that your audience are enjoying what you have to offer.

Once you have given a few lectures you will gain in confidence and gradually become more proficient. Most lecturers have two or three talks they know well and that they are able to deliver at short notice. If possible, talks need to be flexible so that you can easily vary them according to the audience you are talking to. You would probably show less slides to a young audience than you would to a group of adults but this doesn't mean you need to compile two different shows: just keep a list of transparencies you would remove for the children's show.

Exhibitions

Exhibitions give the amateur photographer an opportunity to show work in public; numerous societies present exhibitions, many now including a

nature section. This is where black and white photographs really seem to come into their own, as a large proportion of accepted entries are in this medium. The difficulties and expense of colour printing ensures a smaller colour entry and consequently a smaller selection of exhibits. Many photographers now use colour reversal film, so most exhibitions also have sections purely for transparencies. However the impact of a slide is less than that of a print, because slides are viewed for only a short time by visitors, often with a taped commentary. By contrast, prints accepted for exhibition are on display for visitors to view at leisure.

Most exhibition organizers advertise for entries in the popular photographic press well in advance of the closing date especially if the show is open to all comers. If you want to submit pictures a good place to begin is your local camera club. There you will be able to gain experience by actually being present at the judging, when the judges' thoughts on each exhibit are summarized.

The photographs you choose to submit depend upon the rules of the exhibition, so read these carefully before sending in your entries. Most require you to send the cost of return postage. Do not send dirty or dog-eared prints which have already been exhibited elsewhere: if necessary you should reprint any work which is not technically up to scratch. Transparencies should be clearly marked with the vernacular name and it is usually wise to include the latin name, as well as your own name and address. They should be spotted in the conventional manner described earlier. In some cases the judges request that transparencies should be glass mounted: if so this is clearly stated in the rules.

In nature sections photographs of birds seem to do particularly well but, as always, try for something that little bit different to the general run of the bird portraits. In the exhibition world, awards are seldom of great monetary value, but you have the satisfaction of having your work publicly displayed if selected. There are usually awards for best black and white, colour print, and transparency with a number of honourable mentions. The judges look for photographs that are correctly exposed, in focus, and depicting birds in their natural habitat. If possible, avoid photographs of birds at the nest, as the trend now is to favour shots taken away from the nesting area. Exhibiting is an excellent way of comparing the quality of your work to that of other photographers, and if your submissions are consistently accepted you can be sure that you are on the right track. And there is, of course, the immense satisfaction of seeing your pictures exhibited alongside those of recognized masters in the field.

Competitions

There is an element of the competitor in most of us and for some, the will to win is an irrepressible urge. There are numerous nature photographic competitions and a number of general competitions with nature sections; there are even competitions open only to bird photographers. The prizes vary considerably: some of the more prestigious competitions

offer fairly meagre cash prizes; but prizes in competitions that are less prominent from a purist's point of view might be more valuable – cash, holidays or even photographic equipment. The value really depends upon who is sponsoring the competition and how much financial support they are willing to provide. A few prizes are so attractive that some photographers specialize in taking photographs of birds for competitions and it is surprising how the same names seem to appear time and again in the winner's list.

Forthcoming competitions are usually well advertised in the photographic press or ornithological magazines, but make sure that you also scan the general interest magazines as occasionally they run competitions in which a good bird shot might just catch the eye of the judges. In these competitions you may be competing against a large proportion of very inexpert entrants who are only entering snapshots, thus increasing your own chances of success.

A common failing amongst competition entrants is that they just do not read the rules carefully. This may seem to be such a basic point that it does merit mention. Most competitions have a straightforward set of rules which are usually displayed with the advertisement. Read them very carefully: if the requirement is for transparencies there is no point in submitting prints. There is always a final closing date for entries so make sure yours arrives on time. Most competition rules state that photographs of captive birds are not eligible and it is pointless to try to fool the judges by entering one, as the panel usually includes at least one expert who will easily spot a fake.

In many competitions the winners are chosen by a vote so it is an advantage to know who the judges are and what their particular interests are. The panel is usually named in the competition publicity and in annual competitions the same judges often sit year after year. Time spent perusing the winning photographs of previous years is therefore time well spent because it gives you an idea of a particular panel's preferences and consequently helps you select appropriate entries. You will soon notice that some panels prefer a rather more artistic approach, while others are looking for pin-sharp photographs of birds involved in some interesting or unusual behaviour.

Many entrants submit photographs which are sub-standard and are rejected at the first showing. You can imagine that during the judging of a competition with a large entry the judges will soon become tired, especially if there is a large proportion of mediocre entries. Try to catch the judges' eyes with a shot that makes them sit up and say 'How I wish I had taken that picture!'

No one can tell you exactly how to win competitions but if you ensure that your entries are competent, correctly exposed and in focus, you should be in with a good chance of at least getting short-listed in many competitions. Entering competitions generates an excitement all of its own: there is wonderful sense of anticipation at every stage from your selection of the entries, through the days of waiting for the results to be

published, ending in a sense of achievement if your name appears on the winners' list! It is a feeling which is difficult to beat.

Assessing your Photographs

Just how do you set about assessing the merit of your own work? You can of course, compare it to the published work of others, but it is not always the best work that is published. Friends and acquaintances will often shower you with compliments that are largely unjustified. The best way is to have your photographs appraised by acknowledged masters in the field.

The Royal Photographic Society of Great Britain (RPS) is a parent body which is made up of groups catering for those with a specialist interest. The Society's nature group has a worldwide membership and holds regular meetings and field trips as well as publishing a quarterly newsletter full of useful tips for the nature photographer. There are other such groups in the UK and elsewhere, and by joining one you have the opportunity to meet or correspond with other like-minded photographers and discuss technique. In this way you learn much more than you can by reading books on the subject. The RPS also awards distinctions to photographers who have achieved a certain standard of competence in photography. The award is based on a set of prints or transparencies submitted by the photographer and judged by a panel of experts. Three distinctions are awarded, these being the licentiateship, associateship and fellowship in ascending order of merit. Fellowship is held in high esteem worldwide as an indicator of photographic ability. The great advantage of a society of this type though, is not necessarily in the distinctions it awards, but in the marvellous opportunities the Society provides for bird photographers to meet and exchange ideas.

9. Ethics and the Law

Throughout this book we have stressed that the photographer should always put the welfare of the subject first – even if this means returning home without a picture. For most bird species, and in most of Europe, this rule is not enforced by law, but is a generally accepted code of conduct, the basic tenets of which are accepted by any responsible nature photographer.

In some countries, acceptable practice is formalized into a set of rules. These 'nature photographers' codes of practice' are all similar in content, although that produced by the Nature Group of The Royal Photographic Society in consultation with the Nature Conservancy Council and other interested parties is more comprehensive than most. The points relevant to the bird photographer are reproduced in full below.

The Nature Photographers' Code of Practice

● **Introduction**

There is one hard and fast rule, whose spirit must be observed at all times. The welfare of the subject is more important than the photograph.

This is not to say that photography should not be undertaken because of slight risk to a common species. The amount of risk acceptable decreases with the scarceness of the species, and the photographer should do his utmost to minimize it.

Risk to the subject, in this context, means risk of physical damage, causing anxiety, consequential predation, or lessened reproductive success.

The law as it affects nature photography must be observed. In Great Britain the chief legislation is The Wildlife and Countryside Act 1981 and similar legislation in the form of the Wildlife (NI) Order 1985 covers Northern Ireland. In other countries one should find out what restrictions apply.

● **General**

The photographer should be familiar with the natural history of the subject; the more complex the life-form and the rarer the species, the greater his knowledge must be. He should also be sufficiently familiar with other natural history specialities to be able to avoid damaging their interests accidentally. Photography of scarce animals and plants by people who know nothing of the risks involved is to be deplored.

For many subjects 'gardening' (ie interference with surrounding vegetation) is necessary. This should be to the minimum extent, not exposing the subject to predators, people, or adverse weather conditions. It should be carried out by tying back rather than by cutting off, and it should be restored to as natural a condition as possible after each photographic session.

If the photograph of a rarity is to be published or exhibited, care should be taken that the site location is not accidentally given away.

Sites of rarities should never deliberately be disclosed except for conservation purposes.

It is important for the good name of nature photography that its practitioners observe normal social courtesies. Permission should be obtained before operations on land to which there is not by custom free access, and other naturalists should not be incommoded. Work at sites and colonies which are subjects of special study should be coordinated with the people concerned.

Photographs of dead, stuffed, home-bred, captive, cultivated, or otherwise controlled specimens may be of genuine value, but should never be 'passed off' as wild and free. Users of such photographs (for exhibition or publication) should always be informed, however unlikely it may seem that they care.

● Birds at the Nest

It is particularly important that photography of birds at the nest should only be undertaken by people with a good knowledge of bird breeding behaviour. There are many otherwise competent photographers (and bird-watchers) who lack this qualification.

It is highly desirable that a scarce species should be photographed only in an area where it is relatively frequent. Many British rarities should, for preference, be photographed in countries overseas where they are commoner.

Photographers working abroad should, of course, act with the same care as they would use at home.

A hide should always be used when there is reasonable doubt that the birds would continue normal breeding behaviour otherwise. No part of the occupant (eg hands adjusting lens-settings, or a silhouette through inadequate material) should be visible from the outside of the hide.

Hides should not be erected at a nest site where the attention of the public or any predator is likely to be attracted. If there is a slight risk of this, an assistant should be in the vicinity to shepherd away potential intruders. No hide should be left unattended in daylight in a place with common public access.

Tracks to and from any nest should be devious and inconspicuous. As far as possible they (like the gardening) should be restored to naturalness between sessions.

Though reported nest failures attributable to photography are few, a high proportion of them are the result of undue haste. The maximum possible time should elapse between the consecutive stages of hide movement (or erection), introduction of lens or flash-gear, gardening and occupation. There are many species which need at least a week's preparation.

Each stage should be fully accepted by the bird (or both birds, where feeding or incubation is shared) before the next is initiated. If a stage is refused by the birds (which should be evident from their behaviour, to any properly qualified photographer), the procedure should be reversed by at least one stage; if refusal is repeated, the attempt at photography should be abandoned.

In some conditions it may be necessary to use a marker in the locality of the nest, to enable refinding. Or use a twig at the entrance

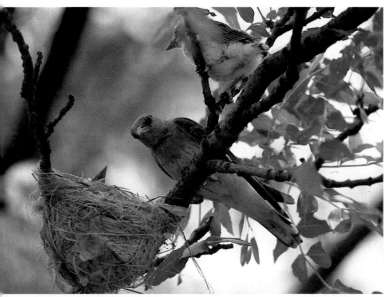

Golden Oriole *(Oriolus oriolus)*, Neusielder See, Austria; June; Nikon F3, Nikkor IF-ED 600mm f5.6, auto @ f5.6, Kodachrome 64; car bracket.

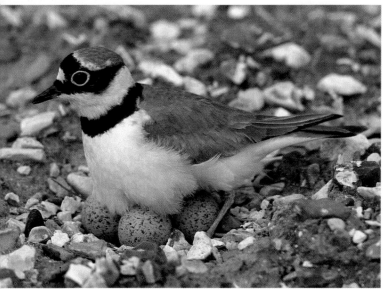

Little Ringed Plover *(Charadrius dubius)*, Berkshire, England; June; Nikon F2, Nikkor 300mm f4.5, 1/250 sec @ f5.6, Kodachrome 64; hide, tripod.

of a nest hole to indicate its occupancy. This type of disturbance should be kept to a minimum.

The period of disturbance caused by each stage should be kept to a minimum. It is undesirable to initiate a stage in late evening, when the birds' activities are becoming less frequent.

Remote-control work where acceptance cannot be checked is rarely satisfactory. Where it involves resetting a shutter, or moving film on manually between exposure, it is even less likely to be acceptable because of the frequency of disturbance.

While the best photographs are often obtained about the time of the hatch, this is not the time to start erecting a hide – nor when the eggs are fresh. It is better to wait till parents' reactions to the situation are firmly established.

There are few species for which a 'putter-in' and 'getter-out' is not necessary. Two or more may be needed for some wary species.

The birds' first visits to the nest after the hide is occupied are best used for checking routes and behaviour rather than for exposures. The quieter the shutter, the less the chance of the birds objecting to it. The longer the focal length of the lens used, the more distant the hide can be and the less risk of the birds not accepting it.

Changes of photographer in the hide (or any other disturbance) should be kept to a minimum, and should not take place during bad weather (rain or exceptionally hot sun).

Nestlings should never be removed from the nest for posed photography; when they are photographed *in situ* care should be taken not to cause an 'explosion'. It is never permissible to artificially restrict the free movement of the young.

The trapping of breeding birds for studio-type photography is totally unacceptable in any circumstances.

The use of play-back tape (to stimulate territorial reactions) and the use of stuffed predators (to stimulate alarm reactions) may need caution in the breeding season, and should not be undertaken near the nest.

● Birds away from the Nest

Predators should not be baited from a hide in an area where hides may later be used for photography of birds at the nest.

Wait-and-see photography should not be undertaken in an area where a hide may show irresponsible shooters and trappers that targets exist; this is really relevant overseas.

The capture of even non-breeding birds for photography under controlled conditions is not an acceptable or legal practice. Incidental photography of birds taken under licence for some valid scientific purpose is acceptable, provided it causes minimal delay in the bird's release. If any extra delay is involved, this would need to be covered by the terms of the licence.

Damage and Restraint

It is strongly argued in some quarters that *any* intrusion at the nest of a breeding bird is damaging to some extent and that all nest photography should therefore be stopped. It is very difficult to measure the extent of

the supposed damage except when a bird is actually forced to desert its nest but desertion is unlikely as long as the photographer takes the proper care. Nesting species are subjected to other insults on a much larger scale such as building development, forestry work, fires and the use of pesticides. Compared to disturbance from these sources, the harm done by photographers is insignificant. Nevertheless, bird photographers *must* maintain their present awareness of the problem and continue to put the welfare of their subjects before a good photograph.

Partly as a result of the controversy, during recent years there has been a welcome move away from nest photography. This trend goes some way towards silencing the critics and has also opened up a whole new field of opportunity for the bird photographer in stalking and other forms of photography away from the nest. The pendulum can swing too far the other way, though, and we should be wary of chasing birds to the point of exhaustion in pursuit of a photograph. The upsurge in interest in birdwatching, with particular emphasis on the rarities, has brought with it an increased pressure on many birds. With a well-informed 'grapevine' at work, as many as several hundred birdwatchers may descend on an exhausted rare migrant within twenty-four hours of its first sighting. The majority of these birdwatcher/twitcher/photographers are well-behaved, but the activities of a minority have accounted for the death of more than a few migrant rarities. With the occurrence of such events and the subsequent media coverage the reputation of all ornithologists and bird photographers quickly becomes tarnished. It is in the interest of everyone as well as the birds themselves that the spirit of the Nature Photographers' Code is adhered to.

The Law

In the UK, certain species may be photographed at the nest only under licence within the terms of the Wildlife and Countryside Act, 1981. Part 1 of this act lists species which are protected by special penalties at all times. The list of species is reviewed annually and new species are added or removed on the basis of recommendations by The Nature Conservancy Council to the Department of the Environment. The distribution of licences is carefully controlled to limit the number of photographers working on these species during a nesting season and the review panel may decide not to issue *any* licences for the photography of certain species on the schedule. Applications for licences should be directed to: The Licensing Section, Nature Conservancy Council, Northminster House, Peterborough, PE1 1UA. With the application you will be expected to give details of your previous experience with nest photography and may even be asked to submit examples of your work.

In the EEC directive outlined on page 129, member governments have an obligation to take special conservation measures concerning the habitat of these species (Article 4 of Directive 79/409). In most European countries restrictions on photography at the nest do not exist, the only

real limitations being related to access to restricted areas. Belgium is the only country apart from Britain to have introduced any such legislation. In Belgium photography of any species at the nest is not allowed. In the absence of legislative restriction in most countries we would implore photographers to act within the spirit of The Nature Photographers' Code of Practice at all times.

WILDLIFE AND COUNTRYSIDE ACT 1981. Schedule 1.

Part I: Protected by Special Penalties at all times

avocet	goshawk	sandpiper, wood
bee-eater	grebe, black-necked	scaup
bittern	greenshank	scoter, common
bittern, little	gull, little	scoter, velvet
bluethroat	gull, Mediterranean	serin
brambling	harrier (all species)	shorelark
bunting, cirl	heron, purple	shrike, red-backed
bunting, Lapland	hobby	spoonbill
bunting, snow	hoopoe	stilt, black-winged
buzzard, honey	kingfisher	stint, Temminck's
chough	kite, red	swan, Bewick's
corncrake	merlin	swan, whooper
crake, spotted	oriole, golden	tern, black
crossbills (all species)	osprey	tern, little
curlew, stone	owl, barn	tern, roseate
diver, black-throated	owl, snowy	tit, bearded
diver, great northern	peregrine	tit, crested
diver, red-throated	petrel, Leach's	treecreeper, short-toed
dotterel	phalarope, red-necked	warbler, Cetti's
duck, long-tailed	plover, Kentish	warbler, Dartford
eagle, golden	plover, little ringed	warbler, marsh
eagle, white-tailed	quail, common	warbler, Savi's
falcon, gyr	redstart, black	whimbrel
fieldfare	rosefinch, scarlet	woodlark
firecrest	ruff	wryneck
garganey	sandpiper, green	
godwit, black-tailed	sandpiper, purple	

Part II: Protected by Special Penalties during the Close Season

goldeneye
goose, greylag (in Outer Hebrides, Caithness, Sutherland and Wester Ross only)
pintail

Breeding birds not on this list may be photographed without permit in the United Kingdom, but we would urge all photographers to abide by the Nature Photographers' *Code of Practice* (see page 123).

Species protected in Europe

In 1979 The Council of the European Communities published a directive in *The Official Journal of the European Communities* regarding the conservation of wild birds. The directive applied to all member states of the EEC with the exception of Greenland.

Article 4 of the directive describes a list of species in Annex 1 which 'Shall be the subject of special conservation measures, their habitat in order to ensure their survival and production in their area of distribution'. Article 5 section (d) prohibits 'Deliberate disturbance of these birds particularly during the period of breeding and rearing, in so far as disturbance would be significant having regard to the objectives of this directive'.

The list of species in Annex 1 was updated in July 1985 and came into force on 31st July 1986. The list of species recommended for such protection is reproduced below:

black-throated diver	ruddy shelduck	capercaillie
red-throated diver	white-eyed pochard	black grouse (continental subspecies)
great northern diver	white-headed duck	ptarmigan (Pyrenean subspecies)
Slavonian grebe	honey buzzard	
Cory's shearwater	black kite	ptarmigan (Alpine subspecies)
storm petrel	red kite	
Leach's storm-petrel	white-tailed eagle	Barbary partridge
cormorant (continental subspecies)	bearded vulture	rock partridge (Alpine subspecies)
	Egyptian vulture	
shag (Mediterranean subspecies)	griffon vulture	rock partridge (Sicilian subspecies)
	black vulture	
pygmy cormorant	short-toed eagle	partridge (Italian subspecies)
white pelican	marsh harrier	
Dalmatian pelican	hen harrier	corncrake
little bittern	pallid harrier	spotted crake
bittern	Montagu's harrier	little crake
night heron	Levant sparrowhawk	Baillon's crake
Squacco heron	goshawk (Corsican– Sardinian subspecies)	purple gallinule
little egret		crane
great white egret	long-legged buzzard	little bustard
purple heron	lesser spotted eagle	great bustard
black stork	spotted eagle	black-winged stilt
white stork	golden eagle	avocet
glossy ibis	imperial eagle	stone curlew
spoonbill	booted eagle	collared pratincole
greater flamingo	Bonelli's eagle	dotterel
Bewick's swan	osprey	golden plover
whooper swan	lesser kestrel	spur-winged plover
white-fronted goose (Greenland subspecies)	Eleonora's falcon	great snipe
	lanner falcon	ruff
lesser white-fronted goose	peregrine	slender-billed curlew
barnacle goose	merlin	wood sandpiper
red-breasted goose	hazel grouse	

ETHICS AND THE LAW

red-necked phalarope
slender-billed gull
Mediterranean gull
Audouin's gull
gull-billed tern
Caspian tern
Sandwich tern
roseate tern
common tern
Arctic tern
little tern
whiskered tern
black tern
pin-tailed sandgrouse
eagle owl
snowy owl
pygmy owl
short-eared owl
Tengmalm's owl

nightjar
kingfisher
roller
grey-headed woodpecker
black woodpecker
middle-spotted woodpecker
white-backed woodpecker
Syrian woodpecker
three-toed woodpecker
Thekla lark
Calandra lark
woodlark
short-toed lark
tawny pipit
wren (Fair Isle subspecies)
bluethroat
black wheatear
aquatic warbler
moustached warbler

oliver-tree warbler
Marmora's warbler
Rüppell's warbler
Dartford warbler
barred warbler
Corsican nuthatch
Krüper's nuthatch
red-breasted flycatcher
collared flycatcher
semi-collared flycatcher
lesser grey shrike
red-backed shrike
cinereous bunting
ortolan bunting
Cretzschmar's bunting
Scottish crossbill
chough

10. Planning an Expedition

The introduction of cheaper air fares and the proliferation of wildlife package holidays has opened up new and exciting horizons for the bird photographer. Safaris and expeditions fire the imagination and provide numerous opportunities for exciting photography.

Excursions fall into several broad categories. Privately-organized expeditions are designed with a definite and possibly specialized objective in mind. They are highly researched and involve a team of specialists whose brief is to find and record new data in the chosen area. Almost certainly, any photographer joining such an expedition would be expected to record all aspects of the trip and not just the bird life. The organizers look for a professional approach from all the expedition members, and if you join such a group, you will probably be expected to carry out your assignment in conditions which are often unpleasant and sometimes hazardous. Contrary to popular opinion, such journeys are usually far from glamorous and a participant would be unlikely to be chosen for photographic ability alone. It takes a special kind of physical and mental make-up to withstand the rigours involved in expeditionary work and most photographers would prefer the less rigorous demands of the other sort of excursion: the wildlife package holiday.

These now take in many of the best locations around Europe, and are arranged by specialist tour companies that relieve the participants of the organizational and logistical load involved in travel abroad. Members of the tour can thus spend as much time as possible following their own interests.

If you are fortunate enough to organize travel for a group of bird photographers, you need not be bound by the itinerary of an 'off the peg' tour; you can instead arrange a 'tailor-made' package at a reasonable price. The great advantage is that you can organize excursions to some of the areas that are off the track of the usual package tours. A custom tour of this type gives you far more flexibility, allowing you to change the itinerary, within reason, should you discover that one particular location is more rewarding than you had expected. The added flexibility also allows you to spend more time in the field, setting out earlier in the morning and returning later in the evening. You would be well advised to arrange such a trip through one of the agents specializing in birdwatching tours as their knowledge of your requirements is far superior to that of the general travel agent.

You may choose to avoid a planned tour altogether: some photographers prefer to travel alone, valuing the total freedom this allows. Without the rigidity of a pre-planned itinerary, you can spend as much or as little time in any one location as you please. Although you will lack the contacts and prior experience of a well run tour, with a little research and correspondence you can easily glean most of the necessary information.

Whichever travel option you choose, careful planning will ensure that you make the best of what may be a once-in-a-lifetime opportunity and

thus increase the chances of a successful venture, at least in photographic terms.

Most people who develop an interest in birdwatching and bird photography soon want to visit Europe's renowned areas for birdlife: the lonely tundra regions of Lapland, the marshlands of Coto Donana in Spain, the arid regions of the Adriatic coast, or the seabird colonies of northern Europe, all attract visitors for the same reason – spectacular photographic opportunities with little effort.

Deciding which of these and other places to visit has never been easy and the increasing range of wildlife tours available makes the choice all the more difficult. First decide exactly what you wish to gain from your proposed visit. If you plan to show your photographs only to friends or perhaps to deliver lectures on your return, any of the well-known areas will hold enough of interest to achieve this aim. However if you hope to sell your photographs you would be well advised to visit previously underworked areas or those which have recently been in the public eye for some reason. Pictures from such places are usually easier to sell than photographs of birds in the more popular locations. Even if you decide to visit a part of Europe already well documented though, you will probably be more than satisfied with the experience of some of the most spectacular wildlife extravaganzas the region has to offer.

Before Leaving

The importance of planning and background research before an expedition cannot be overemphasized. Even on a tailor-made bird photo-safari, which is planned to put you in close contact with the desired subjects, your camera will not take your photographs without your help and a little forethought can save a lot of disappointment later.

Having decided upon the area you intend to visit, the next task is to choose a tour. Most brochures overstate the best features of their own itinerary and for a balanced view you should contact photographers who have been on the tour you wish to join. They will be able to give you useful tips and first-hand information regarding most aspects of the trip including the best areas to photograph particular species. You may even be able to glean information on how close you can approach many species and if lucky you might even get a glimpse of some of the results to whet your appetite.

After registering with the tour of your choice you should be provided with a detailed itinerary and in some cases previous tour reports and species lists. These are useful when selecting your reading material. Many members of local natural history societies can also prove to be exceptionally helpful in providing you with local information. You should be able to contact such societies via addresses available at one of the ornithological libraries in your own country. Approaches made in this way may even result in a guided tour of the best birding spots the area has to offer. Remember that much of this help is given from a local member's own time which might otherwise be spent pursuing birding or

Snow Bunting *(Plectrophenax nivalis)*, Varanger Peninsula, Norway; June; Nikon F3, Nikkor IF-ED 600mm f5.6, auto @ f5.6, Kodachrome 64; stalked with monopod.

photographic projects. A print of one of your better efforts and a grateful letter is a common courtesy, and always well received, especially by those working in isolated areas and who value contact with others sharing similar interests. Any specialities of the region will become apparent from your background reading and from contact with other birdwatchers and photographers.

When travelling with a commercial tour, pay attention to the seasonal weather, and if possible make sure you plan your visit during the best season for birds. This may not coincide with the peak tourist season: in countries which experience a definite division of seasons, a visit during the dry months is usually the most successful. As water sources begin to dry up, it is not unusual to witness massive congregations of birds around the remaining pools and streams.

If you intend to lecture on returning to your home country you should make a provisional 'shooting list' so that you are sure to include enough landscapes and cultural scenes as a springboard for your bird photographs. This point is expanded on pages 116–119. Photographers hoping to sell their work should check on any 'wants' from the area and should contact their agent or potential clients prior to leaving.

As with any other holiday do not forget to arrange both medical and equipment insurance and to carry an adequate first aid kit.

Air travel regulations limit the amount of luggage you can afford to take with you and the decision as to which pieces of photographic

equipment to leave behind is a difficult one. If you use the 35mm format you should be able to cram most of your needs into your usual carrying bag or case. Soft canvas bags with foam inserts are preferable to hard aluminium cases because you can usually take soft bags as hand luggage, even when they exceed the regulation size. A hard metal case meets with less approval from airline officials and usually travels in the main hold, and this introduces the risk of theft or damage.

The basic photographic requirements are one or preferably two camera bodies, a 28mm lens for landscapes and habitat, a 300mm lens for larger or tame birds and, if possible, a lens of 500mm or 600mm focal length for other birds. A mid-range zoom lens of 70–210mm adds versatility to your outfit and is useful for photographing flocks of birds or some of the mammals you may encounter. Camera faults can rarely be repaired in remote areas and consequently relying on a single camera body is risky. If both cameras continue to function correctly they can be loaded with films of different speeds or fitted with different lenses, thereby saving critical time in the field. Longer lenses should be supported by a shoulder pod, monopod or beanbag – to save weight you can fill the bag with beans or gravel when you arrive. A flash unit and close up accessories may also prove useful during your stay but are not essential. A full list of recommended equipment and accessories is shown on page 137, but you may want to supplement this; if in doubt, pack it, is the rule. Unless you are on a specialized expedition it is unlikely that you will be able to use a hide or tripod.

If you purchase new equipment prior to departing on an important excursion, always check that all is in working order. Travel is expensive and it would be exasperating, to say the least, to waste money by discovering upon reaching your destination that your newly acquired camera is malfunctioning. Make sure that the equipment works properly by shooting a few rolls of film under different conditions and seeing the processed results before you set off.

Some countries have strict customs regulations regarding camera equipment. This applies mainly to those parts of the world where such equipment is expensive or difficult to obtain. You may be asked to list all items prior to entry and this schedule will be checked again upon your departure. In order to save time and trouble, make a list of all your equipment before leaving home including serial numbers.

Film Choice

Film is usually more costly abroad than from your usual local source, so you should take all you need with you. Don't underestimate your requirements: a good rule is to judge the amount of film you need and then take along twice as many rolls. Any remaining at the end of the trip can always be used on your return. Film type is a matter of personal preference, but we would usually take the majority of our film stock as Kodachrome 25 or 64 with a few rolls of Ektachrome 200 or 400 and perhaps some black and white negative film.

Always carry exposed and unexposed film in hand baggage and ask for a hand search instead of the usual airport X-ray checks. This request is rarely refused if phrased politely. Although many airport authorities insist that their own particular X-ray machine will not harm film, there is only one way to be sure! Unpacking the film and placing it in easily displayed, clear polythene bags will usually ease your passage through the security checks.

On Location

On arrival most photographers are keen to take pictures at the first opportunity, especially as they will have been planning and anticipating the trip for some time. However, this approach seldom meets with success. At locations such as the northern seabird colonies, the sheer numbers are at first sight quite bewildering and initially time is better spent in getting used to the place and weighing up the potential of the immediate area.

You may be accommodated in a lodge or farmhouse, and some species of birds in the area will probably have become used to the presence of humans. This provides an opportunity to identify and photograph unfamiliar species and also to assess the local lighting conditions at a leisurely pace, while you acclimatize to your new environment. It may also be the last chance you have to get away on your own and tackle subjects without the interference of others.

Thorough background reading should have given you a clue to the highlights of your trip: you may even find the brochures, produced by specialist tour companies, of some help in deciding which locations to visit while you are away. A 'birders' guide' to the area is very helpful in this respect, and will detail which species you can expect to find, the best locations and the times to visit them. As well as the recommended areas, though, it is always worth visiting local parks, gardens, zoos or rubbish tips. Many of the commoner local birds will be present in such areas and will often be quite tame.

Unless you are travelling with other photographers, you will soon learn that not all who accompany you on a package tour share your enthusiasm for taking pictures. Some will be quite happy just to admire a wildlife spectacle, whilst others will be satisfied with a few snapshots. Most package tours visit a number of areas on a well-worn trail and organize 'outings' from your lodgings or camp during the morning and late afternoon. Other travellers in your party may not be willing to spend time getting close to the birds you choose to photograph and would rather be moving on quickly in search of new species. If you are on a fairly large tour, it may be possible to arrange for the serious photographers to travel together; one advantage of being a lone photographer in a group is that you can choose the best photographic positions without too much competition.

Drivers and guides frequently have an excellent knowledge of the locality and its birdlife and will know where certain species can be found

and how closely you can approach without disturbing them. Remember that many photographers will have preceded you, so a good guide will know the best angles of approach with regard to lighting and even composition. Tell the guide exactly what you are hoping to achieve and you will get invaluable help and co-operation.

Owing to the rather slothful nature of man, most 'outings' start too late and finish too early for the enthusiastic photographer. One way round this problem is to hire transport with a small group of others for a day. It is best to be out before dawn so that you are able to utilize the often magical lighting conditions occurring around sunrise.

In southern Europe you are nearer to the equator and the sun will rise and set more quickly, so you need to be able to work hard and fast in order to make use of the best lighting. In the morning the sun climbs rapidly into the sky and lighting conditions soon become too harsh for photography. Lighting from directly overhead produces hard shadows and extremes of contrast which most films cannot cope with. In any case, as midday approaches birds tend to be less active so this is a good time to catch up on much-needed sleep. By contrast, daylight hours in the far northern regions of Europe are considerably extended during summer, allowing you to continue photography well into the evening.

Initially there is a temptation to photograph everything in case the opportunity does not present itself again. After this first flush of excitement on a trip you will probably find that you become more selective in your choice of shots. Film is cheap, though, in comparison with the cost of equipment and fares so do not be too sparing with it. You may otherwise indeed miss an opportunity once and for all. It is far better to have a less-than-perfect shot of a rarity than nothing at all!

Even when conditions are too poor to take photographs you should keep looking for locations which will be ideal in better lighting so that you may return another time. A small notebook is invaluable to record such possibilities.

Whatever your mode of transport outings in isolated regions tend to be rough, bumpy and dusty, and fine photographic opportunities may occur with little warning. To be prepared for the unexpected arrange your equipment so that it is easily to hand but adequately protected from dust and the inevitable tough treatment it will receive. The best arrangement is to have a mid-range zoom or 300mm lens attached to one motor driven camera body, and a 500mm or 600mm lens attached to the other camera, with a shoulder pod for support. The shorter focal length set up – which is used hand held – is kept around the neck, and the other is suspended from the shoulder ready for use. In this way you have two free hands to hold on to and manipulate other items of equipment yet you are prepared for unexpected opportunities. Other equipment, such as wide-angle lenses, is kept either in the carrying bag, protected by foam inserts or placed between the two halves of a folded towel, on a seat within easy reach. If you choose to leave remaining equipment in the bag, leave the zip or lid open and cover the bag with a towel. The

towel protects the equipment, and serves as a light and dust excluder while changing films.

Dress on a trip should obviously be of a weight and style to suit the climate as explained on pages 99–107. Photographic vests with numerous pockets in which to carry films, lenses and other accessories, are available in different materials, each being designed to provide comfort in different temperatures.

Many of your photographs will be taken from a motor vehicle and a good guide will ensure that the engine is switched off at the correct moment to eliminate camera shake from vibration. During the approach to the subject you should have time to select the correct lens and to set up a bean bag or some other support to hold the camera steady. The open top of a safari bus is a convenient vantage point, but do not forget that a lower viewpoint, such as the lower windows of the bus can sometimes produce more dramatic results. A bird of prey looks far more imposing from a lower angle if perched in a tree.

On any expedition one of the more important but less attractive activities takes place upon your return from, hopefully, a successful day; cleaning and maintenance of photographic equipment are vital tasks, even if they seem a chore when food and drink are high on your priority list. Clean lens surfaces first with a soft blower brush and then a lens tissue or cloth. Next, dust the interior of the camera, taking care to avoid damage to the mirror. The equipment bag should be emptied and cleaned of dust, camera bodies reloaded with film, batteries checked, and exposed film packed away in cassettes or polythene bags and stored in a cool, dry place.

A final word of warning. Remember that you are visiting someone else's country and that their social customs and security situation may differ from that in your home region. To an official who does not speak your language the explanation that you are only photographing birds may not justify your barrage of telephoto lenses. Check that you have any permits required, either for photography or for entry into a restricted region, particularly if you are visiting a politically sensitive area.

List of Equipment for Long Expeditions

35mm SLR body × 2
Lenses:
28mm and/or 50mm
70–210mm zoom or 135mm
300mm
500mm or 600mm, or
1.4× and 2× teleconverters
Shoulder support
 and/or monopod
Bean bag
Extension tubes
Cable release

Flash unit (optional)
Power wind
Miniature screwdrivers
Spare batteries for
 motorwind and camera
Film stock:
Kodachrome 25 or 64 colour
 slide film (main stock)
Ektachrome 200 or 400
 colour slide film (few rolls)
Tri X or Panatomic-X black
 and white film (optional)

Accessories:
Notebooks, pencils, pens
Binoculars
2cm paintbrush
Blower brush
Lens cleaning tissue
Cotton buds
Polybags and clips
Extra filters
Field guide(s)
Safety pins

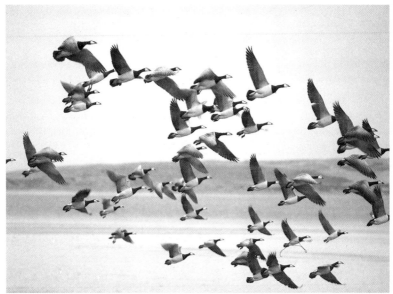

Barnacle Geese *(Branta leucopsis)*, Isle of Islay, Scotland; April; Nikon F3 and motordrive, Nikkor IF-ED 300mm f4.5, 1/250 sec @ f4.5, Kodachrome 64; stalked with monopod.

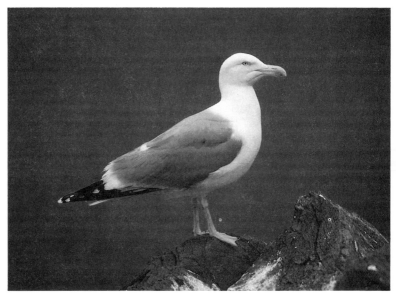

Herring Gull *(Larus argentatus)*, Bass Rock, Scotland; July; Nikon F3, Nikkor IF-ED 300mm f4.5, 1/125 sec @ f8, Kodachrome 64; stalked with shoulderpod.

WHERE TO GO

Europe has much to offer the aspiring bird photographer: within a relatively small area, it is possible to find a tremendous range of habitats and climatic variations, from arctic tundra to semi-tropical plain. Communications are so well developed that two day's travel is usually sufficient to reach even the more remote corners of the continent.

While it may be true that other parts of the world have greater concentrations of bird life or more exotic species, there are nevertheless enough native European species to keep a bird photographer busy for many years. When seasonal visitors are taken into account, it is clear that the enthusiastic birder has enough material for a life-time's study – all within quite a short distance of home.

The gazetteer that follows is intended as a starting point, for the travelling bird photographer, guiding you to some of the better-known and more reliable locations in Europe. To a great extent, it is a personal choice, although some sites have been recommended by other birdwatchers and photographers. We give information on the best times to visit, accommodation and access, and the species likely to be found in each area, but suggest you check up on the details, using the contact provided, *before* you set off, and where possible supplement the guide with first-hand information from local societies, publications, birdwatchers and photographers.

Finally, the best way to keep in touch with the top spots for photographing birds is by first-hand reports – we would welcome *your* corrections, suggestions, additions and improvements; write to Natural History, Collins, 8 Grafton Street, London W1X 3LA.

11. Birds of Town, Park and Garden

**Herons, storks, geese, ducks, occasional raptors, pheasants, coot,
moorhen, occasional waders, some gulls, occasional terns, pigeons, doves, some owls,
swifts, woodpeckers, swallows, martins, some warblers, thrushes, tits,
nuthatch, finches, sparrows, starlings, crows, and chats**

Photographing birds in this category starts no further away than your own garden. Urban environments throughout Europe have their share of public parks, botanic gardens . . . and rubbish tips – all of which are worth investigating through local information offices and bird societies. We give a handful of examples here simply to illustrate the opportunities that such man-made habitats present. See also entries 32, 101, 109, 141 (England); 52 (France); 93 (Yugoslavia); 94 (Austria); 193 (Greece).

The great advantage of public parks and private gardens is that the birds are used to humans and relatively tame, making fine photographic opportunities available which might otherwise be difficult. Imaginatively landscaped areas, the variety of plants, and water gardens, not only attract a fair range of species, but can provide pleasing backdrops for photography. Where there are captive or introduced birds, local wild species are attracted into the area too, and in turn become relatively tame and easier to photograph. It is well worth taking the time to study these relatively tame birds before you start taking photographs. As long as you remain still, many of them will approach close enough to produce a good image size with a 300mm lens. This is the time to practise the techniques of focusing, the use of selective depth of field, and composition techniques in relative ease, with no shortage of approachable subjects. Concentrate on close-ups, as public park backgrounds can look rather scruffy; with water birds, especially, guard against any distracting food, feathers or litter floating in the vicinity. Many captive water birds, although free-swimming, have been pinioned and you should avoid taking photographs from the affected side.

In a private garden, of course, you have much more control over where the birds present themselves – by strategic placing of baiting points, perches, ponds etc. And you can erect a hide exactly where you want. Regular feeding with a mixture of scraps, seeds and fruit ensures a constant stream of visitors. A bird table near a window ensures that feeding birds are within easy range, and by placing the camera on a tripod near the window with curtains drawn and the lens protruding, you can take pictures at leisure. Open the window, though, as photographs taken through glass are significantly inferior.

Photographs of birds at a bird table can look rather contrived – although they are still in constant demand by publishers – and you'll get better pictorial results by placing a natural-looking perch near the table. You can then take photographs as the visitors survey the area *prior* to feeding. Alternatively, set the table near a suitable natural perch in a bush or tree.

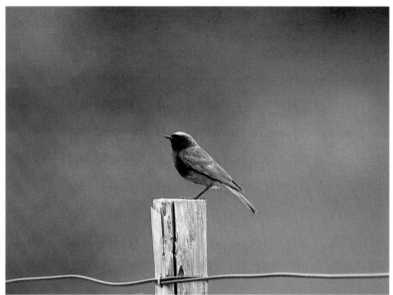

Black Redstart *(Phoenicurus ochrurus)*, Oberammergau, West Germany; June; Nikon F3, Nikkor IF-ED 600mm f5.6, auto @ f5.6, Kodachrome 64; car bracket.

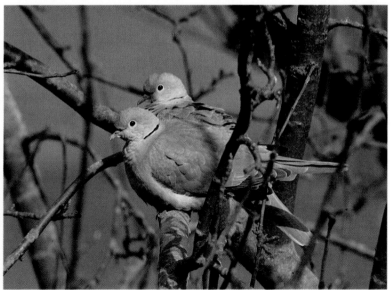

Collared Dove *(Streptopelia decaocto)*, Berkshire, England; April; Nikon F3, Nikkor IF-ED 600mm f5.6, auto @ f11, Kodachrome 64; house window, tripod.

TOWN, PARK AND GARDEN

Urban environments also offer marvellous photographic opportunities in their refuse tips which attract avian scavengers such as gulls, corvids and raptors. Many tips have restricted access, and permission must be obtained from the relevant local authority prior to entry. Find out from the site workmen where the 'fresh' rubbish is being dumped – if this is not already evident from the congregating birds. Some form of hide is usually necessary and in this case a motor vehicle is particularly suitable, as the birds will have become used to the comings and goings of the rubbish vans. A 300mm or 400mm lens fixed to a camera clamp or on a bean bag will usually be adequate to isolate birds from their background especially if you use the maximum aperture to ensure minimum depth of field. Groups of birds involved in disputes over food items are readily photographed using smaller lenses, a medium telephoto zoom being ideal.

Photographing in urban areas may not have quite the challenge and excitement of the really wild countryside, but it does present constant and reliable opportunities to build up a fairly diverse range of species and bird behaviour pictures.

In English gardens alone, the British Trust for Ornithology's garden bird feeding survey recorded over 100 species!

Do remember, that any subject photographed in captivity or under controlled conditions should be labelled as such when you display or publish your photographs. Many pictures like these will be published, so honesty loses you nothing, and at least prevents you from experiencing the embarrassment of having one of your pictures captioned as showing a wild and free subject when it is obviously captive.

Special techniques: see pages 38, 52, 54, 66, 82

Equipment

35mm SLR	Wide angle lens	Car bracket
Spare body	Tripod	Flash heads and supports
300–600mm telephoto lens	Shoulder pod	Cable release
80–100mm zoom lens	Hide, stool	Remote control
1.4× or 2× teleconverter	Bean bag	Medium or fast film

AUSTRIA

1. Schönbrune Palace Gardens, Vienna

A major tourist attraction in the south west of the city. Behind the formal gardens is an area of mature woodland and some grassy areas surrounded by hedges, together offering an interesting variety of birds, many of which are quite tame.

☛ The Palace is well signposted in the city and entrance is free. There is a car park before the main gate. Ample accommodation, to suit most pockets, is available in Vienna.

☞ The mature woodland areas hold lesser, middle and great-spotted woodpeckers; hawfinch, short-toed treecreeper, wryneck, red-breasted and collared flycatchers, great tit, nuthatch and a number of warblers. Grey-headed and green woodpeckers feed on the grass. The low light levels in the woodland make flash or fast film necessary in many instances.

📷 May–August

BRITISH ISLES

2. Regent's Park, London

OS TQ280830

An ornamental oasis among the hustle and bustle of England's capital city, with two man-made lakes, ornamental gardens, open grassland and small stands of native and introduced trees. At the eastern edge lies the famous but compact London Zoo.

☛ Situated north east of London's West End, and reached from Regent's Park underground station. The main part of the park lies just a few minutes walk from here. Car parking can be difficult. No restrictions on access.

☞ Many common species, easily photographed. The lakes hold collections of pinioned ornamental duck which act as a decoy for local species. Small heronry on an island in the large lake which can be photographed using 500–600mm lens from the lake perimeter. Waterfowl include mallard, pochard, tufted duck, shoveler, wigeon, pintail, red-crested pochard, great-crested grebe, little grebe, coot and moorhen. Other birds include blackbird, song thrush, mistle thrush, wood pigeon, collared dove, green woodpecker, robin, willow warbler, chiffchaff, great, blue, and coal tits, nuthatch, chaffinch, greenfinch, house sparrow, starling, magpie, jay and black-headed gull.

📷 All year

3. Royal Botanic Gardens, Edinburgh,

OS NT248760

Typical of the many part-ornamental, part-experimental gardens throughout the UK and particularly suitable for the beginner in search of approachable subjects.

☛ 1½km north of city centre; well signposted on the road to Inverleith. Opening times 10.00hrs – one hour before sunset. Permit required to photograph birds, from Accounts Department, Royal Botanic Gardens, Inverleith Row, Edinburgh, EH3 5LR ☎ (031) 552 7171.

☞ Common species include chaffinch, blackbird, robin, song thrush, mistle thrush and moorhen. During winter redwing and fieldfare are regular visitors. Waxwing and hawfinch have been seen infrequently.

📷 All year

DENMARK

4. Copenhagen

A number of parks hold interesting breeding species and some visitors. The harbour area of Sjaellandsbron is particularly good in winter. Kongelunden, an area of woodland in the southern part of Copenhagen is also of great ornithological interest.

☛ Copenhagen lies on the east coast of Sealand and has an international airport as well as a seaport. Accommodation available throughout the area. Utterslev Mose, a shallow marshy lake is 6km from the city centre in the northern suburbs. Kongelunden is at the southern edge of the city limits south-west of the airport. Sjaellandsbron, the southern harbour, is easily found south of the city centre.

☞ Utterslev Mose holds an interesting variety of breeding species as well as attracting a number of migrants. Breeding birds include a very large black-headed gull colony, a large population of black-necked grebe, greylag geese, little grebe, great crested grebe, shoveler, pochard, tufted duck, and maybe red-necked grebe. Migrant species and non-breeding visitors include goldeneye, goosander, smew, buzzard, honey buzzard, sparrowhawk, osprey, long-eared owl, swift, jackdaw, common tern, thrush nightingale, marsh warbler and icterine warbler. Kongelunden is an area with several habitats worth exploring, including woodland, coastal shallows and meadows. Birds to be expected or passing through on migration or visiting this area for longer periods include whooper swan, eider

duck, buzzard, rough-legged buzzard, honey buzzard, hen harrier, sparrowhawk, merlin, crane, oystercatcher, spotted redshank, redshank, curlew sandpiper, little stint, Temminck's stint, avocet, blue-headed wagtail, great grey and red-backed shrike, chaffinch, brambling and snow bunting. Sjaellandsbron, the southern harbour area, is good for wintering wildfowl including whooper swan, goldeneye, teal, goosander, redbreasted merganser and smew.

📷 All year

ICELAND

5. Reykjavík
Reykjavík is the coastal capital of Iceland and the point from which most visitors start tours. Some useful photographic opportunities are within easy reach of the town.
☛ Reached by air from many European cities or by sea from the UK and Scandinavia. The Smyril Line runs sea trips from Bergen in Norway, Aberdeen in Scotland, and

Hanstholm in Denmark. Full information and brochures regarding travel and accommodation from: Iceland Tourist Bureau, Reykjanesbraut, Reykjavík, Iceland.
☛ Glaucous gull and the occasional Iceland gull in the harbour. Lake Tjörnin in the centre of the town has a large colony of Arctic terns, red-necked phalarope, eider duck, scaup and Barrow's goldeneye. East of the town is the Seltjarnarnes Peninsula which has a coastal lagoon providing ideal nesting for a variety of ducks and waders, including redshank, snipe, and red-necked phalarope. Non-breeders found include turnstone, ringed plovers and purple sandpiper: there is also a colony of Arctic terns, and redwings are fairly commonplace. There is an auk colony at Hafnarbjorg and an eider duck colony at Alftanes; the former location should also provide fine views of Brünnich's guillemot. Further from Reykjavík at Gerdhar and Midnes are breeding grey phalarope, but these are difficult to find. Surrounding marshland supports breeding whimbrel and black-tailed godwit.
📷 May–July

Goldfinch *(Carduelis carduelis)*, Illmitz, Neusielder See, Austria; June; Nikon F3, Nikkor IF-ED 600mm f5.6 + Nikon 1.4× teleconverter, auto @ f11, Kodachrome 64; car bracket.

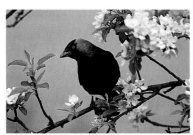
Jackdaw *(Corvus monedula)*, Berkshire, England; May; Nikon F3, Nikkor IF-ED 600mm f5.6, auto @ f5.6, Kodachrome 64; house window, tripod.

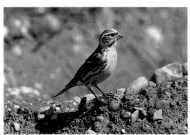
Serin *(Serinus serinus)* Illmitz, Neusielder See, Austria; June; Nikon F3, Nikkor IF-ED 600mm f5.6 + Nikon 1.4× teleconverter, auto @ f11, Kodachrome 64; car bracket.

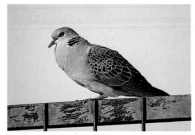
Turtle Dove *(Streptopelia turtur)*, Illmitz, Neusielder See, Austria; June; Nikon F3, Nikkor IF-ED 600mm f5.6, 1/250 sec @ f5.6, Kodachrome 64; car bracket.

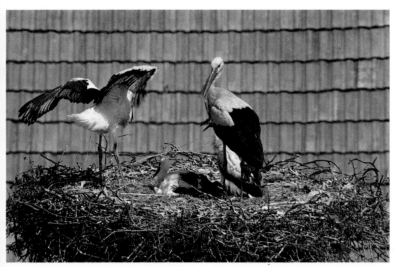

White Stork *(Ciconia ciconia)*, Rust, Neusiedler See, Austria; June; Nikon F3, Nikkor IF-ED 600mm f5.6 + Nikon 1.4× teleconverter, auto @ f8, Kodachrome 64; beanbag, church spire.

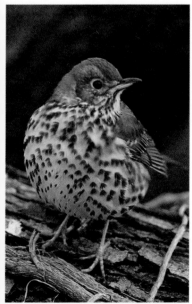

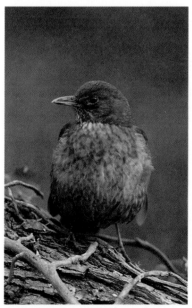

Song Thrush *(Turdus philomelos)*, Sussex, England; February; Nikon F2, Nikkor 300mm f4.5, 1/125 sec @ f5.6, Ektachrome 400; beanbag.

Blackbird *(Turdus merula)*, Sussex, England; February; Nikon F2, Nikkor 300mm f4.5, 1/125 sec @ f5.6, Ektachrome 400; beanbag.

12. Birds of Island, Coast and Estuary

Shearwaters, petrels, gannet, cormorant, skuas, auks, gulls, terns, waders. Herons,
egrets, storks, cranes, geese, duck. Some eagles and hawks, some larks, pipits, wagtails,
warblers, buntings, finches

Northern Europe has some of the most spectacular seabird colonies in the world, many of them in breathtaking island locations. Add to that the coasts and estuaries that provide some of the most important and richest wintering areas for waders and wildfowl and stopover points for passage migrants – and the pickings for the bird photographer are rich indeed.

Islands are probably the most exciting locations of all whatever your standard in bird photography. Groups in this category include shearwaters, petrels, gannets, cormorants, skuas, auks, gulls, terns and waders. The vast numbers of birds and the atmosphere of frenzied activity more than make up for lack of species variety, and a complete range of bird behaviour can be photographed within a relatively short space of time. The temptation is to try too much too quickly – with disappointing results and lots of wasted film. Generally, it is better to concentrate on one species per visit and have a clear idea of what you want to photograph before you go. If you do visit one of the more inaccessible places for a one-off visit, and must get everything right first time, this can only be done with very detailed forward planning and an intimate knowledge of your equipment and the techniques involved in its use.

Access is likely to be the most difficult problem you face. But all of Europe's seabirds can be found somewhere that's reasonably accessible, so you should be able to cover all species eventually. Most birds will be breeding throughout the summer months – visits at any other time are seldom productive as the colonies are vacated in early autumn. It's best to aim for late May–early July, as the adult birds get rather tatty, with worn and dirty feathers as the season progresses.

Many seabirds are quite tame on their breeding grounds, especially where human visitors are frequent. There should be plenty of opportunities for portrait and action photography, and for photography at the nest without the use of a hide. Even so, the nest must always be approached slowly, on all fours if necessary, and photographs taken only if the birds do not seem at all disturbed by your presence. This is particularly important if the adult is incubating; once there are young in the nest, you have more leeway.

Because of the ease of approach, you may be able to use lenses of shorter focal length than usual. A 135 or even 50mm lens may be adequate. Zoom lenses, which have recently been much improved optically, can be a great help in framing and composing your picture.

The disadvantage of large numbers of birds in such close proximity is the difficulty of isolating a single bird without lots of others out of focus

in the background. This may be overcome by the use of a larger lens at its widest aperture, and thus making full use of the small depth of field. Background birds will then be thrown so far out of focus as to be unrecognizable and irrelevant.

Special techniques: see pages 54, 68, 82, 105

Equipment

SLR	300mm lens	Torch
Spare body	Monopod	Slow & fast film –
70–210 zoom lens	Shoulder pod	take twice as much as
Wide angle lens	Flash for shearwaters & petrels	you think you will need!

The coasts of Europe are prime stopover points during the spring and autumn migrations to and from the northern breeding grounds. Relatively few species breed near the shoreline itself – most of what you see will be either on passage or local visitors feeding. The most prominent birds breeding actually on the beach, or just above the intertidal zone are the terns, which usually nest in large colonies among coastal vegetation. Passage migrants are particularly attracted to isolated coastal areas such as spits and points where any vegetation can provide much-needed shelter. Photography in these circumstances is very much a matter of luck – one day an area might be literally hopping with birds, the next it will appear devoid of life.

Migrating birds are often very tame and can therefore be easy to approach. If you are lucky, it may only be necessary to approach the general area taken up by the birds and wait. You will be amazed at how often the bird will ignore you, as long as you remain still. However, do remember that apparent tameness may only be a sign of fatigue and careful observation will reveal the bird which is not feeding and preening normally. Such individuals should be left in peace because, apart from unnecessary harassment, a tired and listless bird seldom results in a natural shot.

Many birds are drawn to where there are marshes just behind the intertidal areas – such as redshank, black-winged stilt, snipe, curlew, ruff, herons and wildfowl, some of which will breed there. Other species stop on passage, continuing their journey after a few days. Sedge and reed warblers and bearded tit may breed in reedy marsh margins, while larger and denser reedbeds may harbour bittern, purple heron or marsh harrier, and you may also see larks, pipits, wagtails, buntings and finches.

There are often reserves in such areas with permanent hides for visitors, though sometimes these are too far away to be suitable for photography. The more successful hides are on reserves where the water level is varied by the warden for management purposes – as the water level rises it brings birds close enough for good photographs.

The main problem of coastal photography is lack of cover. On a tidal lagoon many birds assemble at predictable roosting sites round the

edges, and with luck there will be sufficient vegetation for cover, but a long focal lens will invariably be necessary. Groups of birds on beaches have a large area in which to disperse. This is one occasion when casual human strollers may be of assistance – if you wait in a comfortable lying or sitting position, the birds may be driven towards you. As they approach, follow them by looking through the viewfinder, taking photographs at appropriate intervals. By selecting your position carefully and leaving enough room for them to pass between yourself and the water's edge you should be able to obtain dramatic photographs of your subject against a background of breaking waves.

Special techniques: see pages 38, 54, 68, 105

Equipment

SLR	Medium zoom lens for	Tripod
Spare body	flight and habitat shots	Monopod
300–600mm telephoto lens	2× teleconverter	Shoulderpod
Wide angle lens	1.4× teleconverter	Flash
	Hide	Medium to fast film

Estuaries are immensely productive and satisfying for the bird photographer – a combination of space and remoteness with often vast numbers of waders and wildfowl, together with herons, egrets and storks, gulls, terns and even some eagles and hawks. From the bird's point of view, the fertile shallow seas around Britain combined with the broad estuaries of Northern Europe provide their most important wintering areas following the northern breeding season, offering plenty of food, shelter and diversity of habitat. Enormous numbers of birds are attracted to the invertebrate life of sand or mud exposed at low tide, and estuarine vegetation is also important and may support grazing species of duck and geese. Do pay particular attention to tide times – not only for practical photographic purposes, but also for your own safety – local knowledge of good sites and peculiarities of the tide run should be sought.

Approaching birds in wetlands and mudflats has its difficulties – it's often impossible to be absolutely silent and alert the birds to your presence – but they will usually only fly off if they actually see you. You may be able to get close to species that congregate in the bordering vegetation like herons and waders, but generally, this is the time for a long focal lens!

Special techniques: pages 38, 54, 68, 105

Equipment

SLR	2× teleconverter	Shoulderpod
Spare body	1.4× teleconverter	Tripod
300–600mm telephoto lens	Slow and fast film	Monopod
70–210mm zoom lens	Hide	Bean bag
Wide angle lens	Stool	Car bracket

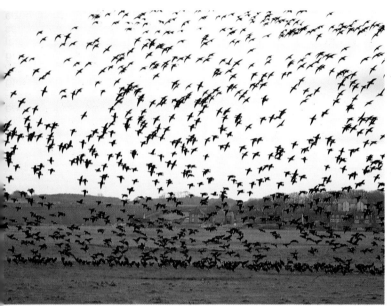

Brent Geese *(Branta bernicla)*, Norfolk, England; March; Canon AE1 and autowind; Canon 135mm f3.5, 1/500 sec @ f3.5, Kodachrome 64; stalked handheld.

BELGIUM

6. Yser Estuary

A small estuary basin, close to the coastal town of Nieuwpoort; despite its size, it is very attractive to migrating waders. Part of the area is a reserve.

☛ Approach from Nieuwpoort near Ostend, or any of the other coastal towns close by. Hotel accommodation and campsites are plentiful along the coast.

🗢 Breeding birds include avocet, shelduck, Kentish and little ringed plovers, and crested lark. Passage waders include curlew sandpiper, little stint, green and wood sandpipers. Migrating ducks, gulls and terns also visit.

📷 Spring and autumn

7. Zwin Nature Reserve

This well-known reserve straddling the Belgium–Netherlands border, is an area of salt marsh and mudflats in what was the mouth of the River Zwin. The vegetation includes species characteristic of this type of habitat including sea lavenders, sea purslane, glassworts and thrift. Within the reserve there is a wildlife park with a large number of captive birds, many of which are not confined, and which act as a draw for truly wild species.

☛ Approach from Knokke, which is on the coast road from Ostend. Accommodation and campsites plentiful in Knokke and Le Zoute. Unrestricted access to most of the reserve, with only a few areas closed off. Guided walks March–September. Further information: Federatie voor Toerisme in Oost-Vlanderen, Koningen Maria-Hendrikaplein 27, 9000 Gent.

🗢 The main features of interest are the waders and wildfowl visiting the mudflats. The introduction of lagoons to the reserve has encouraged some species to breed – including shelduck, redshank, avocet, oystercatcher, Kentish and ringed plovers, common tern and black-headed gull. Other breeding species include black-tailed godwit, hoopoe, golden oriole, and icterine warbler. There are also populations of greylag geese and white stork which originated from injured birds. During the winter, the mudflats in the area hold good numbers of white-fronted geese and bean geese.

📷 All year

ISLAND, COAST, AND ESTUARY

BRITISH ISLES (including the Republic of Ireland)

8. Bardsey Island
OS SH125225

Owned by the Bardsey Trust, approximately 2¼km × 1km at its widest point, situated 3km off the south-western tip of the Lleyn Peninsula. Bird photographers are welcome and erection of hides permitted over most of the island. The resident warden should be given prior warning of your plans.

☛ Access by open fishing boat from Pwllheli harbour on the A497, 20km from Portmadoc. Boat usually leaves Saturday mornings for the three-hour, 30-km crossing of Bardsey Sound. Crossing may be rough, sometimes impossible – and visitors can be stranded on the island for a week or more. Day trips sometimes available: contact the Trust Officer, Dafydd Thomas, Tyddyn Du Farm, Criccieth, Gwynedd ☎ (076671) 2239. The island is open to visitors late March–early November.

Self-catering accommodation in Cristin Farmhouse and elsewhere. Further details on accommodation, sailing times, mainland car parking etc: The Booking Secretary, Mrs Helen Bond, 21a Gestridge Road, Kingsteignton, Newton Abbot, Devon ☎ (0626) 68580.

☛ Resident bird of greatest interest is the chough, but it is almost impossible to photograph at the nest because breeding sites are inaccessible. The birds can be photographed perching outside the caves, but this is considered near the nest and a permit must be obtained from the Nature Conservancy Council. Choughs feed all over the island, and careful stalking with a long telephoto lens (ie., 600mm) can produce satisfactory results. There are around 4000 pairs of breeding Manx shearwater, best photographed at night using a torch to focus and a flash unit as a light source. Migration time is good for small passerines, with the chance of some rarities. Good photographic opportunities for waders in spring and autumn from a permanent wooden hide on a small beach. About thirty species breed on the island including razorbill, guillemot, fulmar, kittiwake, lesser black-backed and herring gulls, oystercatcher, lapwing, little owl, skylark, raven, jackdaw, meadow pipit, wheatear and stonechat. There are no breeding puffins.

📷 March–October, weather and your particular objectives permitting

9. Bass Rock & Craigleath
OS NT605875, NT550870

Two privately-owned islands in the Firth of Forth. It is possible to combine a visit to both in one day – but not advisable, as there's too much to see on each. The local boatman Fred Marr serves both islands; he knows and understands the needs of bird photographers, and length of landing is by arrangement with him.

☛ Boat services from North Berwick, which is on the A198 Edinburgh road. No permit necessary, but landing dependent on weather conditions; daily service to Bass Rock April–September; you have to book for Craigleath. Contact: Fred Marr, 24 Victoria Road, North Berwick ☎ (0620) 2838.

☛ Bass Rock is famed for its gannets – approximately 14,000 pairs nest here. Good photographic opportunities are available from the trail. Birds at all stages of development are seen later in the breeding season. Flight shots are best attempted on the west and north-west faces, where many birds will 'hang' on the wind. Other birds include shag which nest near the landing stage. A few guillemots also congregate in this area. Herring and lesser black-backed gulls nest in the vegetation area to the left of the trail above the lighthouse. Some fulmar in the steep gully on the south west of the island. Small numbers of breeding kittiwake and puffin are also to be found on the island. Most birds are very approachable and long telephoto are seldom necessary, but a medium telephoto of about 300mm may be useful to fill the frame with the bird's head.

Craigleath has at least ten species of breeding seabirds, including puffin, razor bill, shag, cormorant, kittiwake and fulmar. Herring and lesser black-backed gulls and eider duck nest amongst the vegetation on top of the island. Guillemots are probably the least accessible birds, nesting on the steeper cliffs on the eastern end of the island. The rest of the island's birds are remarkably accessible to anyone who has been able to make the landing in the first place, including those nesting lower down on the rocks, and may be photographed against superb backdrops.

📷 Bass Rock: June–August. Craigleath June, July

10. Brownsea Island
OS SZ035880

An attractive 4 × 1½km island managed by the National Trust and the Dorset Naturalists' Trust, at the entrance to Poole Harbour

150

Although near a busy holiday region, its woodland, heath, lake and marsh habitats have proved a great attraction to bird-life.

☛ Open throughout the year. Boats run each hour from Poole Quay or Sandbanks. Warden on site. Enquiries to: The Warden, National Trust, Brownsea Island, Poole, Dorset, or Dorset Naturalists' Trust Nature Reserve, The Villa, Brownsea Island, Poole, Dorset, ☎ (0202) 709445. See 163, 174.

☛ More than sixty species of bird have bred regularly with a total of about 200 species on record. Water birds breeding include tufted duck, little grebe and water rail. Probably the best area to visit is the 28ha salt-water lagoon, where there are three hides, one of which is open to the public, and breeding birds include over 100 pairs of sandwich tern and common tern, as well as herring and black-headed gulls. Also breeding are shelduck, oystercatcher and Canada geese. At high tide in Poole Harbour the shallow water and mudflats attract hundreds of migrating and wintering waders, including avocet, whimbrel, curlew, godwit, grey plover and greenshank. Other breeding birds include Dartford warbler and nightjar on the heathland. Green and great spotted woodpeckers, sparrowhawk, treecreeper and goldcrest in the woodland, and reed buntings, reed and sedge warblers in the reeds around the freshwater marsh.

☒ All year

11. Burry Inlet
OS SS545960

This inlet is the broad estuary of the River Loughor and part of a National Nature Reserve which covers the whole of the Gower Peninsula. The area of about 5000ha includes sandflats and saltmarsh.

☛ Take the A48/M4 Swansea bypass and then the A484 at Junction 47 for Gorseinon. Turn left at Gorseinon on the B4296 for Gowerton and then right on the B4295. The road reaches the shore at Penclawdd. From here a little exploration will be necessary to find the prime locations. Knowledge of local tide times will be of help.

☛ The estuary holds large flocks of oystercatcher during the winter with estimates of over 10,000 birds. Other waders include large numbers of dunlin and knot with smaller numbers of ringed, golden and grey plovers, turnstone, lapwing, sanderling, redshank, curlew, black-tailed and bar-tailed godwits. Wildfowl wintering in the area include up to 2500 wigeon with smaller

numbers of Brent geese, shelduck, mallard, teal and pintail.

☒ Autumn and winter

12. Caerlaverock
OS NY051656

This Wildfowl Trust reserve is situated on the north shore of the Solway Firth and is part of the Caerlaverock National Nature Reserve. The 5500ha reserve includes areas of farmland, foreshore, saltmarsh and fresh-water marsh. The mudflats are dangerous as they are riddled with deep, muddy channels which fill with alarming rapidity as the tide comes in. There are observation towers and hides on the reserve; all visitors are escorted by the warden.

☛ Take the B725 out of Dumfries. The Wild-fowl Trust reserve is at East-Park Farm. Open daily 16 September–30 April (except 24 and 25 December) at 11.00 and 14.00 hrs. Further information: The Warden, Eastpark Farm, Caerlaverock, DG1 4RS ☎ (038 777) 200. There is no access to the National Nature Reserve itself unless a permit is obtained from the Nature Conservancy Council for scientific purposes, and it is unlikely that this would include photography.

There are good views from the B725 across the river and mudflats and saltmarsh at the northern end of Caerlaverock Reserve. There are also good views from the picnic site situated at the point where the road turns inland. A number of good places for waders exist around Cummertrees, Powfoot and Annan further along the road where the side roads lead directly to the shoreline.

☛ The wildfowl are most easily observed at East-park Wildfowl Trust reserve. There are up to 8500 barnacle geese which are easily seen and photographed, the greatest numbers being present from November onwards. Pink-footed geese arrive later with maximum numbers present in late January, early February. Between 3000 and 5000 birds are usually present. The large pond in front of the observation building draws as many as seventeen different wildfowl species to close range. Other visitors include whooper and Bewick's swans and small numbers of greylag geese. Duck include over 2000 wigeon and teal with smaller number of mallard, shoveler, pintail, gadwall, pochard, and tufted duck. Good numbers of waders also occur throughout the area with about 15,000 oystercatchers roosting in October at Caerlaverock. Other waders include golden, grey, and ringed plovers, lapwing, turn-

stone, dunlin, knot, redshank, curlew, and bar-tailed godwit. The small pools at East-park also hold a collection of tame European wildfowl.

📷 October–March

13. Calf of Man
OS SC155652

The Calf of Man is an island approximately 2 × 1½km lying about 600m off the south-western tip of the Isle of Man in the Irish Sea. The coastline is mainly cliff-bound with a few small beaches. Much of the island is covered by bell heather, ling and patches of bracken.

☛ Access to the observatory March–October. The Isle of Man is served by regular air services from a number of airports in Britain to Ronaldsway Airport – about 10km from The Calf of Man. Daily steamer services from Liverpool to Douglas and from Llandudno, Dublin, and Belfast in the summer. Small boat ferries to The Calf out of Port Grin and Port St Mary. Good accommodation available in the old farmhouse, but food and sheets must be taken. There are food shops near the point of crossing. Enquiries regarding accommodation and crossings: The Secretary, The Manx Museum and National Trust, Douglas, Isle of Man ☎ (0624) 25125

☛ The Calf of Man boasts eleven species of seabirds including a small number of Manx shearwater. Others include fulmar, cormorant, shag, great black-backed and herring gulls, kittiwakes, razorbill and guillemot. The Calf of Man is however best known, not for its seabirds, but for its birds of passage. Whilst this provides no insurance for the bird photographer, those interested in rarities or occasional large numbers of commoner species may have some success at peak passage periods. Spring migration includes movements of winter thrushes, wheatears, chiffchaffs, sand martins, meadow pipits, goldcrests and ring ouzel. During autumn there are large numbers of wheatears, stonechats, meadow pipits, linnets and willow warbler. Numerous other species also occur in smaller numbers.

📷 First two weeks of May; late August and early September.

14. Cley Marshes Nature Reserve
OS TG055441

Often called the ornithologists' mecca because of its magical attraction for the

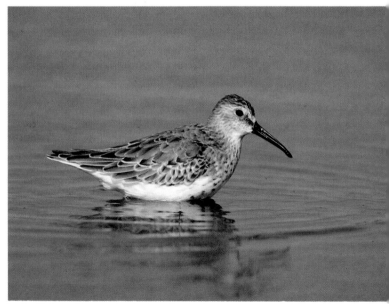

Dunlin *(Calidris alpina)*, Norfolk, England; October; Nikon F3, Nikkor IF-ED 600mm f5.6, 1/250 sec @ f5.6, Kodachrome 64; stalked with monopod.

152

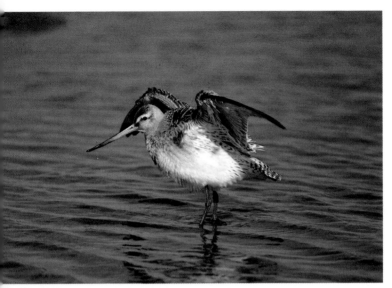

Bar-tailed Godwit *(Limosa lapponica)*, Norfolk, England; October; Nikon F3 and motordrive Nikkor ED 600mm f5.6, auto @ f5.6, Kodachrome 64; hide, beanbag.

rarity hunter, the reserve consists of a 266-ha area of freshwater and saltwater marsh, reedbeds and shallow pools, with an area of grazing land behind a high coastal bank of shingle.

Off the A149 King's Lynn–Cromer road. Although part of the reserve can be viewed from the road this is seldom satisfactory for photography.) Permits, which enable you to use the hides situated at points around the reserve, issued on a daily basis 1 April–31 October except Mondays; 1 November–31 March by special arrangement. Details from: The Warden, Watcher's Cottage, Cley, Holt, Norfolk, NR25 7RZ ☎ (0263) 740380. The East Bank which joins the road to the coastal shingle bank is one of the better-known bird walks in Britain. This gives access to some of the hides for those with permits, but the bank itself is open to all, as is the foreshore.

Some 300 species have been recorded at Cley, many of them rarities. We will restrict ourselves to the birds which can be realistically tackled by the photographer. A number of the hides are too far away to give opportunities for photography but others may be good depending upon the water level. Good shots of redshank, snipe, ruff, ringed plover, black-tailed godwit, avocet, greenshank, green and wood sandpipers are possible.

Generally, a 500–600mm lens will be needed. Shelduck, mallard, teal, wigeon and gadwall are also possible. Careful attention should be paid when walking between hides, as bearded tits are often approachable from the paths. Bittern and marsh harrier may also be photographed in flight for those lucky enough to see them. Sedge warbler have singing posts around the reserve and offer good opportunities, as do yellow wagtail. Some time spent at the end of the East Bank near Arnold's Marsh will often offer chances of geese and duck in flight, as well as small flocks of waders. The grazing area near the car park usually holds a good number of Brent geese in the winter, which may be photographed feeding or in flight, and the small pools around this area offer good chances of stalking dunlin and lapwing. Snow bunting and shore lark are possibilities in winter. Walesey Hills offer the chance of photographing some passerines including linnet on the gorse bushes.

August–May

15. The Copeland Islands
OS 359384

A group of islands situated outside the entrance to Belfast Lough. There is an observatory on John's Island (or Lighthouse

Island), one of the smaller outer islands, approximately 5km off Orlock Point. John's Island is oval in shape with cliffs up to 15m high on the south-east side.

☛ Access to John's Island is by boat from Donaghadee Harbour which is easily reached from Belfast Docks by bus. Boats run Friday evenings and return Sunday evenings; weekdays by prior arrangement. Contact: Bookings Secretary, Neville Mckee, 67 Temple Rise, Templepatrick, Co. Antrim, BT39 0AG ☎ (08494) 33068. There is hostel-type dormitory accommodation on the island. Further information: The British Trust for Ornithology, Beech Grove, Tring, Herts, HP23 5NR ☎ (044 282) 3461.

☛ Breeding birds include great black-backed gull, lesser black-backed gull and about 4–5000 pairs of herring gulls (including Mew Island). Manx shearwaters also breed in an accessible colony. Black guillemot, eider duck, water rail also nest.

📷 May–July

16. The Exe Estuary
OS SX987795

This estuary is south-west England's most important wader and wildfowl feeding area, attracting up to 20,000 waders and several thousand wildfowl. Dawlish Warren Nature Reserve is probably the prime location for the bird photographer, although exploration of the surrounding area is always worthwhile.

☛ Off the A379 Exeter–Dawlish road, turning south at Cockwood Harbour bridge. Turn left under the railway bridge; the wader roost, nature reserve and estuary are reached by walking along the dunes overlooking the beach. From the narrow part of the dunes turn left beside the golf course to the green hide overlooking the roosting site. It is essential to find out the exact times and height of tides for the best photographing opportunities – ie., two hours before high tide.

☛ During winter, large high tide roosts of waders and many Brent geese are pushed up close to the hide. These include up to 3000 oystercatcher and 2–3000 dunlin, as well as several hundred bar-tailed godwit and smaller numbers of curlew, ringed and grey plovers, knot, sanderling and turnstone.

Elsewhere in the Exe Estuary one may find large numbers of wintering wigeon as well as mallard, teal and shelduck. Smaller numbers of goldeneye, pintail, red-breasted merganser and eider duck are also to be found. At Turf Lock higher up the estuary is an increasing flock of wintering avocet which may be viewed at close quarters about two hours before high tide when the feed close in. The bay behind the town of Exmouth on the other side of the estuary to Dawlish Warren is a good place for close views of large numbers of wigeon, and a regular flock of wintering purple sandpiper occurs on the rocks and boulders at the star of Orcombe Cliffs at the southern end of the town.

📷 October–March

17. The Farne Islands
OS NU218358 and NU237375

Thirty National Trust-owned islands lying 3–8km off the Northumberland coast.

☛ By boat from Seahouses, an attractive fishing village approximately 33km from Berwick-upon-Tweed. Boat trips run daily from the harbour, weather permitting.

Two islands are open to the public for landing: Inner Farne and Staple Island. Some boats will arrange a trip around other islands although landing is not permitted. Both islands are open 10.00–18.00hrs, April-end September, except 15 May–end July when Inner Farne is open 14.00–17.00hrs and Staple Island from 10.30–13.30hrs. Boat trip cost does not include landing fee. Many of the boat trips are only for a morning or an afternoon, but you may be able to make special arrangements with the boatmen to stay the whole day. Good accommodation available in Seahouses. Further information available from: The National Trust Information Centre, 16 Main Street, Seahouses ☎ (0665) 720424.

☛ **Inner Farne** Large colony of Arctic tern which breed amongst the vegetation on top of the island. Very approachable and easily photographed from footpaths with medium to long (200–300mm) telephoto lens. Usually a good number near landing point against attractive background of orange yellow lichen on the rocks. A hat is usually necessary to avoid injury from diving terns. Other birds include a few common tern, puffin, eider duck, kittiwake, shag, guillemot and fulmar on cliffs near lighthouse, oystercatcher, ringed plover, migrant turnstone, dunlin and purple sandpiper, and migrant passerines.

Staple Island Exceptionally good for photographs of kittiwake, guillemot, puffin and shag which are easily approachable. Large numbers of guillemot sit atop the pinnacles. Good wide angle shots in Kittiwake

Gully and from boat close by the pinnacles. Other birds include; eider duck on top of the island nesting among sea campion; migrant waders and passerines. Many birds will be found in the sea close to the islands.

📷 June, July

18. Firth of Tay
OS NO350295

This large estuary attracts important numbers of waders and wildfowl. There are several areas worth exploring, but access may be difficult in parts with some locations subject to disturbance from wildfowlers.

☞ From Perth, take the A85 to Dundee, then minor roads along both sides of the estuary.

🦆 Large numbers of redshank, dunlin, oystercatcher; and small numbers of bar-tailed godwit, ruff, curlew sandpiper and spotted redshank. They can be viewed from Kingoodie and Port Allen feeding on the mudflats on the north side of the estuary, at high tide. Thousands of geese also use this section as a roost, in particular, pink-footed geese on Dog Bank and Carthagena Bank. Greylag geese are found around Mugdrum Island which is off Newburgh. The Pink-footed geese fly off early in the day to feed on surrounding farmlands. The greylag geese do not travel so far and feed in the fields in the surrounding area. It is possible to obtain good shots of the geese in flight from several points along Newburgh–Balmerino Road on the south side of the estuary.

📷 November–March

19. Flatholm and Steepholm
OS ST225650 and ST230610

Flatholm (12ha) and Steepholm (19ha) are small islands in the Severn Estuary.

☞ Access by boat from Weston-super-Mare on Wednesday, Saturday and Bank Holiday Monday, April–October. It is possible to stay on Steepholm, which is owned and administered by The Kenneth Allsop Memorial Trust, for a weekend or a week in the Victorian Fort. Numbers limited to 25. Permits needed to land on either island. Details for Steepholm from: Kenneth Allsop Memorial Trust, Knock-na-cre, Milborne Port, Sherborne, Dorset, DTG 5JH ☎ (0963) 32583. Details for Flatholm from J. T. Eyles, South Glamorgan County Council, Terminal Buildings, Wood Street, Cardiff, South Glamorgan, CF1 1EQ ☎ (0222) 499022.

🦆 On Steepholm the 8000 pairs of nesting herring gull are the main attraction. There are also breeding cormorants, lesser black-backed and great black-backed gulls as well as shelduck and peregrine. Photography of the latter species at the nest is not possible owing to inaccessibility, and a *Schedule 1* permit is necessary. The autumn migration may be particularly rewarding for photography.

Flatholm has about 4000 pairs of breeding herring gull and about the same number of lesser black-backed gull. Shelduck may also be found breeding.

📷 May–late July

20. Grassholm
OS SM599093

Uninhabited 9-ha island – the largest gannetry in England and Wales. The reserve is owned by the RSPB.

☞ Access only possible during the best of weather owing to the swift currents and the tide races. There is no landing stage so very calm weather conditions are necessary to land from a rubber dinghy directly on to the slippery rocks. Further information: RSPB, Wales Office, Frolic Street, Newtown, Powys, SY16 1AP ☎ (0686) 26678.

🦆 The 20,000 or more breeding gannets are the main attraction. These are reached by a steep climb from the landing rocks up to the north-west slopes. Other breeding birds include small numbers of kittiwakes, razorbill, guillemot, shag, herring and great black-backed gull. Non-avian photographic subjects include the grey seals which may be seen on the rocks or in the sea.

📷 After mid-June (the only time at which landing may be possible)

21. Great Saltee
OS 294963

Great Saltee covers 86ha and lies 5.4km off the coast of County Wexford. It is one of two uninhabited islands (the other being Little Saltee) and constitutes the only large seabird colony in south-eastern Ireland. The islands are privately owned but day visitors are welcome. Those wishing to camp must obtain permission from the owner.

☞ Boat trips from Kilmore Quay arranged through the local fishermen; sailings, with parties of birdwatchers, almost daily during the breeding season. Enquiries: Irish Tourist Board, Information Office, Rosslare Harbour, Wexford ☎ (053) 33232

🦆 Twelve species of breeding seabird include gannets, Manx shearwater, fulmar, shag, lesser black-backed and great black-backed gulls. Large numbers of kittiwake and puffin, with over 5000 razorbills and

over 9000 guillemots. Approximately 7000 herring gull found on top of the island. During spring and autumn there are vast movements of migrants and vagrants. Large populations of cormorant on Little Saltee, although Great Saltee is more accessible as well as being generally more productive photographically.

📷 Late May, June and July for breeding seabirds

22. Handa

OS NC130480

RSPB-owned, 310-ha island off north-west coast of Scotland. Slopes from sandy bay on which the boat lands, across boggy heathland to sheer 120-m cliffs at the northern end. Resident warden in summer. Nature trail from visitors' centre to the cliffs and then back via the south coast.

☛ Access by boat from Tarbet, which lies on minor road off the A894. Local fishermen run boat trips, timing by personal arrangement except Sundays, April–end September, and bookings can also be made through Mrs A. Munro, Tarbet, Foindle by Larg, Sutherland, IV27 4SS. Accommodation in hotels and guest houses in Scourie on the mainland for day trippers: contact Wester Ross Tourist Organization, Tourist Office, Gairloch, Ross-shire, IV1 2DN ☎ (0445) 75605.

RSPB members can stay in the bothy on the island for extended periods, all food and drink must be taken: contact RSPB Scottish Office, 17 Regent Terrace, Edinburgh, EH7 5BN ☎ (031) 556 5624.

🐦 Many birds including gulls, terns, auks and sea duck may be seen on the short boat journey from the mainland. About thirty species nest on the island. Spectacular views from the cliffs of the Stack, on which many of the 25,000 pairs of guillemot, 9000 pairs of razorbill, 10,000 pairs of kittiwake, 3500 pairs of fulmar and 400 pairs of shag nest. Great for wide-angle shots, but a long lens is necessary for single species, and you may be better advised to search for more accessible nesting birds on the cliffs. The cliffs are also a good vantage point for flight photography as birds hang on the upcurrents. About 5000 pairs of puffin nest in burrows near the cliff-top. Several hundred pairs of herring gull nest across the top of the island and a smaller number of great black-backed gull may be seen. Of particular interest are the nesting great skuas which tend to attack intruders, and the more graceful Arctic skuas, which have bred in increasing numbers in recent years. Black guillemots, eider

duck, shelduck, common tern and common gull nest in small numbers. Rock doves may be photographed away from the nest. Along the shore are breeding oystercatchers, ringed plovers, and lapwings. Red-throated divers do nest on the island but photography at or near the nest requires a *Schedule* permit which is unlikely to be given. You may be able to get some flight shots outside the out-of-bounds breeding area. Migrating passerine birds can be found in the small copse near the bothy.

📷 May–late July running into autumn for migrant passerines

23. Hayle Estuary

OS SW550365

This estuary is one of the county's best locations for waders, attracting good numbers of birds to feed on the mudflats and sandflats at low tide. There is a public hide (erected by the RSPB) at the head of the estuary which gives a clear view of the main estuary channel. The best photographic sites will be found on local exploration of the area. A knowledge of tide times is necessary.

☛ The estuary runs alongside the A30 and lies west of Hayle. The hide is near the A30/A3074 junction to St Ives on the right-hand side as you turn north off the A30.

🐦 Waders to be found here include bar-tailed godwit, spotted redshank, green sandpiper, little stint, curlew sandpiper, golden plover, lapwing, dunlin, ringed plover, turnstone, knot, sanderling and redshank. At Carnsew Pool one may find red-breasted merganser, and tufted duck in winter and one or two Slavonian grebes are annual. Some of the waders using the main estuary also visit this area.

Winter attracts large flocks of gull including about 1500 herring gull, 1000 black-headed gull and about 500 great black-backed gulls. Common gulls and lesser black-backed gull also occur and uncommon single gulls are regular, including glaucous, Mediterranean and little gulls. Winter wildfowl include wigeon, teal, and shelduck with small numbers of goldeneye and goosander.

📷 Autumn and winter

24. Hilbre Islands

OS SJ190885

These three small islands in the Dee estuary are well known as one of the best sites in Britain for photographing large flocks of wading birds. Knowledge of local tide times is essential.

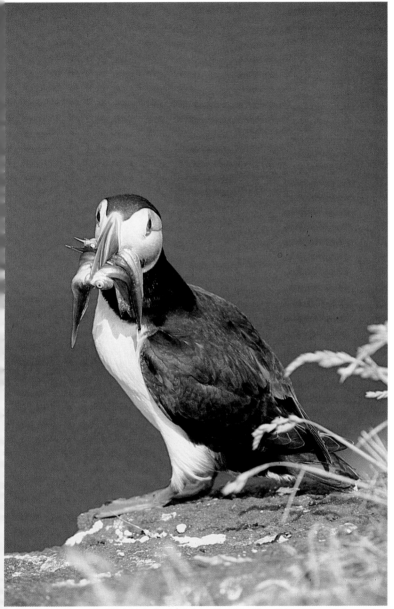

Puffin *(Fratercula arctica)*, Craigleath, Scotland; July; Nikon F3, Nikkor IF-ED 300mm f4.5, auto @ f5.6, Kodachrome 64; stalked with monopod.

☛ Reach West Kirby on the A540 from Chester. For best photographs, you need to leave Dee Lane, West Kirby about 3 hours before high tide and leave about 2½ hours after for the return journey. The crossing is on foot and you will have to carry your own equipment. A portable hide is essential.

The three islands are Main and Middle Hilbre and Little Eye. Permit required for the main island from: The Leisure Services Department, Wirral Borough Council, 8 Riversdale Road, West Kirby, Wirral, Merseyside ☎ (051) 6472366. No permit required for the other two islands which are probably the best places for wader photography. The Bird Observatory on the main island produces an annual report which is obtainable from: The Director, 17 Deva Road, West Kirby, Merseyside.

➤ As high tide approaches, the feeding birds are driven off the mudflats, forming large flocks which fly around until finally settling on the rocks in massive numbers, a sight which at first is bewildering. Placing the hide is really a matter of luck – and judgement. During the autumn neaps, the birds will be pushed up on to the top of the islands. Species include knot, dunlin (numbering up to 40,000 each), curlew, oystercatcher, sanderling, redshank, black-tailed and bar-tailed godwits and grey plover. Other, far less numerous species include little stint, curlew sandpiper, whimbrel, spotted redshank and greenshank. Large numbers of wildfowl also use the estuary during autumn and winter but photographic opportunities are limited.

📷 September–March

25. Isle of Islay
OS NR277673

The most southerly of the Hebridean islands with a picturesque landscape and a mild climate. Many parts are worth visiting, but there is an RSPB reserve specifically for wintering geese at Loch Gruinart in the north west of the island.

☛ Access by ferry daily from Kennecraig, West Loch Tarbert. Ferry bookings: Caledonian MacBrayne Ltd, The Ferry Terminal, Gourock, Scotland, PA1G 1QP ☎ (0475) 33755. Regular flights to the island from Glasgow airport. Accommodation details: Mid-Argyll, Kintyre and Islay Tourist Information Office, The Pier, Campbeltown, Argyll (0586) 52056.

The RSPB reserve is an area on Loch Gruinart covering 1214ha, approximately 5 × 3km. There are no formal visiting arrangements, but it is worth contacting: The Warden, Grainel Farm, Gruinart, Islay, Strathclyde, A44 7PW ☎ (049 685) 440 and visiting the newly-formed Islay Natural History Trust, Islay Field Centre, Port Charlotte, PA48 7UE ☎ (049 685) 288, for the latest information on the status of the bird on the island.

➤ A superb location for photographing the thousands of geese that winter on the island. By the end of October, 20,000-plus Barnacle geese and over 4000 white-fronted geese arrive on the island from their breeding grounds in Greenland, many of them at the RSPB reserve. You can get good shots of flocks of geese in flight and feeding from the road surrounding the reserve. Groups of geese are also seen outside the reserve. Resident birds include; chough, hooded crow, red and black grouse, stonechat, twite, curlew, redshank, oystercatcher, lapwing and ringed plover. Breeding waders include dunlin, snipe, and common sandpiper. Several of the beaches and small offshore islands hold breeding colonies of Arctic and common terns, but the little tern has almost disappeared. Other summer visitors include hen harrier and short-eared owl on the moorland, while the cliffs support good breeding numbers of fulmar and black guillemot. Another attraction in the winter is the 1000-plus scaup that are found in Loch Indaal, attracted by the barley residue deposited by the distilleries. Great northern divers are regular winter visitors.

📷 All year; October–end April for the geese

26. The Isles of Scilly
OS SW910120 and SD 468666

A group of approximately 150 islands situated 45km south-west of the Cornish coast. Only the five largest islands are inhabited and none is more than 5km wide. In recent years these islands have become very popular with birdwatchers, particularly during autumn migration, when many rarities are found. The islanders are used to invasions of large numbers of birdwatchers, most of whom are well-behaved; a friendly approach and smile will go a long way.

☛ British Airways scheduled helicopter service from Penzance, daily except Sundays. Islander aircraft run by Bryman Airways fly from Plymouth, Exeter and Newquay. Enquiries: Bryman Aviation, Roborough Airport, Plymouth, Devon. The *RMS Scillonian* sails from Penzance every day except Sunday; details from most travel agents. Travel between the islands by

arrangement with local boatmen. Some of these trips are on a regular basis and follow a set itinerary, but individual arrangements may be made with the boatmen.

There are no access restrictions on the inhabited islands, but much of the land is privately owned and visitors should always obtain the landowner's permission. Some of the uninhabited islands are off-limits during the seabird breeding season 15 April–20 July, when permits are needed, and may be difficult to obtain. Enquiries: The Warden's Office, Nature Conservancy, Hugh House, St Mary's, Isles of Scilly.

🐦 During spring and summer, some of the islands hold breeding populations which include puffin, guillemot, razorbill, kittiwake, fulmar, lesser black-backed and herring gulls, common and roseate terns. Storm petrel and Manx shearwater also breed as does a small population of shelduck. Other breeding birds include shag, cormorant, oystercatcher and ringed plover. Feeding waders on many of the beaches.

📷 July for breeding birds; September, October for migrants

27. Leighton Moss and Morecambe Bay
OS SD478752

Together, these two adjoining areas provide one of the most important wintering wader haunts in Britain. At low tide, Morecambe Bay's wide expanse of mudflats and sand are feeding grounds for tens of thousands of waders, wildfowl, gulls and terns. In contrast, the Leighton Moss reserve consists of 130ha of marsh, scrub, reedbeds and pools.

🐦 Leighton Moss reserve is reached by leaving the A6, 13km north of Lancaster passing through Yealand and Redmayne. Information centre and a visitors car park at Myers Farm. A causeway crosses the reserve with a public hide that's always open. Reserve hide permits from the information centre. Reserve open April–September (Wednesdays, Thursdays and weekends); October–March (Wednesdays and weekends). Further details: The Warden, Myers Farmhouse, Silverdale, Carnforth, LA5 0SW ☎ (0524) 701601.

Morecambe Bay is accessible at all times, allowing for tides. One of the better viewing points is Hest Bank at the southern end of the reserve. This is reached via the A5105, 6km north of Morecambe. After crossing the railway line, follow the track north along the edge of the saltings. The best time to be there is about 1½ hours before high tide. Explore the area to find the best spots for

photography. Further information is available at the Leighton Moss information centre.

🐦 The reserve's most famous inhabitants are probably its breeding bitterns and bearded tits which are increasing in numbers. Reed and sedge warblers, water rails and reed bunting are also found in the reedswamp. Black-headed gull, some duck, coot, moorhen, and lapwing breed on the reserve's islands. The reserve also boasts breeding garganey. Breeding waders include redshank, snipe and woodcock which are augmented by other species during the autumn migration. These include bar-tailed godwit, greenshank, spotted redshank, and ruff. During the winter large numbers of teal, and other duck are to be found on the reserve.

Morecambe Bay holds one of the largest wader roosts in Europe. In winter mainly knot, dunlin, curlew, redshank, and oystercatcher with smaller numbers of other species such as bar-tailed godwit, grey plover and ringed plover. Peak times are the spring and autumn passages when the largest roosts occur and also include sanderling and whimbrel. As well as shots of the roost there are good opportunities for flight shots of large flocks of waders for the photographer who is prepared to explore the area.

📷 All the year, spring and autumn migration

28. Marazion Marsh
OS SW524309

A small marsh with the largest reed bed in Cornwall – a large expanse of *phragmites* reed with small areas of open water and patches of low sedge and flag iris. Its position makes the marsh and the bay on the seaward side, one of Cornwall's most important bird sites.

🐦 Situated beside the A394 Helston–Penzance Road near the village of Marazion. Car parking facilities within easy reach of the marsh. The marsh can be viewed easily from the A30. Access is via a footpath opposite the small car park at the eastern end. A careful approach is necessary to avoid disturbing the birds.

🐦 Duck are the most common wintering birds with mallard, teal, shoveler, pochard, tufted duck, little grebe, coot and moorhen, and occasional gadwall and scaup, snipe and a few pairs of breeding Cetti's warbler. Other birds include grey heron, some of which nest in the reeds. Up to 20,000 starling roost in the reedbed in autumn and winter.

159

Marazion Marsh is best known for its migrant birds, especially vagrant waders during September and October. Many of these are extremely approachable and easily photographed. Regular arrivals include pectoral sandpiper, lesser yellowlegs and long-billed dowitcher.

Outside the marsh area, freshwater outlets which run into the sea are used by gulls and waders for bathing and preening. Approach these at low tide, using the rocks as cover for some good action photographs. While most of the subjects are of the three common gull species, little, Mediterranean, glaucous and Iceland gulls turn up regularly. Up to 100 sanderling may also be found here during winter and passage periods. Around Penzance and Newlyn during the winter look out for purple sandpiper on the shoreline.

📷 All year

29. Minsmere
OS TM473672
Rated by many birdwatchers as Britain's number-one reserve, this 607ha area of reedbeds, lagoons and coastal foreshore attracts a large variety of birds, about 100 breeding species each year, and a larger number of visiting birds. This superb record is the result of imaginative methods of marshland management utilized by the RSPB. However, its fame has brought many visitors and photographic opportunities have suffered as a result. The patient photographer may get results from one of the hides within the reserve proper.

☞ Visiting restricted to Sundays and Bank Holiday weekends. Admission by permit only; obtain in advance from: The Warden, Minsmere Reserve, Westleton, Saxmundum, Suffolk, IP17 2BY ☎ (072873) 281. (Limited number of permits at the site office daily.) Turn east off the A12 just north of Yoxford following signpost to Westleton. From Westleton take the road to Dunwich. After 3km, follow signposts to Minsmere. Public hide on beach overlooking the reserve always open, but photographic opportunities from here are rather limited.

☞ Much depends upon time of year and water level. The reserve's most famous occupants are the avocets which arrive to breed each year. The Nature Conservancy Council no longer issues permits to

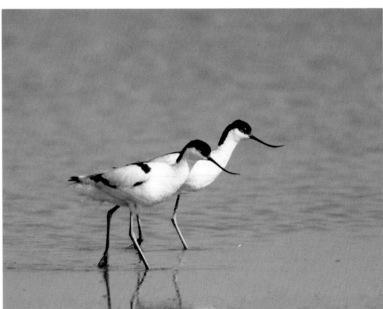

Avocet *(Recurvirostra avosetta)*, Norfolk, England; June; Nikon F3, Nikkor IF-ED 600mm f5.6 + Nikon TC300 2× teleconverter, 1/250 sec @ f11, Ektachrome 200; hide, beanbag.

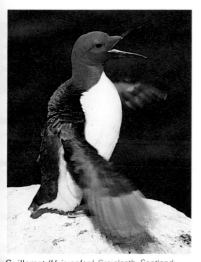

Guillemot *(Uria aalge)*, Craigleath, Scotland; July; Nikon F3 and motordrive, Nikkor IF-ED 300mm f4.5, auto @ f4.5, Kodachrome 64; stalked with monopod.

Cormorant *(Phalacrocorax carbo)*, Craigleath, Scotland; July; Nikon F3, Nikkor IF-ED 300mm f4.5, auto @ f4.5, Kodachrome 64; stalked with monopod.

photograph this species at the nest in Britain; Minsmere is one of the better places to photograph them away from the nest. Some individuals do feed within the range of a 500mm or 600mm lens from the hides. During the spring and autumn large numbers of waders fly in on passage offering the chance of shots of black and bar-tailed godwits, ruff, spotted redshank, little stint, dunlin, curlew sandpiper, various plovers, as well as the resident waders such as snipe and redshank. Other birds of note include bearded tit, marsh harrier, water rail and bittern, the last two species being very secretive. Try stalking tactics along the footpaths.

📷 Avocets May–July, otherwise all year

30. Orkney

A group of some sixty islands (twenty-two of which are inhabited). Low rolling hills with some of the most dramatic cliff scenery in Great Britain are home to more than a million seabirds during the summer months, i.e. about one-sixth of the total British seabird population.

☛ Via car ferry from Scrabster to Stromness, or by air to Kirkwall from Glasgow, Edinburgh, Aberdeen and Inverness. Hotel accommodation available on Mainland in Stromness and Kirkwall. Farmhouse accom-

modation and self-catering available on most islands. Further information on travel and accommodation: Orkney Tourist Board, 6 Broad Street, Kirkwall, Orkney, KW15 1DH ☎ (0856) 2856.

Marwick Head, Mainland (*OS* HY228243)
A 19-ha RSPB reserve on the north-western coast of Mainland Orkney about 24km from Kirkwall which includes a stretch of red sandstone cliffs rising to about 85m. There is some wet meadowland and the northern portion of a rocky bay.

☛ No permit required; no warden. Good but narrow roads from Kirkwall to Marwick Bay and then up a path to the cliff edge. Close views of the breeding colonies from about halfway up the path. The nearest accommodation is in Kirkwall or Stromness. Further information: RSPB, Orkney Office, Smyril, Stenness, Stromness, Orkney, KW16 3JX (enclose SAE) ☎ (0865) 850176.

☛ Seabirds on the reserve include about 35,000 guillemot, 10,000 kittiwake, 700 razorbill, 1000 fulmar, and puffin. Other birds include jackdaw, a few raven and rock dove. The upland areas hold twite and wheatear whilst the wet meadows provide a breeding ground for redshank, curlew, snipe, lapwing and oystercatcher.

📷 May, June and early July

ISLAND, COAST, AND ESTUARY

North Hill, Papa Westray (OS HY496538)
RSPB reserve at the northern end of Papa
Westray, one of the northerly Orkney Isles.
The habitat is mainly maritime heathland
with small cliffs and it is well worth exploring
outside the reserve.

☛ Travel to the island involves a two-
minute journey by air or half an hour on the
ferry from Westray. Access is best mid-May–
July. Travel and accommodation details:
Orkney Tourist Board.

ↄ North Hill reserve is the largest Arctic tern
colony in Britain – over 6000 breeding pairs.
Other breeding birds include about ninety
pairs of Arctic skua; lapwing, oystercatcher,
ringed plover, snipe, curlew, and redshank,
and a few eider duck around the coast. Black
guillemot easily found amongst the stones
above some of the beaches. At the south-
eastern corner of the reserve are cliffs known
as Fowl Craig, an easily viewed seabird col-
ony with guillemot, razorbill, kittiwake, shag
and fulmar. Papa Westray is one of the last
strongholds of the corncrake.

📷 Mid May–July

Noup Cliffs, Westray (OS HY392500) RSPB
reserve with 2½km of cliff top and a narrow
strip of land on the north-west coast of
Westray; a seabird colony in a breathtaking
setting.

☛ Flights (Loganair) from Kirkwall airport.
The cliffs are a short drive or pleasant walk
from the airport. Cars can be hired in
advance. No permit required; access at all
times. Details from: Orkney Tourist Board.

ↄ The vast seabird colony includes about
40,000 guillemot, 25,000 kittiwake, over 1000
razorbill, 1000 fulmar as well as smaller
numbers of puffin and shag, black guillemot
and herring gull. The best viewpoint is at
Kelda Ber. The narrow strip of cliff top south-
ward provides a breeding area for skylark,
meadow pipit, rock pipit and wheatear.

📷 May, June and early July

31. Outer Hebrides

North and South Uist; Benbecula There
are many areas in the southern parts of the
Outer Hebrides which can produce some
exciting photography. A car is essential to
travel around each of the islands and suit-
able sites will soon become evident. Benbe-
cula, between North and South Uist is par-
ticularly worth careful exploration.

☛ The islands are reached by car ferry from
Uig on the Isle of Skye to Lochmaddy, North
Uist. Enquiries to: Caledonian McBrayne

Ltd, The Ferry Terminal, Gourock, PA19 1QP
☎ (0475) 33755. Regular British Airways and
Loganair flights from Glasgow to Benbecula
Enquiries to: British Airways ☎ (041) 887
1111, Loganair (041) 889 3181.
Accommodation: Outer Hebrides Tourist
Board, Tourist Information Centre, 4 South
Beach Street, Stornoway, Isle of Lewis, PA87
2XY ☎ (0851) 3088.

Balranald, North Uist (OS NF707707) This
658-ha reserve owned and managed by the
RSPB, is based on the shallow loch Nam
Feithean and the surrounding marshland
coastal machair and sandy beach.

☛ Access daily April–September. Contact
the summer warden at reception cottage
Goular, near Hourharry, Lochmaddy, North
Uist. Turn off the main road 5km north-west
of Bayhead at the signpost to Houghharry.

ↄ The invertebrate fauna and vegetation
cover of this reserve make it an important
breeding area for ducks and waders. Gad-
wall, wigeon, shoveler, tufted duck, snipe
and redshank, curlew, oystercatcher, lap-
wing, are regular breeding species; red-
breasted merganser breed occasionally.

The crofting land surrounding the marsh-
land maintains an important population of
corncrake. Use the call playback technique,
or rub a comb made from bone. Arctic and
little terns breed on the beaches and sand
dunes. A total of fifty species breed in the
reserve area.

📷 April–September

Loch Druidibeg, South Uist (OS NF782378)
A 1677ha reserve managed by the Nature
Conservancy Council, of lochs, moorland,
croftland, machair and seashore. The
reserve is divided into two parts by a road.
To the east lies the shallow loch dotted with
small islands, with peat moorlands. To the
west is an inhabited area with two crofting
townships, some lochs, marshes and an
area of sand-dunes and machair.

☛ Contact the warden at Stilligarry before
entry. Permit required during the breeding
season; no restriction at other times. Con-
tact: The Warden, Kinloch, Grogary, South
Uist ☎ (08705) 252.

ↄ The loch supports the largest British
colony of greylag geese. Other breeding
species include buzzard, red-breasted mer-
ganser, mute swan, grey heron, red grouse,
common gull and wren. The western section
holds a greater variety of bird life with breed-
ing snipe, redshank, dunlin and lapwing;
others include corncrake, corn bunting and

wite. Arctic tern and ringed plover nest in the sand and shoveler, mallard and teal nest in the wetland areas.

📷 May–July

32. Pagham Harbour

OS SZ857965

A small reserve of about 243ha; one of the outstanding areas in southern England for variety of birds. Managed by the West Sussex County Council, it consists of an area of tidal saltmarsh and surrounds. It is well worth visiting Sidlesham Ferry – a pool surrounded by rough grazing and boggy land, by the Church Norton turning. It is good for small passerines and waders, but go in the morning or the sun will be shining directly into the camera.

☛ Virtually all of Pagham harbour shore is accessible from Sidlesham, Church Norton and Pagham. For the first two points take the B2145 Chichester–Selsey road. Shortly after the Nature Centre at Sidlesham Ferry, turn left to Church Norton. Access to the southern side of the harbour mouth from car park by the church. For Pagham, turn on to the B2166 from the B2145 then right and right again, in the town for the harbour.

🔭 Most birds need to be stalked in this area as there is no access for a car and no ideal positions for hide photography. A long 500–600m lens with monopod or tripod is necessary. Most birds are present in fairly small numbers owing to the size of the area. Wildfowl include Brent geese, shelduck, mallard, teal and pintail. Waders include, oystercatcher, ringed plover, grey plover, turnstone, redshank, greenshank, blacktailed godwit. Dunlin occur in good numbers here. In winter, diving duck including smew, and the rarer Slavonian grebe are found on Pagham Lagoon.

From Church Norton car park there are good opportunities for photographing common birds from the car, including blackbird, song thrush, robin, blue tit, great tit, dunnock, chaffinch and house sparrow which will all come to bait. The hedges and scrubby vegetation around the harbour offer opportunities for stalking linnet and goldfinch.

📷 August–March

33. Radipole Lake

OS SY676796

An RSPB reserve in the centre of Weymouth with reed beds, open water and rough grazing ground, and water meadows.

☛ Approach directly from the town centre. Public footpaths run around some of the

reed marsh. There is an information centre on the reserve. Further details: The Warden, 52 Goldcroft Avenue, Weymouth, DT4 OES ☎ (03057) 773519.

🔭 In winter the lake has many pochard, tufted duck, and teal, shoveler and mallard, and smaller numbers of scaup, goldeneye and gadwall as well as occasional pintail. During winter evenings hundreds of pied wagtail and thousands of starling roost in the reeds. During spring and summer reed and sedge warblers and reed bunting are present; bearded tits also breed in small numbers. Cetti's warbler is also now a well-established breeding species together with chiffchaff, willow warbler, common and lesser whitethroats. During late summer and autumn, migrating, sedge warblers arrive in large numbers and up to 3000 yellow wagtail roost in the reed beds along with tens of thousands of hirundine and starling. Around the edge of the lake are a few, but varied waders, including redshank, greenshank, common, green and wood sandpipers, dunlin and plover.

📷 All year

34. Rathlin Island

OS D120530

Situated about 4km off Fair Head on the north coast of County Antrim. It is approximately 10.5km long and is made up of spectacular basalt cliffs, screes and grassy slopes, lake and marsh covering a total of 50ha. The RSPB has established a reserve along part of the extensive cliff edge.

☛ Access at all times. Crossings from Ballycastle by arrangement with local boatmen:— Neil McFaul ☎ Rathlin 71207 and Dominic McCurdy ☎ Rathlin 71217.

The reserve area is wardened April–August. Details from: The Summer Warden, Kebble, Rathlin Island, Ballycastle, Co. Antrim, BT54 6RT ☎ (02657) 71226.

🔭 The major attraction is the large seabird colony found on the cliffs. You can get there from the reserve but a boat trip around the base of the cliffs is well worthwhile. Seabirds include up to 10,000 kittiwake, 10,000 guillemot, up to 1000 puffin and smaller numbers of fulmar, shag and black guillemot. Up to 10,000 Manx shearwater nest in burrows on the island. A torch for focusing and a flash unit is necessary to photograph these as they are usually only seen on land at night. On top of the island there are between up to 10,000 herring gull and far smaller numbers of lesser, great black-backed and common gulls, and about 100 pairs of breeding black-

headed gull. Eider duck nest on the grassy slopes of Rue Point. Rock pipit, raven and buzzards breed on the cliffs and, whilst nest photography is out of the question, stalking may result in some interesting shots.

📷 May, June, July

35. Ribble Estuary
OS SD374208

The extensive sandflats are popular with wildfowl and waders, and there are many good viewing and photographing points. Generally an area well worth exploring. A knowledge of tide times is useful.

☛ Using Southport, Preston or Lytham St. Anne's as a base, the whole area is well served by small, interconnecting roads and there is a Nature Conservancy Council reserve off Marine Drive, Southport; permits are only given for selected areas. Enquiries to: The Warden, Old Hollow Farm, Banks, Southport, Merseyside ☎ (0704) 25624.

🦢 10–20,000 pink-footed geese roost on the Southport Sands near the mouth of the estuary. During the day they fly off to feed in the surrounding farmland. Explore the field areas, using the car as a hide, for flocks of geese which are very approachable. Waders feed on the estuarine mudflats – including over 25,000 dunlin and 50,000 knot, plus oystercatcher, ringed plover, golden plover, grey plover, lapwing, turnstone, sanderling, black-tailed and bar-tailed godwits, redshank and curlew.

Good views from the coast road overlooking Crossons Marsh.

📷 November, December for geese; autumn–winter for waders

36. Shetland Islands

A chain of some 100 islands about 160km off the north coast of Scotland – ideal for birdwatchers. Details of two of the major seabird reserves are given here, but exploration of the whole area is recommended. Access has improved considerably with the coming of the oil industry. The islands still offer many unspoilt areas of tremendous beauty.

☛ The principal airport is at Sumburgh on the southern tip of the mainland; regular services from Glasgow, Edinburgh, Aberdeen and Inverness. Improved roads make travel relatively easy around the islands; a car is essential and can be hired on the mainland. Regular ferry services and Loganair flights between the islands. Further details: The Shetland Tourist Organization, Lerwick, Shetland, ZE1 0LU ☎ (0595) 3434.

Fair Isle (*OS* HZ217720) This 830-ha, cliff-bordered island is about 48km south of Shetland mainland and about 113km north of Orkney. It is a famed migration watch point and its bird observatory is well-known throughout the world. The red sandstone cliffs which border most of the shore rise about 200m at the highest point.

☛ Access by boat from Grutness, Shetland, twice weekly May–September and once a week October–April. Loganair schedule flights from Tingwall Airport, Shetland. The observatory open March–October. Further details: Shetland Tourist Organization.

Good accommodation available on the island in the observatory itself or in other locations on the island; further information: The Warden, Fair Isle Bird Observatory, Fair Isle, Shetland ☎ (03512) 258, or The Secretary, FIBO. Trust, 21 Regent Terrace, Edinburgh, EH7 5BT ☎ (031) 556 6042.

🦢 In summer, breeding seabirds include about 20,000 pairs of guillemot, 25,000 pairs of fulmar, 12,000 pairs of kittiwake and 1000 pairs of razorbill on the cliff ledges; up to 30,000 puffins and 100 pairs of storm petrel nest in burrows along the cliffs and gullies. The gannet colony stands at about 100 pairs. On the hills are about 120 pairs of Arctic skua and forty pairs of great skua providing good photographic opportunities. Other breeding birds include wren and twite (Fair Isle subspecies). Fair Isle is best known for its migrating birds and you stand a good chance of seeing and photographing a good range of species.

📷 May–July for breeding birds; August–October for migrants

Fetlar (*OS* HU603917) Smallest of the three inhabited northern Shetlands. The RSPB reserve covers 688ha – about one sixth of the island. Major habitat is serpentine moorland and many wet marshes; also cliffs, freshwater lochs, pools and beaches.

☛ Island accessible April–August; Reserve closed in breeding season, restricted access mid-May–end July. Contact RSPB warden at Bealance ☎ (095 783) 246. Car ferry runs three or four times daily from Gutcher on Yell, to Oddsta on north coast of Fetlar. Book early ☎ (095 782) 259. Loganair service Monday–Friday ☎ (059 584) 246. Accommodation in two guest houses near Harbie, plus some self-catering.

🦢 Fetlar is famous for snowy owls which bred 1967–1975; no breeding since then but they may still be seen. The reserve holds other breeding populations of national

Fulmar *(Fulmarus glacialis)*, Shetland Isles, Scotland; June; Canon AE1, Canon 300mm f5.6, 1/125 sec @ f.11, Kodachrome 64; stalked with shoulderpod.

importance including golden plover, curlew and whimbrel, but these may all be seen outside when access is restricted. Breeding snipe and redshank on the marshy areas; also breeding lapwing, oystercatcher and ringed plover. Excellent views possible of breeding red-necked phalarope at Loch Funzie, a feeding place outside the breeding area. More than twenty colonies of Arctic tern. The Lambhoga moorland, which is also outside the reserve, holds major breeding populations of Arctic skua and great skua. Fetlar also has a small breeding population of seabirds with 2500 pairs of puffin, 300 shag, black guillemot, fulmars, Manx shearwater, kittiwake, razorbill, great black-backed, lesser black-backed, and herring gull. Common tern also breed and most lochs hold a pair of red-throated diver. Other birds to be seen include raven, hooded crow, rock pipit, and Shetland wren and twite. Many of these birds are on the *Schedule 1* list (see page 128) and photographers need a permit to photograph at or near the nest.

A portable hide, necessary permits and the usual safari selection of photographic gear should provide some exciting photography.

📷 May, June, late July

Hermaness, Unst (*OS* HP600185) The most northerly headland in Britain with scenery that has been described as some of the finest in the country. The reserve is approximately 5km × 2km and includes spectacular seabird cliffs rising to 183m.

☛ Car ferry from Gutcher on the island of Yell to Belmont at the southern end of Unst, followed by a forty-minute car drive to the reserve. Advance bookings necessary especially at peak holiday season ☎ (095 782) 259. Regular Loganair flights to Unst ☎ (059 584) 246. Full-board hotel, bed and breakfast, and youth hostel accommodation available ☎ (095 785) 237.

✔ The clifftops are honeycombed with puffin burrows. On the cliffs themselves are large numbers of seabirds including guillemot, razorbill, kittiwake, fulmar and black guillemot. Gannets breed on some of the offshore stacks and on the western cliffs of the nature reserve, and are worth seeing from a boat.

On the moorland part of the reserve are breeding great and Arctic skuas which display aggressive behaviour towards intruders by dive-bombing; you should wear a hat to avoid injury. Other birds include breeding waders such as whimbrel, oystercatcher,

lapwing, ringed plover, golden plover, snipe, dunlin and redshank. With luck you may also see a snowy owl.

📷 Late May, June

Noss National Nature Reserve

(*OS* HU550400) A diminutive 283-ha island off the east coast of Bressay, which is situated close by Lerwick harbour. The Noup of Noss rises to some 183m and is an ideal place for watching the thousands of seabirds which nest on the sandstone cliffs.

🛥 Car ferry from Lerwick to Bressay, and a short boat ride to Noss, weather permitting; enquiries: Shetland Tourist Organization (see page 164). Boat trips around the island available from Lerwick. Those landing on Noss should contact the summer warden at Gungstie House. No accommodation, but camping may be possible.

🕊 Superb views of seabirds. Up to 5500 gannets breed along with guillemot, razorbill, puffin, black guillemot and kittiwake, and eider duck. On the high moorland there are breeding great and Arctic skuas. Fulmar nest against a photogenic background of cliff-top flowers including sea pink, spring quill and red campion.

📷 Mid May–June

37. The Skelligs

OS IWC V2762

Great Skellig and Little Skellig are jagged rocks jutting up from the Atlantic Ocean, 13km and 11km respectively from Bolus Head in County Kerry. They are privately-owned.

🛥 Boats sail daily during the summer, weather permitting, from Portmagee or Knightstown which are reached off the T66 road west of Cahersiveen, Co. Kerry. Enquiries: Irish Tourist Board, Information Office, Town Hall, Killarney, Co. Kerry ☎ (064) 31633. No landing place on Little Skellig and there's a constant swell in the surrounding sea. The Great Skellig boats do however pass close to the island and good viewing and photography is possible in good weather conditions.

It is possible to stay overnight on Great Skellig; permission necessary in advance from: Commissioners of Irish Lights, 16 Lower Pembroke Street, Box 73, Dublin 2 ☎ Dublin 682511.

🕊 Little Skellig holds a large population of approximately 20,000 gannets. On Great Skellig at least ten species of seabird breed. The main photographic attraction are the 6000 puffin and 5000 Manx shearwater.

Approximately 10,000 storm petrel are thought to breed here but these present a particularly difficult photographic challenge because of their nocturnal habits and their relative inaccessibility. Smaller numbers of kittiwake, guillemot, razorbill and herring gull are also found.

📷 Late May, June, July

38. Skokholm Island

OS SM738037

Skokholm is over 1½km long by ¾km wide and lies over 3km south of Skomer Island. The exposed west coast forms many rocky points, steep bays, and sheer cliffs, inhabited by thousands of seabirds. The east coast is relatively sheltered and in a narrow cliff in the rocks on the south side is the tiny harbour of South Haven.

🛥 Boat service from Dale to Martin's Haven near Marloes (on the B4327 from Haverfordwest). Round-island boat trips are available but the best photographic opportunities are on the island. Basic but comfortable accommodation in a converted 18th-century farmhouse reached via a steep track from South Haven harbour, contact: West Wales Naturalists' Trust, 7 Market Street, Haverfordwest, Dyfed, SA6 1NF ☎ (0437) 5462. Natural History and photographic courses are run at regular intervals. Minimum stay is usually one week. Landing and leaving depend very much upon weather and sea conditions which can at times be treacherous, especially in the Broad Sound.

🕊 Thirty-six breeding species, the main attraction being the seabirds. The cliff tops are honeycombed with puffin and Manx shearwater burrows, the former being particularly photogenic especially when the pink thrift is in flower, or against the lichen covered rocks. Manx shearwater may be photographed at night with the aid of a torch for focusing and a flash unit. The jagged coastline to the west provides nesting sites for guillemot and razorbill and fulmar are found nesting on the ledges around the island. Storm petrel nest in the dry stone walls on top of the island and amongst the rocky scree on the cliffs. Photography of this species, however, is difficult. In the marshy area around the south pond is a large colony of rather aggressive lesser black-backed gull. Other breeding birds include herring gull, lapwing, oystercatcher, jackdaw, carrion crow, and stock dove, all of which may be photographed with patience. Migration can be spectacular in spring and autumn, with both quality and quantity.

📷 May, which is early in the breeding season and coincides with the best shows of flowering plants for interesting backdrops.

39. Skomer Island
OS SM725095

Skomer is a 292-ha island off the southern end of St Brides Bay owned by the West Wales Naturalists' Trust.

☛ Daily boat service from Martin's Haven car park near Marloes (on the B4327 from Haverfordwest), leaving 10.30–12.30 hrs and returning 15.30–16.30 hrs. The trip takes approximately 20 minutes; a landing fee is charged. Basic accommodation available on the island for members of The West Wales Naturalists' Trust; book in advance, contact: The Warden, Skomer Island NNR, West Wales Naturalists' Trust, 7 Market Street, Haverfordwest, Dyfed, SA6 1NF ☎ (0437) 5462.

On landing there is a steep climb to the start of a 6km nature trail. Visitors are asked to stay on the path because of possible damage to the burrows of puffins and Manx shearwaters.

🗡 Thirty-seven species of birds breed on Skomer, the main attraction being the puffin. Good views of guillemot and razorbill across a narrow inlet called The Wick. Rather fewer kittiwake nest on ledges lower down the cliff. On top of the island are numerous lesser black-backed and herring gulls, with small numbers of great black-backed gull. You should also see buzzard, short-eared owl and raven, although photography is largely a matter of luck and perseverance. Chough no longer breed here but may be seen. The most numerous breeding species is the Manx shearwater but as these are usually only seen on land at night it is necessary to stay on the island, and a torch for focusing and a flash unit are essential. The other nocturnal species, storm petrel, is difficult to photograph at night without elaborate preparation. Wheatear and stonechat are also possible photographic subjects with a long lens and a monopod. Pink thrift and white campion provide beautiful backdrops for some species. Migrating birds may also turn up according to conditions. Other species that can be photographed are fulmar and shag.
📷 May – early in the breeding season when the birds and flowers are at their best.

40. South Stack Cliffs, Anglesey
OS SH205823
This 316-ha RSPB reserve includes areas of maritime heath, ranging from mountainous rocky heathland to lower damper areas, the cliffs rising to 119m. The reserve is particularly renowned for its numbers of seabirds – with excellent opportunities for viewing them. The information centre has windows overlooking the main auk colony.
☛ Signposted from Holyhead harbour at the end of the A5. There is a car park near the RSPB reserve sign on the road leading to the headland. Access at all times along public paths. The information centre is open daily April–September. A summer warden is usually present. Contact: The Warden, Plas Nico, South Stack, Holyhead, Anglesey.
🗡 From Ellen's Tower (RSPB Information Centre) are superb views of the 1500 guillemots, several hundred razorbills and puffins. An expanding kittiwake colony is on Penlas Rock, south of the lighthouse and Ellen's Tower. Other seabirds seen well, include fulmar and shag. Choughs nest in inaccessible caves in the area but may often be seen on the cliff-top around Ellen's Tower; a few pairs of raven also nest; linnet and stonechat breed in the gorse. In the southern area of heathland, Penrhos Feilw Common, are breeding lapwing and redshank and you may be lucky enough to see hunting hen harrier, merlin and short-eared owl at times of passage.
📷 Late May, June, early July

41. The Wash
This vast tidal estuary is second only to Morecambe Bay in its importance for waders and also supports large numbers of wintering wildfowl. Along much of its coast, the Wash is fringed with saltmarsh. It is such a large area that the best opportunities for photography and viewing are at high tide. The whole area is worth exploring for possible photographic sites. We have selected some of the more accessible spots. Many areas around the Wash are more difficult to get at, partly because of changes due to reclamation which make even the most recent maps out of date quickly, and partly because of the type of terrain.

Snettisham (*OS* TF648333) A 1300-ha RSPB reserve; a large area of intertidal mud and sandflats, plus shingle, saltmarsh and gravel pits.
☛ Snettisham is on the A149 Hunstanton–Kings Lynn Road; follow lane to holiday bungalow estate on the beach, where parking is available. Walk south along the beach passing the chain of gravel pits. The

southern-most pit has hides. Further details: The Warden, 18 Cockle Road, Snettisham, Kings Lynn, Norfolk, PE31 6HD ☎ (0485) 40129.

🐦 In winter, high-tide roosts of up to 15,000 waders occur on the islands and the banks of the pits, and up to 70,000 on the coastal mudflats. These include up to 35,000 knot, 12,000 oystercatcher, 10,000 dunlin, 4000 bar-tailed godwit, 3500 redshank, 1000 grey plover, 1500 curlew, 1000 turnstone, 800 sanderling and 250 ringed plover, 5000 pink-footed geese, 2000 shelduck, 1000 mallard and 1000 Brent geese, according to RSPB figures. As the position of the roosts varies, some initial scouting, awareness of tide times and tidal channels is necessary. Barring wader roosts there are good opportunities for group flight shots.

📷 In summer, breeding birds on the shingle banks, in the marginal vegetation and on the islands in the pits include redshank, oystercatcher, ringed plover, reed bunting, common tern, skylarks and meadow pipit.

Gibraltar Point (*OS* TF556581) Gibraltar Point Field Station and Bird Observatory are set in an area of coastal dune and marsh covering 428ha.

🐦 Approach from Skegness sea-front southwards past the golf course. There is a visitor centre, nature trail, and a Field Centre with comfortable accommodation; bird photographers are welcome. Details from: The Warden, Gibraltar Point Field Station, Skegness, Lincolnshire ☎ (0754) 2677.

🐦 Breeding birds include an important colony of little tern which nest on the sand and shingle area known as the spit. Ringed plover also nest here. Short-eared owl and shelduck nest in the dunes. Smaller birds such as yellowhammer, sedge warbler, whitethroat, skylark and meadow pipit, also breed in the reserve. The scrub shelters migrating passerines such as redstart, pied and spotted flycatcher, and the reserve attracts many other birds on migration. During winter large numbers of waders which feed on the Wash are to be found – dunlin, knot, curlew, oystercatcher, grey plover, sanderling, ringed plover and redshank. Wintering wildfowl include pink-footed and brent geese, mallard, wigeon and teal.

📷 May–September for breeding birds; September–March for wintering species

Titchwell Marsh (*OS* TF749436) RSPB reserve of 206ha, salt and freshwater marshes, foreshore and reedbeds. Positive

RSPB management has increased species diversity considerably in recent years.

🐦 Access at all times from the car park to the seawall and new hides overlooking the marshes. Reserve entrance about half way between Thornham and Titchwell on the A149. Visitors' Centre open April–October at weekends; May–August, Monday and Thursday. Hides closed Wednesday. Further information: The Warden, Three Horseshoes Cottage, Titchwell, Kings Lynn, PE31 8BB ☎ (0485) 210432.

🐦 New breeding species include bittern, marsh harrier, avocet and bearded tit. Other species include dunlin, ringed plover, redshank and ruff, the less common curlew sandpiper, little stint, bar-tailed and black-tailed godwit, and rarities such as Baird's and white-rumped sandpipers. Non-breeding spoonbills, black tern and little gull are often present, and in winter there are lots of waders and ducks, and harriers roost in the reedbeds. Hides with views over the marsh are good for photographing waders on spring and autumn passage.

There's a special hide for nest-viewing a thriving colony of little tern on the beach, but whether it's close enough for photography varies from year to year. A walk along

Razorbill *(Alca torda)*, Craigleath, Scotland; July; Nikon F3 and motordrive, Nikkor IF-ED 300mm f4.5, auto @ f4.5, Kodachrome 64; stalked with monopod.

Eider *(Somateria mollissima)*, Isle of Islay, Scotland; October, Nikon F3, Nikkor IF-ED 600mm f5.6, 1/250 sec @ f5.6, Kodachrome 64; car bracket.

the beach may provide good opportunities to photograph flocks of waders in flight when the tide is right.

📷 August–October; mid-March and mid-September (equinoctial tides) for huge flocks of waders forming high-tide roosts on the foreshore

42. Wells-Next-The-Sea
OS TF925442
The tidal inlet at Wells harbour is one of many good wildfowl locations in North Norfolk. It's a popular spot and the birds are relatively tame.
☞ Take the road signposted 'Seafront' off the A149 in the town centre. Parking facilities available.
☞ The speciality is approachable dark-bellied Brent geese which feed at low tide. The town centre car park gives a good angle from which to photograph the flocks. Looking from above allows you to make the best use of the depth of field available and you should get the entire group in focus. Most of the common waders occur here including turnstone, dunlin, ringed plover, redshank, curlew, grey plover and knot; turnstones can be baited, using dead fish. Red-breasted merganser and goldeneye are usually

present. Gulls are regularly present in the harbour.

Further along the coast at Holkham Gap opposite Holkham Hall, on the A149 Hunstanton–Wells road, a regular flock of about 200 white-fronted geese are found in the field beside Lady Anne's Drive, December–March, together with smaller numbers of pink-footed, Brent and occasionally bean geese in the general area.
📷 November–March for geese

DENMARK See also 176.

43. Blåvandshuk, Skallingen and Filsø
A coastal area of sandy beaches, tidal mudflats, heathland, coniferous woodland and lakes in south-west Jutland, south of Tipperne and close to the coastal town of Esbjerg.
☞ For Blåvandshuk drive north from Esbjerg to Varde and then west to Oksbøl. Take the road through Oksby to the coast at Blåvand village. Skallingen Nature Reserve is reached from Ho Bugt, east of Blåvand village. For Filsø Lake take the road from Esbjerg north to Varde and then the road to Oksbøl. A few kilometres outside of Varde,

bear right towards Henne Strand. The lake is about 4km before Henne Strand.

☛ The promontory at Blåvands Huk is an excellent migration point with good numbers of common scoter, shelduck, wigeon, redshank, oystercatcher, and dunlin passing through in autumn. Large numbers of thrushes, finches and pipits also pass through. Skallingen is a good area for passage waders and wildfowl. Species to be expected and often in good numbers include pink-footed geese, eider duck, curlew, bartailed godwit, greenshank, spotted redshank, redshank, dunlin, curlew sandpiper, ruff and avocet. There are a number of good spots for waders around the inlet of Ho Bugt on the landward side of Skallingen. Filsø Lake is mainly known for the large numbers of pink-footed geese which stop here during spring and autumn. Other birds of note here include bean geese, whooper swan and Bewick's swan. Try using the car as a hide as you explore the minor roads.

🦉 Autumn and winter

44. Christiansø

The largest of a group of islands off the east coast of Denmark, which attract some migrating species not usually seen elsewhere in the country. The island has a small population and is less than 1km wide. The nearby island of Graesholm holds a seabird colony.

☛ Daily, all-year boat service from Svaneke on Bornholm; and from other ports May–October. Hotel on Christiansø, open May–October; other accommodation, and campsites on Bornholm. Day trips are quite feasible.

☛ Christiansø is best known for its rare migrants rather than for quantities of birds. Spring migrants include long-tailed duck, bluethroat, thrush nightingale, robin, redbreasted flycatcher, blue-headed wagtail, red-backed shrike, ortolan bunting and icterine warbler. Autumn migrants may include scaup, goldeneye, long-tailed duck, velvet and common scoter, eider duck, hen harrier, thrushes, bluethroat, robin, marsh warbler, icterine warbler, red-breasted flycatcher, great grey and red-backed shrike, chaffinch, brambling, ortolan and snow buntings. During the summer, breeding eider duck, lesser black-backed gull, herring gull, razorbill and guillemot on Graesholm.

🦉 April–October

45. Gilbjerghoved

A particularly good spot for photographing

the numerous spring migrants passing through. As well as the built-up area of the town of Gilleleje, there are woodlands, grassland, agricultural land, scrub, beach and low cliffs. This area is popular with Danish birdwatchers, particularly during spring, and with tourists during the summer. If the migration is thin there are a number of other interesting sites which can easily be reached by car.

☛ From Copenhagen, take the A5 road to Hillerød and then the A6 for a short distance before turning north to Gilleleje. Hotels, hostels, chalets and campsites in and around the town.

☛ On the coast a few kilometres south of the Nivå on the east coast of Sealand is a good spot to see migrating buzzard, rough-legged buzzard, osprey, sparrowhawk, crane, pipits and finches when there's a south-west wind in spring. Gribskov, Denmark's largest wooded area, just north of Hillerød on the way to Gilbjerghoved, holds breeding black woodpecker.

For a good passage the wind should be from the south east. Many of the migrant birds are tired and easily approached but should not be harassed. Expected species are eider duck, buzzard, rough-legged buzzard, honey buzzard, sparrowhawk, herring gull, wood pigeon, swift, swallow, hooded crow, jackdaw, fieldfare, ring ouzel, robin, chiffchaff, willow warbler, meadow pipit, tree pipit, grey-headed wagtail, blue-headed wagtail, starling, siskin, chaffinch, brambling, spotted flycatcher, wood warbler and red-backed shrike.

🦉 April and May

46. Rømø Nature Park and Rømø Dam

Rømø Island is part of a chain of small islands which stretches along the west coast of Jutland into Germany, and is basically a huge sand bank. In the west there are extensive sand dunes and wide beaches, in the centre is heathland with ponds and surrounding reedbeds. On the eastern side are coastal meadows and tidal flats. A causeway joins the island to the mainland town of Skaerbaek.

☛ Approach from Skaerbaek on the mainland via a causeway which has a number of parking places. Further information: Rømø–Skaerbaek Turistkontor, Havnebyvej 30, Trismark, 6791 Kongsmark.

☛ Breeding birds include black-tailed godwit, ruff, avocet, spotted crake, marsh harrier and Montagu's harrier. The major photographic attraction is the large number of

waders and wildfowl which congregate on the tidal flats between the island and the mainland. Species expected include velvet scoter, teal, wigeon, pintail, shoveler, oystercatcher, golden plover, grey plover, curlew, whimbrel, redshank, greenshank, black-tailed and bar-tailed godwit, avocet, dunlin, curlew sandpiper, and purple sandpiper. The best site is actually on the causeway, using the car as a hide, at high tide when the birds are forced close to land.

📷 Autumn and winter

47. Skagen

Skagen nature reserve lies at the extreme northern tip of Jutland. A slender peninsula with several types of dune formation, large sandy beaches, some heathland and stunted pines planted to stabilize the sand. Its situation makes the reserve and surrounding area an excellent migration watch-point.

☛ Approach on the A10 north of Frederikshaven. Access unrestricted. Hotels and campsites in and around Skagen, and bicycles may be hired locally. Further information: Skagen Touristkontor, Sct. Laurentiivej 18, 9990 Skagen.

🐦 The north coast is the best area for migrating duck, waders, gulls and terns and some small passerines; a small sandy hill called Flagbakken is a good place for migrating raptors including buzzard, rough-legged buzzard, honey buzzard, marsh harrier, hen harrier, sparrowhawk, osprey, and sometimes hobby and merlin. Easterly winds seem essential for a good passage. Nearby is some coniferous woodland, an ideal spot for passerines resting on migration. Large flocks of thrushes, pipits and finches also pass along the coast on migration. Breeding birds include crested lark, tawny pipit and red-backed shrike. Skagen harbour often holds Iceland and glaucous gulls. Many of the birds which stop over here are tired and often approachable.

📷 Early April–early June; morning for migrating birds; afternoon for migrating raptors

48. Tipperne-Vaernengene-Nymindestrøm Nature Reserve

A complex of nature reserves at the southern end of Ringköbing Fjord on the west coast of Jutland. Since being cut off from the sea by the formation of a sand bar the fjord has become a brackish lake, surrounded by sand dunes, lagoons, conifer plantations, marshland, water meadows, saltmarsh and some islands, and holds a rich and varied avifauna.

There are marked paths and an observation tower. The surrounding area can be worked from the road using the car as a hide.

☛ Approach from Nyminde which is within easy reach of Esbjerg on the coast. Access to Tipperne is restricted to Sundays, 1 April–30 July, 05.00–10.00 hrs and 1 August–31 March, 10.00–12.00hrs. Further information: Skjern Turistkontor, Banegårdspladsen, 6900 Skjern.

🐦 Breeding birds include avocet, oystercatcher, redshank, black-tailed godwit, ruff, lapwing, sandwich tern, black-headed gull, gull-billed tern, common tern, Arctic tern, black grouse and marsh harrier. Autumn passage brings up to 10,000 pink-footed geese, many of which overwinter; Bewick's swans winter in numbers of up to 10,000. Up to 15,000 wigeon arrive in September, most leaving again in November. Other birds arriving or passing through in autumn include large numbers of bar-tailed godwit, dunlin and avocet as well as smaller numbers of whooper swan, white-fronted geese, greylag geese, Brent geese, spotted redshank, little stint, curlew sandpiper and wood sandpiper. The Vaernengene area south of Tipperne is particularly good for photographing waders, especially black-tailed godwit, using the car as a hide.

📷 Autumn and winter

49. Vejlerne

Wet meadows, coastal marshes, lagoons and extensive reedbeds bordering the Limfjorden, a large shallow inlet in north-west Jutland. The whole northern coast of this inlet is well worth exploring.

☛ Approach from Thisted on the north coast of the Limfjorden. No access to the reserve itself but good photographic opportunities from the roads crossing Vejlerne.

🐦 Breeding birds include a large colony of black-headed gull, greylag geese, marsh harrier, avocet, ruff, black-tailed godwit, bittern, black tern, gull-billed tern, red-necked grebe and spotted crake. The autumn migration brings good numbers of duck and waders through the area including teal, wigeon, bean geese, Bewick's and whooper swans, spotted redshank, curlew, black-tailed and bar-tailed godwits, ruff and dunlin. White storks breed in some of the small towns.

📷 April–October

ISLAND, COAST, AND ESTUARY

FRANCE

50. Baie de Bourganeuf

A reserve on a stretch of coastline south of the River Loire some 60km south-west of Nantes. It consists of a natural bay with sandy mud, sand and rocky outcrops and shallow water. To the west lies Île de Noirmoutier and to the east are areas of marshes with salines. Some interesting breeding species and the shallow waters of the bay prove a major attraction to wintering wildfowl.

☛ Approach from Bouin, about 50km south-west of Nantes. No access restriction. Île de Noirmoutier is linked to the mainland by a causeway at low tide and via a toll bridge from La Barre de Monts.

Accommodation available in Fromentine on the mainland or at Noirmoutier en l'Île. Further information: Délégation régionale au Tourisme des pays de la Loire, 3 place St-Pierre, 44000 Nantes.

☛ The bay is an important overwintering ground for wildfowl with good numbers of Brent geese, wigeon, teal, pintail, scaup and shelduck. Migration brings large numbers of waders. In particular, there is usually a high tide roost of waders by the bridge, Pointe de Nôtre-Dame de Monts, including whimbrel, dunlin, oystercatcher, curlew, grey plover, avocet, greenshank, curlew sandpiper, knot and little stint. Black-winged stilt in the marshes and saltpans, with green sandpiper, little egret, Cetti's warbler, bluethroat and marsh harrier. Other birds include roseate and little terns, Kentish plover, crested lark and short-toed lark.

📷 October–April

51. Baie de l'Aiguillon and Pointe d'Arcy nature reserves

Part of a vast intertidal area north of La Rochelle fed by waters of a large area of reclaimed marshland – Marais de Sèvre. The grazing marshes are protected from flooding by a large man-made bank, on the other side of which is shallow water surrounded by typical marsh vegetation.

☛ The general area is reached on the N137 which leaves route N11 east of La Rochelle. It is worth exploring along the minor roads which pass through the Marais Poitevin Regional Park; access points to the inlet itself along other minor roads. Further information: Maison du parc naturel de Marais Poitevin, 19 rue Bujault, 79000, Niort. Further north is the Pointe D'Arcay Nature Reserve which is also worth visiting although access

is restricted to permit holders only, contact: Conseil Supérieur de la chasse, Fédération Départementale, 17 rue Lafayette, La Roche-sur-Yon.

☛ Breeding birds of interest include garganey, teal, black-tailed godwit, black-winged stilt and black tern. Most interest, however, centres around the migrating wildfowl and waders some of which overwinter. A few Brent and white-fronted geese; ducks include many pintail, mallard, wigeon, shoveler, teal and shelduck. Lots of dunlin, knot, black-tailed godwit, avocet, grey plover and curlew; other waders include spotted redshank, redshank, whimbrel, bar-tailed godwit, ruff, ringed and Kentish plovers. Additional birds of interest are marsh harrier, Montagu's harrier, short-eared owl, hoopoe, green and wood sandpipers, little stint and kestrel.

📷 All year

52. The Camargue See also 179.

One of Europe's outstanding wetland areas between the two arms of the River Rhône. Although the Camargue proper is restricted to the area of wetland we include several nearby areas of interest which can be easily included in a trip to this region. The wetland itself is a complex of marshland, lakes, ponds, brackish pools, saline lagoons, dunes and seashore, with some cultivated areas. A good network of small roads provides access to many superb locations outside the reserve. Much photography must be done from the roadside using the car as a hide.

☛ Approach from Arles on the D570 coast road. Access to the Camargue Regional Park is unrestricted, but permits necessary for the protected national reserve that lies within it, and you will usually need proof that you are a member of a *bona fide* natural history society. Permits from: The Director, La Capelière, 13200 Arles. The old town of Arles is a good base, with adequate accommodation and campsites.

☛ The wetland area holds a huge variety of aquatic birds. Species of particular interest include greater flamingo, purple heron, squacco heron, little egret, night heron, little bittern, slender-billed gull, gull-billed tern, black-winged stilt, avocet, red-crested pochard and cattle egret. Waders are well represented especially on migration, including Kentish plover, curlew sandpiper, little stint, Temminck's stint, greenshank, spotted redshank, redshank, wood sandpiper, green sandpiper, ruff, whimbrel, and occasional

broad-billed sandpiper. The reedy margins of pools and ditches hold sedge, reed, Cetti's, fan-tailed and great reed warblers. Black, whiskered and a few white-winged black terns are seen over the lagoons along with collared pratincole and little gull. Marsh harrier, red and black kite, bee-eater, and rollers, red-backed and woodchat shrikes are commonly seen from the roadside. Areas particularly worth exploring are Mas d'Agon and Basse Méjeanne in the north, the eastern side of Étang, L'Étang de Vaccares and the area around Aigues-Mortes.

Entressen rubbish tip, west of the D5 road north of Entressen not far from Étang Entressen, and the surrounding area are well worth a visit. Birds here include black kite, shrike, great spotted cuckoo, Calandra lark, roller. Little bittern and great reed warbler breed in the reeds around the étang.

Les Apilles is a range of craggy limestone hills lying a few kilometres north-east of Arles. Birds of prey here include Egyptian vulture, Bonelli's eagle and eagle owl. The two sites of particular interest are Les Baux and La Caume near St Rémy. Other birds here are Alpine swift, crag martin, blue rock thrush, black-eared wheatear, rock sparrow and subalpine warbler.

📷 Spring and summer; large wildfowl concentrations in winter

53. The Golfe du Morbihan
The Golfe du Morbihan is a shallow inlet some 20km across on the Atlantic coast south of Vannes. Sheltered by the Quiberon Peninsula, it harbours many small islands. The area is managed as a marine hunting reserve and consequently attracts not only large numbers of wildfowl but also many wildfowlers. Recently a large section has been closed to hunters.

🦅 South of Vannes on the E13 road from Brest to Nantes. Access unrestricted. Further information: Société pour l'étude et la protection de la nature en Bretagne, Faculté des Sciences, avenue Le Gorgeu, 29200 Brest.

🦆 The major attraction is as a wintering ground for a great number of wildfowl. In particular, thousands of Brent geese overwinter here and feed on the eel-grass; there are also thousands of wigeon, eider duck and pintail, and smaller numbers of teal, shelduck, goldeneye, tufted duck, pochard, red-breasted merganser, great-crested and black-necked grebes. Many waders pass through on migration and others overwinter, attracted to the great expanses of seabed exposed at low tide. Species to be expected

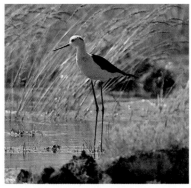

Black-winged Stilt *(Himantopus himantopus)*, Camargue, France; June; Nikon F3, Nikkor IF-ED 600mm f5.6 + Nikon 1.4× teleconverter, auto @ f8, Fujichrome 100; car bracket.

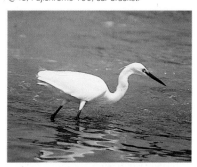

Little Egret *(Egretta garzetta)*, Camargue, France; June; Nikon F3, Nikkor IF-ED 300mm f4.5, 1/500 sec @ f5.6, Kodachrome 64; beanbag.

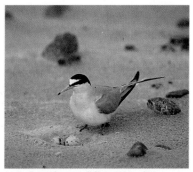

Little Tern *(Sterna albifrons)*, Isle of Islay, Scotland; June; Nikon F2, Nikkor 300mm f4.5, 1/125 sec @ f8, Kodachrome 64; hide, tripod.

include black-tailed godwit, grey plover, knot, whimbrel, curlew sandpiper, green-shank, redshank and dunlin. The eastern side of the bay has accessible marshes, ponds, and saltmarsh. The list of breeding birds is relatively unimpressive, but black-headed gull, common and sandwich terns breed on some islands and some of the mainland areas.

📷 September–April

54. Les Sept Îles Nature Reserve

The most important breeding location for seabirds in France, 7km off northern Brittany. Apart from Île aux Moines, the islands are uninhabited. Breeding auks were severely affected by oil pollution from the *Torrey Canyon* and *Amoco Cadiz* disasters in 1967 and 1978 respectively. Since then the numbers have begun to recover. Nearby is the small coastal bird reserve of Cap-Sizun.

🖝 Round-island boat trips from the seaside resort of Perros-Guirec. Landing usually forbidden on all islands except Île aux Moines, but the boats do go very close to shore. Further information: Ligue Française pour la protection des oiseaux, (LPO) BP263, La Corderie Royale, 17305 Rochefort cedex. Plentiful accommodation in Perros-Guirec. For Cap-Sizun, approach from Kergluan, 42km north west of Quimper. Open 15 March–31 August, 10.00–12.00hrs and 14.00–18.00hrs. Further information: Société pour l'étude et la protection de la nature en Bretagne, Faculté des Sciences, Avenue le Gorgeu, 29200 Brest.

🖝 Breeding seabirds include puffin, gannet, razorbill, guillemot, cormorant, kittiwake, fulmar, shag, herring gull, common tern, storm petrel, raven, wren, rock pipit, kestrel, and starling.

On Cap-Sizun breeding birds include guillemot, razorbill, puffin, kittiwake, cormorant, herring gull, lesser and greater black-backed gulls, ravens, and storm petrel. There are breeding chough and fulmar on Milinou.

📷 May–August

55. Somme Estuary and Marquenterre Nature Reserve

Somme Estuary in the English Channel is about 70km south of Boulogne, and includes large dunes, saltmarsh, mudflats and grassland. The vegetation is mainly marram and lyme grass, and sea buckthorn. Within the reserve are marked paths and hides.

🖝 The estuary and the reserve on the northern bank are reached from La Maye 28km

from Abbéville. The reserve is open 1 April–4 November, 09.30–18.00hrs. Access is unrestricted outside the reserve. Further information: Parc Ornithologique du Marguenterre, St Quentin-en-Tourmont, 80120 Rue.

🖝 In summer the coast is besieged by holiday-makers and some hunters, and consequently the number of breeding species is rather small. During migration and in winter the estuary attracts large numbers of wildfowl and waders. Wildfowl and waders on passage include Brent geese, shelduck, teal, garganey, wigeon, common scoter, scaup, black-tailed and bar-tailed godwits, whimbrel, curlew, grey plover, dunlin, knot, redshank, wood and green sandpipers and avocet. Breeding birds include greylag geese, shelduck, black-headed gull, oystercatcher and Kentish plover. Snow bunting and shore lark are found in winter.

📷 September–April

GREECE

56. Evros Delta

An extensive area of marshland and lagoons at the boundary between Greece and Turkey. Unfortunately, it is changing significantly as a result of land reclamation and construction. There is a strong military presence, and foreign visitors bearing photographic equipment and binoculars are regarded with suspicion. You may well be asked to leave. The delta is extensive and best worked from a car – which acts as a hide and gives cover from the watchful military. Do not wander away from your car.

🖝 Travel east from Alexandroúpolis and explore the rough tracks round the lagoons and marshland areas. Technically, visitors should have a military permit but many do not bother. The best areas are in the military zone, but there is much to see outside of this.

🖝 Breeding birds include spur-winged plover, glossy ibis, black-winged stilt, ruddy shelduck, collared pratincole, roller, bee-eater, common tern, gull-billed, sandwich and little terns, great white egret and white-tailed eagle. This last species, along with the black vulture can sometimes be seen feeding on dead cows. Other birds include spotted eagle, saker falcon, long-legged buzzard, Egyptian vulture, short-toed eagle, imperial eagle, black kite, marsh harrier, Montagu's harrier, Eleonora's falcon, white and black stork, little egret, pygmy cormorant and Dalmatian pelican. A good variety of waders

should be seen in suitable areas including Kentish plover, little-ringed and grey plovers, common, green, and marsh sandpipers, spotted redshank, redshank, ruff, knot, dunlin, red-necked phalarope, little stint and broad-billed sandpiper. Other birds include crested lark, woodchat shrike, red-backed shrike, lesser grey shrike, rufous bushchat, olivaceous warbler, Isabelline wheatear, black-headed bunting and Spanish sparrow.

📷 April–October

57. Gulf of Árta

A massive inlet on the west coast of northern Greece, and although one of the most important wetland areas in the country, relatively ignored by visiting bird watchers and photographers. As a result of silt deposited by the rivers, Árakhthos and Loúros, an expanse of marshland and reedswamp has formed, much of which is now reclaimed. Within the gulf are islands, sandbars and lagoons attracting a good variety of aquatic birds.

🖝 Approach from Árta on the northern side of the gulf. Access to the marshes is unrestricted. Good accommodation available in Árta. Further information: Hellenic Republic National Tourist Organization, Information Department, B/2, 2 Amerikis Street, Athens 133.

🖝 This is a very large area to work but in fact most of the species to be found can be seen by exploring the northern area only. The main attraction is the population of breeding Dalmatian pelican. Other breeding birds include black-winged stilt, collared pratincole, stone curlew, redshank, Kentish plover, bee-eater, roller and penduline tit. Other birds to be expected are pygmy cormorant, white pelican, purple heron, squacco heron, little egret, little bittern, glossy ibis, white stork, Baillon's, little and spotted crakes, crested lark, short-toed lark, golden oriole and short-toed treecreeper. Numerous and varied waders occur on passage.

📷 April–October

58. Pórto Lágo

A village between Lake Vistonia and the sea, which in recent years has become one of Greece's top birdwatching localities. Around the village are areas of marsh, grass, lagoons, sandspit, saltpans and woodland. The whole area is worth exploring as the variety of habitat attracts many interesting species.

🖝 Travel east on the main E5 route from Xánthi towards Alexandroúpolis. Explore the whole coastal area around the village and along the coast road to Fanari. Access unrestricted. Hotels in Xánthi; camping allowed near the village.

🖝 The list of birds to be found here is large. Breeding birds include stone curlew, Caspian tern, spur-winged plover, Kentish plover and a colony of bee-eaters which nest near the coast, south of the harbour. Dalmatian and white pelicans, pygmy cormorant, and good numbers of Mediterranean and slender-billed gulls should be around. Waders include black-winged stilt, ringed plover, little stint, curlew sandpiper, redshank, greenshank, green sandpiper, wood sandpiper, marsh sandpiper, broad-billed sandpiper, black-tailed godwit, curlew, avocet, Temminck's stint and pratincoles. Other birds should include little egret, night heron, greater flamingo, glossy ibis, purple heron, spoonbill, mallard, garganey, teal, water rail, crakes, whiskered, black and common terns, marsh harrier, white-tailed eagle, sparrowhawk, lesser kestrel, red-footed falcon and Eleonora's falcon, hoopoe, Calandra lark, greated spotted cuckoo, great reed warbler, fan-tailed warbler, rufous bushchat and penduline tit amongst many others.

📷 April–October

ICELAND

59. Snaefellsnes Peninsula

On the west coast of Iceland north of Reykjavík. The landscape is dominated by the Snaefellsjokull glacier which overlooks the surrounding fertile meadows and coastal lagoons. The southern coast of the peninsula consists mainly of barren lava flows.

🖝 Easily reached by road from Reykjavík. Access unrestricted. A few hotels and campsites scattered throughout the area. Further details: The Iceland Tourist Bureau, Reykjanesbraut 6, Reykjavík.

🖝 Famous for seabird colonies. Easily accessible fulmar and kittiwake nesting against attractive backdrops, and some black guillemot and puffin. Larger colonies of auk and Brunnich's guillemot further along the coast at Malarrif, and a large tern colony at Sandur. Ptarmigan, golden plover and possibly harlequin duck at Budir. Colonies of glaucous gull along the coast, and the white-tailed eagle breeds here too, but photographing it at the nest is an offence. On

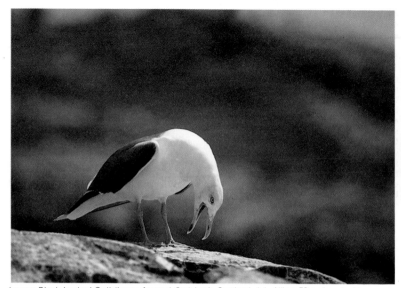

Lesser Black-backed Gull *(Larus fuscus)*, Craigleath, Scotland; July; Nikon F3 and motordrive, Nikkor IF-ED 300mm f4.5, auto @ f4.5, Kodachrome 64; stalked with monopod.

the inland moors are breeding whimbrel, golden plover, snow bunting, ptarmigan and Arctic skua. Whooper swan, greylag geese, gyr falcon and some divers may be seen throughout the area.

📷 May–June

60. Westmann Islands

A group of about twenty islands off the south coast of Iceland and one of Europe's most important seabird colonies. One of the group, Surtsey, was formed by volcanic activity as recently as 1963. The only inhabited island is Heimaey.

☞ Heimaey, the largest of the islands is reached by boat from Stokkseyri, and by boat or aeroplane from Reykjavik. Boats can also be chartered locally for travel between the islands. There is a hotel on Heimaey.

👁 The bird cliffs are spectacular. Breeding birds include gannet, shag, cormorant, fulmar, Brunnich's guillemot, guillemot, black guillemot, puffin, razorbill, kittiwake and great skua. The islands also have the only Icelandic breeding colonies of Manx shearwater, Leach's and storm petrels. As these are nocturnal species, flash will usually be needed. Other breeding birds include glaucous gull and a number of waders.

📷 May–July

ITALY

61. Bolgheri Wildlife Refuge

This reserve on the west coast of Italy is one of the Italian World Wildlife Fund's refuges. Within the reserve of marsh grassland grazed by cattle, are conifer plantations, maquis type vegetation and deciduous woodland consisting mainly of elm and ash trees. The grassland, which floods in winter, is particularly attractive to wintering wildfowl.

☞ Follow the coast road south from Pisa through Cecina. Access by prior arrangement, November–March, Tuesdays and Fridays; contact: WWF Italia, Delegazione per la Toscana, Via san Gallo 32, 50129 Florence.

👁 The freshwater marsh attracts large numbers of waders and wildfowl both on passage and during winter. In January there are usually several thousand duck including pochard, tufted duck, wigeon and ferruginous duck. Large concentrations of coot also occur. The grasslands support good numbers of lapwing, golden plover and curlew. On migration, a good variety of waders is found, with lapwing and black-winged stilt breeding. Purple heron and night heron breed in the woods. In winter

there are usually large evening roosts of starlings in the trees.

📷 October–May

62. Circeo National Park

The park encompasses Circeo Forest, a rocky headland, sandy beaches and coastal dunes, a number of lakes stretching along the coastline with some marshland in between, and a small town.

☞ The park is on the coast road about 90km south of Rome, and approached from Latina. Unrestricted access, except for the forest which is a closed nature reserve, permits from the reception centre at Sabaudia. Further information: Ministero dell' Agricoltura e della Forest, Parco Nazionale del Circeo, Ufficio Amministrazione di Sabaudia, 04016 Sabaudia.

☞ The park is particularly important for migratory and wintering species. At times of passage and during the winter the lakes attract good numbers of wildfowl and waders including greenshank, ruff, curlew sandpiper, black-winged stilt, little stint and avocet as well as wigeon, pintail, pochard and tufted duck.

📷 September–May

63. Lago di Burano Wildlife Refuge

Managed by the Italian World Wildlife Fund, Lago di Burano lies close to Orbetello reserve on the south side of the province of Grosseto, and is of major importance for migrating and wintering wildfowl and waders. As well as the lake, there is an extensive area of maquis-covered sand dunes in which several tree and shrub species grow. The site is wardened and has a nature trail, hide and field station.

☞ Lago di Burano lies about 50km south of Grosseto town. Approach from the railway station at Capalbio. Access September–May, 10.00hrs and 13.00hrs. For visits outside these hours contact: WWF Italia, Delegazione per la Toscana, Via san Gallo 32, 50129 Florence.

🐦 A wide variety of waterfowl and waders. Of interest are spotted, little and Baillon's crakes, which may breed. In winter the brackish lagoons hold pochard, tufted duck, wigeon and ferruginous duck. Cormorants visit the lagoon to feed. The reedy margins hold reed warbler, great reed, Cetti's and fan-tailed warblers. In spring many birds are attracted to the maquis-covered dune system. Regular species are bee-eater, rol-

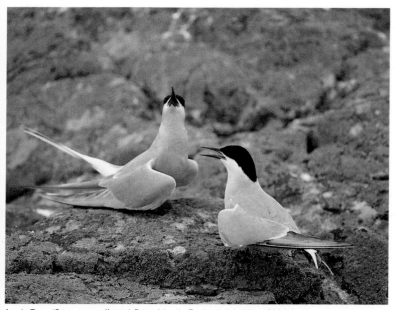

Arctic Tern *(Sterna paradisaea)*, Farne Islands, England; July; Nikon F3 and motordrive, Nikkor IF-ED 300mm f4.5, auto @ f5.6, Kodachrome 64; stalked with monopod.

ler, hoopoe and great spotted cuckoo. Raptors include osprey, buzzard, honey buzzard, sparrowhawk, hobby, martin and harriers. Many migrating small passerines are also attracted to this area.

📷 September–May

64. Maremma Regional Park

One of the chain of four reserves along this part of Italy's Mediterranean coast. Despite surrounding development, this reserve of brackish marshland, sand dunes and marram grass, woodland and rocky outcrops, remains unspoilt, and is an important area for breeding birds. There are marked nature trails.

☞ Approach from Grosseto, 115km south of Florence. Open Saturday, Sunday, Wednesday and public holidays, 09.00hrs–one hour before sunset; 15 June–30 Sept, 07.00–16.00hrs. Limited tickets available daily from the park office or the local post office. Further information: Conzorzio del Parco Naturele della Maremma, 58010 Alberese, Localita Pianacce.

🔎 Brackish marshland attracts numerous waders and other water birds at migration times, including greenshank, wood sandpiper, curlew sandpiper, little stint, redshank, black-winged stilt and avocet. Breeding birds include short-toed eagle, peregrine and hobby, hoopoe, wryneck and kingfishers.

📷 September–May

65. Orbetello Nature Reserve

Orbetello consists of a series of tidal lagoons which link with the larger Ponente Lagoon, and combines a number of different habitats including dunes, fresh water, brackish lakes, fields and mixed woodland strips. Warden on site; information centre and hide. It is well worth exploring outside the reserve.

☞ Reserve lies off main E1 coastal road from Rome between Orbetello (12km south) and Grosseto (30km north). Open October–April, Thursdays and Sundays. Visits at other times by special arrangement; contact: WWF Italia, Delegazione per la Toscana, Via San Gallo 32, 50129, Florence.

🔎 A particularly important reserve for migrating birds. Breeding species include Montagu's harrier, black-winged stilt, stone curlew, bee-eater and several duck species. Large numbers of waders and ducks congregate on migration. Other birds to be seen include a great variety associated with water such as flamingos, spoonbills, purple heron,

night heron, white stork, osprey, terns, collared practicole and avocets.

📷 March–October

66. Punte Alberte Wildlife Oasis

A small part of the expanse of marshland and coastal lagoon in the Po delta. Managed by the Italian World Wildlife Fund, the wealth of birdlife on the reserve has earned it recognition as a site of international importance. Warden on site. Observation tower.

☞ Lies off the Adriatic coast road 60km south of Venice at Contarina. The surrounding area is worth exploring for the many species of waterbirds, but access may sometimes be difficult; try also the nearby Valli di Comacchio and Valle della Canua.

🔎 In the marsh woodland there are 500–1000 pairs of little egret, 50–200 pairs of squacco heron and about 50 pairs of night heron. Breeding species within the general oasis area include good numbers of grey heron, some purple heron, a few pairs of glossy ibis, mallards, shovelers, garganey and ferruginous ducks, black-winged stilt, avocet and Kentish plover plus good numbers of passage waders.

📷 April–October

67. Salina di Margherita di Savoia Nature Reserve

An area of saltland with fresh, brackish, and salt water. Once popular for its shooting, the cessation of this activity has produced an oasis which has become extremely attractive to wildfowl, waders and other water birds. The area outside the reserve is well worth exploring.

☞ Situated on the coast road from Bari just north of Barletta. The reserve is wardened and may only be entered with a guide. Inside the reserve are a number of observation huts. Further information: Ufficio Amministrazione Foreste Demaniali del Gargano, 71030 Foresta Umbra (Foggia).

🔎 The reserve attracts thousands of geese during winter including white-fronted and Brent geese and many ducks including wigeon, shelduck, shoveler, pintail, pochard, teal and coot. The reed and sedge margins attract typical species of breeding warbler including Cetti's, sedge and fan-tailed warblers and bearded tits. Waders are present in good numbers on migration. Notable species include avocet, curlew, greenshank, ruff, curlew sandpiper and little stint. Other species include pratincoles,

penduline tits, short-toed and Calandra larks.
📷 October–May

THE NETHERLANDS

68. Flevoland
One of the most exciting birding areas in Europe, Flevoland is land reclaimed from the IJsselmeer. The area is divided into two main parts, Oostelijk-Flevoland and Zuidelijk-Flevoland, although much of it has been designated a nature reserve covering 100,000ha and includes two major towns. Despite continuous development, there are large areas of woodland, open water, reed-beds, canals, dykes and reed-fringed lagoons. The whole area is well worth exploring and much photography can be done from the roadside and from the car.
☛ Travel eastwards from Amsterdam on the A1 following signs to Lelystad. Accommodation is widely available. The best-known reserve is Oostraardersplassen which is not open to the public, but birds are easily seen from the roads. Further information: Centrum voor natuuvoorlichting, Schouw 12/13 8232 2A Lelystad.
🐦 The birdlife is varied and spectacular. During autumn large numbers of greylag and white-fronted geese arrive to overwinter on the fields and lagoons. Other wintering wildfowl include Bewick's swan, pink-footed geese, pintail, wigeon, tufted duck, pochard, shoveler, goldeneye and scaup.

In spring black tern and little gull are present over the water, and black-tailed godwit and ruff are displaying. Marsh harrier and kestrel are commonplace. The lagoons attract spoonbill, purple heron, black-tailed godwit, avocet, and numerous other waders especially at times of passage. Duck species are well represented in summer with red-crested pochard, smew, shoveler, garganey, wigeon, gadwall and pintail. The hide near Knaardijk is worth a visit and can be productive for the photographer.

Other birds of interest include cormorant, rough-legged and common buzzards, white-tailed eagle in winter, hen harrier, goshawk, long-eared and short-eared owls, dotterel (which breed), bittern, bearded tit, golden oriole, water rail, white stork, icterine, Savi's and grasshopper warblers. This is but a small selection of the birds found.
📷 All year

69. Waddenzee Islands
An arc of islands running parallel to the Dutch coast and enclosing an area of shallow water called the Waddenzee. This is one of the single most important wetland areas in western Europe.

Schiermonnikoog, the smallest of the inhabited Waddenzee islands, with sand dunes, beaches, woods, saltmarsh and freshwater lakes. There are two reserves, Westpunt and Kobbeduinen, although it is well worth exploring the rest of the island.
☛ There's a 50-minute ferry service from Lauwersoog about 40km north of Groningen. Access unrestricted apart from Kobbeduinen which is closed 15 April–15 July. Cars are only available to residents but bicycles, buses or taxis are available. Further information: VVV Schiermonnikoog Reeweg 5, 9166 PW Schiermonnikoog.
🐦 Schiermonnikoog is famous for the waders of the Wadenzee which form high-tide roosts here. Large numbers of dunlin, knot, oystercatcher, bar-tailed godwit, curlew and grey plover fly in. Other waders include redshank, spotted redshank, greenshank, Kentish plover, purple and curlew sandpipers. Sandwich and little terns nest along the shores and marsh and hen harriers are commonly seen. A good variety of gulls and terns are also to be found. Other birds include ruff, bittern, red-throated diver and red-necked grebe.
📷 April–October

Terschelling has three nature reserves, Boschplaat, the largest, Noordvaarder and Koegelwieck. The area is largely of sand dunes, with scrub, meadow and saltmarsh.
☛ Reached by ferry from Harlingen on the coast of northern Holland. Some areas are military zones with restricted access. Some parts of the Boschplaat are closed during the breeding season, 15 March–1 September; access elsewhere is unrestricted. Further information: Natuurmuseum en Zeeaquarium, Burg, Reedekerstraat 11, Postbus 5, 8880 AA, West-Terschelling.
🐦 A rich avifauna; breeding birds include spoonbill, avocet, black-tailed godwit, Kentish plover, eider duck, pintail, stonechat, red-backed shrike, golden oriole, marsh and grasshopper warblers. Migration brings a good wader passage.
📷 March–October

ISLAND, COAST, AND ESTUARY

Texel is the largest and best known of the Waddenzee islands, 15km × 11km, which attracts birdwatchers from all over Europe. The area includes wide beaches, sand dunes, meadows, woodland, wetland, dykes and agricultural land. There are many reserves on the island administered by different organizations. The whole island is worth exploring; we highlight some particularly good spots.

Reached by ferry from Den Helder at the end of the Noord Hollands Kanal, 80km north-west of Amsterdam. Most of the protected areas are either closed for certain periods of the year or are restricted in parts. Within these times there are sometimes guided walks. Good views, however, can often be had from the roads and tracks. Permits for some reserves are available but it is advisable to apply well in advance for these. Further information from Natuurrecreatie Centrum, Ruyslaan 92, 1796 AZ de Koog, Texel, or Vereniging tot Behoud van Natuurmonumentum in Nederland, Herengracht 540, Amsterdam – C.

Texel holds a large variety of interesting breeding and visiting birds. De Muy has breeding spoonbill, grey heron, water rail, red-backed shrike and yellow wagtail as well as a good variety of duck and warblers. The tidal creek and dunes at Slufter holds breeding eider duck, shelduck, avocet, black-tailed godwit, oystercatcher, Kentish plover and terns. De Geul, at the south end of the island, has breeding spoonbill, marsh harrier, avocet, black-tailed godwit, short-eared owl, long-eared owl, and terns. Westerduinen, on the south-west coast, has breeding herring gull and shelduck. The Waalenberg is an area of low-lying meadows which are flooded in winter and attract large numbers of wildfowl. During the summer ruff, black-tailed godwit and shelduck breed. There is no access to this reserve but good views may be had from the roads. The woodlands at Dennen south of De Koog hold golden oriole, icterine warbler, sparrowhawk, woodcock, long-eared owl, nightingale, and short-toed treecreeper. Many of the other smaller reserves are worth a visit if possible.

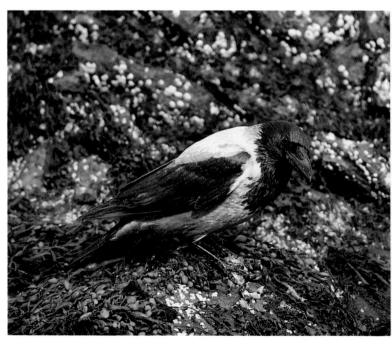

Hooded Crow *(Corvus corone cornix)*, Strathclyde, Scotland; April; Nikon F3, Nikkor IF-ED 600mm f5.6, auto @ f5.6, Kodachrome 64; beanbag.

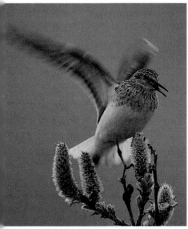

Temminck's Stint *(Calidris temminckii)*, Varanger Peninsula, Norway; June; Nikon F3 and motordrive, Nikkor IF-ED 600mm f5.6, auto @ f5.6, Kodachrome 64; hide, tripod.

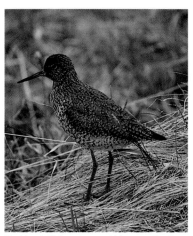

Redshank *(Tringa totanus)*, Varanger Fjord, Norway; June; Nikon F3, Nikkor IF-ED 600mm f5.6, auto @ f5.6, Kodachrome 64; beanbag.

During passage times large numbers of waders form high-tide roosts at various points around the island.
📷 All year

70. Die Wieden and de Weeribben Nature Reserves

The reserves are in the province of Overijssel in northern Holland adjacent to the IJsselmeer delta, in an area of peatland. The bog and marsh habitat and some extensive reedbeds attract a variety of aquatic birds. Zwartemeer, to the south-west is also worth exploring. The area is best worked by boat. Both reserves have marked footpaths and trails as well as visitor centres.
☛ The reserves are reached from Steenwijk off the N32. De Weeribben is open 10.00–16.00hrs, Wednesday–Friday, 13.30–16.30hrs, Saturday–Tuesday. Further information on De Weeribben contact: Natuurreservat de Weeribben, Hogeweg 27, 8376 EM Ossenzijl.

Further information on De Wieden: Bezoekerscentrum 'De Foeke', Natuurmonument De Wieden, Beulakerpad, 8326 Att Sint-Jansklooster.
🐦 Breeding colonies of purple and grey herons as well as bittern. Red-crested pochard, shoveler and gargeney; hen, marsh and possibly Montagu's harrier. Other birds to be expected include curlew, black tern, water rail, reed, great reed, sedge and Savi's warblers, bearded tit and golden oriole.
📷 May–October

71. Zwanenwater Nature Reserve

Two shallow lakes with marginal reedbeds in a dune system covered with heathland vegetation, including bogbean, orchids, sundews and tufted loosestrife.
☛ On the coast north of Amsterdam, reached from Callantsoog 9km north-west of Schagen near the Noord Hollands Kanal. Access unrestricted but visitors are requested to keep to marked trails. Further information: Vereniging tot behoud van Natuurmonumenten, Schaep en Burgh, Noordereinde 60, 1243 JJ 's-Graveland or from VVV Callantsoog, Postbus 10 1759 HA, Callantsoog.
🐦 Over 100 breeding species the main attraction being a large colony of spoonbills. Other breeding birds include avocet, Kentish plover, common tern, sedge and reed warblers and goldcrest. In autumn there is a large passage of waders.
📷 May–October

NORWAY

72. Hornøy

A small island lying a short distance off Vardø on the Varanger Peninsula above the

181

Arctic Circle. The 36-ha island rises to about 70m above sea level; on the west side are low cliffs and grassy slopes; on the east peaty soil is covered with lush vegetation of ferns, sorrel and grass.

☛Vardø is reached from Kirkenes which is served by air from Oslo or by taking the main northern road which runs through the whole of Norway.

Free access loosely controlled by the Vardø boatmen who run boat trips. Arrangements need to be made locally.

☛ The main attraction Brünnich's guillemot breed in small numbers on the cliffs amongst the common guillemot. Other species include great black-backed gull, guillemot some of which are bridled, puffin, razorbill, shag and kittiwake, herring gull and black guillemot.

📷 June–July

73. Rundø

An island off Ålesund in southern Norway. The cliffs on the western side rise to over 300m and hold large numbers of breeding seabirds. Rundø is inhabited with two villages, Rundø and Goksöyr.

☛Ålesund is reached by coastal steamer from Bergen, or by air, and there's a two-hour boat service to Rundø. There are no hotels on the island, but the locals do sometimes take in visitors.

☛The major reason for visiting Rundø is to photograph the prolific seabirds. Rundebranden, a large rocky cliff area near Goksöyr holds good numbers of puffin, kittiwake, guillemot and razorbill, with smaller numbers of gannet. Fulmar nest around the cliffs elsewhere. Other birds include eagle owl, white-tailed eagle, shag, eider, shelduck, curlew and oystercatcher.

📷 Late May–late July

74. Varanger Peninsula

A truly arctic region above 70°N latitude – the land of the midnight sun where the sun does not set for over two months of the year. The whole area, of high fjells, snowfields, bogs, birch and willow scrub, coastal mudflats, sea cliffs, shallow bays, islands and small villages with brightly-painted houses, is worth exploring from Varangerbotn at the head of the Varangerfjord which opens eastwards round to Vardø and Hamningberg further round the coast. Some of the better areas are Varangerbotn, Nesseby, Vadsö, Ekkeröy, Kongsøya, Sylefjordstauran, Kongsfjord, Vardø, and Hamningberg.

☛Reach by road or air. The easiest road route is from Göteborg or Uppsala in Sweden following the main coast road along the Gulf of Bothnia into Finland on to Ivalo and Inari, and from here on up to Varangerbotn and Vardø via the northern route. Alternatively fly from Oslo direct to Kirkenes and then by bus. Hotel accommodation in some towns and a fair selection of guest houses. Camping is also possible.

☛ A large variety of species, in particular many Arctic waders in full breeding plumage. Wildfowl include bean goose, king and Steller's eider, scaup, long-tailed duck, velvet and common scoters; also red-necked phalarope, Temminck's stint, ruff, bar-tailed godwit, purple sandpiper, turnstone, ringed and golden plovers, little stint, dotterel, dunlin, redshank, oystercatcher, greenshank, wood sandpiper, curlew and whimbrel. There are a number of seabird colonies; the speciality is Brünnich's guillemot (see 69), as well as auks. Such colonies are found on coastal cliffs or offshore islands. Arctic and long-tailed skuas and Arctic terns are common breeders. Great black-backed, herring and common gulls breed commonly around the coast and the last also inland. A large colony of kittiwake on the island of Ekkeröy. Passerines include red-throated pipit, Arctic redpoll, snow and Lapland bunting, meadow and rock pipits, skylark, white wagtail, bluethroat and a number of warblers perhaps including Arctic warbler. Other species include redwing, fieldfare, brambling, mealy redpoll, raven, dipper, goosander and red-throated diver.

📷 June, July

PORTUGAL

75. Arrabida Nature Park

An isolated, 500m-high limestone outcrop covered with maquis scrub and over 1000 plant species.

☛ Approach from the adjacent town of Setúbal, about 30km south-east of Lisbon or Sesimbra. Access unrestricted. Further information: Serviço Nacional de Parques, Reservas e Património Paisagistico, Rua da Lapa 73, 1200 Lisbon.

A group of offshore rocks holds a seabird colony including guillemot. Other birds of particular interest include eagle owl, blue rock thrush, black redstart, black-eared wheatear.

📷 May–June

ISLAND, COAST, AND ESTUARY

76. Berlenga Islands

One of two noteworthy groups of rugged offshore islands. The main island, Berlenga lies about 13km off the fishing village of Peniche just north of Lisbon. The other group, the Farilhoes, lie some 20km north-west of Berlenga. Around these islands is a rich marine life attracting large numbers of breeding seabirds.

🕾 Daily boat crossing to Berlenga by boat from Peniche. Camping possible but take your own provisions. No access restrictions. Enquiries for the Farilhoes should be made locally.

🕾 These islands are important as a centre for breeding seabirds. Nesting species include Cory's shearwater, guillemot, shag, herring gull, blue rock thrush, rock sparrow and black redstart. During autumn passage good numbers of migrant birds are seen including Sabine's gull, Manx and Balearic shearwaters, Wilson's storm petrel, great skua, Arctic, pomarine and long-tailed skuas, gannet, phalaropes and numerous small passerines.

📷 May–July

77. Castro Marim Nature Reserve

An area of shallow lakes and lagoons at the mouth of the River Guardiana on the Spain–Portugal border. Some of the lakes are still worked commercially for the extraction of salt. Marked trails within the reserve.

🕾 Reached from Vila Real de Santo Antonio some 50km east of the holiday resort of Faro and conveniently close to the Ria Formosa reserve (79). No restrictions. Further information: Reserva Natural do Sapal de Castro Marim, Vila Real de Santo Antonio.

🕾 A migration and wintering ground for waders and wildfowl. Breeding birds include a large colony of black-winged stilts, avocet, redshank, black-tailed godwit, Kentish plover, marsh harrier and white stork. Spoonbill, greater flamingo and little bustard are also seen. Wintering waders include dunlin, knot, snipe, jack snipe and sanderling. On passage there are green-shank, ruff, curlew sandpiper, little stint and wood sandpiper amongst other, less common visitors. Various terns and gulls also pass through.

📷 All year

78. Estuario do Tejo Nature Reserve

An important reserve on the complex estuarine system of the River Tagus, just outside Lisbon. With its mudflats, marshes, and saline lagoons attracting migrating and wintering waders and wildfowl, this is an outstanding area for aquatic birdlife.

🕾 On the southern and eastern shores of the Tagus estuary, easily reached from Lisbon in the north, or Montijo on the southern side. Access unrestricted except for two strictly protected areas, closed to visitors. Further information: Serviço Nacional de Parques, Reservas e Património Paisagistico, Centro de Estudos de Migracões e Protecção de Aves, Rua da Lapa 73, 1200 Lisbon.

🕾 During winter and passage times this estuarine system attracts most of Europe's wintering avocets. Amongst the thousands of waders are grey and golden plovers, redshank, lapwing, Kentish and ringed plovers, dunlin, curlew and whimbrel. Wintering duck include mallard, wigeon, tufted duck and common scoter. Breeding birds include little egret, cattle egret, night and purple herons, bittern, marsh harrier, avocet, black-winged stilt and collared pratincole. Flamingos and spoonbills are also seen regularly.

📷 All year

79. Ria Formosa Nature Reserve

A long, narrow coastal reserve in the Algarve, one of the most popular holiday resort areas, and next to the town of Faro, yet recognized as a wildfowl feeding ground of international importance. There are marshes, mudflats, lagoons, sandbars and salt pans that extend along the Algarve for about 75km. The site has been under some pressure from the nearby international airport, holiday home development and farming. The reserve has marked footpaths.

🕾 Access is from Faro, Tavira or other points along the coast road. Visiting unrestricted. Further information: Serviço Nacional de Parques, Reservas e Património Paisagistico, Rua Justino Cumaro 5, 1° Dto, 8000 Faro.

🕾 Breeding birds include grey heron, little egret, white stork, redshank, black-winged stilt, Kentish plover, purple gallinule, pin-tailed sandgrouse, gull-billed tern and pratincoles. Non-breeding visitors include flamingo, spoonbill and several species of duck. Visiting waders include wintering snipe, jack snipe, woodcock, sanderling, knot, dunlin, with some greenshank and ruff. Trees bordering the marsh hold white stork, goldfinch and serin, blue-headed and grey wagtails. Hoopoe and bee-eaters are usually seen, the latter breeding near Alvor Marsh,

where there are also black-headed, lesser and great black-backed, herring and occasional slender-billed, little or Mediterranean gulls. Black, whiskered and gull-billed terns may visit the area.

📷 All year

80. Pateira de Fermentelos Nature Park

Marshland, with lagoons, reedbeds and salt-pans at the estuary of the River Vouga; an important wintering area for waders, wildfowl, and migrating birds. Hunting causes a fair amount of disturbance.

☛ Access from Aveiro, about 60km south of Porto in northern Portugal. No visiting restrictions. Further information: Serviço Nacional de Parques, Reservas e Património Paisagistico, Rua da Lapa 73, 1200 Lisbon.

☞ The saltpans in the northern area attract many gulls and waders including redshank, snipe, ruff, sanderling, knot, dunlin, avocet, grey and golden plovers. Black-headed, lesser black-backed and great black-backed gulls overwinter; rarer species occur occasionally. There is a heronry in the pines on the reserve which contains both little and cattle egrets, grey and purple herons. Migration brings a number of passerines.

📷 All year

SPAIN

81. Bonanza Salt Pans

Ancient salt pans in an exposed area flanking the River Guadalquivir. Flooding and scrapping cause constant changes and the whiteness of the salt heaps combined with strong sunlight give a very harsh and extreme lighting effect. On the opposite bank lies the renowned Coto Donãna reserve. The whole area is worth exploring including the beach and nearby pinewoods.

☛ Situated north of Bonanza, a few kilometres north of Sanlúcar de Barrameda, which is 2km north-west of the well-known town, Jerez de la Frontera. For the pine woods, take the C441 from Sanlúcar de Barrameda towards Lebrija. Search the areas on either side of the road here. Accommodation available in nearby towns.

☞ At passage times the saltpans and beach attract huge numbers of migrant waders including avocet, black-winged stilt, bar-tailed and black-tailed godwits, knot, ringed and grey plovers, sanderlings, curlew, and common sandpipers, dunlin, redshank and greenshank. Gull-billed tern and whiskered tern should also be seen. The

Pans are a regular feeding place for up to several hundred greater flamingo. The nearby pinewoods hold azure-winged magpie, short-toed treecreeper and Sardinian warbler. In the same general area are places worth visiting for pratincoles, Calandra short-toed and lesser short-toed larks, and pin-tailed sandgrouse.

📷 April–September, early morning and late afternoon

82. Coto Donãna

Considered by many to be the most important wetland area in Europe. On the coast is a broad expanse of sand stretching from Huelva in the north to Sanlúcar in the south. This is backed by a dune system, 60m high in some places, which holds back the waters of the Guadalquivir and causes winter flooding of the marismas. Within the general area is a diversity of habitats including beach, dunes, lagoons, reedbeds, islands, parkland, grassland and stone pine woods. Despite its status as a reserve, the surrounding area and some parts of the park are under threat from development, cultivation and pollution. The Coto Donãna holds a varied and interesting avifauna which should provide marvellous opportunities for the photographer.

☛ Situated on the Guadalquivir delta, north of Cadiz on the south-west coast, the ideal bases for exploring the Coto Donãna are either the Mexican-style village of El Rocio or the coastal resort town of Matalascanas, where there are campsites and plenty of hotel accommodation. Information centre, just south of El Rocio, is well signposted. Access to the reserve proper is difficult and advance permission must be obtained from Estación Biológica de Donãna, C/ Paraguay No. 1, Seville. Visitors are accompanied by a warden. Some hotels run daily landrover trips into the park. There is, however, no real need to enter the reserve as most species can be seen outside. Further information: Sr A. Camoyan, ICONA, Plaza de Espana, Sector IV, Seville.

☞ An astonishing variety of species with such rarities as breeding white-headed duck, marbled teal, ruddy shelduck, purple gallinule, crested coot, and imperial eagle. Get up-to-date information from the reserve centre. Between the village and the reserve centre is a bridge from which you should see little egret, cattle egret, spoonbill, whiskered tern, black-winged stilt, collared pratincole, red-rumped swallow, black kite, short-toed eagle, white stork and Montagu's harrier. From the hides near the centre you should

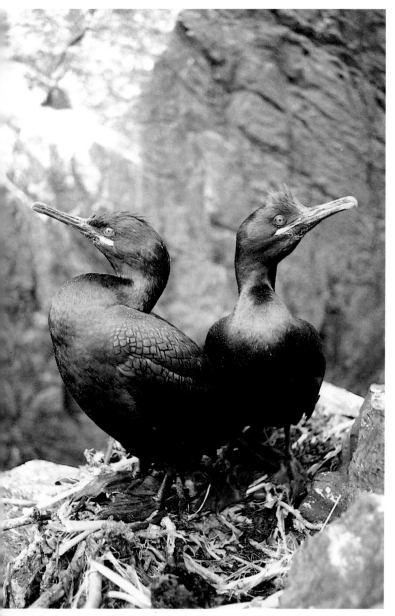

Shag *(Phalacrocorax aristotelis)*, Bass Rock, Scotland; July; Nikon F3, Nikkor 28mm f3.5, 1/125 sec @ f8. Kodachrome 64; stalked handheld.

ISLAND, COAST, AND ESTUARY

see purple gallinule at close quarters, as well as many other species including little egret, purple heron, marsh harrier and great reed warbler. Pools and marshy areas beside the road hold night heron, little bittern, squacco heron, little egret, cattle egret, black kite, marsh harrier, black-winged stilt, whiskered tern and great reed warbler.

Travelling east from El Rocio towards Coto del Rey, the stone pines north of the road hold azure-winged magpie, short-toed treecreeper, griffon vulture, black kite and booted eagle, and maybe even the imperial eagle. Tracks south from this road are well worth exploring as many waterbirds, including greater flamingo can be found. Explore as many of the sandy tracks criss-crossing the area as possible but take care not to get stuck in the sand. Many of the birds here can easily be photographed from the car. Other birds of interest here are greater flamingo, pin-tailed sandgrouse, red-crested pochard, crested lark, short-toed lark, Kentish plover and fan-tailed warbler. In the evening you may see scops owl and red-necked nightjar. Although the Coto Donãna is largely ignored by visitors in the winter it does hold large numbers of wildfowl then. Other species which may be expected are ferruginous duck, Egyptian vulture, black vulture, golden eagle, red kite, short-toed eagle, Baillon's crake, avocet, collared pratincole, gull-billed tern, great-spotted cuckoo, bee-eater, hoopoe, golden oriole, Calandra lark, Cetti's and Savi's warblers, Dartford warbler, great grey and woodchat shrikes, and spotless starling.

📷 April–September

83. Delta del Ebro

Although a wetland of international standing, this area is largely unprotected with only a few places reserved for the numerous variety of birds. The fan-shaped Ebro delta is made up of lagoons, saltpans, reed beds, marshes, dunes, and large areas which have been planted with rice.

☛ The delta is just over 100km south of Barcelona north of Valencia on the main E4 coast road. Access is from Amposta. There is plentiful hotel and campsite accommodation in the resorts which line the nearby coast. Unrestricted access to most areas. Further information: Delegacion Provincial de Turismo, Rambla del Generalisimo 25–2, Tarragona.

🐦 Despite extensive land reclamation this is still an important site for wintering wildfowl including mallard, shoveler, wigeon,

pochard and teal (which may number over 30,000). Migration brings large numbers of waders and duck. Breeding birds include black-headed gull, sandwich, gull-billed roseate and little terns, purple heron spoonbill, Cetti's warbler, Savi's and fan-tailed warblers, avocet and black-winged stilt. Other birds of interest include greater flamingo, whiskered tern and Kentish plover.

📷 All year

84. Mallorca

The largest of the Balearic islands has a varied landscape with rugged mountains valleys, plains, salinas, marshes, dykes and reedbeds. Much of the island is accessible and as a result of the tourist trade, amenities and transport are excellent. See also 200.

☛ Palma airport is well served by airlines from many European cities. Accommodation is plentiful and of a good standard advance booking advisable at peak holiday season.

Albufera is an excellent marshland area south of Puerto Pollensa. Once under threat this marsh which has large expanses of reed mace and *phragmites* reedbeds, channels and lagoons, is now a reserve and should be safe from development. Aquatic birds found include marsh harrier, osprey, Eleonora's falcon, purple heron, little egret, kingfisher Cetti's, Savi's and reed warblers to name a few. Other birds include wryneck, woodchat shrike, hoopoe, bee-eater, nightingale crossbill and serin.

The Salinas de Levante lie at the southern end of the island south of the town of Campos. The evaporation beds attract large numbers of avocet, black-tailed godwit, redshank, greenshank and Kentish plover, and black-winged stilt breed here. Terns include black, white-winged black, whiskered and occasionally gull-billed and Caspian terns Other birds of interest are marsh harrier osprey, booted eagle, greater flamingo, little egret, purple heron, black-necked grebe stone curlew, scops owl, hoopoe, corn bunting, wheatear and Cetti's warbler.

📷 April–September

SWEDEN

85. Falsterbo

This village at the southernmost tip of Sweden is famous as an autumn migration

watchpoint. The migration depends very much on the weather – warm days, especially after a period of bad weather are best – but good or bad spells seldom last more than three days. As the exact passage route varies according to wind direction, it's important to check with the locals for the latest information on the best sites. Falsterbo is an excellent starting point for exploring the area – 10km away is a nature reserve at Foteriken – and also the coastal areas of Höllviksnäs, Vellinge and Flommen.

☞ From Malmö (30km), take the E6 to Vellinge then follow road 100 to Falsterbo. Car ferries from Denmark – Helsingör to Helsingborg or Dragor, south of Copenhagen, to Limhamn; hydrofoil service from between Copenhagen and Malmö. Falsterbo has two small hotels and there's cheap accommodation at the bird observatory. Advanced booking necessary especially during the peak migration period. Further information and bookings: The Warden, Falkvagen 21, 230 10 Skanör.

A number of campsites, usually closed 21 September–27 April. Foteriken – no access to the reserve 15 April–15 July, but access free at all other times.

☞ Thousands of raptors may pass through this area daily during September and October, including large numbers of common buzzard, hen and marsh harriers, sparrowhawk and a few kites. Other migrants include large numbers of passerines (dominated by chaffinches) which nest in the small bushes in the area, ducks, waders, gulls and terns. Foteriken reserve has breeding avocet, ruff and Kentish plover and thousands of passage waders including black-tailed godwit, avocet, ruff, golden plover, short-eared owl and hen harrier. Flommen's breeding birds include shelduck, lapwing, oystercatcher, Kentish plover, redshank and dunlin.

🐦 September and October, mornings, for migrating species; May–early July for breeding species

86. Getterön

A coastal reserve on the shores of Kattegat; of national importance for its passage birds and for some interesting breeding species. Getterön is a marshy area with a lagoon formed by dredging and dumping in the 1930s.

☞ The reserve is north of Varberg, signposted off the E6 road. Access unrestricted except during the breeding season when some parts are closed. Further information:

Statens Naturvårdsverk, Nature Conservation Division, Box 1302, 171 25 Solna. Hotels in Varberg and a campsite 2km from Getterön, open June–September; contact: Getterön Camping, 432 00 Varberg.

☞ Breeding eider duck, pintail, garganey, spotted crake, black-tailed godwit, ruff, avocet, wryneck, black redstart, thrush nightingale, blue-headed wagtail and red-backed shrike. Waders on passage are golden plover, dotterel, bar-tailed godwit, spotted redshank, little and Temminck's stints, dunlin, broad-billed sandpiper, and red-necked phalarope. The south side of the bay near the airfield is a good viewing point. The rubbish tip on the western side of the marsh attracts gulls. Raptor passage, best in autumn, for sparrowhawk, honey buzzard, marsh and hen harriers, osprey, peregrine and merlin, others occurring less frequently. Small numbers of red-throated diver, bean goose, Brent goose, barnacle goose and whooper swan occur on passage.

🐦 April–July for breeding species

87. Öland

A long, narrow island 140×10km off Sweden's south coast. Much of the spine of the island is a limestone plateau separated from the coast by more fertile gardens, fields and woods. Öland is of interest for migratory birds and for its breeding species. There are many reserves on the island. Most of them easily accessible because they are very close to the roads.

☞ Access roadbridge from Kalmar on the mainland. There are many reserved areas on the island, some of which are closed during the breeding season, but most species are also to be found outside these areas. Beijarshamn and Vickleby are good bases from which to work the whole island if you have a car. Hotel 1½km from Beijershamn at Stora Frö, open June–August. (Bookings Pensionat Sandbergen, Stora Frö, Vickleby, 380 62 Mörbylånga ☎ (0485) 36393.)

Summer cottages near Vickleby. (Bookings Ölands Turisförening, Box 115, 380 70 Borgholm ☎ (0485) 302 60.

Campsite and cabins at Beijershamn open 1 June–20 August ☎ (0485) 360 30. Further information: Ölands Turistförening at the above address.

The whole island is worth exploring; we have selected some of the best places.

Beijershamn Breeding birds include pintail, garganey, black-tailed godwit, ruff, black tern, wryneck, red-backed shrike,

Red-breasted Merganser *(Mergus serrator)*, Gothenburg, Sweden; June; Nikon F3, Nikkor IF-ED 600mm f5.6, auto @ f5.6, Kodachrome 64; stalked with monopod.

icterine warbler, blackcap, thrush, nightingale and barred warbler. Passage migrants include greylag geese, Brent geese, eider duck, velvet and common scoters and a number of waders. Good flight shots of Brent geese possible from the end of the breakwater on the border of the bird reserve.

Revsudden and Stora Rör Revsudden is on the mainland and Stora Rör on Öland, each overlooking the channel through which thousands of birds pass on migration. Spring passage peaks in April, May, and early June and autumn passage in September and October. Passage birds include black-throated diver, red-throated diver, long-tailed duck, velvet scoter, common scoter, eider duck, goosander, bean and Brent geese.

Möckelmossen A small lake on the road between Mörbylånga and Stenåsa. Breeding birds include great-crested grebe, pintail, black tern, little gull and black-tailed godwit. Cranes may also be seen.

Mellby Ör A marshy area on the coast reached by a track from Mellby village. Breeding birds include avocet, ruff and black tern. Large numbers of waders occur on passage.

Kapelludden The area around the light house has breeding avocet as well as good numbers of waders on passage.

Other areas worth visiting include Södvken Knisa mosse, and Petgärde träsk which all hold interesting breeding birds and passage migrants. They are however closed to visitors during the breeding season.
📷 April–early June and September and October for migrants, early morning, April–July for breeding birds

Ottenby A nature reserve at the southern end of Öland, with sandy beach, sandspit shingle banks, sheltered coves and woodland. It is mainly known for spring and autumn passage, but also has some interesting breeding birds.
☛ For Ottenby, take the 136 south from Färjestaden for about 50km. Car parking

Great Black-backed Gull *(Larus marinus)*, near Gothenburg, Sweden; June; Nikon F3, Nikkor IF-ED 600mm f5.6, 1/250 sec @ f5.6, Kodachrome 64; beanbag.

within the reserve. Access unrestricted apart from some areas during breeding summer months. Further information: Statens Naturvårdsverk, Nature Conservation Division, Box 1302, 171 25 Solna, Sweden. The bird observatory has limited accommodation and is usually fully booked in spring, summer and autumn; bookings: Ottenby Fågelstation, PL 37, 380, 66 Ventlinge ☎ (0485) 600 80. Other accommodation available at Ottenby Youth Hostel and some rented cottages; bookings: Ölands Turistförening, Box 115, 380 70 Borgholm ☎ (0485) 302 60. No camping allowed within the reserve but there is a site at Sandvik about 20km away.

🐦 Migration is excellent in spring and autumn. Numerous passerines in April including chaffinch, brambling and linnet. Spring waders include whimbrel, bar-tailed godwit, spotted redshank, knot, greenshank and dunlin. Breeding birds begin to arrive in May, with many rarities; avocet, ruff, dunlin, pintail, velvet scoter, eider, corncrake, Montagu's harrier and hobby. Ottenby Lund, the area of birch, aspen and oak woodland at the northern end of the reserve contains breed-ing icterine warblers and red-breasted fly-catcher. Other breeding species include red-backed shrike, barred warbler, wryneck and Arctic tern. The return wader migration starts in July, peaking August and September. September and October bring greylag, Brent and barnacle geese, cranes and birds of prey. Whooper and a few Bewick's swans arrive October. Owls, nutcrackers and cross-bills can turn up during November.

🐦 Late spring–autumn

WEST GERMANY

88. The East Frisian Islands

This group of islands with intervening sand and mudflats on the northern coast forms an area of wetland of international importance. There are twelve nature reserves, some of which hold significant populations of birds; all are important for migratory and breeding birds. This whole coast is worth investigating.

☛ By boat from Norden and other locations along the coast; enquire locally for departure points and times for the various

islands. Permits required for most of the reserves; conditions of entry vary; enquiries: Bezirksregierung Weser Ems, Höhere Naturschutzbehörde, Postfach 2447, 2800, for Dollart, Lütje Hörn, Langeoog, Spiekroog–Ostplate, Elisabeth–Aussengroden; for Memmert: Inselvogt Reinhard Schopf, Bauamt für Küstenschutz, Jahnstrasse 1, 2980 Norden.

Further along the coast is the important Mellum island reserve which is reached from Wilhelmhaven. Access restricted 1 April–30 September; contact: Institut fur Vogelforschung, An der Vogelwarte 21, 2940 Wilhelmshaven. Accommodation available throughout the area.

Mellum Island Whilst not strictly in the East Frisian group this island is most conveniently discussed here. In late summer and early autumn, very large numbers of waders congregate here include redshank, grey plover, curlew and black-tailed godwit, amongst others; also a stopover point for shelduck in late summer. Winter brings Brent geese, snow bunting and shore lark.

Wangerooge Breeding birds include common, Arctic, sandwich and little terns, short-eared owl, oystercatcher, Kentish plover, shelduck and black-headed gull. Good numbers of waders pass through on passage.

Elisabeth–Aussengroden This coastal stretch holds large numbers of waders, especially redshank at migration times.

Speikeroog–Ostplate A sandbank with breeding redshank, oystercatcher, Kentish and ringed plovers, and little tern.

Langeoog Breeding species include a large colony of herring, and smaller numbers of common gulls, common tern, shelduck, redshank, curlew, black-tailed godwit and oystercatcher.

Memmert Apart from a large colony of herring gull there are breeding common gull, shelduck, redshank and oystercatcher.

Lütje Hörn Large colonies of herring and black-headed gulls.

The Dollart Situated in the Ems estuary; mudflats provide rich feeding grounds for large numbers of waders on passage.

📷 May–July for breeding species; July–

October for birds on passage; onwards for wintering birds

89. Nordfriesisches Wattenmeer
An enormous area of sandflats, islands, dunes and water – one of the most important European coastal stretches for birds. The ten islands are largely untouched and include sand cliffs with seabird colonies. A nature reserve is proposed but there are conflicting pressures. The whole area is well worth exploring and local enquiries will provide useful information.

🐦 Husum is a good base. Access unrestricted except for the Norderoog Bird Sanctuary where there are warden-accompanied visits April–August. There is also an information centre. Further information: Vogelwart der Hallig Noderoog, 2551 Hallig Hooge. Further information on the whole area: FVV Schleswig-Holstein, Niemannsweg 31, 2300 Kiel.

🐦 The Norderoog Bird Sanctuary holds a large colony of sandwich and Arctic terns; other birds include common tern, black-headed, common and herring gulls, redshank, oystercatcher, ringed plover, mallard and nesting shelduck in smaller numbers. The fields around Husum have breeding black-tailed godwit and ruff; marsh harrier, colonies of black-headed gull and small numbers of avocet breed in the reedbeds. White storks breed in the town itself. The area as a whole attracts vast numbers of waterfowl, particularly in winter, with barnacle and Brent geese, knot, and bar-tailed godwit. Waders and wildfowl also pass through on migration.

📷 All year

YUGOSLAVIA

90. Hutovo Blato
Part of the extensive marshlands of the Neretva delta which measures several kilometres across. Flooding occurs during the rainy season November–May, when it attracts overwintering duck species. Unfortunately land reclamation is threatening parts of the delta. Reedbeds and pools attract waterbirds – and photographers – the road along the south side of the delta is a good vantage point.

🐦 About 25km from coast, north of Dubrovnik; approach from Capljina, 14km north of Metković. Unrestricted access. Further information: Turistićk Savez Bosne i Hercegovine, Titova 80/1, 71001 Sarajevo.

An important sanctuary for migrating and overwintering birds. Over 230 species have been recorded; particularly well represented are purple, squacco, and night herons, spoonbill and great white egret; others include the usual waders such as little stint, Temminck's stint, wood and green sandpipers, ruff, greenshank, and marsh sandpiper. White-tailed eagles and pygmy cormorant may be seen, but probably do not breed any more. Bean geese usually found in winter.

All year

91. Lake Sas and Ulcinj Solanas

Lake Sas is a small lake about 5×2km between the coast and Lake Skadar, between the Rumija mountains and the Bojane River. Just south are the Ulcinj saltpans.

The lake is reached along fairly poor roads from the coastal towns of Bar or Ulcinj. No restrictions on access; a hotel overlooks the lake from the hillside. Permit necessary for Ulcinj, and apparently available locally. Some visitors, however, have not been allowed into the area even with a permit! An alternative is to explore the area east of Ulcinj near the Bojane estuary.

Nesting rock nuthatch around the hotel at Lake Sas. By the lake itself are breeding grey, purple and night herons, little egrets, a few pygmy cormorant, and spoonbill. Migration brings both black and white storks, shoveler, teal, pintail, teal, garganey and ferruginous ducks. Other birds include marsh harrier, hobby, short-toed eagle, red-footed falcon, glossy ibis, black-necked grebe, Caspian tern and black-eared wheatear.

The Ulcinj saltpans and the Bojane estuary are variably productive, some areas almost birdless; others maybe with many, especially at passage times. Little stint, green, wood and common sandpipers, ruff, dunlin, Kentish and little-ringed plovers, avocets, greenshank and marsh sandpiper; parties of pratincoles may also turn up. Common, little, and occasional Mediterranean gulls, little, gull-billed, black and white-winged black and Caspian terns. Other species include bee-eaters, roller, red-backed shrike, lesser grey shrike, and woodchat shrike and Spanish sparrow.

April–October

92. Petrovac

A coastal town in the Montenegro to the east of which is an excellent area of marsh and wet meadows just outside the village of Buljarica.

South of Titograd, about 130km east of Dubrovnik, on the main coastal road from Dubrovnik to Ulcinj, near the Albanian border. Accommodation theoretically unrestricted, but as in many places in Yugoslavia the military can be rather sensitive about visitors carrying cameras and binoculars.

Buljarica marsh attracts purple heron, squacco heron, little egret, garganey, marsh harrier, buzzard, red-footed falcon, wood sandpiper, black tern, bee-eater, golden oriole, wheatear, black-eared wheatear, lesser grey shrike, red-backed shrike, tawny pipit, short-toed lark, black-headed bunting, yellow wagtail, whinchat and alpine swift. Travelling east along the coast road to Bar there is a signpost for Canj; the rocky areas either side of the road hold breeding rock nuthatch. Other birds here include blue rock thrush, red-rumped swallow, nightingale, sombre tit, Bonelli's and Cetti's warblers. There is a hotel on the coast about 1km from the turning.

April–September

93. Tivat Salinas

Disused saltpans, estuarine mudflats, marsh, phragmites beds, and a rubbish tip make up this compact location in the Gulf of Kotor on the Adriatic coast. It has the advantage of being easily accessible and small enough to be worked realistically. The area is shown on most maps as Soliosko Polje.

Leave Tivat eastwards on the Magistrala towards Budra. About 4km outside the town is the civil airport. Turn right, past the airport, a cement factory, over two bridges, to a cafe. Access unrestricted but visitors have been watched closely by the police.

A good variety of birds include osprey, marsh and Montagu's harriers, booted eagle, honey buzzard, red-footed falcon, purple heron, grey heron, glossy ibis, squacco heron, little egret, little bittern, spoonbill, little gull, white-winged black, whiskered and Caspian terns, oystercatcher, ruff, avocet, black-winged stilt, redshank, greenshank, marsh, wood, and curlew sandpipers, little and Temminck's stints, Kentish, ringed, and little ringed plovers. Other birds include alpine swift, red-rumped swallow, black-headed bunting, red-backed shrike, tawny pipit, orphean, olivaceous, melodious, Sardinian and subalpine warblers.

Late April–September

13. Birds of Inland Fresh Water

Grebes, some cormorants, herons, egrets, bitterns, ibises, spoonbills, storks, swans, geese, ducks, eagles, hawks and allies, cranes, rails, crakes, some waders, some gulls and terns, swifts, swallows, kingfishers, pipits, wagtails, some warblers, some buntings, some corvids

Europe is rich in its tremendous diversity of freshwater habitats – from fast-flowing rivers and large lakes through to gravel pits, ponds and shallow, marshy areas – each supporting its own particular avifauna. The variety of species – resident, breeding or passing through – and the changing activities from season to season, make the larger, stiller expanses of freshwater challenging and productive for both behavioural and species studies.

The more private or isolated waters are ideal for hide photography either at or away from the nest. Reedy margins surrounding many stretches of water provide good camouflage for a hide – and are popular gathering or nesting areas for many birds. Permanent hides on established reserves may often be adequate for birdwatching with binoculars, but too distant for effective photographs, but where there are hides in the grounds of introduced bird collections, these are often very good for photography.

Time your freshwater sessions according to what you want to photograph – and keep in touch with the birdwatching grapevine and local information to catch the peak seasonal activities. Spring sees the start of the breeding season, and soon after the migrant birds begin to pass through, with occasional rarities turning up. Some birds take up

Mute Swan *(Cygnus olor)* and Coot *(Fulica atra)*, Berkshire, England; January; Nikon F3, Vivitar 70-210mm zoom f4.5, 1/125 sec @ f11, Kodachrome 64; stalked handheld.

territories on arrival and start courtship rituals prior to mating and nesting; others merely stop over before continuing their journey to their northern breeding areas. The breeding frenzy continues into summer; often there are two broods to fit in – and in the extreme northern areas, the breeding season has to be condensed into a particularly brief summer.

Autumn brings the return journeys – post-breeding flocks of birds heading south. At the same time, new arrivals from the extreme north escape their harsher winter conditions and fly in to join the residents. The magnitude and timing of their arrival depends upon the harshness of the coming northern winter.

Many freshwater areas are now protected as, or part of reserves. Some, such as the Wildfowl Trust in Britain, hold collections of wildfowl from all over the world in compatible surroundings; these are well worth a visit, especially as wild species tend to be attracted to the area as well. Don't eliminate leisure areas, where water sports intrude upon the scene; the resident wildlife may have become more approachable as a result, and you may even not need a hide.

Special techniques: see pages 38, 51, 54, 68

Equipment

35mm SLR	2× teleconverter	Shoulder pod
Spare body	Wide angle lens	Monopod
300–800mm telephoto lens	Hide, stool	Bean bag or car bracket
1.4× teleconverter	Tripod	Medium or slow film

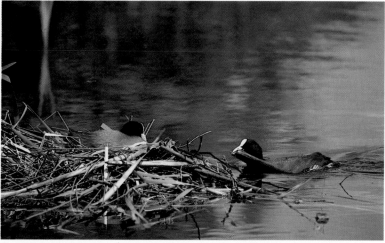

Coots *(Fulica atra)*, Berkshire, England; April; Nikon F3, Nikkor IF-ED 300mm f4.5 + Nikon 1.4× teleconverter, 1/125 sec @ f11, Kodachrome 64; stalked with monopod.

INLAND FRESHWATER

AUSTRIA

94. Neusiedler See

A large, shallow inland lake, 30×7.5km. With the smaller lakes and marshes that surround it, it is one of the three most important wetland areas in Europe. Exploration of the whole area, either by road or on foot, is worthwhile, including the smaller lakes of Langlacke, Zicklacke, the edges of Oberstinkersee and Unterstinkersee, the nearby vineyards, woodlands and plains.

☞ Situated in the east of Austria, close to the Hungarian border; take Route 10 from Vienna to the village of Illmitz – which is a good base from which to explore the smaller lakes of the Seewinkel area on the east side of Neusiedler See, as well as Tadten plain near the Hungarian border. The western side of the lake is best explored from Rust. Campsites throughout the area and hotels and *zimmer-freis* in some of the villages. Access unrestricted apart from some strictly guarded reserves. Further information: Landesfremdenverkehrsverband für das Burgenland, Schloss Esterhazy, 7000 Eisenstadt.

☞ One of the easier species to photograph is the white stork which nests on the chimneys in many of the towns and villages. Rust is ideal, as the birds can usually be photographed at the nest from the church tower, which is open for a small free for an hour in the morning and three hours in the afternoon. The birdlife round the wetlands is truly spectacular, with a number of rare species being present amongst the 300 or so species on record.

Species you can reasonably expect to photograph especially around the smaller lakes and ponds, include white stork, spoonbill, golden oriole, Kentish plover, black-tailed godwit, avocet, wood sandpiper, red-backed shrike, crested lark, penduline tit, grey-headed wagtail and white wagtail. Other species may be more elusive but should include great white egret, purple heron, grey heron, bittern, little bittern, black-necked grebe, red-necked grebe, greylag geese, garganey, ferruginous duck, buzzard, marsh harrier, Montagu's harrier, black tern, common tern, Caspian tern, greenshank, redshank, ruff, curlew sandpiper, little stint, little crake, great reed warbler, Savi's warbler, moustached warbler and bearded tit. There are many other interesting species but a fair amount of luck is necessary to photograph them. Great bustards are found on Tadten plain

but seldom come close enough for photography.

📷 Mid April–July

BELGIUM

95. De Blankaart Nature Reserve

A few kilometres south of Diksmuide in Northern Belgium, some 30km from Ostend, the lake covers about 70ha and is listed in the Directory of Western Palearctic Wetlands, such is its importance for waterbirds.

The River Yser runs along the reserve boundary. There are extensive reed beds as well as floating reeds and the lake is surrounded by water meadows.

☞ Access from Woumen, 4km south of Diksmuide and about 20km north of Leper. The reserve has a visitor centre; guided walks available March–October. Some parts of the reserve are restricted. Further information from Federatie voor Toerisme in Oost-Vlaanderen, Koningen Maria-Hendrikaplein 27, 9000 Gent.

☞ Breeding birds include bittern, little bittern, great crested grebe, black-tailed godwit, marsh harrier, hen harrier, mallard, garganey, shoveler and pintail, great reed warbler, reed warbler, grasshopper warbler, Cetti's warbler and Savi's warbler. Within the reserve there is also a heronry containing over 100 nests. During the winter, several species of duck found on the lake, and during times of passage and winter, many waders.

📷 All year

96. Genk Nature Reserve

A small reserve consisting of a series of thirty-five lakes, originally designed for fish-farming. Extensive reed beds and sand dunes and marsh between the lakes. The surrounding area is heathland.

☞ Situated north of Liège in north-east Belgium. Approach from Genk or Hasselt. Permits required; obtain in advance from: The Conservateur, Genk Natuurreservaat, Kriekboomstraat 10, 3600 Genk.

☞ A total of 85 breeding species are on record for this small reserve while 153 species have been seen. Breeding birds of interest include marsh harrier, bittern, little bittern, long-eared owl, great crested and black-necked grebes, black and whiskered terns and nightjar. At times of passage, migrant waders and wildfowl also visit.

📷 Late April–July

BRITISH ISLES (including the Republic of Ireland) see also 140, 141, 144.

97. Arundel Wildfowl Trust
OS TQO20081

Well landscaped surroundings with areas of open water, grassland, and reedbeds, covering about 24ha. There's an attractive visitor centre with displays and a shop.

☛ About 1km off the A27 Chichester–Worthing road, and well signposted. Open daily 09.30–17.00hrs (or dusk, if earlier) – entrance free to Wildfowl Trust members. Further information: The Warden, Wildfowl Trust, Mill Road, Arundel, Sussex, BN18 9PB ☎ (0903) 883355.

☛ An extensive collection of captive pinioned wildfowl that has attracted many wild birds. From the observation hides which overlook the open water, reedbed, a wader scrape and marshy fields, it should be possible to photograph pochard, teal, tufted duck, shoveler, and wigeon in winter. Lapwing, redshank and bittern are possibilities and the passage brings other wader species. Bearded tit and Cetti's warbler are also found. Wild birds breed in many of the pens containing captive birds. Other likely subjects include pheasant, black-headed gull, water rail, jackdaw, chaffinch, sedge warbler and possibly reed warbler. Captive species also make good subjects if viewed from the right angle. During the summer many waterbirds feed their young on the various ponds around the reserve and are reasonably easy photographic subjects.

📷 All year

98. Dinton Pastures Country Park
OS SU785718

Flooded gravel pits, covering about 111ha. A good, properly-managed example of the many similar habitats in the country which are combined wildlife reserves and leisure centres – and have a very varied avifauna for the bird photographer. Disturbance to wildlife is kept to a minimum, and there are some reserved areas. Hide, nature trail and information centre.

☛ Off B3030 between Hurst and Winnersh close to A329(M) or from junction 10 of the M4 motorway north of Wokingham. Open all year, dawn to dusk. Entry free. Further details: The Warden, Dinton Pastures Country Park, Davis Street, Hurst, Wokingham, Berks, ☎ (0734) 342016.

☛ Good variety of birdlife throughout the year. Unsuitable for hidework, but much can be achieved by stalking, or simply sitting down quietly in a likely area and waiting for things to happen.

In spring breeding species arrive, including common tern, little ringed plover, cuckoo, sedge warbler, reed warbler, whitethroat and blackcap, and other resident birds such as great crested grebe, little grebe, Canada goose, mute swan, skylark, pied wagtail, wren, mistle thrush begin mating. Some waterbird nests are fairly well exposed at the water's edge and care is needed not to cause undue disturbance. It is possible to photograph activity at or near the nest by using the cover around the water margins. We have photographed coot at the nest in this way. Many of the birds are used to the visitors and have become relatively tame. Canada geese and common tern nest on the islands in the pits. Fine opportunities for flight shots of greylag and Canada geese, and for photographing mute swans and their young. In autumn there is a wader passage, but lack of suitable areas limits variety. Goldfinch and linnet feed on the thistle heads and siskins are found in the alders. Woodpeckers of all three British species are often seen but tend to be unapproachable. In winter a number of duck arrive, including teal, pochard, wigeon, gadwall, goosander, with occasional smew and ruddy duck.

📷 All year

99. Fairburn Ings
OS SE450278

Ponds and marshland next to the industrialized part of the Aire Valley, formed as a result of flooding and subsidence of old mine workings. Despite its unlikely appearance and setting this RSPB reserve has 240 species on record, of which 70 have bred.

☛ Immediately west of the A1, 3km north of Ferrybridge; access to the reserve and public hides at all times. Hides found via Cut Lane, Fairburn. The reserve information centre and hide are open at weekends 10.00–17.00hrs. Further details: The Warden, 2 Springholme, Caudle Hill, Fairburn, Knottingley, WF11 9JQ ☎ (0972) 83257.

☛ Fairburn Ings is noted for its wildfowl with the resident population including Canada geese, mute swan, gadwall, mallard, pochard, shoveler, tufted duck, teal, great crested and little grebe. Winter brings whooper swan, wigeon, goldeneye, goosander, scaup and smew, while large flocks of gulls roost on the slurry ponds and black-headed gulls breed. At passage times dunlin, green, wood and common sand-

piper, ruff and spotted redshank join resident redshank, lapwing, snipe, and little ringed plover. Large numbers of hirundines pass through in the autumn; black and little terns in spring. Hawthorn bushes along an area known as the 'cut' attract wintering fieldfare and redwing and some small breeding birds during spring and summer.

📷 All year

100. Grafham Water
OS TL148680

This large reservoir was flooded in the mid 1960s and was intended as a haven for wildfowl, but recreational pursuits have caused a fair amount of disturbance to the birds. It is still, however, one of the best inland reservoirs in England for winter wildfowl. The reserve, owned by the Bedfordshire and Huntingdonshire Naturalists' Trust, is at the western end of the reservoir where two streams enter, and encompasses areas of woodland, farmland and open water.

☛ The reservoir is about 1½km west of the A1 between St Neots and Huntingdon and well signposted at the Buckden roundabout. Access to the sanctuary by permit only. Hide open Sundays, September–February. Details from duty warden in the fishing lodge at Mander Car Park, West Perry, on the B661.

🐦 Goldeneye, long-tailed duck, smew, goosander, scoter and scaup, divers and grebes. Breeding species include great crested and little grebes, shoveler, shelduck, redshank, ringed and little ringed plovers, lapwing, skylark and yellow wagtail. Passage times bring a variety of waders as well as Arctic, black and common terns, occasional vagrants, and the more regular little gull.

📷 Autumn, winter

101. Kingsbury Water Park
OS SP204958

Despite its close proximity to Birmingham, the variety of wetland habitats at this park ensures a varied selection of birds throughout the year. Kingsbury is in the northern section of a series of flooded gravel pits; there are areas of reedbeds and willow swamp. Information centre (from which a leaflet is available), hides and nature trails.

☛ Follow signposts from the A4097 northeast out of Birmingham.

🐦 Breeding species include willow warbler, chiffchaff, blackcap, whitethroat and lesser whitethroat, reed, sedge, garden and grasshopper warblers. Hides overlook shallow lagoons, from which at times of passage,

you might see common sandpiper, greenshank, curlew and spotted redshank; occasionally marsh harrier, hobby and merlin; common and black terns. Other breeding birds include great crested and little grebes, lapwing, snipe and little ringed plover, as well as kestrel, kingfisher and tawny owl; mallard, teal, shoveler and tufted duck. In winter the water and meadow areas attract pochard, gadwall, pintail, goldeneye and wigeon, greylag and white-fronted geese; Bewick's swan, water rail, golden plover, and dunlin overwinter. Short-eared owl can also be expected in this season.

📷 All year

102. Loch Leven
OS NO150010

A National Nature Reserve covering 1580ha and one of the most important sites for wildfowl in Europe. Shallow water and surrounding farmland attract a variety of wintering species. The loch's six islands provide sites for the largest number of breeding duck in Britain.

☛ Permits for serious scientific projects only. Good views, however, from outside the reserve at various access points, particularly from the RSPB reserve at Vane Farm on the B9097 Balingry road which leaves the M90 motorway at junction 5; a picnic site on the same road; Kirkgate Park; Findatie and Burleigh Sands. It is forbidden to walk around the lock perimeter. Details from: The Warden, Vane Farm Nature Centre, Kinross, KY13 7LX ☎ (0577) 62355. Open weekends January–March; April–December daily except Fridays, or contact: NCC Warden, Benarty, Kinross, Tayside.

🐦 One of the main arrival points for pink-footed geese in autumn. Good flight shots should be possible if you choose your site carefully and they arrive during daylight. After resting, the geese disperse to feed in the surrounding fields. Greylag geese also arrive in reasonable numbers, while fewer whooper swan overwinter. Ducks including mallard, wigeon, tufted duck, shoveler, shelduck and gadwall nest on the islands but are rather inaccessible owing to restrictions.

📷 Late September–February

103. Loch of Strathbeg
OS NK063564

A large shallow lake, recently acquired by the RSPB because of its importance as a stopover for migrating wildfowl. The reserve covers 942ha and includes open water, marshes, dunes and woodland.

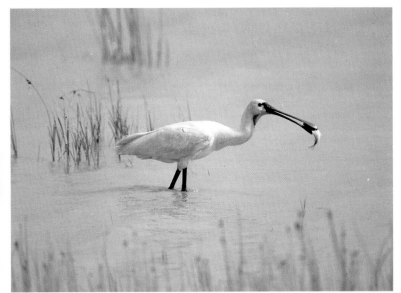

Spoonbill *(Platalea leucorodia)*, Neusielder See, Austria; June; Nikon F3, Nikkor IF-ED 600mm f5.6, 1/250 sec @ f5.6, Kodachrome 64; car bracket.

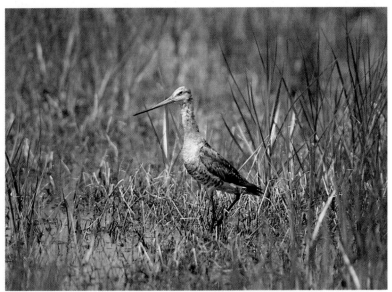

Black-tailed Godwit *(Limosa limosa)*, Neusielder See, Austria; June; Nikon F3, Nikkor IF-ED 600mm f5.6 + Nikon 1.4× teleconverter, auto @ f8, Kodachrome 64; stalked with monopod.

INLAND FRESHWATER

☞ Open all year Wednesdays and Sundays by prior arrangement only. Applications to: The Warden, The Lythe, Crimonmogate, Lonmay, Fraserburgh, AB4 4UB ☎ (0346) 32522. Access limited to the hides and reception area. Good views of the southern half of the loch can be obtained from the unclassified road which leaves the A952 between Blackhill and Gruinard and leads to the sea.

☛ Thousands of ducks, geese and swans visit the loch during the autumn. Some overwinter whilst others stop only for a short time before flying south. On occasions over 20,000 birds may be present. Wintering duck include mallard, tufted duck, wigeon, pochard, teal and goldeneye. Red-breasted merganser and goosander also visit. Both mute swan and whooper swan are usually present in numbers of up to 500. Visiting geese are mostly pink-footed and greylag with occasional barnacle. Other birds include short-eared owl which may be seen hunting over the reserve, and less commonly merlin and sparrowhawk.

📷 October–March

104. Lough Erne
OS HO07603

County Fermanagh is said to be more than one-third covered by water. The source is the River Erne which gradually opens out to form Upper Lough Erne, where there are a large number of small islands. The river then narrows again flowing past the town of Enniskillen before broadening out into Lower Lough Erne. Around this relatively small stretch there are many good spots. It is well worth exploring the area thoroughly in order to get the best from it.

☛ A good starting point is the B127 Lisnaskea–Derrylin road which crosses Upper Lough Erne. 3km outside Lisnaskea turn right to Kilmore Quay from where there are good views of the lough. There are also small unclassified roads leading to the edge of the lough.

☛ Upper Lough Erne is a particularly good spot for wintering wildfowl, with large flocks of mallard, wigeon, teal and smaller numbers of goldeneye and tufted duck. Large flocks of whooper swan are usually present in winter dispersing to feed in the nearby fields. Herons nest on some of the islands and there is a large cormorant roost on the small Lough Barry just north of Upper Lough Erne. Corncrake breed in the fields around Lough Erne. Other loughs well worth visiting for winter wildfowl are loughs Nead, Kilmore and Ross. Inishroosk, at the

southern end of Upper Lough Erne is good for whooper swan and dabbling ducks in winter, and in spring and summer, an important area for breeding waders including redshank, snipe, curlew and lapwing. The lower lough holds fewer winter wildfowl than the upper but does have breeding common scoter and red-breasted merganser in summer along the north-west shore. Further north at Drumgay Lough near Enniskillen you can get good views of wintering wildfowl such as great crested and little grebes, whooper swan, greylag and Canada geese, mallard, teal, pochard, wigeon, tufted duck and goldeneye.

📷 Spring, summer for breeding birds; winter for wildfowl

105. Martin Mere
OS SD428145

This small reserve, one of a chain of sanctuaries created by the Wildfowl Trust, has a collection of captive wildfowl species and important populations of wild birds. There is a reception centre.

☞ Approach from the B5246 between Rufford on the A59 Preston–Ormskirk road, and the A565 Preston–Southport road. Open daily, 09.30–17.00hrs, except 24, 25 December. Evening party visits by arrangement. Further information: The Warden, Wildfowl Trust Martin Mere, Burscough, Ormskirk L400TA, ☎ (0704) 895181.

☛ The man-made mere and surrounding marshland attract a wide range of wild birds augmenting the captive collection. The meadows are a wintering ground for approximately 10,000 pink-footed geese as well as whooper and Bewick's swans. Wintering duck include mallard, shoveler, gadwall, goldeneye, pintail, pochard, shelduck, tufted duck and wigeon. There are also large numbers of wintering teal. Waders include curlew, dunlin, bar-tailed and black-tailed godwits, greenshank, golden plover, grey, ringed and little-ringed plovers and large numbers of wintering ruff. Hen harrier are fairly common, marsh harrier sometimes seen, and short-eared owl occur in winter. Many of the pinioned ducks make good portrait shots provided the clipped wing is away from the camera.

📷 All year

106. Rutland Water
OS SK876072

The second largest man-made lake in England, which despite its relatively recent completion, is nationally important for its wild-

fowl, mainly because it is close to migration routes along the rivers Nene and Welland. It is also carefully planned and managed as a wildlife reserve.

☛ Situated east of Oakham, and signposted from the A606 Stamford road or the A6003 to Uppingham. There are three parts to the reserve. The Burley Fishponds in the northern section is not open to the public. The middle section is open to permit holders or members of the Leicestershire and Rutland Trust for Nature Conservation. Details from: The Warden, Fish Ponds Cottage, Stamford Road, Oakham, Rutland, Leics ☎ (0572) 4101. The southern section of the reserve is open to all. There are hides in both the middle and southern sections.

↝ Well known for the wintering grebes, with all five species on the British list recorded. Up to 1000 great crested grebe can be present, forming the largest concentration ever recorded in Britain. Photography of these and other wildfowl is best during hard winter spells when the water is frozen. Breeding water birds include Canada geese, ruddy duck, greylag geese, great crested and little grebes, mute swan, mallard, shoveler, tufted duck, gadwall, pochard, coot and moorhen. The spring and autumn wader passage is very good with curlew, common, green and wood sandpipers, dunlin, ruff, greenshank, redshank, spotted redshank, and little stint. Others include curlew, snipe, and ringed plover and the occasional bar-tailed and black-tailed godwits. Oystercatcher, ringed and little ringed plovers and snipe all breed. Other breeders include pheasant, partridge, red-legged partridge and a good variety of smaller birds.

Golden plover, jack snipe, woodcock and ruff all winter here. Wintering wildfowl may number up to 9000 goldeneye, red-throated, black-throated and great northern divers amongst them.

📷 Spring, autumn and winter

107. Titchwell Marsh
OS TF749436

A 206-ha reserve of salt and freshwater marshes, foreshore and reedbeds. Positive RSPB management has considerably increased the species diversity.

☛ At all times along from the seawall car park to the new hides overlooking the marshes. Hides closed Wednesdays. Reserve entrance about half way between Thornham and Titchwell on the A149. Visitors centre open April–October at weekends, May–

August, Mondays and Thursdays. Enquiries: The Warden, Three Horseshoes Cottage, Titchwell, King's Lynn, PE31 8BB ☎ (0485) 210432.

↝ New breeding species include bittern, marsh harrier, avocet and bearded tit. Other species include dunlin, ringed plover, redshank and ruff, curlew sandpiper, little stint, bar-tailed and black-tailed godwit, rarities such as Baird's and white-rumped sandpipers and non-breeding spoonbills, black tern and little gulls. In winter good numbers of waders and duck and harriers roost in the reed beds. Hides with good views over the marsh are well suited to photographing waders on spring and autumn passage. 500mm or 600mm lens usually necessary but a 300m lens may be adequate for a large wader such as a godwit. Thriving colony of little tern on the beach (with special hides for nest viewing – whether they are close enough for photography varies each year).

📷 August–October, mid-March and mid-September (equinoctial tides) for huge flocks of waders forming high tide roost on the foreshore

108. Tring Reservoir
OS SP918137

This series of reservoirs forms an important wildlife refuge in chalkland where open water is unusual. The 19-ha NCC reserve includes the banks, woodland and open water of four reservoirs. The leisure activities, including fishing seem to have had little effect on the varied wildlife.

☛ Take the B489 to Ivinghoe from Aston Clinton, which is on the A41 Aylesbury–Tring Road. No permit required, but access is restricted to the footpaths which give excellent views of all the reservoirs. Public hides overlook Tringford and Wilstone reservoirs.

↝ In the spring, great crested grebe, little grebe, coot and moorhen breed and herons build nests at ground level in the reedbeds. Other breeding wildfowl include Canada geese, mute swan, mallard, tufted duck, shoveler and pochard. Smaller breeding birds are reed bunting, corn bunting, pied wagtail, reed and sedge warblers. Numerous migrants including sanderling, ringed and little ringed plovers, black-tailed and bar-tailed godwits. The autumn migration brings ruff, redshank, greenshank, green and common, and sometimes wood sandpipers which feed on the exposed muddy areas.

In winter, large numbers of duck include mallard, pochard, teal, shoveler, tufted duck,

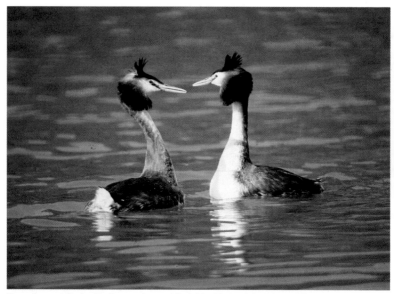

Great Crested Grebe *(Podiceps cristatus)*, Berkshire, England; April; Nikon F2, Nikkor Mirror 500mm f8, 1/500 sec @ f8, Ektachrome 200; beanbag.

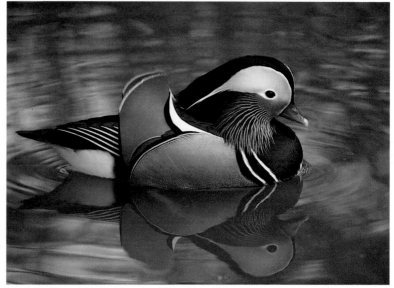

Mandarin *(Aix galericulata)*, Arundel, Wildfowl Trust Reserve, Sussex; April; Nikon F3, Nikkor IF-ED 300mm f4.5, auto @ f5.6, Kodachrome 64; stalked with monopod.

wigeon and maybe goldeneye and pintail. Some Bewick's swans fly in and may be joined by greylag geese and goosander. A large gull roost with black-headed, herring and common gulls is characteristic of winter evenings.

📷 Spring, autumn and winter

109. Virginia Water
OS SU962687
This lake in Great Windsor Park supports a number of common species and is the British stronghold for mandarin duck. Hundreds of visitors pass through the park at weekends. Many of them feed the wildfowl which have consequently become tame.

☛ Blacknest Gate car park on the A329 Ascot road or the Wheatsheaf car park on the A30 Staines–Bagshot road. No permit required. Open all year.

☞ The highest number of wild mandarin duck in the country. During hard winter spells, they come in quite close to the banks, and often a 300mm lens is adequate. Other birds include great crested grebe, Canada geese, mallard, tufted duck, mute swans, black-headed gulls, wigeon, shoveler, and pochard. In the wooded areas, nuthatch, treecreeper and woodpecker are a possibility. Photography from the car in the car parks is possible for robin, blue, great and coal tits, nuthatch, jay, chaffinch, dunnock, blackbird, magpie, redpoll and siskin. Other woodland birds may be seen.

📷 All year; winter for mandarin

110. Welney
This area encompasses the Ouse Washes – the area between the Old and New Bedford rivers that becomes flooded during winter. The flood waters are contained by the high banks beside the two rivers, but at their peak cover the extensive grasslands with several metres of water. They are usually shallower, making the area extremely attractive to wildfowl in winter. The RSPB, Wildfowl Trust, and Cambridge and Isle of Ely Naturalists' Trust all own areas of land within the washes and have established superb reserves here. Worth a number of visits.

While there are many possible points of access the most productive areas are the three reserves.

☛ For the Wildfowl Trust Reserve (*OS* TL539933) take the A1101 from Littleport. After about 6km turn north along the high embankment beside the Hundred Foot Drain. Follow Wildfowl Trust Reserve signs. Open daily, except Christmas, 10.00–

17.00hrs. Entry to excellent hides free to Wildfowl Trust members; charge for non-members; the main one (members only) is centrally-heated and glass-fronted. Overnight accommodation available. Enquiries: The Warden, Pintail House, Hundred Foot Bank, Welney, Wisbech, Cambs, PE14 9TN, ☎ (0353) 860711.

The RSBP Reserve (*OS* TL471861) is signposted from Manea village on the B1093, a turning off the A141 Charteris–March road. Access to public hides at all times; approach by marked paths behind the boundary bank. Visitor centre and car park. Enquiries: The Warden, Limosa, Welches Dam, Manea, PE15 0ND ☎ (035478) 212.

The Cambridge and Isle of Ely Naturalists' Trust also has three public hides.

☞ Up to 3000 Bewick's swan overwinter and provide excellent opportunities for individual portrait, group or flight shots. Small numbers of whooper and mute swans, and grey geese arrive in winter. The winter wildfowl numbers on this reserve are astounding with up to 40,000 wigeon and several thousand mallard, pintail, pochard, teal and smaller numbers of gadwall, shoveler, shelduck, and tufted duck some of which breed here. Photographs of all these species either in flight or feeding should be possible. There is a wader scrape with adjacent hide and possible subjects include lapwing, golden plover, redshank, ruff, snipe, wood and green sandpipers and black-tailed godwit. The reserve's best-known breeders are black-tailed godwit and ruff. In winter, short-eared owl and hen harrier may be sighted by the patient and watchful photographer. The former may often be seen outside the reserves, hunting along the raised banks of the Washes. Using a car as a hide, good shots are possible.

📷 Winter for wildfowl; spring, summer and autumn for other species. The light is behind the hides in the mornings at the Wildfowl Trust reserve and behind the hides at the RSPB reserve in the afternoons. However, afternoon visits to both reserves are worthwhile with the prospect of some superb atmospheric shots.

FINLAND See also 148, 150, 177, 178.

111. Parikkala
The area is close to the Soviet border and provides opportunities to see birds which breed nowhere else outside Russia. It is a patchwork of lakes and marshes with some

woodland and agricultural land, and the World Wildlife Fund reserve at Siikalahti near to Parikkala is well worth a visit for typical marshland breeding species.

☛ Parikkala lies near the main road number 6. Accommodation is sparse but may be found in other villages within the general area.

☛ The speciality is Blyth's reed warbler which may be found around the edge of the lake near the village. Other birds found are pintail, garganey, shoveler, pochard, marsh harrier, osprey, hobby, spotted crake, great crested grebe, little gull, thrush nightingale, sedge warbler, scarlet rosefinch, and ortolan bunting.

📷 June–July

FRANCE

112. Le Lac de la Forêt d'Orient Nature Reserve

As well as a large man-made lake, there are wooded hills and pastures. A popular weekend vacation spot during the summer.

☛ East of Troyes in the Champagne district of France some 180km south-east of Paris. A road around the lake allows access at various points, all apart from the ornithological reserve which is closed to visitors. Accommodation plentiful in St Ozier or Troyes and campsites around the lake.

☛ A main wintering site for bean geese in Western Europe, with around 1000 usually present by February. Cranes roost in the shallows in early morning before flying off in parties to feed in surrounding fields. Flight shots are often possible. From the minor roads around the lake individuals or groups in nearby fields can be photographed. In recent years white-tailed eagle have wintered here and at any one time there are usually two or three around.

The lakes to the north of Lac de la Forêt d'Orient are also worth searching for these and other species. Other wildfowl found on lakes include whooper and Bewick's swan, shelduck, ruddy shelduck, ferruginous duck, scaup, smew, goosander, pochard, mallard, wigeon, teal and goldeneye. Other birds of interest are red-necked and great crested grebe, grey heron, red kite, buzzard, goshawk, fieldfare, hawfinch, great grey shrike, firecrest and Cetti's warbler.

📷 Autumn, winter, spring

113. Villars-les-Dombes Nature Reserve

A collection of ponds and lakes between the Saône and Ain rivers north-east of Lyon near Villars-les-Dombes. Most of the ponds are shallow and surrounded by reedbeds; some are used for fish culture. The land is agricultural or afforested. An area is set aside for a collection of caged birds as well as many free-flying species.

☛ Approach from the town of Villars-les-Dombes which is about 30km from Lyon. Part of the reserve, set aside for biological research is closed to visitors, elsewhere access is unrestricted. Many of the ponds outside the reserve can be viewed from the roads. Further information: Parc Ornithologique départementale de la Dombes, 01330 Villars-des-Dombes. Hotels and camping in Villars.

☛ The ponds hold an interesting variety of breeding birds including purple, grey, night and squacco herons, bittern, little bittern, little egret, red-crested pochard, garganey, gadwall, shoveler, spotted crake, black-necked grebe, black-winged stilt, black tern, whiskered tern, great reed and fan tailed warblers. Montagu's harrier, marsh harrier, black kite and goshawk are also found.

📷 April–September

GREECE

114. Lake Koronia

A shallow lake, 10km × 5km, reed-fringed in parts. The surrounding land is mainly agricultural, open areas with some trees and scrub. The variety of birdlife largely depends upon the water level, which can vary quite markedly. When high, there's a preponderance of herons, while low water attracts waders to the muddy rim.

☛ Take the Thessaloníki–Kavála road east for about 15km. The lake is best seen from the road at the village of Agois Vassillios on its southern edge where there's a car parking space on the shore. Hotel accommodation is widely available in Thessaloniki and numerous tavernas along the way. Access unrestricted. The lake perimeter should also be explored at other points via rough tracks leading off the main road.

☛ At high water night, squacco, purple and grey herons, little egret, little bittern very much in evidence. White storks nest locally and are commonly seen. Dalmatian and white pelicans, glossy ibis and pygmy cormorant are particular attractions. Waders include avocet, black-winged stilt, Kentish plover, greenshank, redshank, marsh and green sandpipers, little and Temminck's

stints. Other birds include buzzard, lesser-spotted eagle, lanner and Eleonora's falcon, hoopoe, bee-eater, roller, red-backed shrike, lesser grey shrike, woodchat shrike, black-headed bunting, cirl bunting, rock bunting, Spanish sparrow, alpine swift, pallid swift, Calandra lark, Caspian and whiskered terns, Savi's, Cetti's, subalpine and great reed warblers, penduline tit and red-throated pipit.

📷 April–October; autumn passage for waders

115. Lake Mikri Préspa National Park

On the Albanian, Yugoslav and Greek borders, the park was relatively unknown until recently. Many parts of the shallow lake are rather inaccessible apart from the northern end. Many roads lead to the lake shore, and large areas of reed swamp and shallow lagoons, which support an interesting variety of aquatic birds.

🛪 In the north-west of Greece, the nearest sizeable towns being Flórina or Kastória. A convenient base is Laimos which lies within the reserve and offers basic accommodation. Access to the reserve unrestricted except for a military zone on the western shore. Further information: Tmina Dason, 1 Arti 42, Flórina.

🛩 Best known for breeding populations of Dalmatian and white pelicans; also spoonbill, cormorant and pygmy cormorant, grey, purple, night and squacco herons, little bittern, great white and little egrets, glossy ibis, black-necked grebe, goosander, red-backed shrike, penduline tit, moustached warbler, subalpine warbler, reed warbler and great reed warbler. Tufted duck, pochard, garganey, great crested and little grebe, little gull, marsh harrier, hobby, goshawk, water rail, black-tailed godwit, Caspian and whiskered terns, alpine swift, hoopoe, black-headed wagtail, bearded tit, little owl, golden oriole, bee-eater and lesser grey shrike amongst many others.

📷 April–October

116. Lake Mitrikon

Lake Mitrikon lies to the east of Porto Lago (another important wetland area, included separately in this section). It is a shallow lake with quite extensive reedbeds and surrounding scrub and small areas of woodland.

🛪 From the village of Pagouria, south-west of Komotiní on the main E5 route, drive east for about half a kilometre, turn south on to a rough track on the right, signposted to the

beach at Molivoti. The lake lies about 7km from here, and can be explored from a rough track to the west and an embankment to the east. Access unrestricted.

🛩 Aquatic species are well represented with purple, grey and squacco heron, spoonbill, glossy ibis, greater flamingo, pygmy cormorant, white stork, ferruginous duck, garganey and marsh harrier. Good numbers of waders are seen from the embankment especially on migration, with black-winged stilt, Kentish plover, curlew sandpiper, black-tailed godwit, dunlin, little stint, wood and green sandpipers, redshank, spotted redshank, lapwing and little ringed plover. Other species include mute swan, little grebe, coot, golden oriole, bee-eater, roller, little and whiskered terns, white-winged black tern, tawny pipit, short-toed lark, Spanish sparrow, skylark, red-throated pipit, black-headed and blue-headed wagtails, great reed warbler, Icterine warbler, oliv-aceous warbler, Cetti's warbler, nightingale, semi-collared flycatcher, red-backed shrike and collared pratincole.

📷 April–September

ICELAND

117. Lake Mývatn

A large lake in a volcanic area among lava flows. It is surrounded by extensive marsh dotted with smaller lakes and luxuriant vegetation. Midges, which form an important part of the food chain supporting the large numbers of breeding wildfowl, are a constant source of irritation to the photographer during summer. The whole area is worth exploring carefully.

🛪 Lake Mývatn lies some 42km from the coast and is reached by road from Húsavík or Grímsstadir. Access is unrestricted except 15 May–20 July when the north-west shore is off limits. There are hotels within the immediate area and campsites at Skútustadir and Reykjahlid. The site is wardened and there are marked trails. Further information from Náttúruverndarrád, Hverfisgötu 26, 101 Reykjavík.

🛩 Lake Mývatn has the largest breeding population of duck in Europe. As many as sixteen species breed here, three of which are American and breed nowhere else in Europe. The latter are the harlequin duck, which nests along the Laxa River, about 1000 pairs of Barrow's goldeneye and more recently a few American wigeon. The great northern diver also breeds on the more

isolated upland lakes. The area also supports large populations of breeding Slavonian grebe, red-necked phalarope and Arctic tern. Amongst the large list of other birds found are whooper swan, greylag goose, mallard, wigeon, gadwall, teal, shoveler, pintail, scaup, tufted duck, pochard, common scoter, long-tailed duck, goosander, red-throated diver and gyr falcon. In particular the visitor should visit the marshy area in the north-east, the Laxa river and the lava fields and sulphur pools in the east.

📷 Late May–July

118. Thingvellir National Park
This park centres upon the largest lake in Iceland, Thingvallavatn famed for its surrounding volcanic landscape and richly vegetated lava flows, and marshes.

🐦 The park lies about 50km north-east of Reykjavík and is reached from Thingvellir. Access unrestricted and there are marked paths within the park. There is a hotel in Thingvellir and camping in the area. Further information: Iceland Tourist Bureau, Reykjanesbraut 6, Reykjavík.

➤ Whilst this location cannot compare to Lake Mývatn for its spectacular number of breeding birds, it does hold three particularly interesting species. Black-tailed godwit breed in the marshy areas and great northern diver also breed. The rivers flowing into the lake hold harlequin duck. Other birds include whooper swan, goosander, ptarmigan, greylag geese, tufted duck, scaup, whimbrel, golden plover, snow bunting and Arctic tern. Barrow's goldeneye sometimes breed also. Birds of prey include gyr falcon and merlin.

📷 May–July

119. Naardermeer
A large natural lake surrounded by large reed beds, alder and willow fen.

🐦 Situated about 16km south-east of Amsterdam. Leave Amsterdam on the Amersfoort road turning right about 3km after crossing the River Vecht. Turn right again, travelling parallel to the main road, and after about 1km turn right on a small road to the warden's house. Further information on permits and boat trips: Vereniging tot Behoud van Natuurmonumenten in Nederland, Herengradt 540, Amsterdam – C.

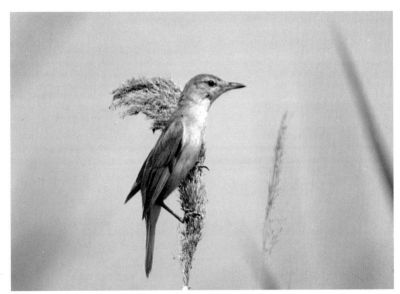

Great Reed Warbler *(Acrocephalus arundinaceus)*, Camargue, France; June; Nikon F3, Nikkor IF-ED 300mm f4.5 Nikkor + Nikon TC300 2× teleconverter, Kodachrome 64; beanbag.

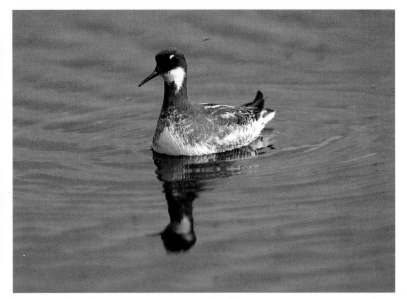

Red-necked Phalarope *(Phalaropus lobatus)*, Varanger Peninsula, Norway; June; Nikon F3, Nikkor IF-ED 600mm f5.6, 1/250 sec @ f5.6, Kodachrome 64; stalked with monopod.

The special attractions are breeding populations of spoonbill and purple heron but the many other species include bittern, little bittern, grey heron, cormorant, red-crested pochard, pochard, garganey, marsh harrier, black-tailed godwit, black tern, great reed, grasshopper and Savi's warblers, bearded tit and golden oriole.

May–July

NORWAY See also 155, 198.

120. Fokstumyra National Park
Predominantly marshy land in the Fokså River valley in southern Norway, near the Rondane and Dovrefjell national parks. There are areas of woodland, lake and open fjell as well as birch forest outside the reserve, all well worth exploring for the rich birdlife.

Adjacent to the main E6 route, approach from Fokstua some 10km north-east of Dombås. Marked trails open all year 07.00–23.00hrs, but the rest of the reserve may be closed off 30 April–8 July. Further information: TTK Oppland, Kirkegt, 74, 2600 Lillehammer. Access outside the reserve unrestricted. Camp-

sites and hotel accommodation in the vicinity.

The main attraction is probably the few pairs of cranes, but these are well protected during the breeding season.

Other breeding birds (which number over fifty species) are lesser white-fronted geese, red-throated diver, hen harrier, rough-legged buzzard, peregrine, whimbrel, red-necked phalarope, dotterel, golden plover, ruff, purple sandpiper, Temminck's stint, great grey shrike, ring ouzel, fieldfare, bluethroat, brambling, siskin, redpoll, snow bunting, Lapland bunting, shorelark, dipper, common gull and great snipe may breed.

June–July

PORTUGAL

121. Paul do Boquilobo Nature Reserve
Freshwater marsh in the River Tagus valley to the north-east of the town of Santarem. This reserve is important for its heronry. There are extensive reedbeds around the lake as well as some tree cover in the form of poplar and willows.

Situated north-east of Santarem, the nearest town to the reserve is

Entroncamento, a few kilometres to the north. Access unrestricted. Further information: Serviço Nacional de Parques, Reservas e Patrimónío Paisagistico, Rua da Lapa 73, 1200 Lisbon.

🐦 The most important feature of this reserve is its heronry which contains little egret, cattle egret, night and squacco herons during the breeding season. Several thousand duck overwinter including mallard, pintail, shoveler, gadwall and teal. Other waterside birds include coot and moorhen.

📷 May–July

SPAIN See also 84, 203.

122. Tablas de Daimiel National Park

A wetland reserve of shallow water with marshland, reedbeds, mixture of brackish and fresh water and a lot of small islands. Round the edge of the park are the only trees – *tamarix gallica* – then agricultural land with vines and cereals.

🐦 Situated about 120km south of Madrid and about 30km north-east of Ciudad Real; approach from Daimiel. Open Wednesday–Sunday, 09.00–20.00hrs in summer; 10.00–17.00hrs in winter, the park is wardened and there are nature trails, observation towers and an information centre. Further information: Parque Nacional de las Tablas de Daimiel, Servicio Provincial de ICONA, Avenida de las Mártimes 31, Ciudad Real.

🐦 Nationally important for breeding and overwintering ducks, there are over 1000 breeding red-crested pochard; other breeding species include mallard, garganey, gadwall, marbled teal and pochard, little egret, bittern, purple and night herons, black-necked grebe, water rail, bearded tit, Savi's warbler, Kentish plover and black-winged stilt. Migrant waders such as avocet, redshank, ruff, dunlin, little stint, black-tailed godwit, common and wood sandpipers, ringed and little ringed plovers pass through in good numbers. Raptors include marsh harrier and Montagu's harrier.

📷 All year

SWEDEN See also 156.

123. Annsjön

A large shallow lake on a plateau in central Sweden, about 500m above sea level. The surrounding area includes peat marsh, birch and pine woods, streams and moraine.

🐦 Next to the village of Ånn on the E75 between Östersund in Sweden and Trondheim in Norway. Train services from major stations in Sweden and Norway to Ånn or Enafors. Youth hostel just over 1km from Ånn station, open mid June–late July, bookings: STF:s Vandrahem, 830 15 Duved ☎ (0647) 71071. Just off the E75, then from Ånn, there is a campsite with cabins to let. No hotels in Ånn, but two in Enafors about 12km away.

🐦 The peat marshes hold breeding crane, whimbrel, golden plover, wood sandpiper and sometimes broad-billed sandpiper. Nesting Temminck's stint found on the east side of the lake. The lake shores have breeding black and red-throated diver, goldeneye, velvet scoter, common scoter and scaup. Red-necked phalarope nest in the delta near Handöl and some parts of the lake shore. The pine and birch woodlands hold breeding capercaillie, willow grouse, black grouse, Siberian jay, three-toed wood-pecker and great-grey shrike. Raptors include rough-legged buzzard, osprey, goshawk and merlin.

📷 End May–late June

124. Hjälstaviken

Probably one of Sweden's best-known nature reserves, consisting of open water, rushes, an extensive reedbed and some coniferous woodland.

🐦 Situated about 60km from Stockholm, near to the main E18 from Stockholm to Västerås. Car parking facilities. Hotels in nearby Enköping and a campsite just south of there. Access may be restricted March–July during the breeding season.

🐦 There are about eighty breeding species, including great crested grebe, bittern, garganey, water rail, spotted crake, long-eared owl and ortolan bunting amongst many others. Ospreys nest nearby and fish in the lake.

Numerous waders on passage; bean geese present on both spring and autumn migrations, using the lake as a roost and feeding on the surrounding fields. Raptors on passage include rough-legged buzzard, sparrowhawk, hen harrier and hobby. Bluethroat and red-throated pipit are regular visitors in autumn.

📷 May–early June for breeding birds; spring and autumn for others

125. Hornborgasjön

A large shallow lake, rather less attractive to birds since attempts at drainage some years

ago, but still notable as a stopping off point for migrating cranes.

☛ Off the main E3 Gottenburg–Stockholm road. Turn off at Skara, about 130km from Gottenburg. Hotels in Falköping and Skara and campsites open June–September.

🐦 About fifty breeding species within the area, including black-necked and Slavonian grebes, bittern, garganey, spotted crake, corncrake, marsh harrier, osprey, wood sandpiper, ruff, and grasshopper warbler. Cranes are the main attraction, however, and in April 2500–3000 birds may be present. They roost on the lake but generally feed in potato fields at Bjurum several kilometres away. Flight shots possible as they fly from the lake at sunrise and return at dusk, from the road between Dagsnäs and the church at Bjurum. The largest flocks are seen during the evening.

📷 Approximately middle two weeks of April for cranes; April–June for breeding birds

126. Tåkern

A shallow lake in southern Sweden which achieved ornithological importance because of man's intervention. During the last century the water level in the lake was lowered, allowing large reedbeds to develop so encouraging the growth of food plants for duck.

☛ Take the E4 road north from Värnamo; at Ödeshög take road 50 to Vadstena. Further information: Statens Naturvårdsverk, Nature Conservation Division, Box 1302, 171 25 Solna. Campsite 2km north of Vadstena open 1 June–1 September; enquiries: Vaterviksbadets Camping, 592 00 Vadstena ☎ (0143) 40088.

🐦 Breeding birds of interest are little, great crested, red-necked and Slavonian grebes, bittern, garganey, marsh harrier, osprey, spotted crake, black tern, icterine, and great reed warblers, parrot crossbill and six wader species. Massive numbers of duck visit the lake, peaking in October. Species to be found include mallard, pintail, scaup and goosander. Up to 35,000 bean geese with some white-fronted geese arrive in spring and autumn using the lake as a roost and feeding in surrounding fields during the day.

📷 April–October

SWITZERLAND

127. Klingnauer Stausee Nature Reserve

Although close to industrial and urban development on the lower reaches of the River Aare, the reserve is of international importance for wintering waterfowl. The northern end of the lake is dammed while the southern end has areas of mud and reedswamp.

☛ Situated close to the West German border about 40km north of Zürich. Access is unrestricted. Further information: Swiss League for Nature Protection, PO Box 73, 4020 Basel.

🐦 More than 250 species have been recorded. Breeding birds include red crested pochard, black-headed gull and terns. During migration good numbers of waders pass through including a number of rarities. The major attraction is the wintering duck which include mallard, gadwall, teal and pintail amongst others.

📷 All year

128. Lac de Neuchâtel

The borders of Lac de Neuchâtel, especially at the northern end, make this the most important wetland in Switzerland, indeed the only one on the Ramsar list of wetlands of international status. At the northern end is the small reserve at Le Fanel which includes open water, extensive reedbeds, marshland and some woodland. Artificial islands have been constructed near the shore and have attracted some breeding birds.

☛ 30km west of Bern, easily reached from Neuchâtel. Access unrestricted. Plenty of accommodation available and there is a campsite nearby. Further information: Verkehrsverband Berner Mittelland, c/o Offizielles Verkehrsbüro der Stat Bern, Bahnhofplatz 10, Postfach 2700, 3001 Bern.

🐦 The shallow water margins are very attractive to migrant waders and the open water holds large numbers of duck in winter including tufted duck, pochard, goldeneye and goosander. The reedbeds hold breeding purple heron, little bittern and great reed warbler. Birds of prey include black kite and marsh harrier. The wooded area has crested tit, pied flycatcher and Bonelli's warbler. The artificial islands attract breeding black-headed gull and terns.

📷 April–October

WEST GERMANY

129. Bodensee Nature Reserves

A series of reserves around the Bodensee on the borders of Germany, Switzerland and Austria. Bodensee connects with two other lakes, Untersee and Obersee, and is crossed

by the River Rhine. The most important reserves are Wöllmatinger Ried, Mindelsee and Eriskircher. Surrounding the lakes are damp meadows and peat bogs which support an interesting flora.

☛ Approach from Konstanz on the Swiss/German border. Accommodation widely available in this area. Access unrestricted. Information centre at the Mindelsee reserve open most days; further information in Mindelsee contact BUND—Naturschutzzentrum, Muulbachstrasse 2, 7760 Radolfzell – Mögginen. Further information on the Wöllmatinger Ried reserve: DBV – Naturschutzzentrum, Wöllmatinger Ried, Fritz – Arnold–Strasse 2e, 7750 Konstanz.

🐦 A splendid variety of breeding aquatic birds which utilize the reedbeds and shallow lagoons around the lakes. Breeding species include great crested and black-necked grebes, black-headed gull, common tern, bittern, little bittern, spotted crake and little crake to name a few. Eight species of breeding duck include red-crested pochard and garganey. In winter there are good populations of duck including mallard, shoveler, teal, gadwall, pintail, pochard, red-crested pochard and tufted duck. Up to 200,000 birds overwinter on the Bodensee. At passage times good numbers of waders pass through and some breed.

📷 All year

130. Dummer Nature Reserve

A large shallow lake in a glacial valley with reedswamp and marshland, sand dunes, raised bog, open meadows and some woodland. Wide tracts of water-lilies surround part of the lake shore.

☛ Situated just over 100km from Hanover, 45km north-east of Osnabrück and easily reached from Lembruch on the Osnabrück–Diepholz road. Access unrestricted; camping facilities at Lembruch.

Further information: Verien Naturpark Dummer e.V. Niedersachsenstrasse 2, 2840 Diepholz.

🐦 Over 130 breeding species including white stork, bittern, little bittern, marsh harrier, black tern, spotted crake, bearded tit, black-tailed godwit, curlew and ruff which all nest in small numbers. Breeding duck species include garganey, pintail, teal, gadwall, shoveler and pochard. Dummer is also an important migrating staging post and overwintering area for duck, with as many as thirty duck species on record.

The wooded area contains typical woodland birds. Raptors passing through include

good numbers of buzzards and some osprey and hen harrier.

📷 All year

131. Federsee Nature Reserve

Between Lake Constance and the River Danube, this is an area of open water with surrounding reedbeds and peatland. There is a boardwalk through the reedbeds. Over the years, reclamation has reduced the size of this wetland although it remains an important area for water birds in south-west Germany.

☛ From Biberach, south of Ulm on the E11 autobahn, Federsee is about 15km west of Biberach. Access unrestricted. Good accommodation available in Biberach. Further information: LFVV Baden-Württemberg, Bussenstrasse 23, 7000 Stuttgart.

🐦 There is a good selection of breeding marsh birds including bittern, little bittern, purple heron, night heron, marsh harrier, short-eared owl, black-headed gull, water rail, little and spotted crakes, red kite, black kite, white stork, black grouse, common tern and Savi's warbler amongst others. Other species include black-necked grebe, garganey, gadwall, grey heron, curlew, blue-headed wagtail, grasshopper warbler and willow tit.

📷 April–July

132. Ismaninger Teichgebiet Reserve

Recognized as an area of international importance for birdlife and has been given the status of a 'Europa–Reserve' by the International Council of Bird Protection. It is privately-owned, and consists of a dammed lake which serves as a purification station for the treated sewage of Munich and a series of fish ponds. The nutrient-rich waters have encouraged an abundant and rich aquatic flora and fauna which in turn is very attractive to large numbers of aquatic birds. There are extensive reedbeds and an area of riverine forest at the southern end.

☛ The reserve is reached from Ismaning some 10km north-east of Munich. Access unrestricted. Further information: FVV München–Oberbayern, Sonnenstrasse 10, 8000 München 2. Accommodation plentiful in and around Munich.

🐦 Breeding birds include great crested grebe, black-necked grebe, black-headed gull, gadwall, shoveler, tufted duck, pochard, red-crested pochard and common tern. On migration, many herons pass through including night heron. There is a large wader passage with most of the com-

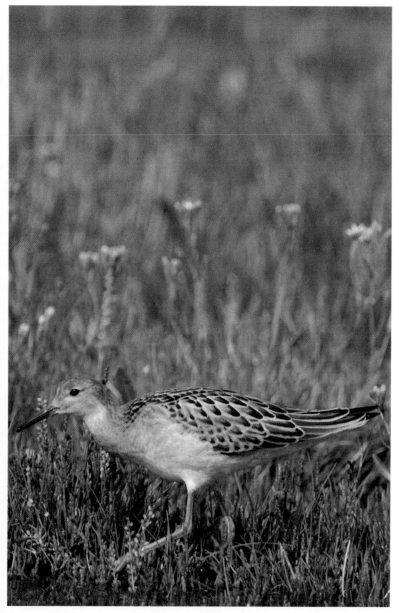

Ruff *(Philomachus pugnax)*, Norfolk, England; September; Canon AE1, Tamron Mirror 500mm f8, 1/250 sec @ f8, Kodachrome 64; stalked with shoulderpod.

INLAND FRESHWATER

mon species represented. Winter brings large numbers of duck including ferruginous duck, smew, red-crested pochard, teal, gadwall, tufted duck, pochard, goosander, garganey and shoveler. Some waders also overwinter.

📷 All year

133. Unterer Inn Reservoirs Nature Reserves
Four reservoirs, along the lower reaches of the River Inn before it joins the Danube, constructed as a link with hydro-electric power stations. The two central ones have been incorporated into the Unterer Inn nature reserve. Silt deposition has transformed the reservoirs into areas of island, shallow water and mudflats, which with lush vegetation and abundant food have attracted a good variety of birdlife.

☛ Worth investigating is the stretch of river between Simbach am Inn and Passau on route 12. The reserve area of the river can be reached from either Simbach or Unterer Inn. Access unrestricted apart from the islands, which are closed. Hotels and campsites plentiful in the area. Further information: FVV München–Oberbayern, Sonnenstrasse 10, 8000 München 2.

🦆 About 120 regularly breeding species, and one of the largest inland concentrations of wildfowl and waders in West Germany. Breeding birds include purple and night herons, little bittern and red-crested pochard, penduline tit, river warbler and common tern. Large numbers of waders pass through in spring and autumn, and passage wildfowl include tufted duck, pochard and goldeneye. Other birds of interest include bluethroat, hobby, black-winged stilt, gadwall and an overwintering white-tailed eagle. Good numbers of duck overwinter.

📷 All year

YUGOSLAVIA

134. Lake Scutari
Situated in southern Montenegro, this lake is 48km long, and 14km at its widest. About one-quarter of the lake is across the border in Albania. It is bound on the coastal side by the Rumija mountains and inland by the Titograd plain. The water level varies, with some flooding of surrounding deciduous woodlands during the early part of the year. Habitats include marshland, woodland, mountains, open water, streams, ditches, small pools and channels.

☛ The best base for exploring the area is Petrovac, a small village just north of the main causeway a few kilometres to the south-west on the Adriatic coast. For the Moraca River, take the E27 from Titograd and park where it crosses the river before reaching the main causeway (from here you can walk along the riverbank to look over open reeds, meadows and trees). About 3km further north on the E27, take a right turn signposted Motel Plavnica; continue for some 8km to the end for good views of the lake, reedbeds and water meadows. The area south of the main causeway starting from Virpazar is rather inaccessible, and photography is banned in an area near the village. The lake as a whole, does not hold reserve status and, access is otherwise, unrestricted. With such a large area to cover, a car is essential and it is worth hiring a boat locally to explore the lake itself.

🦆 The list of birds for this area is large but it is for certain rare species that Lake Scutari is well known. A declining colony of Dalmatian pelican breed and may be seen anywhere on the lake particularly around the Moraca River estuary. Species to be found include pygmy cormorant (which breeds), purple and grey herons, little egret, squacco and night herons, glossy ibis, and black and white-winged black terns at migration times. In winter, large numbers of duck and geese are present including greylag, bean geese and white-front geese. The reed beds and sedges hold little bittern, water rail, little and spotted crake and Cetti's warbler. In the scrubland there are Orphean, sub-Alpine and Sardinian warblers as well as woodchat, lesser grey and red-backed shrikes. In the highlands around the lake are Egyptian vulture and golden eagle, and on passage you might see osprey, short-toed, booted and lesser-spotted eagles. Around the Moraca River bridge are found great crested grebe, little grebe, marsh harrier, peregrine, Dalmatian pelican, spoonbill, pygmy cormorant, squacco heron, night heron, little bittern, shoveler, mallard, pintail, wigeon, tufted duck, garganey, golden oriole, black-tailed godwit, ruff, and wood sandpiper. Near the Motel Plavnica, birds include Dalmatian pelican, pygmy cormorant, little bittern, night and squacco herons, glossy ibis, whiskered tern and great reed warbler. Further around the bay of the lake there is a good chance of finding white-tailed eagle on the headland.

📷 May–October, December–February for wildfowl

135. Obedska Bara

A marshy area with open water and pools, flooded fields and some flooded woods, bound by woodland to the north and the River Sava to the south. The water level, and the extent of flooding, varies according to the time of the year.

☛ Close to Belgrade with its international airport. Take the road from Belgrade, parallel to the River Sava, through Boljevci to Kupinovo which lies on the edge of the marsh. The road follows the northern edge of the marsh to the village of Obrez. Just before this village on the marsh border is a hotel. There are a number of hides around the marsh. Access unrestricted apart from a small reserve for which a permit is necessary.

☛ The marshes have a good variety of aquatic birds with great crested grebe, little grebe, black-necked grebe, pygmy cormorant, purple heron, little egret, night heron, spoonbill, glossy ibis, little bittern, marsh harrier, water rail, lapwing, greenshank, ruff, Savi's warbler, great reed warbler, and penduline tit. The villages have many white storks that nest on the roofs of buildings. Just before dusk there are often good numbers of glossy ibis, spoonbill, little egret, night heron, black stork and white stork flying past over the marsh.

Dry woodlands hold white stork, hobby, middle-spotted woodpecker, golden oriole, cuckoo, hoopoe, hawfinch, pied flycatcher, Bonelli's warbler and lesser grey shrike. Flooded woods should attract black stork, black kite, imperial eagle, buzzard, golden oriole, red-backed shrike and lesser grey shrike.

📷 Late April–September

14. Birds of Forest and Woodland

Some eagles and hawks, some grouse, woodcock, pigeons, doves, owls, woodpeckers, some warblers, some thrushes, tits, some buntings, finches, some starlings, corvids

In many ways this is one of the more difficult habitats to work because the dense foliage gives good cover to the birds and produces poor lighting conditions. The difficulty is even greater for the short-term visitor, because much photography in forests and woodlands must be conducted from a hide. For the stalker or opportunist woodland edges are the best bet, as there is cover as well as better lighting.

Public woods are not usually suitable for hide photography because of the possibilities of vandalism at worst and interruptions at best. It is better to find a private wood and seek permission to erect your hides there. The breeding season is probably the best time to work this habitat, as the birds are tied to their nest site and their movements are more predictable. Outside the breeding season you should find spots which the birds visit regularly; either a small pool or an area which may be baited. It is not easy to isolate good woodland or forest sites unless they hold a rare or unusual species of bird. Try to find a local wood which you can work thoroughly over a long period of time, and this reduces the problems of hides and equipment too. Alternatively, contact a local photographer in the area you are visiting and use already established hides. **NB** Refer also to the gazetteer entries for Mountain Regions (pages 237–245); the lower mountain slopes are often forested and rich in woodland bird species.

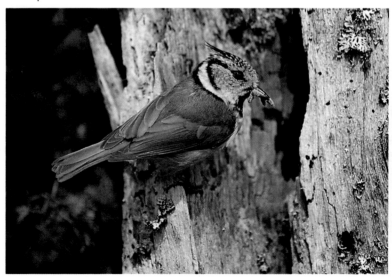

Crested Tit *(Parus cristatus)*. Highland, Scotland; June; Nikon F3, Nikkor IF-ED 300mm f4.5 + Nikon 1.4× teleconverter, auto @ f6.3, Kodachrome 64; hide, tripod.

Special techniques: see pages 38, 51, 54, 82

Equipment

35mm SLR	Wide angle lens	Playback tape
Spare body	Flash heads	Slow and fast film
300–600mm telephoto lens	Remote control	Hide/stool
Bean bag or car bracket	Infra-red	Tripod
70–210mm zoom lens	Bait	Monopod

AUSTRIA

136. Hohe Wand

Hohe Wand is a high plateau with a steep cliff drop into a valley approximately 56km south west of Vienna. The scenery is spectacular and well wooded with coniferous trees. It is a popular tourist spot and best avoided at weekends.

☛ Take the E7 south from Vienna to Wiener Neustadt, from where Hohe Wand is well signposted. Accommodation is widely available in the local villages. A road leads through the coniferous forest to the top of the plateau.

☛ One of the most spectacular locations to see wallcreepers, although photographing them is difficult. The forests hold capercaillie, black grouse, black woodpecker, nutcracker, wryneck, firecrest, crested tit and Bonnelli's warbler. Other birds include rock thrush, rock bunting, raven, peregrine, ring ouzel, crossbill and short-toed treecreeper.
📷 May–August

BRITISH ISLES (including the Republic of Ireland) See also 10, 109, 167.

137. Beinn Eighe
OS NG000610
A 4730-ha national nature reserve of mountainous area with remnants of Caledonian pine forest, extending from Loch Maree in

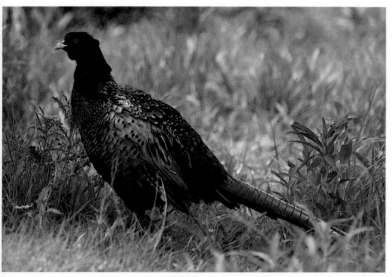

Pheasant *(Phasianus colchicus)*, Sussex, England; May; Nikon F3, Nikkor IF-ED 300mm f4.5 + Nikon 1.4× teleconverter, 1/125 sec @ f8, Kodachrome 64; stalked with monopod.

the north-east to about 400m above sea level. Above the tree line are dwarf scrub heath and limestone outcrops. The southern face of the reserve is the steep scree of Beinn Eighe.

☛ Between the A832 and B858, west of Kinlochewe entrance from the car park at Loch Maree side. Visitor centre with information leaflets open May–September. There are two nature trails. Further details: The Warden, Anancaun Field Centre, Kinlochewe, Ross-shire, IV22 2PD ☎ (044584) 244.

☞ Below the tree line fifteen species are on record as breeding in the pine woodlands, including coal tit, willow warbler, siskin, goldcrest, Scottish crossbill and resident redpoll. Breeding summer visitors include redstart and tree pipit. Above the tree line on the more exposed slopes, typical mountain species such as ptarmigan, buzzard, merlin and golden eagle may be found but are all rather scarce.

🐦 Spring, summer

138. Coombs Valley
OS SK009534

This 104-ha RSPB reserve consists of a narrow, steep-sided wooded valley through which runs Coombs Brook and some meadowland. The wood is mainly oak with birch, ash and holly, and bramble, gorse and wild rose in clearings. The brook is bordered by alder and ferns.

☛ From the A523 Ashbourne–Leek road take a side road 5km from Leek, signposted Apesford. Further details from The Warden, Six Oaks Farm, Bradnop, Leek ST13 7EU, ☎ (0538) 384017.

☞ A total of 130 species have been recorded. Over half of them breed including great spotted and green woodpeckers, redstart, wood warbler, tree pipit, dipper, kingfisher, grey wagtail, long-eared owl, sparrowhawk and pied flycatcher. An observation hide set up by a pool offers opportunities of dipper, kingfisher and grey wagtail. Another hide has been erected in an oak tree and offers chances of pied flycatcher, treecreeper and goldcrest. Siskin and redpoll are present during winter.

🐦 Spring, summer

139. Culbin Forest
OS NH980600

This planted forest owned by the Forestry Commission and covering 2400ha, acts as a stabilizer for the adjacent Culbin Sands. Most of the forest is Scots pine with a few

Corsican and lodgepole pines scattered throughout. The Culbin Sands RSPB Reserve, an important wintering area for wildfowl and waders, is nearby.

☛ Take the road to Kintessack off the A96 about 5km west of Forres. From Kintessack take a minor road to Muirtown and then to Cloddymoss where there is a car park. Further details: Head Forester, Newton Nursery, by Elgin ☎ (0343) 2832.

☞ Noted for crested tits, of which there are about 200 pairs. Breeding birds include Scottish crossbill, siskin, and capercaillie and goldcrest in good numbers. Others found are sparrowhawk, buzzard, short-eared owl and long-eared owl, great spotted woodpecker, nightjar, coal tit, bullfinch, whitethroat and tree pipit.

🐦 Spring, summer

140. Dinas Gwenffrwd
OS SN788472

This 480-ha RSPB reserve encompasses a hilly upland, wooded river valleys, farmland and hanging oak woodlands. A nature trail leads through a representative range of the reserve's habitats, each of which carries its own recognizable range of avifauna.

☛ Entrance to the Dinas woodlands from the car park off the Llandovery–Llyn Brianne road. Access at all times; for information on the nature trail, report to the Dinas information centre, open 10.00–17.00 hrs. Gwenffrwd part of the reserve open April–August, Mondays, Wednesdays, Saturdays. Further information and leaflet: The Warden, Troedrhiwgelynen, Rhandirmwyn, Llandovery, SA20 0PN ☎ (05506) 228.

☞ In the oak woodlands, redstart, pied flycatcher, and wood warbler are common in spring and summer. Breeding birds also include sparrowhawk, buzzard, tawny owl, woodcock. Red kite has bred on the reserve. You may see one if you are lucky.

The rivers provide a different habitat with likely species being kingfisher, dipper, grey wagtail, and grey heron. Common sandpiper breed here. On the Towy river a colony of sand martin nest in the river bank. You may find red grouse, buzzard, raven, wheatear and whinchat, merlin and red kite on the moor if lucky.

🐦 Spring, summer

141. Eastwood
OS SJ972977

A 5-ha RSPB reserve of deciduous woodland within Cheetham park, Stalybridge. The wood is surrounded by the industrial

suburbs of Greater Manchester. A stream and several pools lie within the reserve.

🖝 Pedestrian access only by the Priory Tennis Club sign. Parking available in Trinity Street, Stalybridge. Further details: The Warden, 12 Fir Tree Crescent, Dukinfield, Cheshire, SK16 5EH.

🖝 Typical woodland birds are found here with others attracted to the watery habitat. Breeding birds include tawny owl, treecreeper, robin, nuthatch, great spotted woodpecker. Other inhabitants are redpoll, siskin, grey wagtail, and kingfisher and wood warbler. Winter brings woodcock, bramblings, and sparrowhawk.

📷 All year

142. Epping Forest
OS TQ412981

Epping Forest is a large area (2430ha) of ancient wood pasture, grassland and wetland less than 13km from central London. Oak, beech and hornbeam predominate. Whilst the common woodland birds are well represented here, human disturbance has made them difficult to see in some areas. At weekends in summer, the forest can be inundated with visitors.

🖝 Take the A11 out of London. The forest is between Buckhurst Hill and Epping. Free access to all areas.

🖝 Mainly common woodland species. The mature deciduous woodland areas hold treecreeper, nuthatch, chaffinch, greenfinch, and bullfinch. Hawfinches are sometimes seen. Winter brings siskin and redpoll. Summer visitors include blackcap, willow warbler, chiffchaff, tree pipit. Marsh, coal and long-tailed tits are resident. Almhouse Plain holds garden warbler and whitethroat. Spotted flycatcher breed near Gilwell park. Connaught Water holds mallard, Canada geese and moorhen. In winter, the golf course is the place to find fieldfare and redwing.

📷 Spring, summer

143. Fore Wood
OS TQ756126

A 55-ha mixed woodland RSPB reserve with both sweet chestnut and hornbeam well represented, oak and birch in smaller numbers. Additional features are the steep-cut tree-lined ghylls and an artificial pond.

🖝 Entrance off the main street of Crowhurst, which lies west of the A2100 Battle–Hastings Road. Car parking available at the village hall by the church. Further details: The Warden, 2 Hale Farm Cottages,

Hart Lake Road, Tudeley, Tonbridge, Kent ☎ (0732) 359245.

🖝 Typical species of southern English woodland; those breeding include blackcap, nightingale, garden warbler, nuthatch, treecreeper, green, great and lesser spotted woodpeckers and tawny owl. A pair of sparrowhawk and probably hawfinch breed each year. Six species of titmice occur. The artificial pond has breeding moorhen and mallard, and is visited outside the breeding season by kingfisher, green sandpiper and grey wagtail.

📷 All year

144. Loch Garten
OS NH977185

The reserve, owned by the RSPB, is part of the Abernethy Forest and comprises five distinct habitats including pine forest, lochs, farmland, moorland and peat bogs. Despite the variety of species occurring, most of the 50,000 people per year only visit the observation hide to view the osprey.

🖝 The reserve is well signposted off the Boat of Garten–Nethy Bridge road. Access within the reserve is limited to marked paths. The Observation hide is open 10.00–20.30hrs, end April–end August. Further details: The Warden, Grianan, Nethy Bridge, PH25 3EF ☎ (047983) 694.

🖝 The most popular attraction is the osprey. These have, in the past, arrived each April to breed. There are excellent viewing facilities from the observation hide. Good record photographs of the osprey are possible from the hide, erected especially for photographers. A 600mm to 800mm lens is necessary. Other common woodland species on the reserve include chaffinch, treecreeper, goldcrest, wren and coal tit. Visiting summer breeders include willow warbler, spotted flycatcher, redstart, siskin, nightjar and common sandpiper. There is a good population of breeding crested tits and Scottish crossbill most years. Capercaillie breed in the woodland. Goldeneye breed on the lochs which are also important roosting sites for black-headed gull in the spring months and greylag geese, whooper swan and duck during the winter. Breeding birds of prey include kestrel, sparrowhawk and buzzard. Black grouse breed on the moorland.

📷 Late April–late August

145. Northward Hill
OS TQ784761

This 54-ha RSPB reserve is an area of mixed

woodland with large tracts of dense haw-thorn scrub and oakwoods. A high-level observation platform affords views over the treetop heronry.

☛ From Rochester take the A228 to High Halstow then follow a footpath from North-wood Avenue. Escorted visits, only, by prior arrangement; contact: The Warden, Swigs-hole Cottage, High Halstow, Rochester, ME3 8SR ☎ (0634) 251874.

☛ The biggest heronry in Britain, with over 200 pairs, is situated in the oak trees. The heronry is not open to visitors but can be viewed from a distance. There is also a large rookery. Other breeding birds include nightingale, all three woodpeckers, little owl and long-eared owl and possibly hawfinch.

📷 Spring, summer, February–August for breeding herons

146. Warburg Reserve
OS SU720879
A 102-ha reserve in the chalk valley of Bix Bottom, with mixed deciduous chalk wood-land, scrub and grassland, an area rich in animal and plant life. A wooden hide has been erected by the warden, overlooking a small pool and may be rewarding.

☛ From Henley-on-Thames take the A423 to Oxford; after 1½km take the B480 to Watling-ton. Turn left at Middle Assendon on the road to Bix. Bear right at the next junction where the road leads directly to the reserve car park. Open all year, dawn to dusk. No permit required, access free. Further details The Warden, Warburg Reserve, Bix Bottom, Henley-on-Thames, Oxfordshire ☎ (0491) 641727.

☛ Breeding birds include sparrowhawk, tawny owl, wood warbler, willow warbler, chiffchaff, blackcap, wren, nuthatch, treecreeper and woodcock.

📷 Spring, summer

147. Wyre Forest
OS SO750760
This 300-ha NCC reserve is said to be one of the best remaining native woodlands in Eng-land. A fast stream, Dowles Brook, flows through the mixed woodland of oak with some birch. Vegetation around the brook consists of hawthorn, hazel and blackthorn.

☛ Take the A456 from Kidderminster to Bewdley and then the B4194 for 3km as far as Buttonoak; from there use footpaths. Visitor centre, car park and nature trail. Further

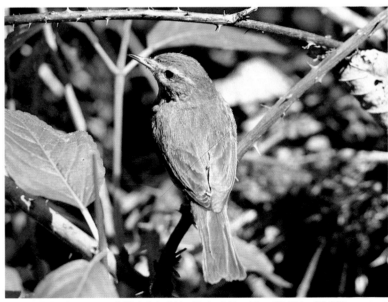

Chiffchaff *(Phylloscopus collybita)*, Oxfordshire, England; May; Nikon F3, Nikkor 80–200mm zoom f4, auto @ f5.6, Kodachrome 64; hide, tripod.

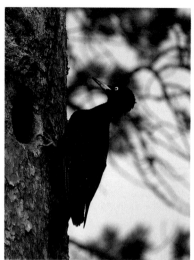

Greenfinch *(Carduelis chloris)*, near Helsinki, Finland; June; Nikon F3, Nikkor IF-ED 600mm f5.6, auto @ f5.6, Kodachrome 64; stalked with monopod.

Black Woodpecker *(Dryocopus martius)* Kuusamo, Finland; June; Nikon F3, Nikkor IF-ED 600mm f5.6, 1/250 sec @ f5.6, Kodachrome 64; hide, tripod.

details: The Warden, Lodge Hill Farm, Bewdley, Worcestershire ☎ (0299) 400441 or J. Mountfield, 20 Ellesmere Drive, Bewdley, Worcs. DY11 2PS ☎ (0299) 403771.

🐦 Birds attracted to the stream include dipper, kingfisher, grey wagtail and pied flycatcher. In the woods, the three woodpeckers breed, also redstart, nuthatch, tits, crossbill, hawfinch, siskin, woodcock, wood warbler, kestrel, sparrowhawk and tawny owl. Long-eared owls sometimes found in the conifers next to the reserve.
📷 Spring, early summer

DENMARK See 45.

FINLAND

148. Kuusamo
Kuusamo lies close to the Arctic Circle near the Finnish–Soviet border, just to the south of Oulanka National Park. It is a region of fir and birch woodland, with many lakes, marshes, meadows, ravines and rivers. It is easy to get lost and advisable to keep to the tracks.
🚗 Reached on the main Route 5. Several hotels and log cabins for rent at a campsite

near Juuma, some 30km north of Kuusamo off main route 5. No restrictions on access. Further information: Office for National Parks, National Board of Forestry, Box 233, 00121, Helsinki 12.
🐦 Wooded areas hold black woodpecker, fieldfare, redwing, Siberian tit, crested tit, Siberian jay, redstart, pied flycatcher, crossbill, scarlet rosefinch and brambling. Cranes and capercaillie may be photographed feeding by the roadside. Other breeding birds include osprey, whimbrel, Tengmalm's, hawk and eagle owls, greenshank and spotted redshank. The area around Kuusamo is said to be a breeding site for red-flanked bluetail and broad-billed sandpiper. Some of the smaller roadside lakes hold red-necked phalarope, tufted duck, pintail, black-headed gull, grey-headed wagtail and wood sandpiper. The marshes around Kuusamo hold whooper swan, bean geese, and ruff. The larger lakes are harder to work but should yield black-throated diver, goldeneye, wigeon and smew.
📷 June, July

149. Lemmenjoki National Park
The largest of Finland's national parks is an area of great scenic beauty with river valleys, lakes, pine and birch forest, mountains and

fell country. Working the terrain can be test-ing but the superb variety of breeding species makes the effort worthwhile.

☛ From Inari travel south-west for about 50km on route 955 to Kittilä. Access unrestricted, and there are trails, campsites and cabins within the park. Enquiries to: Office for National Parks, National Board of Forestry, PO Box 233, 00121, Helsinki 12.

☛ Pine forests hold crossbill and occasional parrot crossbill, great grey owl and wax-wing. Marshy areas hold a good variety of breeding waders including spotted red-shank, greenshank, ruff, whimbrel, wood sandpiper, Temminck's stint, red-necked phalarope, broad-billed sandpiper and snipe. Higher up in the fells are dotterel, golden plover, whimbrel, bar-tailed godwit and some shore lark. Other birds may include hen harrier, long-tailed skua, snowy owl, hawk owl, hooded crow and osprey. More familiar birds should include redwing, fieldfare, brambling, red-throated pipit, Lap-land bunting, mealy redpoll and white wagtail.

🏕 June, July

150. Oulanka National Park

Dramatic scenery near the Russian border just south of the Arctic Circle, with habitats ranging from rivers, waterfalls, deep valleys, and meadows to birch woodland, heathland, marshes and lakes. The meadowlands exhibit a varied and attractive flora during the summer months.

☛ Approach from Käylä some 45km north of Kuusamo. Unrestricted access; marked trails, campsites and cabins. Further infor-mation: Office for National Parks, National Board of Forestry, PO Box 233, 00121, Hel-sinki 12.

☛ Woodlands hold Siberian tits, brambling, redpoll, crested tit and crossbill. The lakes should reveal mallard, goldeneye, pintail, wigeon, black-throated diver, and maybe smew and whooper swan. Wood sandpiper breed in the open wooded heathland. Birds of prey include rough-legged buzzard, golden eagle, and honey buzzard. Teng-malm's owl are common and eagle owl are also seen.

🏕 June, July

151. Pyhähäkki National Park

Largely coniferous forest, bogs, small ponds and peatland.

☛ About 30km north-east of Saarijärvi on the edge of the Finnish lake district. Saarijärvi is found off the main E4 route

several hundred kilometres north of Hel-sinki. Access unrestricted; trails and campsites within the park. Further informa-tion: Office for National Parks, National Board of Forestry, PO Box 233, 00121, Hel-sinki 12.

☛ Typical Finnish forest birds are found within the park including capercaillie, hazelhen, Siberian jay, waxwing, woodpeck-ers, and Tengmalm's owl. Other common birds are pied, spotted and red-breasted fly-catcher, redstart and siskin.

🏕 June, July

FRANCE See 112, 189, 190, 191.

GREECE See also 58.

152. Asprovolta

Set in an area of olive groves, allotments, grass, bushes and trees, a wooded valley with a stream, and to the north, hills.

☛ Situated between Thessaloníki and Kavála east of Asprovolta along the main E5 coast road. Access free. There is a campsite between the E5 and the sea, just beyond a military camp, and the Europa campsite fur-ther east. There are many tavernas around Asprovolta.

☛ The major attraction is the Eleonora's falcon which hawk for insects around Asprovolta campsite. Just outside the eastern boundary of the site is a dead tree in which a number of falcons roost regularly. Bushes and trees north of the main road hold masked shrike, Syrian woodpecker, hoopoe, cirl bunting, black-headed bunting, wood-chat and red-backed shrike, middle spotted woodpecker, cuckoo, golden oriole and whitethroat. The olive groves have oliv-aceous warbler. At or around the campsite are Scop's owl and nightingale.

🏕 April–September

ITALY See 195, 197.

LUXEMBOURG

153. German–Luxembourg Nature Park

This large reserve is the outcome of cooperation between two countries in the interests of nature and conservation. The border runs right through the centre of the reserve following the course of the Our and Saver rivers. The northern part of the re-

serve is well wooded with oak, sycamore, beech, ash and alder. The southern part is more rugged with plateaux, valleys and gorges.

☛ Approach from Luxembourg and Ettelbrück on the Luxembourg side and from Bitburg or Trier in Germany. Access unrestricted; and there are an information centre and marked trails. Hotels and campsites within the park. Further information: Vereinigung Deutsch–Luxemburgischer Naturpark, 5521 Irrel, West Germany.

☛ The area holds typical woodland species and birds of prey include goshawk, sparrowhawk, buzzard and red kite.

☛ April–July

THE NETHERLANDS See also 68, 69.

154. De Hoge Veluwe and Veluwezoom National Parks

These two reserves lie in an area of sandy forest between the reclaimed land of Flevoland and Arnhem in central Holland. The area which was once rather barren drifting sand, is now, as the result of tree planting nearly a century ago, a landscape of mixed woodland with some pine forest and heathland. The whole area holds some interesting bird species.

☛ The two parks lie to the north of Arnhem. For De Hoge Veluwe travel north on route N50 taking a left turn to Hoenderloo on the edge of the reserve some 10km before Apeldoorn. Alternative access from Otterloo to the west of the park. Access unrestricted except mid-September–mid-October during the rutting season. There are marked paths and a campsite in the park. Further information: Het Nationale Park De Hoge Veluwe, Apeldoornseweg 250, Hoenderloo. Veluwezoom park is also reached along route N50 some 5km north of Arnhem. Some areas are restricted. Facilities include a visitor centre and marked footpaths. Further information: Bezoekerscentrum 'De Heurne', Nationale Park Veluwezoom, Heuvenseweg 5A, 6991 JE Rheden.

☛ Birds of interest include buzzard, hobby, honey buzzard, merlin, sparrowhawk, Montagu's harrier, goshawk, black woodpecker, curlew, woodcock, black grouse, great grey shrike, golden oriole, crested tit and short-toed treecreeper. In the nearby Deelerwoud reserve which lies between De Hoge and Veluwezoom, the raven has been introduced as a breeding bird.

☛ May–July

NORWAY See also 120.

155. Øvre Pasvik National Park

Situated on a tongue of north Norwegian territory which extends down from the Varangerfjord between Finland and The Soviet Union. High above the Arctic Circle, this relatively flat area forms the most westerly extension of Siberian taiga country. It has fine stands of primeval forest consisting of Scots pine and birch trees, and a large number of lakes and marshy areas. The south-western section of the park, known as the Pasvik valley, is most popular.

☛ The park can only be reached from the north, at Gjøkåsen some 100km south-west of Kirkenes. Access unrestricted, but take care near the Soviet border. There are footpaths within the park and some cabins are available. Further information: Øst Finmark Statens Skog District, Box 90, 9901 Kirkenes.

☛ Breeding birds of interest include great grey owl, whooper swan, bean geese, bar-tailed godwit, red-necked phalarope, yellow-breasted bunting and Arctic redpoll. Other birds are red-throated diver, long-tailed duck, velvet scoter, king eider, and eider duck, Steller's eider, black grouse, common crane, dotterel, purple sandpiper, little stint, Temminck's stint, long-tailed skua, Arctic skua, snowy owl, fieldfare, redwing, red-throated pipit, bluethroat, mealy and Arctic redpolls, Lapland and snow buntings, shore lark, brambling, pine grosbeak, Arctic warbler and willow tit, rough-legged buzzard and three-toed woodpecker.

☛ June, July

PORTUGAL See 183.

SPAIN See 81, 82.

SWEDEN See also 87, 123.

156. Muddus National Park

At the heart of Swedish Lapland, this expanse of forests, bogs and water contains three separate bird sanctuaries. Spruce and Scots pine forest covers more than half of the whole area with peat and marsh over most of the rest.

☛ Approach from Ligga, 20km north of Jokkmokk. Jokkmokk is reached either by road or rail, and hotel accommodation is available there. Access unrestricted, although the central bird sanctuary is closed March 15–

July 31. Cabin accommodation available within the park. Enquiries and further information: Domänverket, Nationalparks-förvaltningen, V Torggatan 8, 960 40 Jokk-mokk. There are well-marked trails, but the more adventurous should have appro-priate provisions for survival in an isolated area.

☛ About 115 species have been seen. Cranes and whooper swan are a major attraction and as many as eleven of the thirteen species of European owl may also be seen, thanks to the abundance of small rodents. Breeding waders include spotted redshank, ruff, greenshank, wood sand-piper, broad-billed sandpiper and red-necked phalarope. In the wooded areas are capercaillie, Siberian jay, bluethroat, cross-bill, mealy redpoll, brambling, pine grosbeak and rustic bunting.

Other interesting species amongst the wide variety found here are waxwing, Siberian tit, siskin, and several species of woodpecker including the elusive black woodpecker.

📷 June–September

SWITZERLAND See 128.

YUGOSLAVIA See also 135.

157. Biogradska Gora National Park
This relatively small park includes the River Biograd valley and the Bjelasica mountains which surround Lake Biograd, reaching a height of over 2000m. About two-thirds of the park is covered with virgin forest, around the lake is mixed woodland with ash, beech, sycamore, hornbeam and fir.

☛ Take the E27 road some 90km north from Titograd to Titova Užice. The nearest entrance point is at Mojkovac. The park is wardened and trails are well-marked. Boats are available to explore the lake. Access unrestricted. There is a campsite within the park. Further information: Turistički savez, Crne Gore, Bulevar Lenjima 2/1, 81001, Tito-grad.

☛ Woodland birds include great spotted, grey-headed, green and black woodpeckers, nuthatch, wren, willow and sombre tit, bull-finch and jay. Raptors include golden eagle and buzzard among others. Red-breasted flycatchers arrive for the summer. At higher altitudes, yellowhammer and tree pipit; grey wagtail and common sandpiper near the streams.

On the main road from Titograd to Lake Biograd one passes through the Morača Gorge which holds several interesting spe-cies including dippers near the streams. Higher up are alpine chough, wallcreeper, blue rock thrush, crag martin, short-toed eagle and rock sparrow.

📷 April–October

158. Petrovac
A coastal town in the Montenegro which is central to a number of notable birdwatching localities. Behind the town are hills with scrub and woodland; east is an excellent area of marsh and wet meadows just outside the village of Buljarica.

☛ South of Titograd, about 130km east of Dubrovnik. On the main coastal road from Dubrovnik to Ulcinj near the Albanian border. Accommodation available in the town. There is a hotel on the coast about 1km from the turning for Canj. Access theoreti-cally unrestricted, but as in many places in Yugoslavia the military can be rather sensi-tive about visitors carrying cameras and binoculars.

☛ The scrub and woodland behind Petrovac are particularly attractive to migrant birds and typically hold scops owl, hawfinch, cirl bunting, black-headed bunting, ortolan bunting, red-backed shrike, woodchat shrike, bee-eater, roller, nightjar, wryneck, pied and spotted flycatcher, whinchat, red-start, olive-tree warbler, olivaceous war-bler, subalpine warbler, Orphean warbler, Sardinian warbler, icterine warbler, nightingale, and alpine swift, overhead. Further east at Buljarica Marsh are purple heron, squacco heron, little egret, garganey, marsh harrier, buzzard, red-footed falcon, wood sandpiper, black tern, bee-eater, golden oriole, wheatear, black-eared wheatear, lesser grey shrike, red-backed shrike, woodchat, shrike, tawny pipit, short-toed lark, black-headed bunting, yellow wagtail, whinchat and alpine swift. East-wards along the coast road towards Bar there is a signpost for Canj; the rocky areas either side of the road hold breeding rock nuthatch. Other birds here include blue rock thrush, red-rumped swallow, nightingale, sombre tit, Bonelli's and Cetti's warblers.

📷 April–September

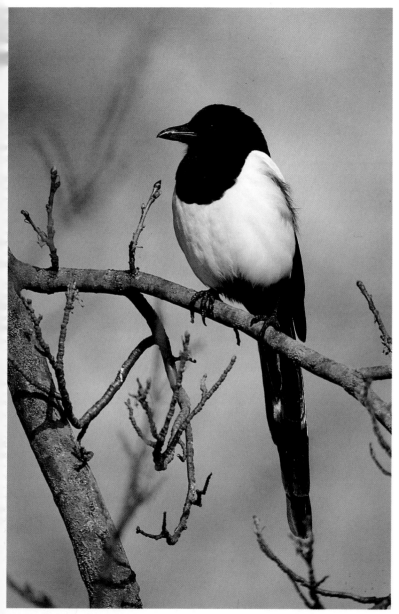

Magpie *(Pica pica)*, Surrey, England; February; Nikon F3, Nikkor IF-ED 600mm f5.6, auto @ f5.6, Kodachrome 64; car bracket.

15. Birds of Open Country – Grass, Heath and Moor

Some geese, some eagles, hawks and allies, grouse, pheasant, bustards, some waders, owls, bee-eaters, some larks and pipits, shrikes, wheatears, some buntings and chats

This type of habitat is probably the most difficult of all to work because of lack of cover for the photographer and the limited variety of species contained. With a few exceptions, most of the species are very shy and will not allow the photographer on foot to approach close enough to obtain a reasonably-sized image. The general lack of relief ensures that the bird will see you as soon as you rise above the horizon. This means that most photography has to be carried out from a hide, and aided by a good local knowledge of the area and its birds. The stalker will need a very long telephoto lens and a fair amount of luck and skill in order to obtain good results. It may sometimes be worth using taped calls to entice the bird nearer. Another approach worth trying at the nest is to use a wide angle lens and remote-controlled shutter release to obtain a dramatic, low viewpoint, close-up shot of the bird against the expansive background.

Many heath and grassland areas are now being lost in England and some parts of Europe as a result of urban development, and this type of habitat is also particularly prone to fires during the summer months. Fortunately many of those remaining are now officially protected areas. There are still, however, extensive and relatively undisturbed moorlands in the north of England, Wales, Scotland and some parts of Europe. Remember weather conditions can change dramatically in a short time in the highland areas and appropriate safety precautions are necessary to avoid the real danger of suffering from exposure.

Special techniques: see pages 38, 52, 54

Equipment

35mm SLR	1.4 × teleconverter	Bean bag or car bracket
Spare body	Medium and fast film	Medium and fast film
300–600mm lens	Playback	Hide/stool
Wide angle lens	Remote control	Tripod
2 × teleconverter	Bait	Monopod

BELGIUM

159. De Zegge Nature Reserve

A small reserve with heathland, bog and swamp, supporting an interesting selection of birds.

🦅 Located in north-eastern Belgium, 25km east of Antwerpen near the town of Herentals. Hotels and campsites in the area. Access to the reserve is restricted; prior permission in writing to: Koninklijke Maatschappij voor Dierkunde van Antwerpen, Koningin Astridplein 26, 2000 Antwerpen.

🦜 Bluethroat nest in the scrub. Wet areas hold bittern, water rail, spotted crake, snipe, and black-tailed godwits. Duck and some other waders occur on migration. Golden oriole breed, as do a number of species of warbler. Birds of prey include Montagu's and marsh harrier.

📷 April–October

160. Haute Fagnes Nature Reserve

Part of the much larger Haute Fagnes–Eifel National Park. The reserve consists of a plateau of peat moor and bog, about 500m above sea level, surrounded by woodland. The woodland was once far more extensive but has suffered as a result of exploitation. Replanting has taken place and the commonest species of tree is now spruce.

🦅 Situated in east Belgium near Liège and the German border; approach from Verviers, Eupen, or Malmédy. Unrestricted access except during the times of greatest fire risk. The site is wardened and visitors are expected to keep to the marked trails. Information centre on the reserve; hotels and campsites within the park. Further information: Fédération du Tourisme de la Province de Liège, Bd de la Sauvenière 77, 4000 Liège.

🦜 A number of interesting moorland and woodland species; those breeding include Tengmalm's owl, long-eared owl, black grouse, red grouse, goshawk, hen harrier, buzzard, black woodpecker, ring ouzel, fieldfare, firecrest and short-toed treecreeper, and great grey shrike. Cranes may stop on migration.

📷 Late April–July

161. Kalmthoutse Heide Nature Reserve

A heathland reserve with marshland, sand dunes and woodland, and a number of lakes. The wet areas sometimes flood during the winter.

🦅 From Antwerp take the main E10 north, then a left fork at Maria-ter-Heide on to Kalmthout. Access unrestricted except for some of the sand dunes. Marked trails inside the reserve. Further information: Bestuur van Waters en Bossen, Houtvesterij Antwerpen, Weidestraat 60, 2600 Berchem.

🦜 Over 100 breeding species on record. The woods hold long-eared owl, black woodpecker, black grouse and hobby. The wetter areas have black-necked grebe, black tern, ruff and several species of duck including garganey, teal, pochard and shelduck. At passage times, a variety of species of wader and duck passes through.

📷 March–October

BRITISH ISLES

162. Arkengarthdale Moor and Redmire Moor

OS SD045995

These areas of moorland are part of Swaledale in the Yorkshire Dales. The moors are privately-owned but are part of the Yorkshire Dales National Park.

🦅 Situated north and south of the small town of Reeth, which is on the B6270 Richmond–Brough Road. Arkengarthdale Moor is well signposted on the road leading north out of Reeth. For Redmire Moor take either of the roads south out of Reeth to Redmire or Leyburn. Unrestricted access. Further details: Yorkshire Dales National Park, Colvend, Hebden Road, Grassington, Skipton, North Yorkshire, BD23 5LB ☎ (0756) 752748.

🦜 The roads crossing the moorland are especially good for photographing red grouse which feed right up to the edge of the road. Use the car as a mobile hide with a bean bag or window clamp for lens support. Other species include grey partridge, curlew, lapwing, wheatear, skylark, meadow pipit and ring ouzel.

📷 April–May

163. Arne Heath

OS SY984885

This 525-ha RSPB reserve is one of the largest tracts of lowland heath in Britain, with heather and gorse on acid peat. However, the habitats are varied and include coniferous and deciduous woodland, marsh and reed swamp, fields and roadside verges, and saltings. A new hide has been erected overlooking a salt marsh. It should be noted that there is a real danger of fire from cigarette ends on this reserve. Smoking is not allowed. See also 10.

🦅 Approach from Stoborough off the A351 Swanage–Wareham road, 5km east of Ware-

ham. Further details: The Warden, Syldata, Arne, Wareham, BH20 58J ☎ (092 95) 3360.

☛ Best known for its resident breeding Dartford warbler population which nests in the gorse. It is forbidden to photograph this species at the nest within the reserve; shots away from the nest are possible. Other breeding birds include stonechat, nightjar, bearded tit, redshank, sparrowhawk, yellowhammer and linnet.

The wooded areas have breeding tits, treecreeper, and willow warbler. As well as bearded tit, the reed beds and marshes hold reed warbler, reed bunting, water rail, mallard and teal. At passage times, the mudflats hold a variety of waders including redshank, curlew, dunlin, oystercatcher, black-tailed godwit and spotted redshank. Winter brings good numbers of duck including mallard, shelduck, wigeon, teal, goldeneye and red-breasted merganser.

🐦 All year

164. Ben More Coigach
OS NC095042

A large reserve of some 6000ha with mountain and moorland and some coastline with islets.

☛ Take the A835 north from Ullapool for about 15km then turn left at Drumrunie. Access at all times, but no access to the islets in Loch Lurgainn. Further details: The Royal Society for Nature Conservation, The Green, Nettleham, Lincoln LN2 2NR ☎ (0522) 752326, or The Scottish Wildlife Trust, 25 Johnston Terrace, Edinburgh EH1 2NH ☎ (031226) 4602.

☛ Breeding species include raven, ring ouzel, ptarmigan, golden plover, greenshank and twite.

🐦 Spring, summer

165. Bodmin Moor Nature Observatory
OS SX216741

A privately-owned observatory in a converted farmhouse which nestles into the eastern side of the upper River Fowey. Facing south, it affords a magnificent view down the valley. The road is relatively flat for about 6km. There are many vantage points from the road, overlooking the river, the surrounding marshes and gorse scrubland. Attached to the observatory are 8ha of pastureland, 2ha of gorse scrub, 2.5ha of marsh and a tumbling moorland stream. A short walk up the hill at the back brings you to a large conifer plantation with open moorland on either side.

☛ Leaving the A30 Bodmin–Launceston road, signposted to St Cleer at Jamaica Inn, near Bolventor, or from the A38 Bodmin–Liskeard road by heading north at Dobwalls. Accommodation available at the observatory for most of the year. Further details: Tony and Pamela Miller, Bodmin Moor Nature Observatory, Ninestones Farm, Common Moor, Liskeard, Cornwall, PL14 6SD ☎ (0579) 20455.

☛ Breeding moorland birds include snipe, curlew, meadow pipit, stonechat, whinchat, wheatear, skylark, dipper, yellowhammer, and reed bunting. Other non-breeding birds include merlin, dotterel, golden plover, hen harrier, dunlin, jack snipe, whimbrel, and redshank.

🐦 Spring, summer

166. Breckland

An expanse of sandy heathland, much of which has disappeared or been planted with conifers, reducing its attraction to many birds. Some reserves remain; while others are under Ministry of Defence control; although firing does occur, the restricted access has proved to be of benefit to some important breeding species.

☛ Centred on Thetford in South Norfolk. East Wretham Heath is a Norfolk Naturalists' Trust reserve (OS TL914886) of about 147ha of heathland, meres and mixed woodland; open all year 10.00–17.00hrs, except Tuesdays; nature trail and information centre. Permit required; visitors should report to the warden. Further details: Peter Steele, East Wretham Heath Nature Reserve, Thetford, Norfolk, IP24 1RU ☎ (095382) 339.

Weeting Heath (OS TL755880) is another Norfolk NT reserve, open April–August. A small fee is payable to the warden at the site. Observation hides overlook the heathland, and are off the Hockley Road west of Weeting. Further details: Miss Moira Warland, 72 Cathedral Close, Norwich, NR1 4DF ☎ (0603) 625540.

Permission to enter some of the Ministry of Defence ground is available on occasions, and enquiries should be directed to the Commanding Officer in charge of the station or camp in a particular area in which you are interested.

☛ These heathland areas do not attract large numbers of birds but are more renowned for specialities. East Wretham Heath holds a wide range of birds in small numbers including hawfinch in winter. Summer visitors include nightingale, redstart, grasshopper warbler, whinchat, wheatear

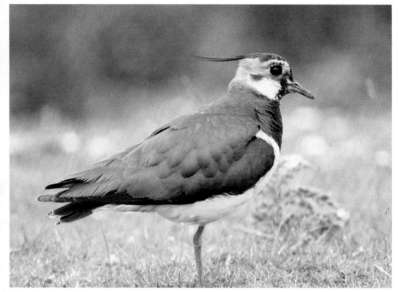

Lapwing *(Vanellus vanellus)*, Norfolk, England; June; Nikon F3, Nikkor IF-ED 600mm f5.6 + Nikon 1.4× teleconverter, 1/250 sec @ f11, Ektachrome 200; beanbag.

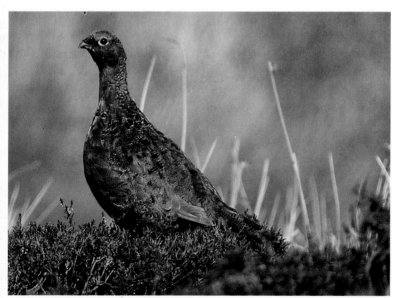

Red Grouse *(Lagopus lagopus)*, North Yorkshire, England; May; Nikon F3, Nikkor IF-ED 600mm f5.6, auto @ f5.6, Kodachrome 64; beanbag.

and nightjar; birds of prey include hen harrier, hobby, tawny and long-eared owl. The meres attract small numbers of wildfowl including gadwall, pochard, teal, wigeon, shoveler and goldeneye.

Weeting Heath is known for its breeding stone curlew. Unfortunately, it is not a suitable site for photography, and it is better to try on privately-owned farmland – with the owner's permission and a *Schedule 1* permit.

Other Breckland birds include golden pheasant, woodcock, woodlark, sparrowhawk, red-backed shrike, crossbill and redpoll; great grey shrike found occasionally in winter; red-legged partridge, grey partridge and pheasant. Wooded areas hold great and lesser spotted woodpecker, tree pipit and cuckoo.

📷 All year

167. The Cairngorms and Ben Macdhui
OS NJ010010

The largest reserve in Britain, managed as a National Nature Reserve apart from an area recently acquired by the RSPB. The highest point is Ben Macdhui which reaches 1310m. At this altitude only the hardiest of plant species can survive the harsh conditions typical of such an exposed area. Further down the mountain slopes, heather and deer grass dominate the vegetation. Lower down still lie extensive pine forests.

☛ Take the A9 to Aviemore, then the Coylumbridge road; at Coylumbridge take a minor road off the B970 to Loch Morlich. The White Lady chair-lift to the Cairngorm summit is well signposted from here, and worth using to allow more time for photography. From the summit it is possible to walk across the plateau to Ben Macdhui.

Access unrestricted. Accommodation plentiful in Aviemore. Further details: The Warden, Nature Conservancy Council Sub-Regional Office, Aviemore ☎ (0479) 810477.

➤ Breeding birds include dotterel, ptarmigan, golden eagle, snow bunting and a number of waders; others are golden plover, ring ouzel, hooded crow, wheatear, meadow pipit, peregrine, merlin and buzzard. The pinewoods below hold crossbill, siskin, crested tit, capercaillie and black grouse.

📷 May–July

168. Dartmoor
OS SX590925

This 94,500ha national park of large tracts of moorland with granite tors and wooded valleys on the periphery is far too large to

discuss at length here. We focus on a small part of the moorland habitat around Okehampton and Cranmere.

☛ Take the A377 through Okehampton and turn left along a minor road in the town centre, signposted Dartmoor National Park and Battle Camp. Drive up a steep hill past the army camp, through a gate on to a military road. Explore the area between Okement Hill and Fur Tor. When the army firing ranges are in use, red flags are flown from the tors, and firing times are published in local newspapers.

Further details: information caravans on the moor or Dartmoor National Park, Parke, Haytor Road, Bovey Tracey, Devon, TQ13 9JQ ☎ (0626) 832093.

➤ One can find breeding red grouse, wheatear, ring ouzel, skylark and meadow pipit. A small number of dunlin and golden plover breed at the southern limit of their range. Other species include raven, carrion crow, buzzard and occasionally merlin and peregrine. In view of the impoverished avifauna, this habitat is not really for the one-time visitor but requires a fair amount of careful research.

📷 Late spring, early summer

169. Langsett Moors
OS SK215997

Part of the much larger Peak District National Park area (104,378ha) managed by the Peak Park Joint Planning Board. Much of the land is privately-owned but special agreements have ensured that visitors can enjoy access to many areas of open moorland. Langsett Moors are readily accessible and frequently visited. As with most open moorland, photography is very much a case of patience and careful planning, and you are unlikely to achieve much during a single visit.

☛ Follow the road from the A616 in Langsett, signposted 'Derwentdale and The Shrines'. Pass the reservoir and on through Upper Midhope. Parking 90m further on. Head round the southern end of the reservoir, and continue through the gate on to a track to the open moor. Further details: Peak District National Park, Aldern House, Baslow Road, Bakewell, Derbyshire DE4 1AE ☎ (062981) 4321.

➤ Typical moorland birds found include hen harrier, golden plover and red grouse. Short-eared owl breed and other birds of prey should include kestrel and sparrowhawk with occasional merlin and peregrine. Curlew and snipe should be heard and seen, and dippers and ring ouzel

may be found around Mickelden Beck.
📷 Spring, summer

170. Long Mynd
OS SO424901

This 1812ha National Trust reserve comprises three types of habitat. In the main it is featureless plateau moorland some of which is managed as grouse moor. Other habitats are farmland, with various broad-leaved trees, and grassland, which is bracken-covered during the summer months.

☛ From Little Stretton, off the A49, take the road to Minton and continue about 1km through the village. Parking on the verge near the farm, provided access is not blocked. Access unrestricted. Leaflet available from the Shropshire Hills Information Centre.

🦅 Worth visiting for the possibility of close sightings of raptors, particularly buzzards, near the small valley to the north of Shooters Knoll. In the trees near the farm are redstart, spotted flycatcher and green woodpecker in summer. The hawthorn hedge holds mixed flocks of tits in autumn, including long-tailed tit. Several cuckoos are usually present in the hollow in the summer and may be seen perching on hawthorn bushes on the hillside. Other birds include jay, goldcrest and coal tit in Knoll's plantation. Ring ouzel, whitethroat and yellowhammer are also found. Red grouse nest in the heather.
📷 Spring, summer

171. Orkney

A group of some sixty islands (twenty-two of which are inhabited). Low rolling hills with some of the most dramatic cliff scenery in Great Britain are home to more than a million seabirds during the summer months, i.e. about one-sixth of the total British seabird population. See also 30.

☛ Via car ferry from Scrabster to Stromness, or by air to Kirkwall from Glasgow, Edinburgh, Aberdeen and Inverness. Hotel accommodation available on Mainland in Stromness and Kirkwall. Farmhouse accommodation and self-catering available on most islands. Further information on travel and accommodation: Orkney Tourist Board, 6 Broad Street, Kirkwall, Orkney, KW15 1DH ☎ (0856) 2856.

Mainland Orkney contains some of the finest moorlands in Britain, and these are the areas of interest. Around Orphir (A964) between Finstown and Kirkwall (A965) and from Finstown north to the Loch of Swannay

(A966). Included in the latter is the RSPB reserve of Birsay Moors and Cottasgarth.

☛ Access to the RSPB reserve is from Lower Cottasgarth (HY 370194). Access to other areas varies and you should ask permission to enter private land.

🦅 Breeding birds include hen harrier, short-eared owl, kestrel and a few merlin. The wader population is impressive with at least eight species including dunlin, golden plover and a large number of curlew. Teal, wigeon and red-breasted merganser are among the breeding ducks. Starlings, hooded crow, and even wood pigeon are among the ground nesters here. Some of the lochans on the moors support breeding red-throated divers. A hide at Burgar Hill overlooking Lowrie's Water is a good place to see these birds. It is reached by taking the A966 out of Finstown and turning left about ¾km north of the B9057. Small numbers of red grouse and Arctic and great skuas are to be found on the moors along with colonies of five species of gull.

During the winter thousands of wildfowl arrive. The Loch of Harray attracts up to 7000 duck, nearly half of which are pochard; long-tailed duck and goldeneye on Loch of Stenness; several hundred greylag geese, large numbers of whooper swan and wintering waders around Loch of Skaill.
📷 Breeding species May–August; wintering birds October onwards

Hobbister (OS HY381068). This 759-ha RSPB reserve is mainly heather moorland with boggy areas found on the southern side by cliffs reaching a maximum height of 30m.
☛ Access restricted to the area between the A964 and the sea. Approach is via a minor road on the east side of Waulkmill Bay, an area of tidal sandflats (HY381067). Car park. The private houses and surrounding grounds are private property.

🦅 The moorland area holds breeding hen harrier, kestrel, merlin and short-eared owl as well as a few red grouse. Smaller breeding birds include meadow pipit, wren, skylark, twite and stonechat. Breeding waders include curlew, snipe and redshank. The freshwater loch holds teal, tufted duck and red-throated diver. Behind Waulkmill Bay is a small salt marsh – a feeding ground for waders. About 200 common gull breed on the lower moors. Common sandpiper nest on the loch shoreline. The cliffs hold raven, jackdaw and rock dove, and small numbers of fulmar and black guillemot.
📷 May–August

227

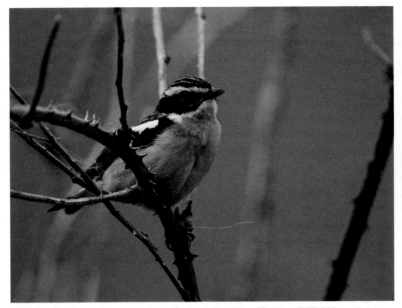

Whinchat *(Saxicola rubetra)*, Isle of Islay, Scotland; May; Nikon F3, Nikkor IF-ED 600mm f5.6 + Nikon 1.4× teleconverter, auto @ f8, Kodachrome 64; beanbag.

Dale of Cottasgarth and Birsay Moors *(OS* HY370194) This RSPB reserve of 2000ha covers a very large area of moorland typical of a habitat which is rapidly disappearing as heather is replaced by cultivated grasses. It includes dry and wet heath, marsh, and several burns, and small lochans.

☛ Situated near Dounby, Lower Cottasgarth is reached by turning left off the A966 5km north of Finstown; take track leading from the car park. Unrestricted access.

☞ Eight species of wader nest here including golden plover, dunlin, redshank, snipe, and large numbers of curlew. Birds of prey include several pairs of merlin, short-eared owl, kestrel and hen harrier. The most commonly seen moorland birds are skylark and meadow pipit with smaller numbers of wheatear, stonechat, twite and wren, as well as colonies of ground-nesting starlings. The moors hold large colonies of gulls and both Arctic and great skuas. Breeding wildfowl include teal, wigeon, and red-breasted merganser. Red-throated diver can be found on the hill lochans. There is a small hide from which many birds can be seen near the ruined farm buildings at Dale.

📷 April–late July

North Hoy *(OS* HY220010) This is one of the RSPB's newer acquisitions and covers a vast area of 3929ha of hill and moorland fringed by spectacular cliffs. The island of Hoy possesses the highest ground in Orkney rising to 458m at Ward Hill.

☛ Daily passenger ferry from Stromness on Mainland to Moness Pier or by ferry from Houton to Lyness. Enquiries: Orkney Tourist Information Office. Access unrestricted. Contact: the Warden, Kingshouse, Hoy, Orkney ☎ (085 679) 304.

☞ The moors and lochans also hold typical breeding species including peregrine, merlin, hen harrier, and red throated diver; golden plover, snipe and dunlin, wheatear, twite, stonechat and rock pipit also breed. It should be remembered that a *Schedule 1* permit is required to photograph some of these birds, at or near the nest, even in these remote areas.

📷 May, June, early July

172. Shetland Islands

Lumbister, Yell *(OS* HU505970) Mainly peaty moorland with small lochs covering 1720ha. See also 36.

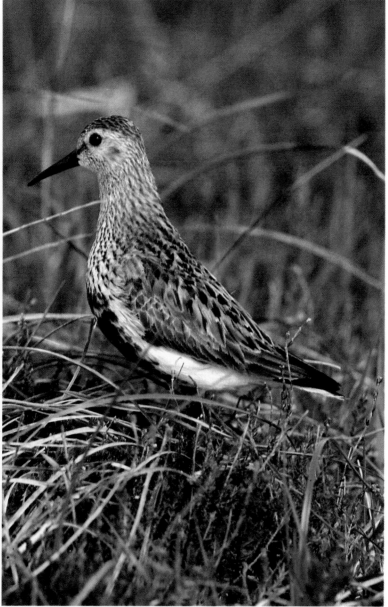

Dunlin *(Calidris alpina)*, Isle of Islay, Scotland; May, Nikon F3, Nikkor IF-ED 300mm f4.5, auto @ f5.6, Kodachrome 64; hide, tripod.

Good general views of the moorland from the A968 Mid Yell–Gutcher Road on its eastern flank. Access to the reserve area, April–August, preferably by arrangement with the summer warden, RSPB, Shetland Office, Houss, East Burra, Shetland, ZE2 9LE ☎ (095 783) 246. Accommodation details: Shetland Tourist Organization, Lerwick, Shetland, ZE1 0LU ☎ (0595) 3434.

Breeding specialities include whimbrel and red-throated diver. Great and Arctic skuas breed on the moorland. There is a large breeding wader population which includes golden plover, curlew, oyster-catcher, ringed plover, lapwing, snipe and dunlin. There are also one or two pairs of merlin and twite, meadow pipit, wheatear, raven, and hooded crow. Arctic and common terns nest by Lumbister Loch and there is a colony of great black-backed gull on the mainland. Herring and common gull also breed. Other birds to be seen include eider duck and red-breasted merganser on the lochs. Shetland wren nest along the shore of Whale Firth. Many of the species require a *Schedule 1* permit and need to be worked from a portable hide.

📷 Mid May–July

173. Snowdonia National Park
OS SH575610
Over 200,000ha of mountain, including Snowdon, the highest mountain in England and Wales, moorland, valleys and coastline.

Several towns giving access into Snowdonia, including Caernarvon, Conway, Bala, Machynlleth and Portmadoc. The area around Llanberis on the A4086 Caernarvon–Betws-y-Coed road, can be good for birds, particularly Llanberis Pass. Here one can take the mountain railway to the summit of Snowdon as an alternative to one of the six marked footpaths. Further details: Snowdonia National Park, Penrhyndeudraeth, Gwynedd, LL48 6LS ☎ (0766) 7707274.

In the highest regions one might expect to find raven, buzzard, wheatear, ring ouzel, skylark, and meadow pipit. Further down on the moorlands are red grouse, lapwing, curlew, redshank, snipe, merlin, short-eared owl, hen harrier and sparrowhawk.

📷 Spring, summer

174. Studland Heath
OS SZ034836
Studland Heath reserve, covers an area of 631ha, and consists of a number of different habitats including dry and wet heathland, woodland and lagoon. Fire is always a risk

on this reserve and great care should be taken.

From Wareham take the A351 towards Swanage. Turn left on to the B3351 to Stud-land, through the village towards the ferry. A small fee is payable at the tollgate. There is a car park near South Haven point. Open all year; sand dune trail; leaflet available. Further details: J. R. Cox, Coronella, 33 Priest's Road Swanage, BH19 2RQ ☎ (0929) 423452.

Dartford warbler and nightjar are the main attractions. Dartford warblers present throughout the year and should be seen on top of gorse bushes with a little patient watching, other heathland birds include linnet and stonechat.

📷 April–August for breeding birds; winter months for wildfowl, May–August, just before dusk for nightjar

175. Torridon
OS NG905557
This large area belonging to the National Trust for Scotland covers some 6500ha and boasts some of the most spectacular scenery in Scotland. There are three peaks, all reaching 1000m; the vegetation is mostly heather, deer and cotton grass on the lower regions and bog myrtle in the wet areas. Higher up, the vegetation is more lush and varied.

From A832 at Kinlochewe at the southern end of Loch Maree, take the A896 for about 15km.

Visitors centre open 1 June–30 September; information booklets and guided walk programmes available ☎ (044 587) 221. Further details: National Trust for Scotland, 5 Charlotte Square, Edinburgh, EH2 4DU ☎ (031226) 5922.

On the higher areas, birds are rather scarce and take some finding, but may include peregrine, golden eagle, raven, ptarmigan, ring ouzel and twite; on the lower slopes are golden plover, wheatear, and meadow pipit. The hill lochans hold red-throated diver and the boggy areas are attractive to the few nesting greenshank.

📷 Spring, summer

DENMARK

176. Hanstead Nature Reserve
An area of heathland with dunes, reedbeds and lakes on the north-west coast of Jutland which stretches from Hanstholm to Klint-møller. It is of interest mainly as a migration

watchpoint but also has a few interesting breeding species.

☛ Approach from either Hanstholm to the north or from Klintmøller to the south. No visitors allowed during the breeding season. Further information: Hanstholm Turistkontor, Centervej 31, 7730 Hanstholm.

☜ Breeding birds include a pair of cranes, spotted crake, ruff, wood sandpiper, golden plover, curlew and crested lark. Migrating wildfowl include greylag geese, bean geese, pink-footed geese, tufted duck, teal, smew, goosander, red-breasted merganser, whooper and Bewick's swans and finches.
📷 May–October

FINLAND See also 149, 150.

177. Kevo and Surrounding Area
The reserve itself lies in the Kevojoki canyon, in an area of tundra, and dwarf birches in the valleys at the northern limit of their range. The whole area is well worth exploring and the reserve holds no birds which cannot be found outside.

☛ A good base is the village of Karigasniemi on a main road 11km west of the Kevo nature reserve. Permits in advance from: Office for National Parks, National Board of Forestry, PO Box 233, 00121, Helsinki 12.

☜ A varied birdlife with many typical tundra breeding species. On the open tundra are ptarmigan, golden plover, whimbrel, rough-legged buzzard and long-tailed skua as well as occasional gyr falcon. The scrubby dwarf birch holds Arctic warbler, bluethroat, red-wing, snow bunting, Lapland bunting, brambling and redpoll. Marshy areas hold a good variety of breeding waders including spotted redshank, Temminck's stint, wood sandpiper, broad-billed sandpiper, red-necked phalarope and ruff. Other birds include waxwing shore lark, red-throated pipit and Siberian tit.
📷 June–August

178. Pallas–Ounastunturi National Park
An enormous area of mountain plateau with typical Lap peatland and forest, lakes and meres. The area is rugged and the climate can be harsh.

☛ Reach from Muonio (at the park's southern tip) on route E78 or from Enontekiö in the north. Access unrestricted; marked linking trails; campsites and cabins within the park. Further information: Office for National Parks, National Board of Forestry, PO Box 233, 00121, Helsinki 12.

☜ The lower slopes hold pied flycatcher, robin, chiffchaff, bullfinch, and song thrush, Siberian tit and Siberian jay. Higher up are ptarmigan, dotterel, golden plover, wheatear, snow bunting, shore lark, Lapland bunting and long-tailed skua. Marshy areas hold ruff and whimbrel. Raptors may include rough-legged buzzard and golden eagle. The lakes hold breeding duck including garganey and goldeneye, and the pine forests have three-toed and lesser spotted woodpeckers. Other birds to be seen are raven, hooded crow, whooper swan, black-throated diver, wood sandpiper and great grey owl.
📷 June–August

FRANCE

179. Camargue
Le Crau is a flat stony plain within the Camargue, south-east of Arles. Parts of this area are either restricted or of difficult access.

☛ Take the N113 road St Martin de Crau–Salon road where it crosses the D5.

☜ Exploration should yield little bustard, pin-tailed sandgrouse, quail, short-toed lark, Calandra lark and stone curlew; Egyptian vulture, Montagu's harrier, short-toed eagle, lesser grey shrike, Orphean warbler and crested lark and black-eared wheatear.
📷 Spring and summer

GREECE See also 114.

ICELAND See also 59.

180. Skaftafell National Park
Superb scenery with a wide variety of wild flowers. It is noted for its spectacular waterfalls, ravines, luxuriant vegetation and three glaciers including the largest in Iceland. Hot springs rise from the basaltic rocks.

☛ 15km north-west of Hof on the south coastal road from Reykjavík, open 1 June–15 September; marked trails. Camp site within the park boundary. Further information: Náttúruverndarád, Hverfisgötu 26, 101 Reykjavík.

☜ The moorlands hold snipe, meadow pipit, golden plover, snow bunting, wheatear and wren. The birch woods have nesting redwing. The large sand plain of Skeidararsandur has a large colony of great skua and Arctic skua and there are also

some colonies of great black-backed gull.
📷 May–July

ITALY See 61.

THE NETHERLANDS

181. Biesbosch
The area incorporates the Dordtsche, Sliedrechtse and Brabantse Biesboch reserves, and lies south-east of Rotterdam in between two branches or River Rhine, namely the Nieuwe Merwede and the Berge Maas which flow into the Hollandsch Diep. It is predominantly pastureland with a large area of polders, creeks, marshland, swampy woodland and reservoirs. The Haringvliet dam across the Rhine reduced tidal flow, and changes in the vegetation and birdlife are taking place.

Short-eared Owl *(Asio flammeus)*, Isle of Islay, Scotland; May; Nikon F3, Nikkor IF-ED 600mm f5.6, auto @ f5.6, Ektachrome 200; beanbag.

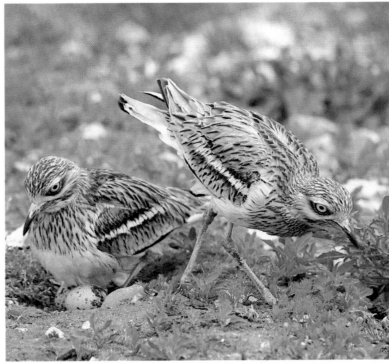

Stone Curlew *(Burhinus oedicnemus)*, Norfolk, England; May; Nikon F3, Nikkor IF-ED 300mm f4.5, auto @ f8, Kodachrome 64; hide, tripod.

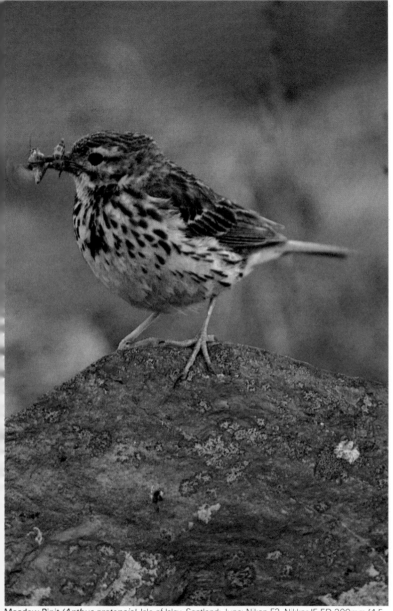

Meadow Pipit *(Anthus pratensis)*, Isle of Islay, Scotland; June; Nikon F3, Nikkor IF-ED 300mm f4.5, auto @ f5.6, Kodachrome 64; beanbag.

☞ The Dordtsche and Sliedrechtse Biesboch reserves are reached from Dordrecht on the A16, or from Sliedrecht. The Brabantse Biesboch reserve is reached from Lage Zwaluwe, 15km north of Oosterhout. The area is best explored by boat which may be arranged locally. Further information on the Dordtsche and Sliedrechtse reserves: Het Staatsbosbeheer, Van Speykstraat 13, 2518 EV ś–Gravenhage; on the Brabantse reserve: Het Staatsbosbeheer, Prof. Cobbenhagenlaan 225, Box 1180, 5004 BD Tilburg.

☛ Breeding birds include grey heron, night heron, greyling goose, marsh harrier, shelduck, gadwall, avocet, corncrake, kingfisher and bearded tit. Good wader passage in spring and autumn with spotted redshank, avocet, Kentish plover, curlew sandpiper, wood and green sandpipers, and lots of greylag and white-fronted geese in winter.
📷 All year, but particularly spring, autumn and winter.

182. De Hoge Veluwe and Veluwezoom National Parks

These two reserves lie in an area of sandy forest between the reclaimed land of Flevoland and Arnhem in central Holland. The area which was once rather barren drifting sand, is now, as the result of tree planting nearly a century ago, a landscape of mixed woodland with some pine forest and heathland. The whole area is worth exploring.

☞ The two parks lie to the north of Arnhem. For De Hoge Veluwe travel north on route N50 taking a left turn to Hoenderloo on the edge of the reserve some 10km before Apeldoorn. Alternative access from Otterloo to the west of the park. Access unrestricted except mid-September–mid-October during the rutting season. There are marked paths and a campsite within the park. Further information: Het Nationale Park De Hoge Veluwe, Apeldoornseweg 250, Hoenderloo. Veluwezoom park is also reached along route N50 some 5km north of Arnhem. Some areas are restricted. Facilities include a visitor centre and marked footpaths. Further information: Bezoekerscentrum 'De Heurne', Nationale Park Veluwezoom, Heuvenseweg 5A, 6991 JE Rheden.

☛ Birds of interest include buzzard, hobby, honey buzzard, merlin, sparrowhawk, Montagu's harrier, goshawk, black woodpecker, curlew, woodcock, black grouse, great grey shrike, golden oriole, crested tit and short-toed treecreeper. In the nearby Deelerwoud reserve which lies between De Hoge and Veluwezoom, the raven has been introduced as a breeding bird.
📷 May–July

NORWAY

183. Hardanger Vidda

A vast area of high plateau with steep-sided valleys, granite rocks, lakes, rivers and patches of woodland. It is a popular winter and summer holiday resort for the people of southern Norway.

☞ The park lies close to the Bergen to Oslo road; approach from Odda or Kinsarvik. Plentiful accommodation around and within the park, although the latter can be rather basic. Further information: TTK Buskerud, Storgt 2, 3500 Hønefoss. Access unrestricted and there are huts and marked paths.

☛ The best areas are in the relatively low areas in the northern part of the park. Many typical Arctic birds at the southern end of their range nest here – dotterel, purple sandpiper, Temminck's stint, greenshank, whimbrel, wood sandpiper, great snipe and long-tailed skua. Other birds are raven, scaup, velvet scoter, goldeneye, Tengmalm's owl, pygmy owl, black woodpecker, three-toed woodpecker, fieldfare, bluethroat, redpoll, brambling, ringed plover, wheatear and white wagtail. Birds of prey include osprey, golden eagle and merlin.
📷 May–July

PORTUGAL

184. Alentejo

Farmland with plantations of cork oak, wheatfields, and rocky hills, stretching from Montemor-o-Novo in central Portugal across to the border with Spain.

☞ The best areas are near the Spanish border between Elvas in Portugal and the town of Badajoz in Spain. A good plan is to work from the main E4 road using Elvas as a base and exploring the area thoroughly including land beside the numerous minor roads which cross the area. This is not a reserve area and access is only limited by private land ownership.

☛ The outstanding bird of this area is the great bustard which may well be seen from the roads. This is an extremely wary bird and distant views are the norm. Careful planning and considerable luck will be necessary to get close enough for good photographs. The cork oak forests hold hoopoe, great spotted

cuckoo, azure-winged magpie and numerous warblers. Other birds include little bustard, Andalusian hemipode, crested lark, thekla lark, white stork, woodchat shrike, great grey shrike and black-eared wheatear and various raptors.

📷 April–August

SPAIN See 82.

SWEDEN

185. Abisko

Probably the most accessible of the parks in Swedish Lapland. The diversity of habitats, including open water, marshes, scrub on the lower mountain slopes, alpine meadows and boulder fields and high tundra, is reflected in the variety of birds.

☛Abisko cannot be reached by road; fly to Kiruna in Sweden or to the coastal port of Narvik in Norway and then take the train to Abisko *turiststation*. A coastal steamer service runs from Bergen to Svolvaer in Norway, followed by a further boat trip to Narvik. Good hotel called Abisko *turiststation*. Advanced booking essential, July and August; contact 980 24, Abisko ☎ (0980) 400 00 or via the Swedish Touring Club. Motor boat excursion trips across the lake from the ski lift near the hotel. Next to the hotel is a hut with 12 beds; only basic facilities provided. The network of mountain huts throughout Swedish Lapland and owned by the Swedish Touring Club, are particularly useful for those exploring the area on foot. Further information: Svenska turistförening, Stureplan 2. Fack 103 80 Stockholm. The area is subject to wide climatic variations and walkers should take the appropriate precautions, including good boots, layered waterproof clothing, mosquito repellent, maps, compass, emergency rations and first aid kit. This is particularly relevant for excursions of more than one day. Always let someone know your intended route. Further information: Statens Naturvårdsverk, Nature Conservation Division, Box 1302, 171 25 Solna.

🐦 A fine place for Arctic birds. Breeding birds include rough-legged buzzard, merlin, ptarmigan, willow grouse, golden plover, dotterel, whimbrel, greenshank, Temminck's stint, red-necked phalarope, long-tailed skua, hawk owl, raven, fieldfare, Arctic redpoll, brambling, lapland bunting and snow bunting.

An uncommon breeder is the Arctic warbler which breeds in the birchwoods on the slopes of Mount Njulla. Birds relying upon a plentiful supply of small rodents – such as hawk owl, snowy owl, long-tailed skua and rough legged-buzzard – will be less common in bad years. There is a good chance of seeing a golden eagle.

📷 May, June, July; June the best month for breeding birds.

YUGOSLAVIA

186. Petrovac

A coastal town in the Crna Gora which is central to a number of notable birdwatching localities. Behind the town are hills with scrub and woodland; east is an excellent area of marsh and wet meadows just outside the village of Buljarica.

☛ South of Titograd, about 130km east of Dubrovnik. On the main coastal road from Dubrovnik to Ulcinj near the Albanian border. Accommodation available in the town. There is a hotel on the coast about 1km from the turning for Canj. Access theoretically unrestricted, but as in many places in Yugoslavia the military can be rather sensitive about visitors carrying cameras and binoculars.

🐦 The scrub and woodland behind Petrovac are particularly attractive to migrant birds and typically hold scops owl, hawfinch, cirl bunting, black-headed bunting, ortolan bunting, red-backed shrike, woodchat shrike, bee-eater, roller, nightjar, wryneck, pied and spotted flycatcher, whinchat, redstart, olive-tree warbler, olivacious warbler, subalpine warbler, Orphean warbler, Sardinian warbler, icterine warbler, nightingale, and alpine swift, overhead. Further east at Buljarica Marsh are purple heron, squacco heron, little egret, garganey, marsh harrier, buzzard, red-footed falcon, wood sandpiper, black tern, bee-eater, golden oriole, wheatear, black-eared wheatear, lesser grey shrike, red-backed shrike, woodchat, shrike, tawny pipit, short-toed lark, black-headed bunting, yellow wagtail, whinchat and alpine swift. Eastwards along the coast road towards Bar there is a signpost for Canj; the rocky areas either side of the road hold breeding rock nuthatch. Other birds here include blue rock thrush, red-rumped swallow, nightingale, sombre tit, Bonelli's and Cetti's warblers.

📷 April–September

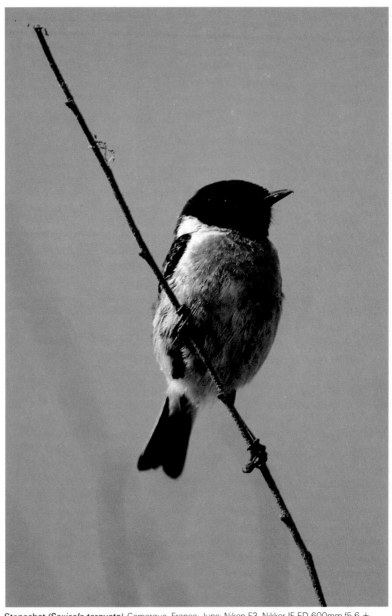

Stonechat *(Saxicola torquata)*, Camargue, France; June; Nikon F3, Nikkor IF-ED 600mm f5.6 + Nikon 1.4× teleconverter, 1/125 sec @ f8, Kodachrome 64; car bracket.

16. Birds of Mountain Regions

Some eagles and hawks, some pheasants, a few waders, some accentors, some thrushes and chats, some corvids, buntings and skuas

This is probably the least productive of all habitats, at least in terms of numbers of species. Many of the birds are rather shy and have specialized to adapt to their rather harsh environment. This is not the environment to visit in the hope that you may find something to photograph but one where you would be working a particular species and have done a good deal of preparation. Above all, thorough knowledge of the quarry is necessary to avoid disappointment. Many hours of travel and preparation are usually unavoidable and all equipment must be carried for long distances over difficult terrain. There are, in addition, the dangers of exposure or injury in an isolated area, and meticulous attention to safety and survival details is essential. This type of work demands physical and mental fitness and a good deal of commitment on the part of the photographer. He or she will often spend many lonely hours alone in a hide in some of the most hostile conditions. The rewards, however, are potentially great. Anyone who is unsure of the commitment needed or the exhilaration of success should read Eric Hosking's account of his honeymoon spent photographing golden eagles at the nest in his book *An Eye for a Bird*.

Special techniques: see pages 38, 54, 102, 103

Equipment

35mm SLR	Wide angle lens	Rucksack
Spare body	Slow or medium film	Climbing gear
300–600mm telephoto lens	Hide, stool	Survival kit
70–210mm zoom lens	Tripod, monopod	Compass, knife, etc

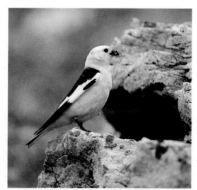

Snow Bunting *(Plectrophenax nivalis)*. Varanger Peninsula, Norway; June; Nikon F3, Nikkor IF-ED 300mm f4.5, auto @ f5.6, Kodachrome 64; hide, tripod.

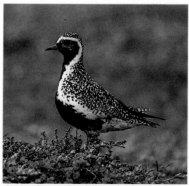

Golden Plover *(Pluvialis apricaria)*, Varanger Peninsula, Norway; June; Nikon F3, Nikkor IF-ED 600mm f5.6, auto @ f5.6, Kodachrome 64; hide, tripod.

MOUNTAIN REGIONS

AUSTRIA

187. Gross Glockner Pass

One of the main mountain passes between Austria and Italy, to the east of Gross Glockner peak within the proposed Hohe Tavern National Park. Gross Glockner is Austria's highest mountain, rising to about 3800m. The scenery is splendid with mountain, pine forests and waterfalls. The road makes an ideal point from which to view and photograph a number of alpine species.

☛ From Salzburg take the E17 to Lofer, the 168 road to Bruck, then the 107 road across the Gross Glockner pass to Italy. The road itself is good and there are many laybys at which to stop.

☛ On the way up into the pass there should be citril finch, red-backed shrike, nutcracker, siskin and black redstart. Once up amongst the snow and ice, snowfinch and alpine chough are very much in evidence, and water pipit and alpine accentor should be seen. Birds of prey include golden eagle, hobby, peregrine and maybe griffon vulture. Other birds should include alpine swift and crag martin.

📷 June, July

188. Hafelekargebirge

Rising to over 2000m, Hafelekargebirge is a typical tyrol mountain region, with spectacular mountain peaks and forests, alpine pastures, lakes and streams.

☛ Situated just north of Innsbruck, which is a good base, with plentiful accommodation. Cable car service from Innsbruck, and there are paths back down through the coniferous woodland to the valley floor.

☛ Alpine chough are numerous around the upper cable car station, and nearby you should find alpine accentor and snowfinch. The wooded slopes hold black redstart, nutcracker, buzzard, as well as the usual small passerines. Other species to be expected include black kite, raven, nuthatch, crossbill, alpine swift, crag martin and water pipit.

📷 May–August

189. Mayerhofen

A small but popular ski resort at the head of the Ziller valley, set in a flat valley floor at the convergence of three streams. Around the village are fields, some of which are cultivated, leading up to the steep valley sides. The hillsides are covered with conifers with alpine pasture above the treeline.

☛ Situated about 80km south-east of Innsbruck, off the main E86 through Austria from Kurfstein, Germany to Vipetino in Italy via the Brenner Pass. Accommodation plentiful. There are two cable cars from Mayerhofen, the Penkenbahn and the Ahornbahn, and both give easy access to the mountain areas either side of the town. The whole area is criss-crossed by paths and it is possible to walk back down to the town.

☛ Song thrush, mistle thrush, blackbird, ring ouzel, fieldfare, serin, dipper, and possibly red-backed shrike on the valley floor. The cable car stations seem to attract birds, and around the Penkenbahn upper station one can expect citril finch, crossbill, nutcracker, and possibly three-toed woodpecker and alpine chough are common at both upper stations in winter. Birds of prey should include buzzard, goshawk, honey buzzard and kestrel; alpine species are snowfinch and alpine accentor, black grouse, capercaillie; small passerines, black redstart, siskin, redpoll, lesser whitethroat, goldcrest and firecrest and crested tit.

📷 May–August

BRITISH ISLES See 164, 167, 175.

FRANCE

190. Pyrénées National Park

The French Pyrénées National Park abuts the Spanish border and the Spanish National Park of Ordesa (see page 243). The landscape is breathtaking with mountain peaks, valleys, steep rock faces, lakes, waterfalls, and pine woodland, and a rich alpine flora. A particularly striking feature of the park is Cirque de Gavarnie – also a prime spot for birds.

☛ A good starting point is the ski centre and its approach road just outside Gavarnie, south of Lourdes (the whole of this valley is worth exploring). Access unrestricted. Information centres throughout the park; hotels and campsites round the park. Further information: Parc National des Pyrénées Occidentales, route de Pau, B.P. 300, 65013 Tarbes.

☛ Around Gavarnie you can expect alpine chough, chough, rock thrush, blue rock thrush, alpine accentor, dipper, crag martin, wheatear, black redstart, water pipit, rock bunting, snow finch and alpine swift. Birds of prey include lammergeier, Egyptian vulture and peregrine. Black woodpecker, white-backed woodpecker, middle spotted woodpecker, serin and Bonelli's warbler in

the surrounding woodlands. From Gavarnie a valley leads to the cirque. The woods of the steep-sided valley contain alpine chough, firecrest, cirl bunting, red-backed shrike, crossbill and alpine accentor. In the highest wooded areas there should be citril finch. The Vallée d'Ossoue lies just outside Gavarnie. High above the stream, passing through the valley, is a steep mountain rock face. Lammergeier usually nest in a cave in the rock face and can be seen soaring around the entrance. Other birds of prey which may be seen in the area are griffon and Egyptian vultures, golden eagle, Bonelli's and booted eagles, red and black kites, peregrine, goshawk and sparrowhawk. Other birds include wallcreeper, rock bunting and crag martin.

📷 May–July; winter can also be rewarding

191. Vanoise National Park
Situated in the Central Alps on the Italian border adjoining Gran Paradiso National Park (see page 241). It encompasses many mountain peaks, the highest rising to well over 3500m, and villages, agricultural land and fields line the valley floors. Higher up extensive pine forests begin to thin out until finally disappearing, leaving bare rock. An extremely popular park for both natural history and leisure and sporting activities.
☛ Reached from Val d'Isère. Accommodation is widely available on the periphery and there are refuges within the park proper. Access unrestricted. There are many ski lifts in the area. Further information: Parc national de la Vanoise, 135 rue du Docteur – Juilliand, B.P. 105, 73003 Chambéry cedex.
☛ Typical mountain and forest birds. At higher altitudes are alpine chough, chough, alpine accentor, snow finch and ptarmigan; black woodpecker, three-toed woodpecker, nutcracker, crested tit, citril finch, crossbill, hazelhen and black grouse in the forests; other birds of interest are eagle owl, Tengmalm's owl, pygmy owl, golden eagle, buzzard and wall creeper.
📷 May–September

GREECE See also 114.

192. Ávas Gorge
Scenically attractive, with high limestone crags beside the road, the gorge is a superb location for raptors. South of the village is a ruined castle on a mound, and nearby olive groves and scrub which are also of ornithological interest.

☛ North of the village of Ávas which is some 10km north of Alexandroúpolis (where accommodation is available). Access unrestricted.
☛ Raptors are plentiful in the gorge and in the area around the castle mound; species should include imperial eagle, golden eagle, lesser spotted eagle, short-toed eagle, booted eagle, Egyptian, griffon and black vultures, steppe, honey and long-legged buzzards, Levant sparrowhawk, and Lanner falcon. Eagle owls nest locally and are regularly seen. Other birds of interest include black stork, white stork, roller, hoopoe, bee-eater, Syrian woodpecker, crag martin, red-rumped swallow, woodchat shrike, masked shrike, olivaceous and Sardinian warblers, cirl and black-headed buntings, Spanish sparrow, blue rock thrush, sombre tit, hawfinch, and golden oriole.
📷 April–September

193. Delphi
In addition to the architectural wonders of the ancient Greek civilization, for which Delphi is best known, there is a varied and interesting avifauna. To the north of the village, Mount Parnassós rises to nearly 2500m, while lower down are olive groves, scrubby bushes, gentle slopes and some open areas. Many of the birds have become quite tame as a result of the thousands of visitors passing through the region each year.
☛ Delphi is reached by taking the E92 northwest from Athens and then following the road through Thebes on to Levádhia and Delphi. Campsites around Delphi. Access to Mount Parnassós National Park and the general area is unrestricted. The ruins themselves harbour many birds.
☛ Birds of prey include griffon, Egyptian, and black vultures, golden and imperial eagles, buzzard, and if you are lucky, lammergeier. Around the ruins are rock nuthatch, Sardinian, subalpine and Orphean warblers, rock thrush, rock sparrow and sombre tit, amongst others. Higher up on the hillside are rock partridge, Cretzschmar's bunting, ortolan, cirl, and rock buntings. Rüppell's warbler are often found in an open area with some bushy cover just above the ruins. Around the campsite just outside Delphi village are rock nuthatch, Cretzschmar's and cirl buntings, blue rock thrush, Sardinian warbler, and in the evening Scop's owl. To the east, on the way to the Arachova ski lift, the open plains hold black-eared

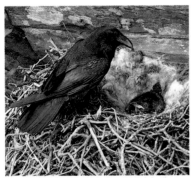

Raven *(Corvus corax)*, Dyfed, Wales; April;
Nikon F3, Nikkor IF-ED 600mm f5.6, auto @
f5.6, Kodachrome 64; hide, tripod.

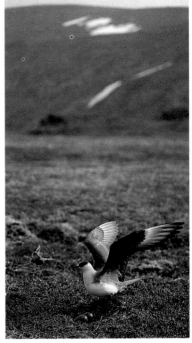

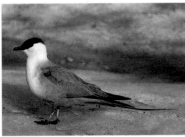

Long-tailed Skua *(Stercorarius longicaudus)*.
Varanger Peninsula, Norway; June; Nikon F3,
Nikkor IF-ED 600mm f5.6, 1/250 sec @ f5.6,
Kodachrome 64; stalked with tripod.

Arctic Skua *(Stercorarius parasiticus)*.
Varanger Peninsula, Norway; June; Nikon F3,
Nikkor 80–200mm zoom f4, auto @ f8,
Kodachrome 64; hide, tripod.

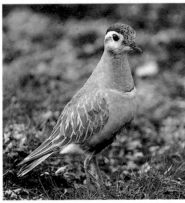

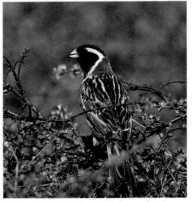

Dotterel *(Charadrius morinellus)*, Highland,
Scotland; June; Nikon F3, Nikkor IF-ED 300mm
f4.5, auto @ f5.6, Kodachrome 64; stalked with
monopod.

Lapland Bunting *(Calcarius lapponicus)*.
Varanger Peninsula, Norway; June; Nikon F3,
Nikkor IF-ED 600mm f5.6, auto @ f5.6,
Kodachrome 64; hide, tripod.

wheatear, cirl bunting, woodlark and shorelark; in the wooded area near the lift are middle spotted woodpecker, crossbill, sombre tit, firecrest and Bonelli's warbler, and around the lift itself are rock partridge, rock thrush, rock bunting, black woodpecker, alpine chough and serin. Higher up still are snow finch and alpine accentor. Continuing east from Arachova is a cliff rising above the north side of the road which is said to hold breeding griffon vulture and lammergeier.

📷 April–September

194. Meteora

Spectacular scenery, in central Greece, an area famous for the monasteries which are perched high up on inaccessible summits of sandstone rocks and columns. Meteora is also a stronghold for birds of prey, and the cliffs north of the small town of Kalambáka are particularly worth exploring.

☛ Reached on the only major road which crosses Greece from the Aegean to the Ionian sea, on the edge of the Pindus mountain range. Campsite just south of Kalambáka. Access unrestricted.

🦅 The local rubbish tip is probably well worth visiting and one of the better places to photograph the Egyptian vulture, which comes well within photographic range from a hide. Other birds here include black kite, raven and hooded crow. In the scrub and woodland at the base of the cliffs are bee-eaters, crested lark, tawny pipit, cuckoo, woodchat shrike, orphean and subalpine warblers, sombre tit, red-rumped swallow, black and white storks. Higher up, around the monasteries, are alpine swift, crag martins, red-rumped swallow, booted eagle, golden eagle and honey buzzard.

📷 April–September

ITALY See also 189.

195. Abruzzo National Park

A big park in the Apennines – the backbone of Italy. There are still large areas of unspoilt beech forest which clothe the mountains almost to their summits. Black pine, flowering ash and maple also grow in the forests. Above the treeline is a band of grassland, below the barren rocky summits. Lago di Barrea on the River Sangro is at the eastern end of the park.

☛ Best approach is from Pescasséroli, which is about 65km from Isernia to the south-east. Access unrestricted at all times.

Accommodation available at Pescasséroli, where there is also an information centre. The site is wardened and there are mountain refuges in the park. Further information: Ente Autonomo Parco d'Abruzzo, Via Livorno 15, Rome.

🦅 Birds are abundant, with breeding golden eagle, chough, alpine chough, snowfinch, raven and rock partridge. Blue rock thrush, black redstart, crag martin, dotterel and white-backed woodpecker are rare breeders. Beech woods contain subalpine, melodious, Orphean and Bonelli's warblers as well as collared flycatcher and short-toed tree creeper. Other woodland birds include buzzard, chaffinch, nuthatch and marsh tit.

📷 May–July

196. Gran Paradiso National Park

A big national park near the French border (see also p. 239). Rising to around 4000m above sea level this area includes bleak mountains capped in snow and ice, wooded mountain valleys, alpine meadows, some open water and glacial streams.

☛ By road from Aosta or Pont Carnavese approximately 50km north of Turin. Access unrestricted at all times. There are mountain refuges within the park and accommodation is widely available in nearby villages and towns. Further information: Ente Autonomo Parco Nazionale Gran Paradiso, Via Della Rocca, 47, 10123, Turin.

🦅 Best known for its role in preserving the alpine ibex, but in addition it harbours a representative selection of the European alpine avifauna. Birds are abundant but variety is naturally restricted to those eighty or so species adapted to living in this habitat. Notable amongst these are golden eagle, eagle owl, Tengmalm's owl, ptarmigan, capercaillie, alpine chough, black grouse, buzzard, black woodpecker, nutcracker and ring ouzel; others include rock thrush, rock bunting, blue rock thrush, alpine swift, wall creeper, alpine accentor, citril and snow finches.

📷 May–July

197. Stelvio National Park

An enormous national park covering about 137,000ha, in the northern Italian Alps next to the Swiss–Italian border. Snow-covered mountains rising to nearly 3800m dominate deep river valleys, alpine pastures, forests of larch, Norway spruce and arolla pine and some open water.

☛ Numerous points of entry by road from Merano and Tirano. The park centre is in the

resort of Bormio. Many of the ski lifts operate throughout summer. Accommodation plentiful all the year; tourist huts and hotels within the park. Access unrestricted. Further information: Direzione del Parco Nazionale, Bormio (Sondrio).

🐦 Most of the typical alpine birds as well as some more generally associated with lowland areas. About 130 species have been recorded in all, and include capercaillie, golden eagle, eagle owl, black grouse, rock partridge, ptarmigan and alpine chough. Others might include black woodpecker, nutcracker, crested tit, tree creeper, ring ouzel, dipper, rock thrush and blue rock thrush, alpine accentor, siskin, citril and snow finches, three-toed woodpecker and alpine swift.

📷 May–July

NORWAY See also 183.

198. Börgefjell National Park
A harsh and beautiful mountain landscape near the Swedish border, with a number of mountain peaks, the highest of which reaches over 1700m: survival precautions are necessary. The park is crossed by wide rivers and there are many attractive waterfalls and lakes. Only a small part is wooded, the rest being covered with typical upland vegetation.

🐦 From Majavatn take the main E6 road north to Börgefjell. Access unrestricted. Some local campsites and reindeer herdsmen's huts available in the park itself. Further information: TTK Nordland, Boks 434, 8001 Bodø.

🐦 On the uplands are ptarmigan, long-tailed skua and snow bunting and occasional snowy owl. The rough-legged buzzard is probably the commonest bird of prey. Lower down, along the rivers are common scoter, goosander and goldeneye. The woodland holds redwing, fieldfare, brambling, siskin, pied flycatcher, willow warbler and bluethroat. On the lakes and surrounding marshes are red-necked phalarope, Temminck's stint, long-tailed duck, bean and lesser white-fronted geese.

📷 June, July

SPAIN See also 75.

199. Gredos National Reserve
The most prominent feature is Pico de Almanzor which rises to over 2500m. The River Tietar runs through the reserve, bordered by steep, rocky slopes; there are many waterfalls, some afforested areas, and on the higher slopes the rich alpine flora is well worth a visit.

🐦 Situated about 120km west of Madrid. Access from the Arenas de San Pedro, only restricted during the hunting season. The site is wardened and there are refuges within the park. Further information: Delegacion Provincial de Turismo, Alfonso Montalvo 2 prpal, Avila.

🐦 The reserve is best known for mammals such as the Spanish ibex, but raptors are well represented with golden eagle, honey buzzard, red kite, black kite, Egyptian, black and griffon vultures. Other birds include alpine chough, rock thrush, crossbill, crested tit, rock bunting, bluethroat, citril finch, goldcrest and firecrest.

📷 May–July

200. Mallorca
The largest of the Balearic islands has a varied landscape with rugged mountains, valleys, plains, salinas, marshes, dykes and reedbeds. Much of the island is accessible and as a result of the tourist trade, amenities and transport are excellent. See also 81.

🐦 Palma airport is well served by airlines from many European cities. Accommodation is plentiful and of a good standard; advance booking advisable at peak holiday season.

The Artá Mountains are not particularly productive – or accessible, without some difficult driving. The best place is at the foot of the mountains between the road to Colonia San Pedro and the coast. Birds to be expected from the road include raven, crag martin, booted eagle, red kite and cirl bunting.

The Boquer Valley in the north of the island, north of Puerto Pollensa, is especially good at migration time. Breeding birds include Eleonora's falcon, peregrine, raven, blue rock thrush, rock sparrow, Sardinian and Marmora's warblers. Other interesting birds are scoops owl, hoopoe, crossbill, firecrest, goldfinch, wryneck and red-rumped swallow.

📷 April–September

201. Monfragüe Natural Park
An area of high mountains in the Extremadura region of south-west Spain. The hills either side of the River Tagus are

covered with cork oak and holm oak woodland. Despite strenuous efforts by conservationists, the area is under threat from replanting eucalyptus trees.

☛ Approach from Navalmoral de la Mata on the main E4 from Madrid to Badajoz, or from Cáceres or Trujillo to the south. Access unrestricted. Further information: Director conservador del Parque Natural de Monfragüe, Servicio Provincal de ICONA, calle General Primo de Rivera 2, Cáceres.

🦅 Renowned for its birds of prey – about sixty pairs of black, good numbers of griffon and some Egyptian vultures; others include short-toed, imperial, golden, Bonelli's and booted eagles, peregrine, goshawk, buzzard, black kite, marsh harrier, black-shouldered kite and eagle owl. The ridge east of the castle can be good for raptor flight shots. Other birds include breeding black and white storks; Alpine swift, house martin and rock sparrow nest under the modern bridge over the river in the north of the park. Near the river one can expect to see cattle and little egret, night heron and spoonbill as well as a small selection of waders during times of passage.

📷 May–September

202. Ordesa National Park

In the central Pyrenees in northern Spain close to the French border. Originally the park consisted only of the Ordesa valley, a steep wooded valley with impressive cliffs and rocky buttresses through which runs the River Arazas. More recently it has been extended to cover three other valleys. The scenery is impressive with rocky cliffs, gorges, forests, waterfalls and glaciers, and there's a very rich flora.

☛ Reach from Huesca, the nearest large town some 90km south west, and enter at Torla where there is an information centre. Unrestricted access; wardened. Hotel, campsite and refuges within the park. Further information: Parque Nacional de Ordesa, Servicio Provincial de ICONA, General Las Heras 8, Huesca.

🦅 Lammergeier are said to nest and other birds of prey include Egyptian and griffon vultures, golden, booted, short-toed, and Bonelli's eagles, black and red kites, Montagu's harrier, peregrine, goshawk and eagle owl. Other species are alpine chough, chough, alpine swift, rock thrush, hoopoe, bee-eater, black-eared wheatear and black wheatear, rock sparrow, citril and snow finches, wall creeper and alpine accentor.

📷 May–August

203. Serrania da Ronda

A region of rugged mountainous country with some stunted trees and open scrub. Ronda, a good base for exploring the area, is set on the gorge of the Rio Grande which passes through the town centre.

☛ Situated between Málaga and Sevilla, a few hours' drive from the Costa del Sol. Take the E26 coast road towards Algeciras. Turn right on to the C339 and follow the Ronda road. The reserve is passed before reaching Ronda. Access here is unrestricted. Further information: Delegacio Provincial de Turismo, Puerto del Mar 12 – 2°, Málaga. The Teba gorge is reached by taking the C341 from Ronda for about 45km.

Continuing north of the Teba gorge, pass through Campillos on to Sierra de Yeguas. A right turn here takes you on to the Salinas de Fuente de Piedra just before the town of the same name. This is a good location for breeding greater flamingo, when water conditions are suitable, as well as numerous other waterbirds.

🦅 The area is particularly good for mountain species – birds of prey such as Bonelli's, booted, golden, and short-toed eagles, buzzard, honey buzzard, Egyptian and griffon vultures; black wheatear, black-eared wheatear, alpine swift, red-rumped swallow, crag martin, chough, blue rock thrush, rock sparrow, rock bunting, and serin. Warblers include melodious, fan-tailed, Sardinian, subalpine, Dartford, Bonelli's, orphean and olivacious warblers. Other birds of interest include lesser kestrel, pallid swift, great grey and woodchat shrikes, thekla and Calandra larks, bee-eater, rock dove, hoopoe and spotless starling. The Teba Gorge, although relatively small, holds a particularly good variety of species.

📷 April–September

204. Sierra de Guadarrama

This rugged range of mountains with pine forest and scrub rises at its highest point to over 2400m. A network of roads makes the area quite accessible.

☛ Situated about 60km north-west of Madrid and easily reached from Segovia on the N603. Good accommodation available in Segovia or local villages.

🦅 Of particular note are the birds of prey of the mountains and pine forests, and are well seen from the mountain roads. These include black and griffon vultures, golden, imperial, Bonelli's, booted and short-toed eagles, red and black kites, goshawk, buzzard, honey buzzard, peregrine, hobby,

and lesser kestrel. White storks nest in the villages. Other birds include great grey shrike, woodchat shrike, great spotted cuckoo, hoopoe, roller, rock thrush, bee-eater, little owl, crested and Calandra lark, cirl bunting, rock bunting, rock sparrow, citril finch, serin and golden oriole. Warblers include Bonelli's, melodious, subalpine and Dartford warblers.

📷 April–September

SWEDEN See 185

SWITZERLAND

205. Grindelwald
This ski resort in the Bernese Oberland, is a popular tourist spot in both winter and summer, and well served with railways taking you to surprising heights, thus giving relatively easy access to a number of alpine bird species. The whole area is worth exploring, including Wengen, Lauterbrunnen and Kleine Schedegg.

☛ Grindelwald itself is a good base for exploring using a combination of trains, chairlifts and walking. Plenty of accommodation June–September.

🐦 The pine forests shelter birds such as crested tit, nutcracker, grey-headed woodpecker, firecrest and citril finch. Higher up are alpine chough, alpine swift, alpine accentor, wallcreepers, rock thrush, and black redstart. Snowfinches are found at the highest altitudes. Alpine chough are often seen to congregate at the top of ski-lifts and cable car stations.

📷 June–September

206. Vallée de Joux et Haut Vaudois Nature Reserve
An area of limestone mountains – part of the Swiss Jura – with mixed forests of beech and sycamore, and alpine meadows. Lac de Joux lies within the reserve and at its southern end are reedswamps and lagoons. The area has a particularly rich flora. Mont Tendre, the second highest peak in south-west Switzerland, is well worth exploring.

☛ Located in south-western Switzerland on the French border. Reach from Vallorbe, 40km from Lausanne. Access unrestricted and there are hotels and campsites within the reserve. Further information from Swiss League for Nature Protection, PO Box 73, 4020 Basel.

🐦 At the ridge summit are ring ouzel and black redstart. Nutcracker and citril finch found in the conifer forests along with firecrest, goldcrest, crested tit, greyheaded woodpecker and sometimes crossbill. Black woodpecker and Tengmalm's owl are also present but rather elusive. The marshy area at the southern end of Lac de Joux attracts good numbers of passage waders.

📷 April–late July

WEST GERMANY

207. Oberammergau
Better known for its staging of the passion play every decade, than for its birdlife, Oberammergau is a superb place to find some of Europe's typical alpine species. It is a good base from which to explore the Ammer valley and surrounding mountains. The area has mountain woodland, meadows and snow-covered mountain peaks, each holding interesting bird species.

☛ Situated some 80km south-east of Munich in the Bavarian Alps. Take the E6 autobahn from Munich. There are a number of hotels, *zimmer-freis*, and campsites in Oberammergau and other villages in the Ammer valley. Cable car (open summer) and chair-lift (closed summer) in the town.

🐦 In the valley meadows, shrubs and a few areas of woodland are golden oriole, red-backed shrike, black redstart, pied fly-catcher, wryneck, serin, tawny pipit, grey wagtail and dipper. The conifers clothing the steep valley sides hold grey-headed, green, great spotted, middle spotted and lesser spotted, white-backed and three-toed wood-peckers. Other species include capercaillie, nutcracker, long-eared owl, buzzard, hobby, crossbill, fieldfare, crested tit and siskin. Alpine species above the tree line include rock thrush, alpine accentor, rock bunting, alpine chough and crag martin.

📷 May–July

YUGOSLAVIA See also 134, 158.

208. Galičica National Park
This mountainous area with a diverse flora sits between two important wildfowl refuges. The forested areas are made up of an interesting variety of trees including Grecian juniper and Macedonian oak. The two lakes have marshy areas which are important for migrant birds.

☛ Situated between lakes Prespa and Ohrid on the Albania/Greece border. The park lies

south of Skopje and the town of Bitola makes a good base from which to walk the area, including nearby Pelister National Park. Access is unrestricted and there are campsites within the park. Further information: Turistički savez Makedonije, Maršala Tita 39, p.fah 25, 91001 Skopje.

🦅 Cormorants nest on an island called Golem Grad in Lake Prespa. Lake Prespa also has a colony of breeding Dalmatian pelican. Other species found include various herons, pygmy cormorant and glossy ibis. Raptors include short-toed eagle, goshawk, marsh harrier and red-footed falcon. A variety of waders are to be found, especially on migration, including little stint, wood sandpiper, ruff, greenshank and marsh sandpiper. Passerines include tawny pipit and red-throated pipit, moustached, Savi's and Cetti's warblers.

📷 April–October

209. Lovćen National Park

The smallest of Yugoslavia's national parks forms part of the south-eastern Dinaric Alps and reaches 1700m. In the lower regions there is some deciduous woodland, including beech, hornbeam and downy oak.

🪶 Situated to the north-east of Kotor and west of Cetinje. The nearest airport is Tivat on the Adriatic coast, and the park can be reached via Kotor or from Titograd via Cetinje. Access unrestricted; vehicular tracks and mountain refuges within the park. Further information: Turistički Savez Crne Gore, Bulevar Lenjina 2/1, 81001 Titograd.

🦅 A number of interesting species occur, including rock partridge, alpine chough, rock thrush, blue rock thrush, alpine swift and raven. Raptors include golden eagle, goshawk, peregrine, buzzard, honey buzzard, griffon vulture and red-footed falcon. At lower levels, in the cultivated areas, you may find woodlark, black-eared wheatear, red-backed shrike, barred warbler and black redstart.

📷 April–September

210. Mavrovo National Park

The largest of Yugoslavia's national parks with a variety of habitats such as rocky cliffs, extensive beech and fir forests, mountain peaks, highland pasture and a large lake. Mammalian species include bears, wolves and lynx.

🪶 Approach from either Gostivar or Debar on the road from Skopje which goes on to the Albanian border. Access unrestricted. Hotels and cable cars within the park.

Further information: Turistički savez Makedonije, Maršala Tita 39, p.fah 25, 91001 Skopje.

🦅 Best known for its variety of raptors such as golden, imperial, spotted and booted eagles, Egyptian and griffon vultures, lammergeier, common and rough-legged buzzards, osprey, goshawk and eagle owl. Although present, these will be difficult to photograph without prior research. A good number of peregrine and red and black kites also occur. Smaller birds found are rock and blue rock thrushes, alpine chough, alpine accentor, nutcracker and snow finch.

📷 April–October

Species Index

Figures in bold type denote photograph.

SPECIES INDEX

Technical Index

Location Index

THE BRITISH ISLES

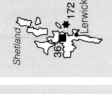

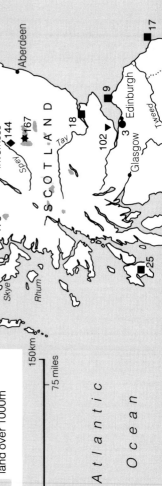

Type of habitat

● town, park and garden

■ island, coast and estuary

▼ inland fresh water

◆ forest and woodland

★ open country -
grass, heath and moor

▲ mountain regions

47 site number

land over 1000m

150km

75 miles

0

Atlantic

Ocean

North

Sea

Shetland

Shetland

172 Lerwick

36

17

Aberdeen

103

Orkney

Kirkwall

171

30

139

Inverness

144 167

Spey

SCOTLAND

Tay

18

9

Edinburgh

Tweed

102

3

Glasgow

164

22

137

175

Lewis

Skye

Rhum

25

31

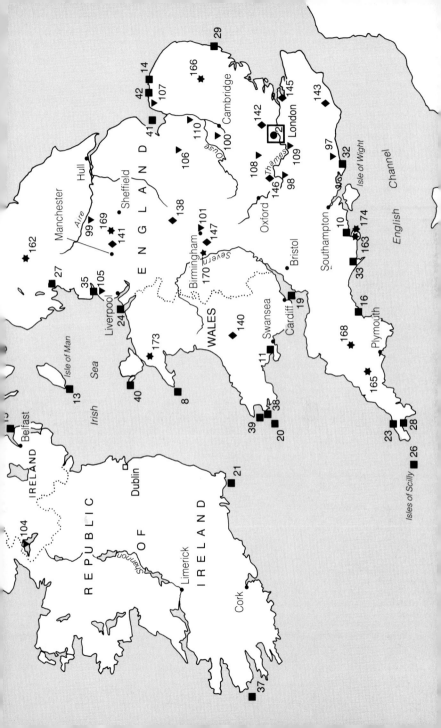

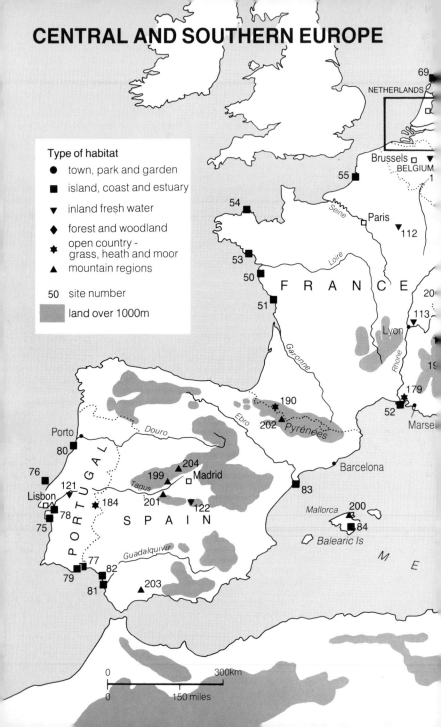

CENTRAL AND SOUTHERN EUROPE

Type of habitat

- ● town, park and garden
- ■ island, coast and estuary
- ▼ inland fresh water
- ◆ forest and woodland
- ★ open country - grass, heath and moor
- ▲ mountain regions

50 site number

land over 1000m

NETHERLANDS

69

Brussels
BELGIUM
1

55

Seine

Paris 112

54

53

Loire

50

F R A N C E

51

20

Garonne

113

Lyon

19

179

190

52

Marse

202 Pyrénées

Porto

Ebro

Douro

80

Barcelona

76

204

83

199 Madrid

Lisbon

121

Tagus

Mallorca 200

P O R T U G A L

184

201

84

78

122

Balearic Is

75

S P A I N

M

77

E

Guadalquivir

82

79

203

81

0 300km

0 150 miles

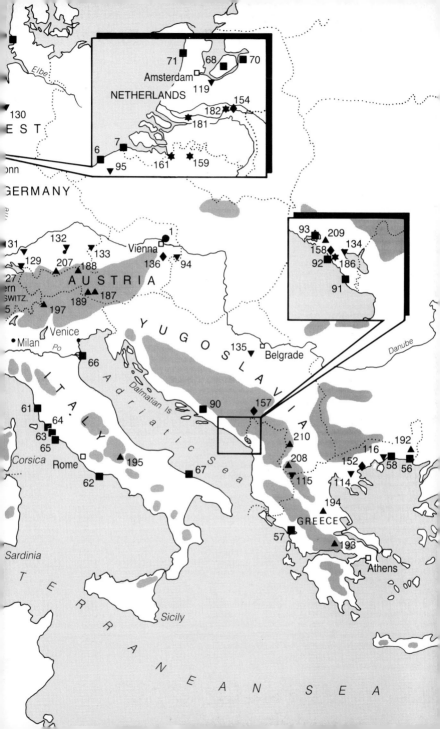

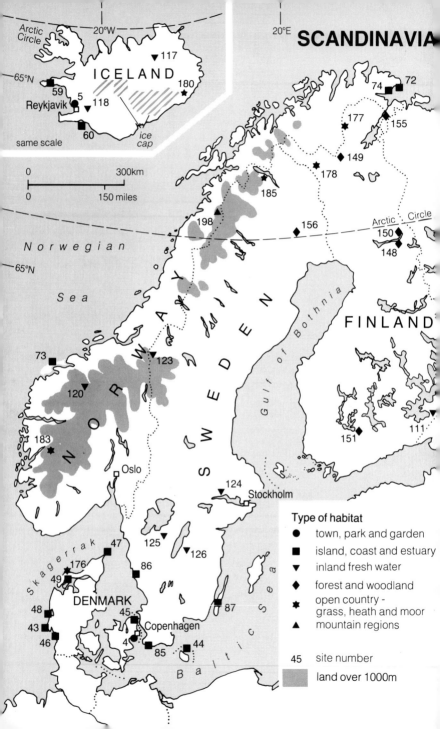

SCANDINAVIA

ICELAND

Arctic Circle

20°W 20°E

65°N

117

180

59
Reykjavik 5
 118
same scale
60

same scale

0 300km
0 150 miles

74 72

177

155

149

178

185

198

156

Arctic Circle

150
148

N o r w e g i a n

65°N

S e a

FINLAND

Gulf of Bothnia

73
120
123
151

183

N O R W A Y

S W E D E N

Oslo

124
Stockholm

125
126

Type of habitat

- ● town, park and garden
- ■ island, coast and estuary
- ▼ inland fresh water
- ◆ forest and woodland
- ✶ open country –
 grass, heath and moor
- ▲ mountain regions

45 site number

land over 1000m

47
176
49
48
43
46

Skagerrak

DENMARK

86

45
Copenhagen

4

85 44

87

B a l t i c S e a

111